OFF THE WALL

OTHER BOOKS BY CALVIN TOMKINS

OFF THE WALL

A Portrait of
Robert Rauschenberg

CALVIN TOMKINS

PICADOR / NEW YORK

www.picadorusa.com

Picador® is a U.S. registered trademark and is used by St. Martin's Press under license from Pan Books Limited.

For information on Picador Reading Group Guides, as well as ordering, please contact Picador.
Phone: 646-307-5629
Fax: 212-253-9627
E-mail: readinggroupguides@picadorusa.com

Much of the material in chapter 27 appeared, in somewhat different form, in *The New Yorker*.

ISBN 0-312-42585-6
EAN 978-0-312-42585-2

First published in the United States by Doubleday & Company, Inc.

10 9 8 7 6 5

ACKNOWLEDGMENTS

A good deal of the material in this book has been drawn from interviews for "Profiles" and other articles that have appeared over the last forty years in *The New Yorker*. (The newly added Chapter 27 ran, in somewhat different form, as a Profile in the issue of May 23, 2005.) My debt to the magazine, its editors, and its staff is immense. I am also indebted to the many people who submitted to being interviewed—more than once in some cases—at what must have seemed inordinate length. They are too numerous to list here, but I would like to extend my warmest thanks to Bob Rauschenberg and his coworkers and associates, especially Darryl Pottorf, Bradley Jeffries, and David White. Without their good-humored tolerance and trust, the book could not have been written.

CALVIN TOMKINS

CONTENTS

PREFACE TO THE NEW EDITION

In the late nineteen-fifties, when I was just starting to look at contemporary art, a painting at the Museum of Modern Art stopped me cold. It was in an exhibition called "Sixteen Americans," and the artist, whose name sounded vaguely familiar but whose work I'd never seen, was Robert Rauschenberg. The painting—its title was *Double Feature*—was covered with a number of apparently unrelated passages of messy paint, some of it dripping down in the Abstract Expressionist style, along with several odd collage elements: magazine photographs, stenciled letters, a segment of a flattened umbrella, part of a man's shirt, with pocket, things which retained strong overtones of their previous existence in the real world while managing to look very much at home in this artwork. Glancing around to make sure nobody was watching me, I fished a quarter out of my pocket and slipped it into the pocket of the shirt in the painting. It was a dopey thing to do, but I felt good afterward. I'd made a connection to something that would become, for reasons I didn't even suspect, increasingly important to me. Marcel Duchamp claimed that the creative act is bipolar, in that it requires not only the artist who sets it in motion but also the spectator who interprets it, and by doing so completes the process. In that spirit, for the last

forty years it's been my ambition to write about contemporary art not as a critic or a judge, but as a participant.

I've written a good deal about Rauschenberg, starting with a *New Yorker* profile in 1964. We stayed in touch after that, and I went to all his New York shows. As my initial fascination with his work deepened into a conviction that he was one of the most inventive and influential artists of his generation, it seemed natural to make him the focus of this book, which deals with the radical changes that have made advanced visual art such a powerful force in the world. The book was published in 1980, four years after a huge Rauschenberg retrospective, appearing in five major U.S. museums, had enthroned him at the highest levels of art and fame. There would always be critics for whom Rauschenberg was too protean, too experimental, or too outrageous to be taken seriously as an artist, but by then the majority of his detractors had been won over. The 1976 retrospective, as Benjamin Forgey wrote in *Art News,* made it clear that Rauschenberg's work "encompasses a range of human experience that no other artist in our time has dared to take on."

After that, of course, it became modish to write Rauschenberg off as an artist. This sort of thing happens a lot, and not only in America. There was a period when people said Picasso had done nothing of interest after 1935; now the line was that Rauschenberg had lost his "edge" in the mid-sixties. Rauschenberg kept right on working, of course. Paintings, sculptures, prints, and drawings emerged from his various studios in too great profusion. He embarked on a quixotic, collaborative project called Rauschenberg Overseas Cultural Interchange (ROCI), which took him and his art to ten different countries in the service of world peace and understanding. The critical establishment largely ignored ROCI, and barely took notice of Rauschenberg's later work. It became possible for younger artists, coming of age in an art world whose basic assumptions Rauschenberg had challenged and significantly altered, to be unaware of his influence. That sort of myopia couldn't last. Another gigantic retrospective, at the Guggenheim Museum in 1997, made a number of more recent art reputations seem puny by comparison. Since then,

young artists have been rediscovering Rauschenberg, and his star is once again ascendant. I'd like to think that this edition of *Off the Wall*, revised and updated, will introduce new readers to the most all-encompassing artist of the last half-century, the irrepressible innovator who once said, in his generous, American way, that he wanted to create a situation "in which there was as much room for the viewer as for the artist."

OFF THE WALL

1

VENICE, 1964

More than once during the chaotic week before the opening, Alan Solomon, the United States Commissioner for the 1964 Venice Biennale, had the distinct impression that too many people were trying in too many languages to tell him what to do. Some of them, like Alice Denney, his outspoken Vice-Commissioner, thought he was being too aggressive, too demanding. Leo Castelli seemed to think he was not being aggressive enough. Castelli's New York gallery represented both Robert Rauschenberg and Jasper Johns, which gave him a certain leverage. All the same it was annoying for Solomon to hear the rumors that Castelli was really running the American show at the Biennale this time, with the canny assistance of his ex-wife, the Paris dealer Ileana Sonnabend, a *mano fina* if ever there was one. The worst of it was that Rauschenberg, a strong contender for the Biennale's grand international prize in painting (a prize no American artist had yet won), was suddenly in danger of being disqualified through a series of mistakes that could be attributed to his, Solomon's, inexperience, or his aggressiveness, or both.

The problem was that only one of the twenty-two Rauschenberg works on exhibition was hanging in the official United States pavilion at the Biennale; the rest were installed in the former United States Consulate on the Grand Canal. Solomon thought this had all

been worked out months before.[1] The U.S. pavilion was a joke, an imitation-Georgian house with ridiculously oversized columns and hardly any space inside. Americans who visited the Biennale, the oldest and most prestigious of the great European art fairs, were nearly always surprised and chagrined to find that the U.S. pavilion was so much smaller than those of France, Britain, Germany, or even the Scandinavian countries. It had been erected in 1929 by the Grand Central Art Galleries, a private New York art firm that sponsored American participation in the Biennale until the Museum of Modern Art took over that function in 1948. When the museum dropped its sponsorship in 1962, pleading inadequate funds, the federal government stepped in at long last (all the other national exhibitions are government-sponsored), and entrusted the responsibility to the United States Information Agency, whose director at the time happened to be Edward R. Murrow. Instead of simply shouldering the financial end and asking the Museum of Modern Art to continue putting together exhibitions every two years, as had been anticipated, the USIA made inquiries around the art world and then offered the job of assembling the 1964 exhibition to Solomon, a gifted art scholar who had proved, during his previous year as director of the Jewish Museum in New York, to have a genius for installation and a lively sympathy for the latest currents in American art. (His opening show at the Jewish Museum was a major Rauschenberg retrospective, which helped to establish that artist as a hero to the younger generation; in 1964 he would devote an equally influential show to Johns.) Solomon asked for and was promised an entirely free hand in putting together the exhibition, and, pleased by the competence of the USIA people he talked with and by what he considered the new cultural tone of the Kennedy administration, he accepted the job.

There was some talk at this time (1963) of enlarging the American pavilion in Venice. The architect Philip Johnson had volunteered to design the addition free of charge, and the USIA had expressed interest. John F. Kennedy's assassination, which happened while Solomon was on his way to Venice that fall to make preliminary

arrangements, put an end to this plan; appropriations would be held up indefinitely during the transition period in Washington, and with only six months left until the Biennale opening, there would not be enough time to do anything. Shaken by the news from Dallas, uncertain whether to proceed with his mission or just turn around and go home, Solomon arrived in Venice and met the Biennale officials. He went out to the Giardini, the green park toward the Lido end of the island that serves as a permanent exhibition area, and inspected the United States pavilion. It struck him as hopelessly inadequate for the kind of exhibition he had in mind. Solomon had heard that other countries were sometimes given extra space to exhibit in the large Italian pavilion, but when he asked about this he was told that too many such requests had already been made. He then inquired whether it would be all right to show some of the American work in a building outside the Biennale grounds. This was a possibility, he was told. After looking at several spaces, Solomon was shown the former United States Consulate, directly across the Grand Canal from the Gritti Palace Hotel and adjoining the squat, rather ugly palazzo of Peggy Guggenheim. Officially closed a month earlier— one of a series of such closings in a State Department economy drive—the building still belonged to the U.S. Government, and its cool, graceful salons seemed made to order for exhibition purposes. After receiving from the president of the Biennale, Professor Mario Marcazzan, what he took to be adequate assurances that any paintings hanging there would be part of the official U.S. exhibit, he carefully measured the downstairs rooms and flew back to New York to start planning his show.

His plans, as they evolved, were characteristically ambitious. Solomon wanted to put on an exhibition that would wake the Europeans up to what American art had become in the last ten years—that would do for Europe, in a sense, what the 1913 Armory Show had done for America. Since the first, pioneer generation of New York Abstract Expressionists had already received some exposure at previous Biennales—Jackson Pollock and Willem de Kooning and others in a group show in 1950; a one-man de Kooning show in 1952—

Solomon decided to focus on the two major developments since Abstract Expressionism, as he saw them: the pure chromatic abstraction of Morris Louis and Kenneth Noland, and the highly complex paintings and assemblages of Rauschenberg and Johns, in which Abstract Expressionist techniques were brought to bear on subject matter taken straight from everyday life. In addition to these four "germinal" artists, Solomon was including the work of four younger men: Claes Oldenburg, Jim Dine, Frank Stella, and John Chamberlain.

In Europe, at least, Rauschenberg was already known. Still something of a *bête noire* in America, where his more outrageous constructions incorporating such flotsam as a stuffed chicken, a goat with a tire around its middle, and the artist's own quilt used as a canvas, were considered rather bad jokes by the older generation of Abstract Expressionists as well as by most art critics, the youthful, Texas-born artist recently had excited considerable attention in Paris, where Ileana Sonnabend had given him two shows in 1963, and also in London, where his retrospective exhibition at the Whitechapel Gallery the preceding February had broken all attendance records, and had led the *Sunday Telegraph*'s critic to call him "the most important American artist since Jackson Pollock." Rauschenberg's rapidly escalating reputation in Europe, among other factors, had helped Solomon decide that he could become the first American painter to win the Biennale.

The system of prize-giving at the Biennale traditionally gave rise to intense political in-fighting among the nations.* There were two major international awards, one of which usually went to a painter and the other to a sculptor (in 1964, each included a payment of $3,200). The City of Venice also gave prizes to outstanding Italian artists, and there were a number of other awards as well, but the two international prizes were the important ones, and only one American artist had ever taken one of those—Alexander Calder, for sculpture, in 1952. In fact, the only two Americans to win *painting* prizes of

*The prizes were abolished in 1970.

any kind at the Venice Biennale had been Mark Tobey in 1958 and James Abbott McNeill Whistler in 1895, the year the Biennale was inaugurated. Since the Second World War, the grand prize for painting had gone almost without exception to School of Paris artists with long-established reputations: Georges Braque in 1948, Henri Matisse in 1950, Raoul Dufy in 1952 (the year America was represented by de Kooning), Max Ernst in 1954, Jacques Villon in 1956, Jean Fautrier and Hans Hartung in 1960 (no sculpture prize that year), and Alfred Manessier in 1962. The spectacular rise of the New York School, which since the late forties had produced the strongest body of painting in contemporary art, which had helped to make New York the new capital of the international art world, and whose influence was now so widespread that a great many of the paintings on view at the 1964 Biennale, in pavilion after pavilion, looked like weak imitations of Pollock or de Kooning—all this had not received as yet the slightest notice from the juries of the Biennale.

The opportunity to change this situation was at hand, Solomon felt, except that part of the jury wanted to disqualify Rauschenberg because his work was not hanging on the Biennale grounds. Solomon had assembled a small Rauschenberg retrospective— twenty-two paintings and assemblages—and installed it magnificently in the Consulate, together with paintings by Johns, Stella, and Dine and sculptures by Oldenburg and Chamberlain. Noland's targets and chevron paintings and Louis's poured veils of color were hanging in the pavilion in the Giardini. Nearly everyone agreed that Solomon had done a brilliant job of installation, but now Professor Marcazzan was insisting that when he had told Solomon it would be all right to exhibit works outside the Biennale grounds, he had not meant to imply that such works would be eligible for prizes.

Marcazzan's duties included the selection of the seven Biennale judges, an exercise in finesse that was supposed to leave no nation feeling that its vital interests were being neglected. From nominations made by the commissioners of the thirty-four participating countries, he had selected two Italians, a Brazilian, a Pole, a Dutchman, a Swiss, and—at the very last moment, and supposedly under

great pressure from various sources—an American, Sam Hunter, the chairman of the art department at Brandeis University and a well-known art historian. Hunter had persuaded his fellow judges to come to the U.S. Consulate for a viewing, but the president of the jury had let it be known that he would never agree to award a prize to paintings hanging outside the official Biennale premises. (One small Rauschenberg *was* at the Biennale, in a temporary plywood shelter in the courtyard, together with a single work by each of the other Consulate artists, but nobody believed the judges would award the prize on the strength of one picture.)

The jury, in a preliminary poll, had voted four to three for Rauschenberg, Solomon learned, but the president had then threatened to resign in protest, and everything was uncertain. Rumor had it that the judges might compromise by giving the prize to Noland, in honor of the superiority of American painting in general; when Solomon heard that he announced that if Rauschenberg were disqualified he would withdraw all the Americans from competition. It was a classic Venetian tangle, worse even than the one in 1962 when the Canadian painter Jean-Paul Riopelle had been on his way to a victory party in his honor when he found out that the prize had gone instead to France's Alfred Manessier. All very upsetting to Solomon, who liked to think himself rather a *mano fina*, who even looked somewhat Venetian, with his neatly trimmed dark beard and his piercing dark eyes and his passable and rapidly improving command of Italian invective. Solomon rarely appeared at the Caffè Florian on the Piazza San Marco, which served as the main meeting place for the Biennale crowd, nor did he dine at Angelo's or at La Columba, the favored restaurants that year. At Florian's, Leo Castelli and his French second wife held court at one crowded table, receiving and dispensing the latest news and conjecture, while his first wife Ileana and *her* second husband, Michael Sonnabend, presided at another table nearby. The latest intelligence was that the painting prize would go to France's Roger Bissière or to Belgium's Karel Appel; the main sculpture award was reportedly a toss-up between France's Jean Ipousteguy and Zoltan Kemeny, a Hungarian

exile showing in the Swiss pavilion. Kemeny was considered such a strong bet that every one of his sculptures on exhibit had been sold, an indication of the value in crass, art market terms of winning a major Biennale award. Ileana Sonnabend, a formidable strategist in her quiet way, sighed with impatience when told yet again, by some new rumor-bearer, that it was too bad Rauschenberg was not going to get the prize. "I hate this game of politics that goes on here," she confided to Michael, "but I think if we are going to play it at all, we should play it right."

AT THIS CRITICAL JUNCTURE, RAUSCHENBERG HIMSELF ARRIVED IN Venice. He arrived in his capacity as stage manager and lighting director of Merce Cunningham's modern dance company, which was to perform in La Fenice theater the following evening. Cunningham's Venice engagement had been booked months in advance, but the timing was seen by some as another ploy in the Americans' game of pressure politics—especially since Rauschenberg's sets, costumes, and lighting received, in Venice, approximately equal billing with Cunningham's choreography and John Cage's music. Actually, Rauschenberg had been scheduled to come two days earlier, ahead of the company, to appear on a local radio show and be interviewed by the press, but several telephone calls from Castelli had convinced him that the political imbroglio was something he wanted to avoid. He stayed with the company at the Serenissima Hotel (far from serene, the dancers complained), and the next day he kept out of sight, working backstage at La Fenice. Late in the afternoon he made a quick visit to the Consulate to see Solomon's installation, which delighted him. "The pictures have the intimate feeling they used to have in the studio," he told Solomon. "The early ones look like kids—the kind that won't ever grow up." Rauschenberg also gave his approval to the repair of one of his smaller constructions, a piece called *Coca Cola Plan*, which incorporated three Coca-Cola bottles in a wooden frame. One of the bottles had been broken in transit, and Castelli and Count Giuseppe Panza di Biumo, who owned the work, had been enormously distressed to find that Euro-

pean Coke bottles were neither the same size nor the same hue as their American counterparts. A replacement had finally been flown in from New York, but Panza, the most energetic and dedicated European collector of the new American painting and sculpture, was anxious for the artist to see and approve the work before it went on exhibition.

Rauschenberg, who was thirty-eight years old, had the look of someone who was in no hurry to grow up, himself. An inch or so under six feet, slim, with neatly trimmed brown hair and boyishly handsome features, he had a way of listening and talking that made him seem open and friendly, which he was, and at times very unsophisticated, which he was not. He spoke slowly, in a resonant voice softened by an unplaceable but recognizably southern accent. Laughter had a way of overtaking him in mid-sentence. He got on wonderfully with the Italian stagehands, communicating through gestures and unself-conscious English and an occasional Italian phrase that he picked up (*"Lui prima,"* he said, marveling; *"lui prima.* Louis Prima?"), managing to seem relaxed in the midst of the most intense confusion. He was not drinking very heavily in those days, but there was always a bottle of Jack Daniel's around when he wanted it. His brown eyes were watchful and alert. "I have a peculiar kind of focus," he once told an interviewer. "I tend to see everything in sight."[2]

The tension that had started to build up between Rauschenberg, on one side, and Cunningham and Cage, on the other, was not yet evident to outsiders. Rauschenberg was several years younger than either of them, and his extravagant admiration for Cunningham had enabled him more or less to put aside his own painting for the six months during which he would be traveling with the company on its world tour. Collaboration had always been, for him, the ideal working situation, and there was no one he would rather collaborate with than Cunningham, the most rigorous, the most dazzlingly inventive modern dance choreographer since Martha Graham. John Cage, the composer, had been even more important to him than Cunningham. It had never been a question of influence. Cage once described their

friendship as a case of "understanding at first sight." But Cage had provided encouragement at a moment in Rauschenberg's young career when he needed it badly, and the example of Cage's work and Cage's attitude toward work and Cage's incorruptible experimentalism had been a continuing support and source of inspiration to the younger artist. They worked well together, these three, each one doing his job independently of the others, confident that they would do theirs and that the result, when lighting and music and dance came together on stage, would interest and often amaze them as much as it did the audience. There were tensions building up nevertheless, under the surface, and the fact that in Venice Rauschenberg was the focus of so much attention, the one most sought after for interviews, was not helping.

La Fenice is an architectural Fragonard, all gilded, sweeping curves and rococo accents and attendants in gold breeches and blue tunics, an intimate, eighteenth-century drawing room of a theater, where every seat seems close to the stage. The ticket crush in the lobby was appalling. Everyone in Venice, it appeared, not only wanted to get in but expected to get in, had influential friends who had *seen to it* that they would get in. What with the confusion and the shouting outside, the start of the performance was held up for nearly an hour, and the audience, impatient and keyed up, generated a volatile electricity of its own. In this setting, the Cunningham dancers surpassed themselves. Wild cheering shook the theater after and sometimes during each dance, countered by whistling and sustained booing, some of which was presumably directed at the electronic music by Cage and others, or at the Rauschenberg sets. The set for *Story* differed with each performance; it consisted, in fact, of whatever Rauschenberg happened to find lying around backstage or in the neighborhood where they were performing; on this occasion Rauschenberg had instructed several of the Italian stagehands to move about in the background, pushing brooms or carrying props. This seemed to infuriate certain highly vocal segments of the audience, but the Cunningham troupe was accustomed to this sort of reaction and the dancing never faltered. When Rauschenberg came out on stage with the dancers for one of their many curtain calls,

the cheering and the booing reached a new pitch, becoming positively warlike. The cultural pride of nations was clearly at stake.

Early the next morning, the Italian photographer Ugo Mulas took a picture that would be widely reproduced. It showed two men carefully lowering a large Rauschenberg painting into a motorized barge, in the stern of which another canvas was propped. Subsequent accounts in the press used the photograph as evidence of the Machiavellian plots surrounding the Biennale, as though the paintings were being moved illegally or in secret. The explanation was simpler. Alan Solomon had come to an understanding with the Biennale jury. He had agreed to move three Rauschenbergs from the Consulate to the U.S. pavilion in the Giardini, and the judges had agreed to award the international painting prize to Rauschenberg.

The news spread rapidly. By early evening, a victory party was in progress at Angelo's, organized by a group of younger Italian artists who had been passionately in favor of seeing Rauschenberg win the prize (their hero worship of Rauschenberg reflected at least in part their disillusion with the School of Paris). Through another misunderstanding, Rauschenberg had gone with Castelli and others to a dinner party elsewhere, but the artists at Angelo's carried on merrily without him, hoping he would show up sooner or later. When he finally did show up, much later, in the Piazza San Marco around midnight, the Italians rushed in a body to embrace him. They picked him up on their shoulders and paraded around the square, singing and cheering, and then everyone went back to Angelo's (where the waiters were cleaning up to go home) and stayed until four in the morning, drinking vodka provided by the Polish member of the jury, and champagne on the house.

Later that morning, after the formal prize ceremony in the Giardini (Rauschenberg for painting, Kemeny for sculpture), Leo Castelli threw another victory party for forty people, at a restaurant on the island of Burano. *Motoscafi* ferried us across the lagoon. The day was clear and warm, the seafood was delicious, the wine was sparkling. Lunch continued, course after course, for more than three hours at the long table. When it was over, and we were strolling in

small groups back to the dock, I asked Rauschenberg how he felt about winning the Biennale (I was working on a *New Yorker* profile of him at the time, and had come to Venice partly in anticipation of his victory). He thought for a minute, concentrating hard on the banal question. "That scene in San Marco yesterday really got to me," he said. "Butterflies in the stomach and a lump in the throat—like it really did mean something after all."

We walked on for a while in silence. Later—weeks later—I realized that what moved me so much in those few moments was the really intense effort he was making to understand what had happened to him. A lot of things in his life were about to change. The freedom that he had used to such brilliant excess in his own work might even be turned against him, now that the international art world had declared its stake in his career; whatever he did now would be done in public. "It's as though I've slipped into the wrong skin," he said, "which is a little bit scary. I mean, if your work is more or less all you're doing, you could get to feel sort of isolated. I'm starting to get this sense of, well, how difficult is it going to be to stay in touch?" He was silent for another several seconds. "And I can't afford to lose touch with myself," he added, laughing, "because that's really all I've got."

PORT ARTHUR

It used to be thought that growing up in America was a serious handicap for an artist. The society whose proper business was business neither valued nor understood the artist's role; culture, as everyone knew, was something that happened in Europe. The change in this point of view came about fairly recently. According to Marcel Duchamp (who exchanged his French passport for an American one in 1955), it occurred when American artists began to realize that they did not have to do battle constantly with the past—that they could virtually skip it and go straight to the new. "In France, in Europe," said Duchamp, "the young artists of any generation always act as grandsons of some great man—Poussin, for example, or Victor Hugo. They can't help it. Even if they don't believe in that, it gets into their system. And so when they come to produce something of their own, the tradition is nearly indestructible. This doesn't exist over here. You really don't give a damn about Shakespeare, you're not Shakespeare's grandsons. So it's a better terrain for new developments."

Until he was eighteen years old, Robert Rauschenberg never realized there was such a thing as *being an artist*. The drawings he did all through his childhood and adolescence were nothing special to him; he assumed anyone could draw. When he amused himself, one

long summer afternoon while he was alone in the house, by painting red fleur-de-lis all over the woodwork and furniture in his bedroom he expected to be punished for it, and he was. His sister Janet was ten years younger; she liked just about everything he did, which made her unique in the family. Throughout most of his early years, in fact, Rauschenberg was something of a misfit, a puzzle to his parents and an outsider to his peers, but somehow, to hear him describe it, his childhood was not unhappy.

He was born October 22, 1925, in Port Arthur, an oil refining town on the steamy Gulf Coast of Texas. Port Arthur is one foot below sea level, and it rained there nearly every day. Visitors to the Rauschenbergs' house would complain that the sheets were damp, but to this day Rauschenberg believes that he does his best work in a hot, moist climate and that he freezes up aesthetically in cold weather. The family was not poor, but there were some hard times. As a boy Rauschenberg remembers sleeping in the living room because the two bedrooms were rented out to boarders (his parents slept in the kitchen). Ernest Rauschenberg, his father, was the son of a Berlin doctor who had immigrated to the United States before the turn of the century and made his way to Texas, where he married a full-blooded Cherokee woman. Rauschenberg never knew his Indian grandmother, or any of his grandparents, three of whom died young of tuberculosis. His father worked for Gulf States Utilities, the local light and power company, but Ernest Rauschenberg's true vocations were hunting and fishing. He raised and trained the best bird dogs in that part of Texas; men would come from miles away to go duck hunting with him. Naturally he wanted his only son to learn how to shoot and fish, but Milton—the name they gave him, which he dropped permanently in 1947—had no talent for either. He was nearsighted, which nobody knew until much later. He couldn't hit anything with a shotgun, and he wasn't much better at catching fish, and so his father, who was a gentle and a rather easygoing man, masked his disappointment and let the boy go his own way. What interested him the most was collecting and caring for animals of all kinds. Janet remembers a period when he had as pets "a horned toad

frog, a nanny goat, a banty rooster, some goldfish, two adult hunting dogs that had a family of nine puppies." His parents didn't object. "My mother and father never paid too much attention to me," Rauschenberg recalls. "They were so close that there didn't seem to be too much room for anybody else. They'd sit holding hands. Until the last few years of my father's life they never spent a night apart."

Dora Rauschenberg (the former Dora Carolina Matson, from Galveston) had three younger sisters and a younger brother, and each of them came to live with the Rauschenbergs at one time or another. When one sister got married, another would move in to take her place. Family outings and churchgoing were the main social occasions. Both the elder Rauschenbergs belonged to the Church of Christ, an austere fundamentalist sect that frowned on social dancing, card-playing, movies, and almost everything else. "Our church was so strict that it was a full-time job for any Christian just to search for evils," according to Rauschenberg. "Even so, I was going to be a preacher until I was about thirteen. I was really serious about it. Finally I decided I couldn't spend the rest of my life thinking everybody else was going to hell, but I kept on going to church—I still went when I was in the Navy and for some time afterward. Giving that up was a major change in my life."

He had a consistently hard time at school. Learning to read was a problem, having to concentrate was a problem, and he lived with the nagging fear of falling further and further behind the others. He was no good at sports, and too shy to make more than one friend at a time (and that one changed fairly frequently). "The only way I related at all socially was that I loved to dance—in spite of or maybe because of the church—and I was considered quite good at it," he remembers. "Also I loved the school plays. I painted scenery, and I always volunteered for committees on publicity, on decorating for the dances, all that kind of thing. I only acted in a play once, and then of course I fell to pieces and couldn't remember my lines." For the most part he was a loner, an outsider, and yet, somehow, there was in his nature even then an odd streak of sophistication, an ironic humor that led him, for example, to run for class president in his se-

nior year at Jefferson High. "I liked the ridiculous notion that any-one as unpopular as I was should do that," he recalls. His campaign was novelty itself. One day he brought his pet goose to school; he went around releasing it in a room where a class was in session, shouting "Vote for Rauschenberg!" then running around to the other door to catch the flustered goose coming out. He painted posters of Veronica Lake saying "Vote for Rauschenberg." Veronica Lake was easy because you only had to draw one eye. Most of his classmates were simply bewildered by his electoral tactics, and he got only two votes.

No subject interested him until he took chemistry in the ninth grade. He liked the tactile aspect of it, working with real substances and liquids, and he got A's in all the tests, but the teacher gave him a D for the year because, as she put it to him, "You did so poorly in everything else that I knew you must be cheating."

Nobody ever said much about his drawings. He drew all the time, in the margins of his schoolbooks and on scraps of paper and pieces of wood and any available surface, but, as he said, he thought anybody could do that. It wasn't until he got into the Navy and started doing pencil sketches of his fellow recruits for them to send home that he started to see this as a special skill, something that others admired.

After graduating from high school in 1942, he made a deal with his parents about college. His father was hell-bent for him to go, of course; Ernest Rauschenberg had never gone beyond the third grade. Rauschenberg said he would go for a year, and they agreed that if af-ter that he didn't want to continue he wouldn't have to. What he re-ally wanted to be then was a veterinarian, but the only state school that offered courses in veterinary science was Texas A&M, and Rauschenberg didn't want to go there because it was a military school. Instead, he entered the school of pharmacy at the University of Texas in Austin, where he lasted a little more than six months. The crisis that ended his college career was not academic but disci-plinary: he refused to dissect a live frog in anatomy class. It was not just a quixotic gesture. He was willing, he said, to watch a classmate

dissect *his* frog, and then write a report on it; but having had any number of frogs as pets, Rauschenberg was not about to cut one up himself. Just before going to see the dean about it, he released his frog in some bushes. The dean suspended him. A month later, he got his notice from the draft board.

For young men of Rauschenberg's generation, the armed services provided a quick education in the indifference of authority. Decisions that quite literally affected life and death were in the hands of people who could hardly have cared less—who in fact could not afford to care. On the bus from Port Arthur to Houston to take their physical, several of Rauschenberg's fellow draftees were talking about the relative disadvantages of the two services, and each of them said he hoped he would get into the Navy rather than the Army. That afternoon, having passed all the tests, Rauschenberg went before a tribunal consisting of a bored army lieutenant and a very young navy ensign. They asked him which service he wanted, and he said the Army. They asked why. He didn't really want to be in either one, he explained, but he knew a lot of the others wanted Navy, so he figured he might as well choose Army. "Sounds like Navy material to me," said the lieutenant, with a smirk. The fact that he was one of only two men in the entire group selected for the Navy embarrassed him painfully.

At boot camp in Farragut, Idaho, he was an honor recruit. "I was so naive I'd do everything they told me," he remembers. "I would stand two watches in a row because my replacement didn't show up. The possibility of goofing off was something I didn't learn until much later." For the first time in his life he was popular. His pencil portraits were in great demand. "People kept telling me they wished they could do that, and I wasn't so dumb that I didn't take notice. Somewhere along in there I got hold of a set of oil paints. I started a portrait of a guy, and because the john was the only place with lights on after taps, I sat in there to finish it. When I ran out of red, I pricked my finger and rubbed it into the skin tone. I think the guy's name was Hubler."

When his group finished boot training, Rauschenberg told the

chief petty officer that they'd better not give him a gun because he was not going to shoot anybody. For this slight insubordination he was left behind at Farragut when the rest of the company shipped out. Two weeks later he was assigned to the hospital corps and sent out to San Diego Naval Hospital for training. For the next six months he shuttled back and forth among various medical facilities in California, until another chief decided he had the makings of a neuropsychiatric technician and sent him back to San Diego for further training. He spent the remainder of his service time—about a year and a half—at Camp Pendleton, near San Diego, working with everything from disturbed draftees to people with acute combat psychosis. The experience taught him a great deal. "This is where I learned how little difference there is between sanity and insanity and realized that a combination is essential," he said once.[1] "I did a good job, but mainly out of compassion. I didn't have enough objectivity—another couple of months and I would have been one of my own patients. I had a few tricks I'd developed, such as how to get everybody to go to bed: the guys would take bets on how many foots of beds I could walk across without falling, but they all had to be in bed before I'd start. Actually I always liked the patients best before they were cured, before they became boring and adjusted. I knew I was taking it too personally to be effective for any long time, although for a while I toyed with the idea of becoming a psychiatrist."

He was still making a lot of drawings, mainly portraits. He had had a major revelation in California, before going to Camp Pendleton, when he visited the Huntington Art Gallery in San Marino and saw original oil paintings for the first time. He had been on furlough, hitchhiking his way down the coast, and had gone to the Huntington Library because someone had told him about the gardens there; he didn't even know there was an art gallery. "It sounds really corny," he says, "but my moment of realization that there was such a thing as being an artist happened right there." Three paintings did it: *Pinkie* (Thomas Lawrence's portrait of Miss Sarah Moulton-Barett); Gainsborough's *The Blue Boy*; and Joshua Reynolds's portrait of *Sarah Siddons As the Tragic Muse*. Three bravura full-length por-

traits in a style that was once considered a pinnacle of the art of painting, and (who knows?) may someday be thought so again. He recognized the first two, having seen them in reproduction on the backs of playing cards, but the originals hit him very hard. As he described the experience years later to *Time*'s Robert Hughes, what struck him was "that someone had thought those things out and made them. Behind each of them was a man whose profession it was to make them. That just never occurred to me before."[2] Even today, he says, he can't remember seeing a brown painting as interesting as Reynolds's *Sarah Siddons*.

Painting was something you could do for a living, then, but it would be a while before Rauschenberg started to think of it as something he could do. He still assumed that when he got out of the Navy he would go back to Port Arthur to live. When he did get out, in the summer of 1945, he went straight home on the train, planning to surprise his family. He found the house occupied by total strangers. The family had moved away—his father's company had transferred him—and nobody had bothered to write and tell Rauschenberg. Too embarrassed to ask other family members where they had gone, he found out from a storekeeper that they had moved to Lafayette, Louisiana, about a five hours' drive from Port Arthur. He hitchhiked to Lafayette and went into a drugstore to look them up in the telephone book.

His father was having a cup of coffee at the counter.

MOSTLY MESSES

He didn't stay long in Lafayette. It was fun to be with Janet, ten years old and getting prettier all the time (at sixteen she was voted Louisiana Yam Queen), but he felt more distant than ever from his parents and their world. California seemed as much like home to him then as any other place, so that's where he went, to Los Angeles, early in 1946. For the next year he worked at a succession of menial jobs and lived in a succession of rooming houses, until Pat Pearman took him in hand.

They met when he came to work for Ballerina Bathing Suits, as a packer in the shipping room. She was an assistant designer there, a big, capable girl from Joplin, Missouri, good-looking in her way— Rauschenberg thought she was beautiful—with red hair and freckles and an open, friendly manner. He showed her his drawings, and she began urging him to take what she insisted on calling his talent seriously (Pat used to say cheerfully that she had no talent). They became close friends, in an older sister–younger brother sort of way. When Pat's mother got sick in Joplin, she had to quit her job and go home, but before leaving she made him promise that if she could arrange to get him enrolled in the Kansas City Art Institute, which was not far from her home, he would go. She wrote back almost immediately to say it was all arranged. The GI Bill would pay his tu-

ition and provide living expenses. He got together the bus fare by working for two days as a stand-in for a movie company.

It was three o'clock in the morning when his bus pulled into the Kansas City station. Sitting there in the nearly deserted terminal, drinking coffee and waiting until he could call Pat, he decided to change his name. He had always disliked his given name, Milton, and "Rauschenberg" was enough of a burden all by itself. What he wanted was a perfectly common name, Bob or John, and right there in the bus station he made up his mind that the first person who asked him his name, he would say "Bob," and if that person believed him it would be Bob from then on. As it happened, the first person to ask was the registrar at the Art Institute, who seemed to have no trouble at all believing him. (Later he found that people would also accept "Robert.")

The Kansas City Art Institute has probably never had a more enthusiastic student than Rauschenberg. He took every course he could squeeze in, day and night, approaching each with an acquisitive energy that made some of his teachers nervous. In addition he had three paying jobs. One was building sets for a movie company that specialized in short features on local businesses; another was making models for industrial exhibits; the third involved doing window displays for a haberdashery and novelty store near the Institute. In retrospect, he thinks he got more out of these jobs than he did from his formal courses. He was completely responsible for the finished product in each case, and being able to satisfy the clients gave him confidence and a sense of professional pride. He earned good money, most of which he put aside to finance his trip to Paris. He had heard that if you wanted to be an artist you had to go to Paris to study. It wasn't true any more, but in Kansas City nobody knew that.

An artist's myth is not entirely of his own making, but the parts of it that he chooses to perpetuate can be revealing. Rauschenberg claims, for example, that on his way from Kansas City to Paris in February 1948, he got off the train at Newark, New Jersey, thinking the conductor had said "New York," and stayed in a YMCA there for three days before realizing his error. What stands out is the

artist's sense of his own naiveté. Susan Weil, his future wife, didn't find him excessively naive when they met in Paris two weeks later. But then Susan was only eighteen, and not many people seemed naive to her.

She was tiny and dark-haired and very bright, and, like Rauschenberg, extremely shy. She had been in a terrible accident as a child. A motorboat in which she was riding with her father and her older brother had caught fire and exploded; her brother died, and Susan had been frightfully burned—she was still scarred, and partially crippled in one leg. She had grown up in New Jersey, but when she was fourteen her family moved to New York City and she entered Dalton, the most progressive of the established Manhattan private schools. At Dalton she had studied art with Rufino Tamayo, the Mexican painter, and then with Aaron Kurzon and Vaclav Vytlacil, and by her senior year she knew very clearly what she wanted to do with her life. Rauschenberg did not seem to her, at first, to be nearly as sure about painting as she was. "Of course he had all that vitality and intelligence," she recalls, "but I felt he was trying to figure out whether painting was really for him." By chance they were living in the same *pension* in Montparnasse, on the Rue Stanislas, just off the Boulevard Raspail. She had come over with three other girls, whose parents had entrusted them to the care of an older woman as chaperone. Rauschenberg, who had crossed on a converted troopship loaded to the Plimsoll line with students, had made friends with one student who had a list of cheap places to stay, the Rue Stanislas *pension* among them. There were only two art schools in Paris that Americans could attend under the GI Bill, the Grande Chaumière and the Académie Julian; Rauschenberg had written to both, and had been accepted by the Julian. Since Susan was going there too, they could hardly not have met. Both of them later admitted to thinking the other was the worst student in the class.

Rauschenberg's work at this point still leaned heavily to portraits, done in a chaotic style that he did not know enough to call "expressionistic." Susan's paintings looked somewhat more advanced—all those art classes at Dalton—but they too were largely representa-

tional, with a lot of bright fauve colors. The Académie Julian offered little encouragement to either of them. The other students seemed complacent and un-serious, and the teaching, in the form of perfunctory criticism once a week, was hardly helpful, especially to Rauschenberg, who didn't understand a word of French. By the end of their second week they were pretty sure that you didn't have to study in Paris to be an artist. They went less and less often to the Académie. Instead, they took to the streets, wandering around with their sketch pads and oil crayons, absorbing the somewhat grim atmosphere of postwar Paris, where milk was still rationed and housewives could buy only one egg a week. They even persuaded some of the *pension*'s elderly residents to pose for portraits. The concierge was a dragon, but she let them use the downstairs front room as a studio, mainly because nobody else ever used it. There was an ancient oriental carpet on the floor, its design nearly obscured by years of grime. When one of them spilled a drop of paint on it, they would carefully put dabs of the same color in corresponding places so the concierge wouldn't notice. Gradually the parlor began to seem brighter and brighter.

They went together to the Louvre. Susan knew a good deal of art history, and could help him to place what he was looking at. They also went to galleries and saw, for the first time in Rauschenberg's case, canvases by the modern masters. Picasso made almost no sense to him; he liked Matisse better, for his economy and exactness. "I was so incredibly excessive," he says. "I'd even stopped using brushes in my work; I loved the medium so much I was painting with my hands, trying to get as involved as I could with the act of painting. What came out were mostly messes. I saw some of those things not too long ago, on a visit to Lafayette. Not having anything else to do, I thought it might be interesting to look at some of the stuff stored in the garage. They were really lousy, the ugliest paintings you've ever seen."

Their only encouragement in Paris came from one another. They were seriously in love, as it was still possible to be in 1948 without going to bed together—the chaperone saw to that. Susan went home

in late August. She was entering Black Mountain College in North Carolina that fall, mainly because her parents wanted her to go to college and she had found out that Aaron Kurzon would be teaching there. Rauschenberg had decided to apply to the same place, to be with Susan, but also because he had read an article in *Time* about Josef Albers, who had been for years the guiding intelligence at Black Mountain. Albers, a veteran of the Bauhaus in the thirties, was a master art teacher; the *Time* article called him the greatest disciplinarian in America. For Rauschenberg, who had come to the conclusion that discipline was what he needed most—that energy and emotion and an overpowering love of paint could not get him past the dead end of self-indulgence that he saw looming ahead of him—Albers seemed to embody the necessary next step.

He had to wait until his parents could send him money for his passage back. It was the only time in his adult life that he ever asked them for help. His ship ran into a hurricane and took fourteen days to cross. Rauschenberg went straight to Black Mountain for his interview, then home to Lafayette for a quick visit with the family. He entered after the fall term had begun, in October.

BLACK MOUNTAIN

Black Mountain College never had more than ninety students, and there were times when the enrollment slipped below twelve. In the twenty-three years of its precarious existence, though, from 1933 to 1956, this tiny enclave in the mountains of North Carolina became a sort of testing ground for ideas and attitudes that would help to shape the cultural climate of the nineteen sixties. Its faculty sometimes taught without pay rather than give up the experiment, and its students exemplified, twenty years before the Beat or the Hippie generations, the search for a "meaningful" counterculture. The college also attracted an amazing number of seminal American artists at critical moments in their development—Buckminster Fuller, John Cage, Merce Cunningham, Willem and Elaine de Kooning, Franz Kline, Charles Olson, Paul Goodman, and Josef Albers all taught there at one time or another—and the sympathetic attention of the Black Mountain community had an incalculable effect on their subsequent careers. For a small and sometimes rather foolish institution, Black Mountain cast a very long shadow.[1]

Controversy attended its very origin. John Andrew Rice, a professor of classics, had been fired from Rollins College in 1933 as a man "disruptive of peace and harmony," an iconoclast accused of such picturesque enormities as calling a chisel one of the world's most

beautiful objects, and, worse yet, helping to alienate a female student from her sorority. Although the charges against him were eventually dismissed by a two-man investigating committee of the American Association of University Professors, Rice left Rollins and so did eight teachers who had taken his side, and that fall Rice and three of his former colleagues started a new college in buildings that they rented from the Blue Ridge Assembly of the Protestant Church (which used them only in the summer), in a beautiful mountain valley not far from Asheville, North Carolina.

Rice shared many of the educational ideas of A. S. Neill, and from the start Black Mountain College had a good deal in common with Neill's Summerhill school in England. There were no fixed requirements—no required courses, no periodic exams, no rigid schedules. Students were expected to have an important voice in all matters affecting the school, and also to take the major responsibility for shaping their own education. The curriculum was divided into junior and senior divisions; before passing from junior to senior, a student had to pass a comprehensive series of oral and written tests, and it was up to the student to decide when he or she felt ready to do so. The same applied to graduation. Since few students ever felt ready for the final testing, not many graduated, although it was not unusual to stay six or seven years. Some students never found any place afterward that they liked so well, and there were others who could not have fitted in anywhere else.

One of Rice's guiding principles was that the arts should be at the center of the curriculum. Faculty members were chosen with this in mind, and students were encouraged to take courses in music, painting and drawing, drama, and poetry. In the thirties, this was rather a daring innovation, since American schools and colleges still treated the practice of art then as "fun and games," something quite apart from serious education. Although Rice was far from wanting to have a professional art school, he saw participation in the arts as the best kind of training for life. In his view this had nothing to do with "self-expression" and everything to do with the discovery of personal integrity, an integrity that came from dealing honestly with

materials, and that could be translated into dealing honestly with one's fellow creature/creator. "Don't ask me how or why I know it," Rice said, "but I know it: if I can't get the right man for art, then the thing won't work."

He got Josef Albers through a kind of long-distance intuition. The Bauhaus in Berlin, where Albers taught, had closed its doors in 1933 rather than accept Nazi party members on its staff. A number of Americans were already working then to get prominent German artists and intellectuals out of Germany, and when Rice, early in 1933, visited the Museum of Modern Art in New York to discuss his needs with Edward M. M. Warburg, Warburg called in Philip Johnson, who was then the museum's curator of architecture and industrial design, and Johnson suggested that Rice hire Albers to run the art department at Black Mountain. There was only one problem, Johnson said: Albers didn't speak English. Something about the way Johnson spoke of Albers convinced Rice that this didn't matter. "If you ever meet anybody who has seen a great teacher in action," he explained later, "something happens as soon as you mention his name. Something happens to the person that's talking to the person who's talking about him. You see a vision."[2] A cable was sent to Berlin inviting Albers to join the fledgling Black Mountain staff, letters were exchanged, and just before Thanksgiving 1933, Josef Albers and his wife, Anni, neither of whom had heard of North Carolina until a few months before, arrived at the Black Mountain train station.

"I want to open eyes," Albers said, in halting, newly acquired English, on his first day there. It was a fine description of his teaching method and of the philosophy behind it. The Bauhaus had always focused its attention on the necessary relationship between design and use, art and life. Albers, like Rice, had nothing but scorn for the excesses of self-expression; he believed that art's real role lay in the "training of consciousness," a process that involved learning to know the true nature of materials and of the relationships between them. In his *matière* studies at Black Mountain, he would have his students handle all kinds of materials—newspaper, straw, leaves,

stones, string, or wire—handle them at first without tools, so that the qualities of each could be clearly understood. In his drawing classes he told students to draw only what they saw, to "train the pencil to do what your eye sees" and not worry about self-expression or style. Sometimes he had them draw page after page of straight lines, training the hand to be steady.

As a teacher, Albers was authoritarian and rigid. He hated sloppiness. He could be witheringly sarcastic in class, to the point that many students detested and feared him. But he did open eyes. His old-school, European stiffness might have seemed absurdly out of place in a college where the students wore sandals and denim cut-offs, grew their own vegetables on the farm, and conversed on more or less equal terms with their other teachers, but Albers's teaching was what many of them remembered the longest.

In the fall of 1948, when Rauschenberg came to Black Mountain, Albers was in complete command there. Rice had been fired in 1940. His arrogance and general abrasiveness had offended too many people, and his open affair with a girl student had scandalized the college's oddly Puritan standards. A decade of schisms and faculty turnovers had followed, during which the Alberses (Anni Albers taught weaving, and was as authoritative in many ways as her husband) provided almost the sole link of continuity. The college had moved in 1941 from the rented church buildings to land it had purchased on Lake Eden, across the valley, and in spite of constant financial crises, a sharply fluctuating enrollment, and a great deal of hostile suspicion in the neighboring community (which tended to see the place as a behavioral sink of communism and free love), it had established itself in the minds of many people around the country as a place where new and interesting things were going on. A good deal of its outside reputation stemmed from the summer programs, which brought prominent or innovative people in to teach special workshops. The 1948 summer had been a particularly brilliant one. John Cage and Merce Cunningham, who had visited the campus for the first time that spring, were invited back for the summer session, Cunningham to offer a workshop in modern dance and Cage to

teach a course in "The Structure of Music and Choreography," an assignment that he somehow managed to convert into a summer-long series of concerts and lectures devoted to the music of Erik Satie. Willem de Kooning and his wife Elaine, also a painter, were there at Cage's suggestion, and so was the sculptor Richard Lippold. Albers himself had invited Buckminster Fuller, who captivated everyone with his "comprehensivist" thinking and his experimental geodesic dome, made of venetian blind slats and bolts, which failed to stand up when assembled; Fuller had said in advance that it probably wouldn't (the materials weren't right), and blithely referred to the experiment as "the supine dome." The summer had ended in a blaze of vanguard glory with the production of Satie's pre–World War I play, *Le Piège de Méduse*, translated for the occasion by Black Mountain's literature and writing teacher, Mary Caroline Richards, directed by a talented student named Arthur Penn, and starring Elaine de Kooning as Medusa, Cunningham as a "mechanical monkey," and Bucky Fuller as the Baron Medusa. While all this was taking place, the college itself was going through another of its administrative crises, which resolved itself in August by Albers's agreeing to become the new rector.

Nothing, that year, appears to have displeased Albers so much as having to teach Rauschenberg. "I represented everything he hated most," Rauschenberg himself once said. "Coming that way in mid-semester, and his knowing I'd been in Paris, I think he assumed I was going to be some kind of show-off. I was willing to submerge any desires I had into his discipline, but he never believed that. I don't think he ever realized it was his discipline I came for. I was Albers's dunce, the outstanding example of what he was *not* talking about. He'd pick up something of mine and say, 'This is the most stupid thing I have ever seen, I dun't even vant to know who did it.' If I hadn't had such great respect for him I could never have put up with the treatment."

Susan Weil confirms that Rauschenberg tried hard to please Albers, and to do what he wanted. The fact that he did not succeed has not prevented him from speaking of Albers ever since as his most im-

portant teacher. "He was a beautiful teacher and an impossible person," Rauschenberg said, fifteen years later. "He didn't teach you how to 'do art.' The focus was on the development of your own personal sense of looking. When he taught watercolor, for example, it was about learning the specific properties of watercolor—not about making a good picture. Drawing was about the efficient functioning of line. Color was about the flexibilities and the complex relationships colors have to one another. All these things in a sense were about—don't trust your own ideas, because things are more specific than that. I found his criticism in class so excruciating and devastating that I never asked for private criticism, which you could do there. Years later, though, I'm still learning what he taught me. What he taught had to do with the whole visual world, and it applies to whatever you're doing, gardening or painting or whatever."

Albers, who left Black Mountain for good in the spring of 1949 and subsequently became chairman of Yale's Art Department, refused in his later years to be drawn out on the subject of Rauschenberg. He had had many students, he said, and he could not be expected to remember them individually. Others on the Black Mountain faculty recall that he considered Rauschenberg frivolous and irritating, though, and there seems no reason to doubt Rauschenberg's sense of their relationship. What happened, as it turned out, was that Rauschenberg accepted Albers's teaching but rejected the intention behind it. Albers was a painter as well as a teacher, and he spent the last thirty years of his life painting squares—square canvases in which a square of one color encloses concentric squares of subtly different colors; knowing everything there was to know about color, he applied this knowledge in the purest possible distillation, working with the precision and patience of a scientist, imposing his own strict order on the chaos of nature. Albers's rule was to make order, but it was just this imposed order that Rauschenberg found he could not accept. When he learned from Albers that one color was as good as another, it became almost impossible for him to decide to use one color instead of another, because to decide would be to express a personal preference, and this

was something he did not want to do. His own freedom, when it came, was in direct opposition to Albers's kind of order.

If Albers found him frivolous, though, most of the other teachers and students found him friendly and appealing. He threw himself into the life of the college with great zest, taking every course he could fit in (including singing and Russian). He and Susan volunteered for the job of garbage collection; every student had to do some sort of community labor, and the trash, they found, often yielded up treasures they could use in the outlandish costumes they made for themselves and their friends. They were nearly always together—Albers called them "the Bobbsey Twins." On Sundays, though, Rauschenberg went to church in town with a beautiful black student named Dolores; he felt more at home in her church than in the whites-only Methodist one. "Albers noticed Dolores, too," he remembers. "He may have painted squares, but he had quite an eye for what he called 'the hills and the valleys.' "

As more and more is written about Black Mountain, it becomes clear that the place affected none of its students or teachers in exactly the same way. For some, the time they spent there remains in the memory as a sort of golden age, a period when they felt more free and more alive than ever before or since. Others recall more distinctly the frustrations and the contradictions. For one teacher, the defects were summed up in a comment made to him by a disconsolate fellow faculty member about the problems he was having rehearsing a play: "It's the students," he lamented. "They'll philosophize about the play, but they won't learn their lines."[3]

Both Rauschenberg and Susan Weil loved Black Mountain, and they both came back to it in later years. "I'm not sure I didn't learn more just from being there than from any class," Rauschenberg told me. "Which doesn't mean it was always smooth sailing. There was always some super-emotional revolution going on, with people on one side or the other, so that every morning at breakfast half the student body would be in tears. The year before Sue and I came it was about birds versus cats. The bird people wanted the cats out. The year we came it was communism. There was such a terrific amount

of activity going on all the time. We were all each other's means of growth, which may have had a lot to do with the way I've led the rest of my life."

By the end of the spring term, though, he felt an urge to leave. He had heard that "everything" was going on in New York just then—everything in this case meant the emergence of Abstract Expressionist painting. For all his naiveté and ingenuousness, Rauschenberg had a sure sense of what was right for him, a directional Geiger counter that some people found far from ingenuous and not entirely charming. He and Susan passed up the summer session (directed by Bucky Fuller, who put up a successful dome this time), and left at the beginning of June.

5

TRAGEDY, ECSTASY, DOOM, AND SO ON

Something unprecedented took place in American art during the rather spiritless decade following the Second World War. While the nation gave its divided attention to large events in other spheres— the fall of China to the Communists; the trial of Alger Hiss; the Soviet Union's acquisition of the atomic bomb; the Korean War—a small and virtually unknown group of New York painters changed the course of modern art, and created a body of work that will mark their historical era as indelibly as its dubious politics or its technological balance of terror.

The painters to whom the term "Abstract Expressionist" was applied, in 1946, by *The New Yorker* art critic Robert Coates,[1] did not represent a movement or a school. They ranged in style and attitude from Willem de Kooning, whose work was rarely altogether abstract, to Barnett Newman, who was never an expressionist. What drew them together was a common experience, an aesthetic breakthrough in middle life that led to the forging of a radical new style. Jackson Pollock led the way when he began, in 1947, to pour and drip ordinary house paint on unstretched canvas laid flat on the floor, producing complex networks of color in which there was no center of focus, no "composition" in the formal sense. De Kooning's epiphany took place the same year. He abandoned the closed and

cleanly outlined forms of late Cubism and produced a group of powerful black-and-white paintings that had a spontaneous, uncomposed look, pictures with the same "all-over" and "all-at-once" impact as Pollock's. "Jackson broke the ice," de Kooning would say some years later, giving his friend and rival full credit. But none of the painters in this first, pioneer wave were followers or imitators. Clyfford Still's great, slab-like color fields invaded by jagged vertical forms, which date from 1947, looked nothing like Pollock's tangled skeins. Franz Kline, who had always painted figuratively, made his breakthrough in 1949 when he looked at one of his sketches in a Bell-Opticon magnifier, and saw the rough, thrusting horizontals and verticals that became the basis of his new abstract style. Mark Rothko's mature style crystallized in 1949, in paintings where luminous rectangles of color float horizontally, one above the other, in a vertical space. And it was in 1948 that Barnett Newman began to paint his darkly brooding monochromes divided by one or more vertical stripes of a contrasting color or tone.

"At a certain moment the canvas began to appear to one American painter after another as an arena in which to act—rather than as a space in which to reproduce, redesign, analyze, or 'express' an object, actual or imagined. What was to go on the canvas was not a picture but an event." That was how the critic Harold Rosenberg described what had happened, in his famous 1952 essay on "The American Action Painters."[2] Rosenberg was referring specifically to Pollock and de Kooning (although he mentioned no names), and his famous, if somewhat melodramatic description applies much better to their agitated, gestural methods than it does to the more austere, reductive styles of Newman, Rothko, and Still. For the action painters, the process itself—the "encounter," as Rosenberg called it, between the individual and the canvas—had become the work's essential subject. Pollock painted with his whole body, moving around the edges of the canvas as it lay on the floor, weaving in and out with his webs of dripped pigment, performing a sort of dance whose rhythmic energy translated itself into paint. Such painting, Rosenberg insisted, was "inseparable from the biography of the

artist," and the test of its seriousness was "the degree to which the act on the canvas is an extension of the artist's total effort to make over his experience."[3]

While for Newman, Rothko, or Still the process and the act were carefully considered, rather than spontaneous, their post-conversion work had the same kind of "all-at-once" impact as Pollock's and de Kooning's. Their paintings were meant to be experienced whole, in a single rush of sensation. They were also intended to carry an emotional content commensurate with the emotion of the artist when he made them. "You might as well get one thing straight," Rothko once told an interviewer. "I'm not an abstractionist . . . I'm not interested in the relationship of color or form to anything else. I'm interested in expressing basic human emotions—tragedy, ecstasy, doom, and so on. And the fact that a lot of people break down and cry when confronted with my pictures shows that I can communicate those basic emotions . . . The people who weep before my pictures are having the same religious experience I had when I painted them."[4] In this sense of communicating emotion, the two strains of Abstract Expressionists were in perfect agreement. All these painters were after aesthetic big game—the biggest, the masterpiece—and as their paintings grew larger and larger in the late forties, the artists' self-confidence expanded accordingly. For the first time in America, a group of painters had created a new art that did not depend on European models. They knew it, and some of their friends knew it—poets and musicians, mostly, and a handful of critics—and by 1949 the word was starting to spread beyond their tiny underground circle. It would shortly become a cliché to announce that New York had replaced Paris as the vital, creative center of contemporary art. But how on earth had such an unlikely thing happened? What changes in the national psyche had beckoned that distinctly un-American muse to these shores—specifically, to mercantile New York?

WHEN HE WAS OFFERED THE OPPORTUNITY TO STUDY ABROAD, THE nineteenth-century American artist William Merritt Chase exclaimed with unwonted fervor, "My God! I'd rather go to Europe than to heaven!"[5] It was not an uncommon sentiment among Amer-

ican artists, most of whom did go abroad to study at one time or another in their careers, and some of whom, from Benjamin West to James Abbott McNeill Whistler, elected to stay there. Even the most self-consciously American artists of the last century followed European methods of picture-making; no new aesthetic idea had ever come from the new world.

The radical European art movements of the twentieth century seemed for a time to discourage American attempts at emulation. Confronted with the results of Fauvism, Cubism, and other advanced European trends at the New York Armory Show in 1913, American artists (with one or two notable exceptions, such as Stuart Davis and Arthur Dove) retreated into the backwashes of Regionalism—Thomas Hart Benton's mountaineers—or Social Realism, which Arshile Gorky once ironically defined as "poor art for poor people."[6] It was the Depression, oddly enough, that helped to fertilize this somewhat worked-out soil. One of the more successful of the Roosevelt administration's efforts to create jobs was the Federal Art Project of the WPA, which provided small salaries and art materials for a great many artists. Most of the future Abstract Expressionists were employed by the project—Gorky, Pollock, de Kooning, Rothko, William Baziotes, Adolph Gottlieb, Philip Guston, James Brooks. Few of them had ever been able before this to devote themselves entirely to painting, and the fact that they could paint any way they liked—the only requirement for those on the easel project (there was also a mural project) was that every so often they produce a painting, which might then be hung in a post office or some other government facility, or, perhaps, consigned to a storage closet—allowed much room for growth and experiment. The most important benefit that they drew from the experience, though, was finding each other. The project gave them a sense of community that few American artists experience, something akin to the solidarity provided by the cafe life in Paris. Barnett Newman, who had a teaching job at City College and was therefore ineligible for the WPA, said later that he had paid "a severe price for not being on the project with the other guys; in their eyes I wasn't a painter; I didn't have the label."[7]

The solidarity of the WPA days carried over for many of the New York artists after the project had ended. They kept in touch, looked regularly at each other's work, and met frequently for long and earnest discussions that usually centered on the latest news from Paris. One center of information was Hans Hofmann's art school on West Eighth Street. A European artist of the generation before the First World War, Hofmann had seen the emergence of Cubism at first hand in Paris; he had known Picasso, Braque, and Matisse, and later he had gone to Munich, where Kandinsky and Paul Klee were working. He brought to his American students a thorough grounding in the whole range of the modern movement—his teaching methods were based on Picasso's composition and Matisse's color; he also brought (which made an even deeper impression) the European artist's unswerving belief in the importance of art and of the artist's function in society. None of the leading Abstract Expressionists studied with Hofmann (who started his New York school in 1933), but they often dropped by his studio in the evening to hear his impromptu lectures, after which they usually went to a local cafeteria to continue the discussion. Nobody had the money to drink in bars then, but you could sit over a coffee at the local Horn & Hardart until the bums made life too miserable.

Several associations of like-minded artists took shape in New York in the thirties. Mark Rothko and Adolph Gottlieb were the leaders of a group called "The Ten," most of whom painted in fairly free representational styles. Another informal (and nameless) group formed around Gorky, de Kooning, the sculptor David Smith, and the older artists Stuart Davis and John Graham; their god was Picasso. The American Abstract Artists (AAA), a more formal association set up in 1936, looked to Piet Mondrian and the methods of Neoplasticism, which offered a set of rules for painting a modern picture in the style of pure geometric abstraction. None of the Abstract Expressionists belonged to AAA. One of their shared beliefs was that pure abstraction was a dead end—increasingly so in the light of ominous political developments in Europe. The youthful Robert Motherwell accused Mondrian of a "loss of contact with

historical reality," and of having failed "to express enough of the felt quality to deeply interest us."[8] All the Abstract Expressionists were marked by the romantic ambition in art. They wanted to expand the limits of the known in order to tap new sources of emotion and feeling.

They still looked to Europe for guidance, though, no doubt about that. Arshile Gorky, born in Armenia and brought to the United States when he was sixteen, spent most of his too-brief career painting skillful but frank imitations of Picasso, Matisse, Miró, and other School of Paris masters. When some new Picasso paintings appeared in New York in 1937, canvases on which the wet paint had been allowed to drip and run in places, a fellow artist kidded Gorky, saying, "Just when you've gotten Picasso's clean edge, he starts to run over." "If he drips, I drip," Gorky proudly replied.[9] Once Gorky called a meeting of the artists he knew, in de Kooning's studio, to announce that the time had come to acknowledge their "defeat." Since they could never catch up with Picasso, he proposed that they pool their talents and try to produce a masterpiece through collaboration. The response was not enthusiastic.

The New York artists devoured every issue of *Cahiers d'Art,* which documented the latest Paris developments, and naturally they all haunted the Museum of Modern Art, which, since its opening in 1929, had focused its attention on the European vanguard. Alfred H. Barr, Jr.'s brilliant exhibitions of "Cubism and Abstract Art" (1936), "Fantastic Art, Dada, and Surrealism" (1936), and "Picasso: Forty Years of His Art" (1939) provided first-hand familiarity with the key works of the modern movement and the ideas behind them. The museum was rapidly acquiring a comprehensive collection of these works, some through Barr's shrewd purchases, others as gifts from wealthy donors who trusted Barr's eye, and New York was well on its way to becoming the best place in the world to see modern art. Paris had no modern museum until 1939, and even then the French showed scant interest in collecting the masterworks of the School of Paris, and no interest whatsoever in the works of Kandinsky, Klee, and other artists who had the misfortune to live elsewhere.

The provincials in New York, in their eagerness to catch up with Europe, were in some ways ahead of the Paris avant-garde. By 1940, as the critic Clement Greenberg wrote later, "a number of relatively obscure American artists already possessed the fullest painting culture of their time."[10] It was at this crucial moment that the School of Paris arrived to sit out the war in New York.

Not quite *in toto*. Picasso, Matisse, and Miró, the big three, elected to stay behind and take their chances. But Marcel Duchamp, Fernand Léger, Jacques Lipchitz, Piet Mondrian, Amédée Ozenfant, Ossip Zadkine, and virtually all the leading French Surrealists—André Breton, Max Ernst, Yves Tanguy, Salvador Dali, André Masson, Marc Chagall, Kurt Seligmann, and Roberto Matta Echaurren—migrated to New York shortly before or after the fall of France in 1940. The Europeans did not mix too readily with the New York artists. Although the Surrealists adopted Gorky, Motherwell, David Hare, and one or two others into their circle, they remained for the most part somewhat aloof; Breton, the founder and "pope" of the movement, refused on principle to learn any English during the time he was here. But their presence in itself was invigorating, and it led a number of Americans to look more closely at Surrealism as a potential source of new ideas and energies.

Conceived by Breton in the early thirties as a literary movement, Surrealism drew its major inspiration from the revolutionary theories of Sigmund Freud and Karl Marx. Breton, himself a poet, had dragooned his followers into politics by attempting to ally the movement with the Communist Party in France, until it became depressingly clear that the Communists wanted no part of such undisciplined allies. For Breton, Surrealism meant permanent revolution. Its basic goal was to transform human life, not only politically but at the deepest emotional levels, and one of its principal means to this end was the exploration of the unconscious. The Surrealists had experimented with a variety of subconscious techniques designed to shatter rational (and therefore inhibiting) thought patterns: dream imagery, automatic writing and drawing, the use of chance effects. American artists were aware of this. Julien Levy had been showing

Surrealist work in his New York gallery since 1932, and Pollock and others had even made automatic drawings—letting the hand operate without conscious direction, e.g., while blindfolded. But now, stimulated by the Europeans' presence among them and in particular by Matta, the youngest of the Surrealist group and the only one who made a deliberate effort to get to know the New York artists, several of the Americans began to delve more deeply into Surrealist ideas.

Under the influence of Matta and Breton, Gorky found his way to a looser and more poetic form of abstraction that allowed him at last to break free of Picasso's influence. (His friendship with Matta eventually proved disastrous. Gorky's wife fell in love with the mercurial, Chilean-born Surrealist, and a year later, in despair over that and other blows of fate, Gorky committed suicide.) It has never been established whether or not Pollock knew about Max Ernst's experiments with dripped paint in the early forties in New York; Ernst's method was to drill holes in the bottom of a can and swing it over his canvas. Pollock did not begin his own dripped paintings until 1947, and when he did it was not simply one technique among others, as in Ernst's case, but a total immersion in the act of painting. About 1943, though, Pollock's canvases began to loosen up. Along with Rothko, Gottlieb, and others, Pollock also started to explore primitive myths and symbols as a form of abstract subject matter. Since primitive myth suggested Jung rather than Freud, it was not acceptable to Breton. (Pollock was in analysis with a Jungian at the time—his alcoholism and other psychiatric problems were responsible for the 4F draft board rating that kept him out of the armed services.) But for Pollock, mythical themes and symbols offered a useful means of tapping his own unconscious. "I am particularly impressed with their [i.e. the Europeans'] concept of the source of art being the unconscious," he said in 1944. "This idea interests me more than these specific painters, for the two artists I admire most, Picasso and Miró, are still abroad."[11]

The Surrealist headquarters in New York was Peggy Guggenheim's "Art of This Century" gallery, on the top floor of 30 West

Fifty-seventh Street. Peggy Guggenheim's passion for modern art had been shaped and channeled by Herbert Read, the British art historian, and by Marcel Duchamp, for whom her admiration was admittedly more than aesthetic. She had bought a large collection of modern works in Europe before the war, shopping for masterpieces in Paris until the German advance forced her to flee. She then managed to get her collection over to America. It included Max Ernst, the German-born Surrealist, whom she married soon after Pearl Harbor because, as she put it in her blithe autobiography, "I did not want to live in sin with an enemy alien."[12] Frederick Kiesler, the visionary Viennese architect and sculptor, designed her New York gallery-museum, whose unconventional look attracted a lot of publicity. One of the two rooms (the Surrealist gallery) resembled a dark tunnel, with curved walls on which the paintings were spotlighted for maximum dramatic effect. The other room was for abstract art, and the paintings there were mounted on what appeared at first glance to be baseball bats—rods with ball joints so they could be tilted to catch the best light. At the gallery's formal opening in October 1942, the ebullient Peggy, grown a trifle stout, wore one earring by Yves Tanguy (a former lover) and one by Alexander Calder, to show her impartiality between Surrealist and abstract art. At this point her interest lay exclusively with the European artists, and her gallery served as the principal meeting place for the European artists-in-exile.

On the advice of her young assistant Howard Putzel, Peggy had put on a group "Exhibition of Collage" in which she included, among the Europeans, works by Pollock, Baziotes, Motherwell, and Ad Reinhardt. Her 1943 "Spring Salon" again had works by Pollock, Baziotes, and Motherwell, and soon afterward, at Putzel's urging, she agreed to represent Mark Rothko and signed a contract with Pollock under which she would pay him $150 a month, against future commissions. At the time Pollock was working as a janitor and custodian at Peggy's uncle Solomon Guggenheim's Museum of Non-Objective Paintings (which later became the Guggenheim Museum); the arrangement meant he could quit his job there and devote

himself full time to painting. In the fall of 1943 she gave Pollock his first one-man show. The well-known modern art historian and curator James Johnson Sweeney wrote the catalog note; Clement Greenberg praised the pictures (in *The Nation*) as "among the strongest paintings I have seen yet by an American"; and Alfred Barr bought one of the works, *She-Wolf*, for MOMA. From then on Pollock was the gallery's center of attention, so much so that several of the European artists eventually left and went to Samuel Kootz's new gallery down the street.

Four other Americans had their first one-man New York shows at "Art of This Century": Baziotes, Hofmann, and Motherwell in 1944, and Clyfford Still in 1946. But Pollock was clearly the star. His dense, powerful paintings with their interlocking abstract forms reflected a growing confidence and daring. After seeing his 1945 show at "Art of This Century," Greenberg pronounced him "the strongest painter of his generation and perhaps the greatest one to appear since Miró"[13]—an astonishing perhaps. This was the year that Pollock moved out to The Springs, a quiet village near the eastern tip of Long Island. With a $2,000 loan from Peggy Guggenheim (to be repaid in pictures), he took a mortgage on a small farmhouse and married the painter Lee Krasner, with whom he had been living since 1941. Working in the country, coming to New York once a week to see his analyst and then, all too often, drinking himself into an incoherent stupor, Pollock became increasingly a figure of legend. Born in Cody, Wyoming, he liked to play the rugged outdoorsman, blurt cowboy truths, and pick fights in bars. His surliness to people who annoyed him and his western-style swagger tended to obscure the fact that he was a highly intelligent, sensitive, and cultivated man, and totally committed to art. Pollock knew how good he was, or could be, and the knowledge would not let him alone.

As soon as the war ended the Europeans went home. Peggy Guggenheim closed her gallery in 1947 and moved permanently to Venice. Max Ernst had run off with a young artist named Dorothea Tanning; one gathers that Peggy, at last, was a trifle weary of Surrealists. Her departure left her New York artists temporarily stranded,

for none of the established galleries would take them on. Even Pollock's reputation was shaky. The Museum of Modern Art had not included him in its 1946 exhibition of "Fourteen Americans," the first and, until 1952, the museum's only gesture of recognition toward what was just beginning to be called Abstract Expressionism. Peggy could not persuade anyone to take over her contract with Pollock, which by that time allowed him $300 a month to live on. Eventually Pollock, Rothko, Still, and Hans Hofmann (who had emerged as a painter only in 1947, when he showed at "Art of This Century") went to Betty Parsons, who had recently opened a new gallery on East Fifty-seventh Street. Baziotes and Motherwell went to Sam Kootz (Adolph Gottlieb was already there), and several others found a home with Charles Egan. De Kooning, whose underground reputation among the artists was equal to if not greater than Pollock's, had consistently refused to have a one-man show anywhere. He had great trouble finishing his pictures; he destroyed as many as he kept. Finally Egan persuaded him to have a show, in 1948. By this date de Kooning, influenced by Pollock's first series of dripped paintings, had broken through into his mature, gestural style. Catching fire from these two, artist after artist began to paint more freely, to abandon strict Cubist composition for spontaneous gesture. A surge of new energy and excitement permeated the loft studios around Tenth Street. Nobody was buying their work, but all the artists seemed to sense that something important was building up.

When the outside world did begin to take notice, the reactions were generally hostile. This was not the "new humanism" in the visual arts that Henry Luce's publications had been demanding, at fairly regular intervals, since the end of the war. *Life* did publish in 1948 the proceedings of its "Round Table on Modern Art,"[14] in the course of which three or four of the fifteen participants (critics and connoisseurs) spoke intelligently about the work of Pollock and others, and this in turn led to a two-page color spread on Pollock in 1949, with a text headed: "JACKSON POLLOCK—Is He the Greatest Living Painter in the United States?"[15] *Life* left the question hanging, and the article, which helped to make Pollock famous, did

nothing for his sales. *Time*'s snide jeers at "Jack the Dripper" were no more myopic, on the whole, than the attitude of the leading art magazines, most of which either ignored the new painting entirely or evaded it with faint praise. *Art News* was consistently hostile until Thomas B. Hess became its managing editor in 1948. The friendly critics Clement Greenberg, Harold Rosenberg, and Meyer Schapiro, writing in small-circulation magazines such as *The Nation* and *Partisan Review,* seemed to belong to the enclosed world of the artists themselves, a world that in the late forties, as Harold Rosenberg described it, had the feeling of a "stockade" surrounded by hostile or indifferent outsiders. In the forties, after all, a great many Americans still considered modern art a hoax or worse. The State Department canceled a European exhibition of seventy-nine contemporary American paintings in 1946 because of complaints by members of Congress (several of whom viewed the work as "Communistic"), and President Truman said at the time that, in his opinion, "so-called modern art is merely the vaporings of half-baked, lazy people."

Most of the Abstract Expressionists remember the late forties as a good time, a "pure" and honest period when they stood together against a society going fat and selfish. There were only about fifty modern artists living in New York then, and for the most part they all knew each other. They gave one another the necessary encouragement, helped to hang each other's shows, and didn't worry about sales because obviously there were not going to be any. Friendships were strong and intense. In the Cedar Street Tavern one night, Pollock and de Kooning got into an argument that became heated. De Kooning suddenly hit the much bigger Pollock in the face. Pollock looked surprised and a little dazed. "Aren't you going to do anything?" a bystander asked him. Pollock said, "What? Me hit an artist?"[16]

The stockade mentality led to the formation of The Club, which became the focal center for the New York artists and an important factor in their development. De Kooning, Kline, the sculptor Philip Pavia, and a few others used to meet regularly at the Waldorf Cafe-

teria on the corner of Sixth Avenue and Eighth Street, which stayed open until eleven at night—when it closed they would often continue talking under the awning of a nearby cigar store. As more and more artists sought to join in the running discussion, they decided to rent a loft where they could talk more privately and at leisure. They found one in the fall of 1949, at 39 East Eighth Street, and took up a collection to pay the rent and buy some secondhand chairs. At first The Club—or The Eighth Street Club, as it was sometimes called—restricted itself to panel discussions for members only, but gradually its activities expanded to include Friday night lectures by invited speakers, to which members could bring guests, and Sunday night social gatherings with music and dancing.[17] The Club really centered around de Kooning, the most universally admired of its members. Born and educated in Holland, he retained traces of a Dutch accent and had some difficulty speaking English, in spite of which he usually expressed himself with great acuteness. "Painting is a way of living," he said, "that is where the form of it lies"[18]—a credo that applied to him and, his admirers earnestly hoped, to themselves as well. De Kooning's total dedication to art, his refusal to exhibit before he was ready, his deep knowledge of art history, and his extraordinary personal charm had made him a charismatic figure, especially to women. Pollock hardly ever came to The Club, perhaps for that reason. On the nights he was in town, he preferred to sit out the discussions in the Cedar Street Tavern, on University Place a block or so away, where most of the artists usually showed up after Club meetings. The Cedar was another sort of club, a dingy neighborhood bar with booths in the back and a bartender who could often be talked into giving credit if an artist was broke. When the owner put in a television set, the artists made him take it out—it interfered with their conversation.

Eventually, though, the world outside the stockade did begin to take notice. The artists, who were not quite as aloof as they sometimes liked to suggest, had become increasingly conscious of the need to assert themselves publicly. In 1947 Motherwell and Rosenberg published the first issue of *Possibilities,* a sort of vanguard

house organ with statements by Pollock, Baziotes, Rothko, David Smith, and others; in the tradition of such publications, there was no second issue. When the Institute of Modern Art in Boston voted in 1948 to change its name to the Institute of Contemporary Art because, as its director explained, modern art was an obscure and hermetic style that communicated nothing, the New York artists organized a well-publicized protest meeting at the Museum of Modern Art. Two years later, eighteen Abstract Expressionist painters and ten sculptors sent an open letter to Roland L. Redmond, the president of the Metropolitan Museum of Art, which was preparing to hold an exhibition of "American Painting Today—1950." The letter, accusing the members of the museum's selection committee of being "notoriously hostile to advanced art," was printed on the front page of the *New York Times,* and after the show had opened *Life* ran a photograph of the eighteen artist "Irascibles," looking suitably truculent and, in Pollock's case, potentially dangerous. Pollock's fame was spreading rapidly, thanks in large part to the 1949 *Life* article. In the art schools that had proliferated around the country since the end of the war—part of the general boom in higher education—students and teachers were already splashing paint around in the loose-elbow style of Pollock and de Kooning, whose paintings most of them had seen only in reproductions. No more "well-made pictures" in tasteful School of Paris colors, no more painting with the wrist. The result was secondary; *process* was all. The New York painters, isolated as they felt they were, had given modern art a new dynamism and a new toughness that seemed to identify it as unmistakably American and in some ways unmistakably New York, with its gritty texture and harsh light. Tom Hess summed it up some years later as a "shift from aesthetics to ethics; the picture was no longer supposed to be Beautiful, but True—an accurate representation or equivalence of the artist's interior sensation and experience. If this meant that a painting had to look vulgar, battered, and clumsy—so much the better."[19]

WHITE NUMBERS

Rauschenberg and Susan Weil spent the summer of 1949 with her parents on Outer Island, a small, wooded place off the Connecticut coast where the Weils owned a summer house. Their style of living was a little hard for Rauschenberg to take in at first ("Salad on salad plates? A library, and a piano, and important people dropping in all the time—it was something I hadn't run into much in Port Arthur"). Susan's father had an independent income and wrote plays. Her mother came from a wealthy New Jersey family. They were both extremely good-looking, intelligent, energetic, and interested in the arts, and they accepted Rauschenberg with warmth. Susan had spent all her childhood summers on Outer Island. This was where she had been so badly burned in the boat explosion that killed her older brother, but the memory of that horror had receded into a haze of happy times and pleasant events; she loved the place, and Rauschenberg, who had never seen anything remotely like it, was entranced.

In the fall they both entered the Art Students League in New York. They were together constantly, but not *living* together—not in 1949. Susan lived with her parents in their apartment on East Eighty-seventh Street; Rauschenberg found a furnished room a few blocks farther east, beyond Third Avenue, for four dollars a week. Later he moved downtown to Willett Street, in a slum neighborhood

underneath the Williamsburg Bridge. He and some other League students had found a condemned building there, and talked the landlord into letting them use it in exchange for fixing up the premises. Willett Street was "the grimmest neighborhood" he ever lived in, he said once. "It seemed frightening to be inside, and even more frightening to be outside."

At the League, he took classes with Vaclav Vytlacil (one of Susan's former teachers at Dalton) and Morris Kantor, a somewhat academic painter who nevertheless managed to offer him some much-needed encouragement. One day in Kantor's life drawing class, Rauschenberg came into the room late and overheard a group of students asking Kantor what possible justification there could be for the kind of painting he was doing. On his easel at the moment was a maze-like design in white, with groups of numbers scratched into the white ground with a lead pencil. "Kantor said he didn't see any reason why I *shouldn't* be doing that," Rauschenberg remembers. "It wasn't his sort of thing, but his attitude was, 'Well, why not?' I was tremendously encouraged by that. In those days I was touched by the slightest evidence of toleration."

Students at the League worked for the most part on their own, with criticism once or twice a week if they asked for it. That winter Rauschenberg was feeling his way toward a personal approach, trying to apply what he had learned from Albers in ways that did not reflect Albers's ideas about order. "Albers's rule was to make order," as he said, "but I only consider myself successful when I do something that resembles the lack of order I sense." He no longer made messes. His paintings were small and often quite delicate, with semi-abstract images that were uniquely his own. In the *White Painting with Numbers* that the other students had complained about, there is a penciled-in box containing the words "The Lily White," which came from an old song he remembered hearing as a child in Port Arthur (later this became the title of the painting);[1] in the bottom right-hand corner is a five-pointed red star, which he painted in because he had just learned that art galleries used little red stars to indicate that a work has been sold. Some of his other pictures looked

like blowups of frames from animated films. In *Garden of Eden* a series of lollipop shapes marched across the surface in a row; all were black except the last, which was red. He painted constantly, at the League during the day and at Willett Street at night. He and Susan were both averaging five paintings a day. Most of these were later scraped off and painted over, to save buying new canvas.

Although the Weils liked Rauschenberg, his relationship with Susan bothered them increasingly. Mr. Weil spoke to them about it finally: when two people were constantly together, as they were, without being married, there was bound to be talk. On the spot (it was in a soda shop) Rauschenberg proposed that they get married. Susan said she would love to. It just had not occurred to him to ask before.

They were married in June, on Outer Island. Rauschenberg's mother and father and his sister Janet came from Lafayette for the ceremony; Susan could barely understand anything Ernest Rauschenberg said because of his deep-South accent. The best man was Donald Droll, who had been at Black Mountain with them (and who later became an art dealer). There was a wonderful party at the house afterward, and the bride and groom stayed on and on, as brides and grooms often do, but finally they left and drove to New York, and went up to the room that Droll had reserved for them that night at the Sherry-Netherland. The room was so elegant and formal that they couldn't stand to be in it; they left and spent the night instead in the Willett Street studio, with the rats and the roaches and the cracks in the wall. Afterward they went back to Outer Island. The Weils gave them the fish house that went with the property, and they spent the summer happily there, painting and swimming and lying in the sun.

That fall and winter they lived in a tiny ground-floor apartment on West Ninety-fifth Street, between Columbus and Amsterdam avenues. They continued to take classes at the League, but Susan was pregnant and it had become necessary to think about making some money. For a while they thought they could use their blueprints for that. Susan had fooled around with blueprint paper years before, at Dalton School, but like so many other things they did together it was impossible to say which of them invented the large-scale blueprints.

During the summer, they had found that they could go to blueprint supply houses and get sheets of it, free, from rolls that had been partly exposed. They experimented with larger and larger sheets, placing various objects down on the paper and then exposing it to the sun; when developed, the paper turned blue except in the areas that had been covered. One day they got Sue's younger brother, Jimmy, to lie down on the paper, and that was the start of the life-size figure studies. Back in New York that fall they kept on experimenting. Pat Pearman was the nude model for one of their most successful prints (and the only one that still exists as an independent work). Pat was married and living in New York then; the marriage had turned out to be a disaster, and she used to hide out from her husband in the Ninety-fifth Street apartment. By this time the Rauschenbergs had found that they could use a sun lamp instead of the sun, which made it almost like painting with light.

Everybody who saw the blueprints said they ought to do something with them commercially. Rauschenberg showed them to Eugene Moore, the display director for Bonwit Teller, and Moore liked them so much that he put them in all of Bonwit's windows on Fifth Avenue and around the corner on Fifty-seventh Street, and paid the Rauschenbergs a fee of five hundred dollars. The editors of *Life*'s "Speaking of Pictures" department were also intrigued, and the magazine sent a photographer and a model around to West Ninety-fifth Street to document the process. When Rauschenberg found out that the model was getting twenty-five dollars an hour, while all he would get was a hundred dollars, he was sufficiently annoyed to send a much larger bill. *Life* paid it, and ran the story in its April 9, 1951, issue. "Although the Rauschenbergs make blueprints for fun, they hope to turn them into screen and wallpaper designs," the accompanying article explained. Nothing like that ever materialized, but one of the full-length figure studies (with the title *Blueprint: Photogram for Mural Decoration*) was shown at the Museum of Modern Art that spring, in an exhibition called "Abstraction in Photography."

All the time he was trying to peddle the blueprints, Rauschenberg was also taking classes at the League and painting several pictures a

day. In his work at home (he had given up Willett Street) he was overflowing into collage. This was not an *educated* response to Picasso or to anything else, he maintains; it was simply inevitable, given his obsessive involvement with every aspect of picture-making, that he should take up this preeminently twentieth-century technique. For a while he was embarrassed to show the collages to Morris Kantor at the League, but when he finally did bring some in Kantor was very excited by them. What they showed was a quality that has marked Rauschenberg's work ever since—an absolutely unerring design sense. He juxtaposed totally unrelated images: a cutout illustration of several dozen clock faces; the inked imprint of his own foot; a tiny reproduction of a Monet seascape; a diagram of foot movements from a learn-to-dance manual; a cut-out portion of a magazine illustration reading "Should love come first?"—all of which appeared in a now-vanished collage called *Should Love Come First?* These images did not "harmonize," but somehow they worked together. The balance in a Rauschenberg is a balance of elements in tension, each one retaining its own freshness and individuality. Kantor evidently saw in the collages clear evidence of a young artist on the way to finding his own style.

On a snowy day that winter, Rauschenberg collected a bunch of his paintings and went to see Betty Parsons. Her gallery was the most advanced in town then—she showed Pollock, Rothko, Newman, and Still, among others—and his going there must have required somewhat more self-confidence than his own explanation of it would suggest. "She asked me, in her low voice, did I want criticism," he said, recalling the day a dozen years later. "I said no, I didn't. It wasn't criticism I wanted, but it's hard to say what I did want—just a response of some kind. It was the liveliest gallery, and I wanted to see what would happen, to see whether there was anything in what I was doing that related to the energy of her gallery. 'I only look at paintings on Tuesday,' she said. This was a Monday. 'Well,' I said, 'couldn't you pretend this is Tuesday?' She said all right, and told me to take the pictures into her office. I went in there and sat with my paintings, trying to figure out whether I should just

flee. Then Betty came in and I started to show them to her. 'You're going too fast,' she said. I was just trying to hurry up and get out of there. 'Well,' she said, 'I can't give you a show until May.' I was just flabbergasted. That hadn't even been in my mind. So I had a show at Betty's in May."

A PLACE WHERE ART GOES ON

Saul Steinberg once drew a portrait of Betty Parsons as a dog. The likeness is uncanny and not at all unflattering—the spaniel ear transformed into her straight, smooth hair, the high forehead instantly recognizable. "It is the philosophical forehead of Leonardo," according to Steinberg, "and of babies, and of spaniels. Like all the best art dealers, Betty has a fictitious quality, even physically. She looks like a photograph from a different period—you know who it is but you are not quite sure. If you look closely at Betty you see the Sphinx, the Garbo-like quality. And strictly *entre nous*, the Sphinx *is* doggy."

Betty Parsons came from a well-to-do, conservative, and thoroughly conventional New York family in which art was something that nice people did not discuss. Married at nineteen to a handsome drunkard, she went to Paris to divorce him and stayed there for ten years, having discovered that what she really wanted in life was to be an artist. She studied with Antoine Bourdelle, the sculptor, and with Ossip Zadkine, and she got to know most of the livelier spirits of the Paris art world. When the Depression cut off her funds she came back to America, but not to New York. She went out to Hollywood, where she supported herself by giving lessons in drawing and sculpture, painting portraits, and working in a liquor store. She also played tennis with Greta Garbo, for whom she was frequently mistaken. Even-

tually she came back east and started a small gallery in the basement of the Wakefield Bookshop on East Fifty-fifth Street. Here she presented Adolph Gottlieb's first abstract paintings, showed work by Joseph Cornell, Alfonso Ossorio, Theodoros Stamos, and others, and gave Saul Steinberg, newly arrived from Romania via Paris, his first exhibition. Her reputation for spotting new talent spread, and when Mortimer Brandt, an established Old Master dealer, decided to open a modern section in his gallery on Fifty-seventh Street he asked her to come and run it, which she did from 1944 to 1946. Brandt had the whole fifth floor of the building at 15 East Fifty-seventh Street. In 1946 he moved to another building nearby, and, having decided that he did not want to be bothered with modern art after all, told Mrs. Parsons to do whatever she liked with his former space. She rented half of it to Samuel Kootz, then took a deep breath, borrowed a thousand dollars apiece from four friends (Saul Steinberg was one of them), and opened the Betty Parsons Gallery.

From her opening show of "Northwest Coast Indian Painting," in the fall of 1946, it was clear that this was not going to be a conventional gallery. Most of the New York galleries then copied the European look, with dark, fabric-covered walls, thick carpets, and small paintings in elaborate frames—art presented as expensive decoration. Betty Parsons's was the first to look like an artist's loft studio: white walls, bare wood floors, no decoration—emphatically not a middle-class interior. Being an artist herself (as well as an aristocrat), Mrs. Parsons felt most at home with other artists, and her gallery was always, as Clement Greenberg once wrote, "a place where art goes on and is not just shown and sold."[1]

Her best friend and closest adviser in those years was Barnett Newman. Although he did not have his first one-man show until 1950, Newman had been a well-known art world figure for a decade or more. Some of his friends considered him principally a writer; he wrote a constant stream of articles and catalog essays calling attention to the new painting, and as early as 1943 he had predicted, in print, that America would soon become the new center of world art. He was gregarious and witty, a born talker, polemicist, theorizer, and

also a native New Yorker (almost the only one among the first-generation Abstract Expressionists) whose wife, Annalee, held an important job with the Board of Education. Newman himself once ran for mayor of New York, on a platform that advocated, among other things, playgrounds for adults. Although Mrs. Parsons often said that Newman had taught her more about aesthetics than any book she had ever read, Newman was no bookish intellectual. "Aesthetics," he once remarked, "is for artists as ornithology is for the birds."[2]

Newman had organized an exhibition of "Pre-Columbian Stone Sculpture" at the Wakefield Gallery when Betty Parsons was in charge there, and it was his idea to open the new Parsons Gallery with paintings (most of them borrowed from the basement of the American Museum of Natural History) of the Northwest Coast Indians, among whom, as Newman wrote in his catalog essay, "abstract art was the normal, well-understood, dominant tradition."[3] A few months later he put together a group show at Parsons called "The Ideographic Picture," with paintings by Clyfford Still, Hans Hofmann, Mark Rothko, Ad Reinhardt, Theodoros Stamos, and himself. "Spontaneous, and emerging from several points, there has arisen during the war years a new force in American painting that is the modern counterpart of the primitive art impulse," Newman wrote in the catalog to this important show. ". . . here is a group of artists who are not abstract painters, although working in what is known as the abstract style."[4] He was making a vital distinction. The artists in question were not abstract, according to Newman, because they were concerned not merely with spatial and color relationships but with subject matter of the most serious kind, with what Newman called the "pure idea . . . that makes contact with mystery—of life, of men, of nature, of the hard, black chaos that is death, or the grayer, softer chaos that is tragedy."[5] Newman was not alone in refusing to consider the new painting abstract. When Motherwell and Rothko set up an art school in 1948 they called it "Subjects of the Artist," to emphasize the great importance to them of just such emotional subject matter. The new American painting, they felt, was taking art back to its primitive origins in mystery and magic; the artist

was becoming once again a shaman, a seer in the true sense of one who sees profoundly into the depths of human experience. Newman was so much the spokesman for this aesthetic point of view that most of his contemporaries were surprised and not a little put out when he made his own artistic breakthrough, in 1948, into the "pure idea" of single-color paintings divided by one or more vertical stripes.

Although Betty Parsons listened productively to Newman, Arshile Gorky, and a few others, she was not afraid to trust her intuition or her own sure eye. What she looked for in painting was the sense of something behind the work, a sense of authority and conviction— "what Cézanne meant when he spoke of trying to paint what was behind the apple." Hofmann, Pollock, Still, and Rothko all came to her gallery from Peggy Guggenheim's because she was so obviously stirred by their work. "Picasso could never have done what Pollock did," she said, years later. "Pollock really released the imagination of this country, freed the creative urge. It was such an incredible period, really a magic time. It'll be another hundred years before anything like that comes again."

The trouble was, Betty Parsons often seemed to be more interested in her artists as artists than as clients. She loved them, but she couldn't sell enough of their work. In part this was a matter of timing. The climate in the early fifties was still extremely hostile to modern art. Pollock never made more than $5,340 from a painting sale during his lifetime, even after he left Parsons in 1952 to join the Sidney Janis Gallery (Janis sold Pollock's *One* to Ben Heller in 1953 for $8,000, and took a 33⅓ percent commission), and he never sold enough to alter his status as a poor man. Rothko's top price in his first show at Parsons was $150, and very few were sold. "Most of the artists don't think I'm tough enough," Mrs. Parsons said once, "that I don't go out and solicit, call people up all the time. I don't. I know how people hate that sort of thing because I hate it myself, so I don't do it." One evening in the early fifties, Rothko, Still, Pollock, and Newman came to her apartment for dinner. "They sat on the sofa in front of me, like the Four Horsemen of the Apocalypse, and suggested that I drop everyone else in the gallery, and they would make me the most famous

dealer in the world. They were right, too, probably, but I just didn't want that. I told them with my nature I liked a bigger garden, and they understood." All four left her eventually, and their financial success (posthumous in Pollock's case) followed their leaving.

Although the Abstract Expressionists were still selling poorly or not at all in the early fifties, their self-confidence was very much on the rise. It received a great boost from the Ninth Street Show in the spring of 1951, a self-generated group exhibition in a former Greenwich Village antique shop. The idea of having a group show originated when somebody at The Club mentioned that the building at 60 East Ninth Street, around the corner, was going to be demolished, and that meanwhile the vacated antique shop space on the ground floor was just sitting there. The Club itself did not want to get involved in sponsoring exhibitions, but several of its members now threw themselves into the job of organizing one. Leo Castelli, a Club member by virtue of his enthusiasm for the new art (he had not yet opened his gallery), put up the money to whitewash the space and to print the announcement, which Franz Kline designed. There was an installation committee, but most of the artists just came in, argued over space, and hung (or rehung) their own paintings. In the end there were sixty-one works by sixty-one artists, a brave display and the first chance anyone had had to see the full extent of the Abstract Expressionist conquest—a great many of the paintings in the show reflected the new, free-swinging, gestural style. Hundreds of people came to the festive opening (a banner had been stretched across Ninth Street), and for some of these it was a revelation. Alfred Barr, whose Museum of Modern Art had paid little attention thus far to Pollock or the others, spent several hours there. When Castelli brought him back to The Club afterward, where a victory celebration was in full swing, they were greeted by a spontaneous burst of applause.

One picture in the show that did not seem to have much to do with the predominant strain was Rauschenberg's white painting with numbers. It had also been in his show at Betty Parsons, that same month, along with sixteen others, not one of which was sold. That show had turned out to be rather a surprise to Mrs. Parsons

herself, because it contained very few of the canvases that she and Clyfford Still had picked out when they came to the Ninety-fifth Street apartment, a couple of months before. Rauschenberg had painted over most of those, convinced as he was in those days that the next one would be better. She had been surprised, but not too surprised—young artists did odd things. "I could see right off that he was on his own tangent," she said, "that he wasn't influenced by anyone else or in the school of anything."

Rauschenberg's first show at Parsons drew some mildly condescending reviews. "There is nothing niggardly in Bob Rauschenberg's power to invent," Stuart Preston wrote in the *New York Times*. "His works at the Betty Parsons Gallery introduce bits of looking glass, stylish doodles in black and white, and liberal helpings of silver paint. The fact that his pictures seem to be spawning grounds for ideas rather than finished conceptions gives them a restless look."[6] *Art News* described them as "large-scale, usually white-grounded canvases naively inscribed with a wavering and whimsical geometry."[7] Of them all, the white painting with numbers is the only survivor. He had taken it out of Betty Parsons's to hang in the Ninth Street Show, replacing it with another. Later, he stored all the Parsons paintings, together with some others he thought worth saving, in the Weils' house on Outer Island, and they were still there several years later when the house burned to the ground. The painting with numbers he had kept in New York.

There was not much in his first show that could be seen as a challenge to Abstract Expressionism. He was on his own tangent, true, but he was not making much noise about it, and the work was not at all self-assertive. Rauschenberg had looked very carefully at the paintings of the leading Abstract Expressionists, and had been, as he put it, both "bewildered and seduced." De Kooning and Pollock were doing some of their most impressive work in this period. In his 1950 show at Parsons, Pollock exhibited *Lavender Mist* and *Autumn Rhythm*, two of his masterpieces. De Kooning had started his series of "Woman" paintings, which shocked even his most ardent admirers by reintroducing the human image. Rauschenberg saw his first Franz Klines at the Egan Gallery in 1950, going there late one

afternoon when the lights in the gallery were out and the pictures struck him as powerful presences glowing in the dark. "I still didn't know what those people were doing," he recalls. "I'd never studied with anyone who even mentioned that they existed. I saw a Rothko show at Betty's—the room was filled with fever, really a charged atmosphere. But early on I had the feeling that there was enough room for everybody, and that no two people had to do it in the same way. Besides which I couldn't really emulate something I was so in awe of. I saw Pollock and all that other work, and I said, Okay, I can't go that way. It's possible that I discovered my own originality through a series of self-imposed detours."

His next detour would take him into much stranger terrain and please no one, the Abstract Expressionists least of all.

JOHN CAGE

Rauschenberg met John Cage for the first time in the spring of 1951, at the Betty Parsons Gallery. Cage made a point of looking at the work of young artists, and he had come in especially to see the Rauschenbergs, which he liked so much that he asked to have one; the price was unimportant, he said, because he couldn't pay anything. He went away with a pink-and-tan collage that would have been the second survivor from the Parsons show if Rauschenberg had not come to Cage's New York studio some time afterward and, finding no one at home, whiled away his time by painting over the picture in the black enamel he was using then.

Cage, with his dark hair standing straight up from his head in a medium-short brush (someone once suggested that this was how his excess mental energy escaped), made a fairly indelible impression; he was above medium height, with sharply defined features, a wide mouth, and a sunny, frank, and humorous nature that hardly prepared people for the radical cast of his thinking.

They saw each other often in New York that fall, and even collaborated on a twenty-two-foot-long Rauschenberg "print" created by automation; guided by Rauschenberg, Cage drove his Model A Ford through an inked section of downtown pavement and then across a series of twenty sheets of paper pasted together. Their real friendship

dates, however, from the summer of 1952, which they both spent at Black Mountain. The college had come to seem like a second home to Rauschenberg, a retreat from the pressures and anxieties of New York. He had come back in the fall of 1951, a little more than a month after Susan gave birth to their son, Christopher—had come back uninvited and unannounced, as it was possible for students to do there; Susan had seen nothing wrong or precipitate in his going, although her parents were not pleased. He had returned to spend most of that winter with his wife and son on West Ninety-fifth Street, going sporadically to the Art Students League and working, also sporadically, on free-lance window decorating jobs that he got through Gene Moore. But a strain had developed in their marriage, an uneasy restlessness that Rauschenberg would later attribute mainly to his own immaturity, his fear of being "too married." They both came down to Black Mountain in the early summer of 1952. Susan left after a few weeks, though, and Rauschenberg stayed on.

Cage had been invited by the Black Mountain music department to teach composition that summer, but because no students signed up for his course he did no formal teaching. Thirteen years older than Rauschenberg, an intellectual of the most adventurous kind, he had arrived via a series of arduous mental journeys at certain attitudes and convictions toward which the younger artist was still feeling his way instinctively. Their backgrounds were quite different. Cage, the son of an engineer and inventor, had grown up in southern California, where he was a straight-A student all through school and the valedictorian of his graduating class at Los Angeles High. At Pomona College, he had discovered Gertrude Stein, whose writings opened up to him the non-rational side of the modern movement. He dropped out at the end of his sophomore year and went to Paris. After briefly studying architecture there, he dropped that, too, and wandered about Europe for a year, trying his hand at painting, poetry, and even modern dance. Music had been his childhood passion, though; he remembers playing on the piano his parents had bought him while the movers were carrying it into the house. Eventually, having made his decision to dedicate his life to that art, he went back

to California to study with Arnold Schönberg, who was living then in Los Angeles.

Schönberg was to Cage what Albers had been to Rauschenberg, a stern disciplinarian (Austrian instead of German) who gave him no encouragement whatsoever. "In all the time I studied with Schönberg he never once led me to believe that my work was distinguished in any way," according to Cage. "He never praised my compositions, and when I commented on other students' work in class he held my comments up to ridicule. And yet I worshiped him like a god." Years later he was greatly cheered to hear from a mutual friend that Schönberg, speaking of Cage, had said that he was "not a composer, but an inventor—of genius."

Cage's early work, after his studies with Schönberg ended, was largely in the field of percussion music. He had no feeling for harmony, as he was the first to admit. Increasingly, moreover, it had struck him that sounds could be interesting in themselves—could be, in fact, music. Schönberg had always stressed the structural function of harmony, as a means of relating the parts to the whole. But in Cage's developing conception, traditional harmonic structure had been in a process of disintegration ever since Beethoven, a process that showed itself very clearly in the music of Wagner and in Schönberg's own twelve-tone, "serial" method of composition. What, after all, was so sacred about harmony? Of the four physical components of sound—pitch, timbre, loudness, and duration—harmony related only to pitch. It most certainly did not relate to silence, which Cage had come to consider an essential complement to sound. The only one of sound's four characteristics that *did* relate to silence was duration. Realizing this led Cage to begin experimenting with percussion music, based on rhythmic structures of carefully plotted time lengths. Later he found that this same system had been followed for centuries in India.

For a time in the late 1930s and early 1940s, his career was a rising one even within the somewhat sclerotic music establishment. His invention of the "prepared piano"—a method of damping the sound by inserting screws, pieces of wood or felt, and other impedimenta between the strings, thereby converting the instrument into a one-

person percussion orchestra with a wide range of sounds—won him an award from the Guggenheim Foundation and also from the National Academy of Arts and Letters, which cited him for "extending the boundaries of musical art." His percussion music was in demand with modern dance companies, which often had great difficulty finding modern scores they could dance to. CBS radio in Chicago had commissioned a piece from him, and the Museum of Modern Art, when Cage moved to New York in 1943, had sponsored an evening of his music. Cage agreed with Gertrude Stein's notion that all original art was irritating at first, though, and he tended to believe that when something that he did became generally acceptable, it was time to take the next step. By 1950, at any rate, he had moved into composing music by means of chance operations, with results that almost nobody found acceptable. He had also gone deeply into the study of Zen Buddhism, whose anti-rational and at times harsh logic took for him, as he said, the place of psychoanalysis. In his music he was moving away from ideas of order, structure, and control toward ideas of no-order, no-structure, and no-control. What he really proposed, in his music and in his life—for Cage was a great talker and proselytizer; like Rauschenberg, he had wanted as a child to become a minister—was nothing less than the overthrow of some of the most basic assumptions of Western art since the Renaissance. The power of art to communicate ideas and emotions, to organize human life into meaningful patterns, and to express universal truths had ceased, in Cage's view, to be worthy of effort. In place of an art created by the imagination, skill, and taste of the individual artist, Cage espoused an art of chance, in which every effort would be made to extinguish the artist's personality, his memory, and his desires.

Behind this seemingly negative quest lay an intensely positive idea. Cage had come to feel that art, in our time, was much less important than daily life, to which so many of us had become more or less oblivious. The real purpose of art was not, he felt, the creation of enduring masterpieces for the delectation of an elite class, but rather a perpetual process of discovery, in which everyone could participate. Art was "purposeless play," but this play was also "an affir-

mation of life—not an attempt to bring order out of chaos nor to
suggest improvements in creation, but simply to wake up to the very
life we're living, which is so excellent once one gets one's mind and
one's desires out of its way and lets it act of its own accord."[1] Cage
believed in breaking down all barriers between art and life, and not
for art's sake, either.

It was a strategy that found little favor among the Abstract Ex-
pressionists. Although de Kooning and Pollock made use of chance
effects, letting the paint run and drip in their spontaneous encoun-
ters with the canvas, they were not about to hand over the whole
process to accident. "It is only when I lose contact with the painting
that the result is a mess," Pollock had written.[2] This contact, this
control, was precisely what Cage wanted to give up. He wanted to
get beyond his own personal and imaginative limitations, to make
the jump into a whole new field of human awareness; by doing so he
believed that he could come closer to the true imitation of nature *in
her manner of operation*—a manner that, as contemporary physics
and biology were in the process of finding out, was largely indeter-
minate. The Abstract Expressionists continued to have great admi-
ration for Cage. They came to his concerts (as most of his fellow
musicians did not), they invited him to lecture at The Club, they fol-
lowed with interest the direction of his ideas. Cage was the music
editor of *Possibilities,* the short-lived but influential magazine of ad-
vanced art that came out in 1947. Some of the artists could even dis-
cern, in Cage's music, the same kind of "all-over" texture that
characterized Pollock's post-1947 paintings in which there was no
center of interest—field paintings, as they later came to be called.
But Cage's denial of the artist's central control was a heresy that
seemed to most of them simply negative or quixotic. They would
most likely have agreed with a remark made about this time by
Pierre Boulez, the leading French avant-garde composer, after meet-
ing Cage: "I love John's mind, but I hate what it thinks."

In Rauschenberg's case, Cage's thinking became an unexpected
source of support. "I didn't know then whether the way I was think-
ing was crazy or not," he recalls. "The fact that John was so cele-

bratedly intelligent gave me confidence he didn't even know I needed. The whole art world looked up to him then. And we did seem to agree about a lot of things." Cage goes further. "There was from the beginning a sense of absolute identification, or utter agreement, between us," he said. "So much so that there have been times, for example on a lecture platform when Bob was answering questions from the audience, that I've had the feeling I would have given the same answer, in almost the same words. I respond to circumstances as he would. Of course, we are very different people in a great many ways, but there has always been this sense of identification."

Cage was specifically encouraging about Rauschenberg's work. In the year since his show at Betty Parsons, Rauschenberg had moved in the direction of austerity, toward emptiness. At first his pictures had simply gone darker and darker—"night plants," he called them, with forms emerging from blackness. He limited his palette to matte and enamel blacks, white, and white with dirt rubbed into it to make rough-textured gray tones that could not be duplicated. He also used red lead, which takes on a different color when removed from the can. All this, he believes, was in reaction to Albers's teaching. "Albers believed that it was important to know everything there was to know about color, but he said that if you thought one color was better than another you were just expressing a personal preference. I really didn't trust my own taste, and I didn't want to do something that I knew would be just a personal preference of mine. I didn't want color to serve me, in other words—didn't want to use green to intensify red, because that would mean subordinating green."

At Black Mountain in the fall of 1951 he had reduced his palette even further, but in the opposite direction. He had made a series of white paintings with no images at all, canvases to which ordinary white house paint had been applied evenly with a roller. In several the identical white panels had been joined together to make larger paintings, up to nine feet long. "I always thought of the white paintings as being, not passive, but very—well, hypersensitive," he told an interviewer some years later. "So that one could look at them and almost see how many people were in the room by the shadows cast,

or what time of day it was." Shadows, reflections of moving or still objects, could usually be made out on these intensely white surfaces, proving, to Rauschenberg's satisfaction at least, that there was no such thing as an empty canvas. Life entered into them from the outside, without benefit of the artist's control.

John Cage once described the white paintings in an essay as "airports for lights, shadows, and particles."[3] Cage himself had been thinking for some time of making a piece of music that consisted entirely of silence. After seeing the white paintings for the first time, in the summer of 1952 at Black Mountain, he wrote his famous 4'33", a composition in three movements, lasting four minutes and thirty-three seconds, during which the pianist never touches a note (the pianist David Tudor solved the problem of delineating the movements by opening and closing the keyboard cover three times). At its first performance in Woodstock, New York, that August, Tudor played 4'33" in an auditorium that was open to the woods at the back; during the first movement, attentive listeners could hear the sound of the wind in the trees; during the second, rain began to fall; during the third, the audience added its own perplexed mutterings to the other "sounds not intended" by the composer. Whether this was a case of art imitating nature or nature imitating art is perhaps open to question.

After white, black. During the 1952 summer, Rauschenberg was busy dipping torn strips of newspaper into black paint and gluing them to canvases, then painting over them with more black. The torn newspapers provided a rough texture, activated the surface so that "even the first stroke in the painting had its own unique position in a gray map of words." Although it was easy to see the black paintings as aggressive, ugly, or "negative," in Rauschenberg's mind they were something quite different. "I was interested in getting complexity without their revealing much," he said. "In the fact that there was much to see but not much showing. I wanted to show that a painting could have the dignity of not calling attention to itself, that it could only be seen if you really looked at it." Like Cage, he was exploring ways of limiting the artist's control over the final result, principally by trying to make the viewer work harder and be-

come more involved in the process. "I don't want a painting to be just an expression of my personality," Rauschenberg said. "I feel it ought to be much better than that."

Cage knew what sort of reactions this would provoke. The musical establishment considered his own work a joke at this point. Cage believed that for artists of his and Rauschenberg's temperament it was necessary to develop an inner toughness and an almost total indifference to the opinions of others—not an angry, go-to-hell indifference but a firm conviction that the opinions of others were their affair rather than yours. An incident that summer gave him the opportunity to make this clear. "Bob knocked on the door to my studio one day, and brought in a painting he had just finished. It was a new one in the black series. I think he felt my reaction to it was not sufficiently enthusiastic. I had been very enthusiastic about his work, and he may have felt I was disappointed. In any case, I suddenly realized that he was terribly upset, close to tears. He asked me if there were something wrong with the painting. Well, I gave him a good talking-to about that. I told him he simply could not be dependent on anyone's opinion, that he could never, never look to another person for that sort of support."

Neither Rauschenberg nor Cage, to be sure, was without allies or admirers at Black Mountain that summer. The college had changed considerably since Rauschenberg's first visit in 1948. Albers had left, and the new rector and dominant spirit was Charles Olson, a six-foot-seven-inch, two-hundred-and-fifty-pound poet whose enormous energy was committed to turning Black Mountain into the true "arts center" it had never quite become. Under Olson's mercurial guidance, the college entered its truly radical, final phase—four years later it closed for good. In 1948, Cage had shocked and deeply offended the entire faculty (many of them German scholars in exile) by delivering a lecture in which he denounced Beethoven.* It is unlikely that anyone there for the 1952 summer session would have been

*By making harmony his structural principle, said Cage, "Beethoven was in error, and his influence, which has been as extensive as it is lamentable, has been deadening to the art of music."

shocked. The experimental impulse was so strong that some twenty to thirty people actually sat through Cage's reading, one night after dinner, of the entire Huang-Po Doctrine of Universal Mind, a decidedly abstruse Zen text, which took nearly three hours.

Rauschenberg's white and black paintings also received a tolerant viewing by the Black Mountain community. The black paintings were actually harder to accept, in part because one tended to associate them at first with burned or charred relics. On the other hand, Franz Kline and Jack Tworkov, New York artists down for the summer session, found them interesting. Kline supposedly said that one of them made him feel "helpless"—no one knew quite what he meant, or whether in fact he had said "hopeless," but it was taken as a compliment. Tworkov, whom Rauschenberg had met previously in New York, liked the energy and the directness of his approach; they became close friends, so much so that Tworkov undertook to store a number of the white and black paintings in his New York studio when the summer was over.

The great event of the 1952 summer at Black Mountain was something that Cage, who instigated it, called a "concerted action" but which is generally referred to simply as "The Event." According to Cage, it came about as a result of many different factors: the Black Mountain environment, the presence of so many lively young people and artists, the close feeling that existed among them, and Cage's own deep involvement in Zen and in the theatrical visions of Antonin Artaud, whose book *The Theater and Its Double* he had recently read. Cage, David Tudor, and Merce Cunningham, who were all at Black Mountain that summer, had occasionally talked about doing a theatrical piece in which a number of non-connected activities would take place within the same time structure, along the lines of Cage's work with Cunningham, in which Cage would write the music and Cunningham would choreograph the dance movements independently of one another, the only connection being the final one when music and dance unfolded at the same time on the same stage. As Cage recalls, he took it upon himself to carry out the idea, invited the people he wanted to collaborate with, and in one after-

noon, after consulting his cast, jotted down on a piece of paper a sort of rough scenario of what would take place.

The Event unfolded in the dining room after dinner that evening. Cage and his colleagues had arranged the chairs into a hollow square, four blocks of chairs facing inward with diagonal aisles between them. On each chair a white cup had been placed. The entire school came. What they witnessed is virtually impossible to pin down with any accuracy. In his book on Black Mountain, Martin Duberman describes the recollections of five eyewitnesses, whose accounts diverge so drastically that the result is hilarious.[4] Cage, at any rate, remembers that he stood on a ladder and delivered a lecture; that Cunningham danced a solo, around the audience and sometimes in the aisles between them, and that for much of the time he was followed by a small and interested dog; that Tudor played Cage's music on the piano; that Charles Olson and Mary Caroline Richards read sections of their poetry; that movies and still photographs were projected on Rauschenberg's white paintings, which had been hung at an angle from the rafters; and that Rauschenberg, whom Cage had wanted to involve personally, played old and scratchy phonograph records on an ancient windup Victrola with a loudspeaker horn. It took about an hour, and when it was over some students brought in coffee for the white cups.

The Event has gone down as the first multimedia spectacle, the precursor of the happenings and other "artists' theater" performances of the late 1950s and early 1960s. For most of those who saw it that evening, though, it was simply part of the Black Mountain experience—another far-out experiment, more ambitious perhaps but not essentially different from others that took place nearly every day. Cunningham remembers the audience being "caught" by it, "because they were never sure what was going to happen next," something that could also be said of the performers. Like most milestones, though, it did not seem as momentous at the time as it would in retrospect.

9

FETICCI PERSONALI

Susan Rauschenberg started divorce proceedings in the fall. Some of their friends thought she did not really want the divorce, and might not have asked for it if her family had not been so insistent. Rauschenberg's bisexual nature was apparent to everyone concerned by now (Rauschenberg included), but he and Susan were still in love, and still deeply dependent on one another, and the break was extremely painful for them both.

Shaken and depressed, Rauschenberg felt he had to get far away from the whole situation, and the opportunity to do so suddenly presented itself. Cy Twombly, a young artist who had been at Black Mountain that summer (he and Rauschenberg had met earlier at the Art Students League), was going to Europe on a grant from the Virginia Museum of Fine Arts, in Richmond, and he urged Rauschenberg to come along. Twombly's particular aesthetic tangent was as original as Rauschenberg's, and in some ways more fully developed. He was evolving a kind of abstract calligraphy that resembled at first glance a child's scribblings on a wall—the subtlety of line and color, the elegant sensibility behind the informal look of the work required closer scrutiny. Twombly came from Lexington, Virginia. His father, like Rauschenberg's, was an outdoorsman, a former pitcher for the Chicago White Sox, a former pro golfer, and in later years the

head of the athletic department at a small college. Rauschenberg greatly admired Twombly's work. He also admired Twombly's self-confident eccentricity and his tall, aristocratic good looks. They went to Rome together that October.

Rome was inexpensive and infinitely seductive. They lived in a flat on the Piazza di Spagna, at the foot of the Spanish Steps, and they covered most of the old city on foot. Rauschenberg had to be dragged to the museums; it struck Twombly as odd that someone as active as his friend should be so difficult to move. After a month or so of this it became clear that Twombly's museum grant, which had seemed such a great sum before they left, was not going to support two people for very long. Rauschenberg had brought three hundred dollars with him. When this had dwindled to about fifty, he decided to look for work.

At a cafe they met an American who told them he was making good money working for an American building contractor in North Africa. This sounded like a fine idea to Rauschenberg, who did not relish the prospect of spending the winter in their underheated apartment. He used his fifty dollars to buy an airplane ticket to Casablanca, where he presented himself confidently at the employment office of the U.S.-owned Atlas Construction Company. He was willing, he said, to do any sort of work. This turned out to be the wrong thing to say. Bureaucracy reigned at Atlas Construction. One had to apply for a specific grade of job, and one had to have papers and references. Sitting dejectedly on a bench outside the employment office, wondering what to do next, he looked up and saw a young woman from the office coming toward him. She had heard that he was from New York. They struck up a conversation, in the course of which it came out that she was from New York, too, and that she knew a number of artists there, about whom he was able to provide news. The young woman then said that perhaps she could help him get a job with Atlas after all, but that he would have to memorize a lot of information. She went back inside and returned, after an interval, with a folder from the files. The applicant to which it referred had been a shopkeeper. Rauschenberg spent the next hour memoriz-

ing his references and experience, after which he again presented himself at the employment office.

Neither he nor his benefactress had considered that he might draw the same interviewer he had talked with before, but this, of course, was what happened. The man asked him a few questions, jotted down some notes, and then said, without the slightest trace of disbelief, "Why didn't you tell me all this before?" He had simply needed some data for his own bureaucratic records. Rauschenberg got the job, at $350 a week. He spent the next two months as a shopkeeper, which, at Atlas Construction, consisted mainly of taking inventory. Rauschenberg would go around with two other employees, one French and one Arab (hiring regulations specified quotas of each); he would point to an item on a shelf, the Frenchman would take note of the item number and the quantity required, and the Arab would write it down. It was rather enlightening for Rauschenberg, who had always supposed jobs to have some correlation with work. When he had saved a thousand dollars, he quit.

North Africa fascinated him. Twombly flew down from Rome, and they took a bus to the edge of the Sahara, as far south as it was possible to go then. They went to Spanish Morocco and stayed for a time in Tetuán, where they met the American expatriate writer Paul Bowles. "It wasn't too satisfactory a meeting," according to Rauschenberg. "I'd heard he had known Gertrude Stein in Paris, and all I was interested in was his stories about her."

Before leaving Rome, Rauschenberg had decided that he would not do any painting while he was away. He took photographs instead, with his secondhand Rolleiflex. At Black Mountain he had studied photography with Hazel-Frieda Larsen, and had also met the photographers Harry Callahan and Aaron Siskind, and gone to lectures by Beaumont Newhall, the Museum of Modern Art's first curator of photographs. Rauschenberg had become so interested in photography, in fact, that he was forced to decide whether he wanted to be a photographer or a painter. He became obsessed at Black Mountain with the idea of photographing the entire United States, virtually foot by foot, an idea so ambitious that it would

probably have taken him, as he later calculated, about ten years just to get from Black Mountain to Asheville.

His photographs at Black Mountain and later are similar in several respects to his paintings and collages of that period, quiet images that envelop the viewer's attention without calling attention to themselves in any way: the inside of an old, black buggy; a shaft of sunlight falling diagonally across the back of a wooden chair in an empty room; a bare light bulb against a tin ceiling; a crumbling Roman wall with a torn poster of the recently dead Soviet leader and the headline reading STALIN É MORTO. Although his decision was to stick with painting, photographs became an important element in much of his subsequent work. One of his Black Mountain photographs, the black buggy, was moreover the first of his works to be acquired by any museum; Edward Steichen bought it for the Museum of Modern Art in 1952, six years before that institution acquired anything else by Rauschenberg.

Taking pictures, however—the actual process—never quite satisfied Rauschenberg's need for physical involvement in the medium. Even when he was traveling around North Africa he found it necessary to do something with his hands. He began making small collages and strange, primitive-looking objects—bones, hair, bits of cloth, broken fixtures, feathers, painted sticks, rocks, shells, and other flotsam, tied and tangled in lengths of rope or string. He also made some rough wooden boxes with objects inside them (this was before he had ever seen a work by Joseph Cornell). His materials were whatever he could find or pick up on the street. Two of the boxes involved sound; when you turned them gently, small stones fell across antique, hand-wrought nails, making a delicate, Cagean music. Other boxes were left open, with the idea that anyone could rearrange the objects in their compartments, or even add new ones. Several contained mirrors glued face to face, reflecting a miniature infinity. "*Scatole contemplative e feticci personali*," the owner of the Galleria dell' Obelisco called them, when he showed these curious objects that spring in Rome—"thought boxes and personal fetishes." The show, according to Rauschenberg, was considered a

joke by everyone, the gallery owner included. The objects were priced so low that several people bought them for laughs; Rauschenberg took his revenge by making others as much like those as possible, so that nobody would have an "exclusive."

Twombly had fallen in love with Rome and its inhabitants. He would return to it four years later, marry the daughter of the distinguished and wealthy Franchetti family (his in-laws had once owned the Ca' d'Oro in Venice; they had a large house in Rome, a castle in the Dolomites, and a house in Venice), sire a son, and settle down permanently in Rome. He was a well-known and very successful artist in Europe years before his reputation was established in the United States. For Rauschenberg, on the other hand, there was never the slightest possibility of becoming an expatriate. Six months abroad was plenty for him, and he had made enough money from his show in Rome to buy his passage home. First, however, he had to go up to Florence, where the avant-garde Galleria d'Arte Contemporanea was showing his *scatole* and *feticci*. The show opened on March 14. One of the more eminent Florentine art historians wrote a long review of it, covering half a page in a local newspaper. The critic described how, on his way to the exhibition, he had passed by the Uffizi with its treasures, had seen once again the Duomo and the Campanile and the great monuments of the city, had contemplated its noble and inspiring history as the cradle of the highest art, and then, at last, he had come to what he called the "psychological mess" at the Galleria d'Arte Contemporanea. His conclusion, after a good deal of scathing prose, was that the works of Robert Rauschenberg should be thrown into the Arno.

Rauschenberg had the review translated. His first thought about its conclusion, he claims, was "What a wonderful idea!" He was leaving Europe in a few days, and he had packing problems. Putting aside five or six of the objects to carry back with him on the plane, he bundled up the rest and, early on the Sunday morning before his Monday departure, he went walking along the Arno until he came to a fairly secluded spot where the water looked sufficiently deep— he didn't want somebody fishing the objects out later; it was impor-

tant to him that they "really disappear." Nobody saw him throw them in, and not one of them has ever been seen since. Rauschenberg insists that he was not making a Dadaist gesture, but he did say that he thought it might make the eminent art critic feel uneasy if he knew about it, so before leaving the next day he wrote him a note saying, in effect, "I took your advice."

When he was going through customs on his return to New York, the customs officer had him open the wicker trunk with the remaining boxes and rope-objects in it. "What are those?" the man inquired. Without thinking, Rauschenberg said they were ceremonial objects made by American Indians, and added the information that he had been lecturing in Europe on the culture of the American Indian. The official thought he looked a little young for a lecturer, but he passed him through anyway.

ENFANT TERRIBLE

He had come back with two wicker trunks and five dollars in cash, and for a while that spring and summer he lived on the far edge of poverty. With his customary good luck he found a loft on Fulton Street, near the fish market, a big attic space with twenty-foot ceilings but no heat or running water; the rent was fifteen dollars a month, but he talked the landlord into letting him have it for ten. A hose and bucket in the backyard served as his basin, and he bathed at friends' apartments, sometimes surreptitiously, asking to use the bathroom and taking a lightning shower at the same time. His food budget was fifteen cents a day, usually spent at Riker's cafeteria, and supplemented by bananas he picked up on the United Fruit Company's docks.

Living that far downtown, he saw few other artists. Most of the New York artists lived in Greenwich Village then, or farther uptown, and Rauschenberg could rarely afford the subway fare (still only a dime) to socialize. He liked the area around Fulton Street, the old wooden houses coexisting with steel skyscrapers, the river traffic, the clear sense, so quickly lost uptown, of New York as a seaport. From nine to six on weekdays the streets were full of people and activity, but in the evenings and on Saturdays and Sundays it was eerily quiet. During the summer he worked mostly at night. The loft was too hot during the daytime. He would get up early and take

the ferry to Staten Island and spend all day on the beach out there. Often he found things on the beach—castoff clothes, pieces of wood or metal—that he picked up and brought back with him, thinking he might use them in a collage. He was doing black paintings for the most part, but the North African boxes and rope-objects had quickened his interest in sculpture, and his paintings included more collage elements than the earlier ones had.

Betty Parsons was no longer his dealer. In later years Rauschenberg would say that he had been thrown out of the gallery because Barney Newman didn't like his white paintings and Ad Reinhardt didn't like his black ones, but the situation was a little more complicated than that. He had gone up to see Betty as soon as he got back from Europe, bringing one of the boxes that had been spared from the Arno. She said that Philip Johnson, who was coming in that same afternoon, might be interested. Rather than spend the extra dime on the subway, Rauschenberg waited around uptown for several hours. When he went back to the gallery, Betty said, "You're very lucky. I talked him into buying it." This bothered him. He didn't much like the idea that somebody should be talked into liking his work, but he desperately needed the twenty-five dollars he got from the sale. Some time afterward he borrowed the box back from Johnson for a show, and kept it for two years. He didn't want Johnson to have it unless he really wanted it, and when two years had gone by and Johnson had not asked for it back, he gave it away to a friend. The incident rather soured his relationship with Mrs. Parsons, and when she showed no great enthusiasm for his white and black paintings he concluded that she no longer cared to represent him.

Eleanor Ward, meanwhile, had decided that she wanted to show both Rauschenberg and Cy Twombly, who had also come back from Rome and who was dividing his time between the Fulton Street loft and his family's home in Virginia. Eleanor Ward was a woman of independent means who had recently opened the Stable Gallery, on Seventh Avenue between Fifty-seventh and Fifty-eighth streets, and she was on the lookout for new talent. Her first show, the preceding January, had been a direct successor to the 1951 Ninth Street Show, the group exhibition organized by several of the Abstract Expres-

sionists as an invitational salon. Although Rauschenberg had been away in Europe at the time, Jack Tworkov, his staunch ally, had managed against considerable opposition from other artists to get one of his black paintings into this first "Stable Annual" (as the continuing event came to be called; there were five in all). Tworkov kept urging Mrs. Ward to go down to Rauschenberg's studio, and early that summer she did go to Fulton Street, where she saw the white and black pictures and several of Twombly's abstractions. She offered them a joint show in the fall. When the two young artists came uptown to see the gallery, they discovered that it had an unused cellar that struck them as ideal for showing Rauschenberg's sculptures. Mrs. Ward was agreeable, so they spent the next few weeks cleaning it out. The building had once been a stable, and their labors were Augean. "Those boys worked like galley slaves," Mrs. Ward recalls. "Dozens and dozens of loads of junk had to be carted away, debris that was two to three feet thick on the floor. They whitewashed the floor and the walls and the ceiling. There was a sort of grating at one end of the room, high up, through which a little daylight filtered in, and it gave the whole room a sort of underwater feeling."

The Rauschenberg-Twombly show, which ran from September 15 to October 3, managed to offend and even to outrage a relatively large number of people. Twombly's scribblings seemed to many viewers almost as dismaying as Rauschenberg's all-white and all-black canvases, but the Rauschenberg "fetishes" and box sculptures in the cellar were the worst offenders. "I lost friends over that show," Mrs. Ward said. "A great many people really thought it was immoral. I had to remove the guest book from the gallery, because so many awful things were being written in it." More damaging from the artists' point of view were the angry reactions of their fellow artists. Barnett Newman was supposed to have said, when he saw the all-white Rauschenbergs, "What's the matter with him? Does he think it's easy?"[1] Some painters assumed that the whole thing was a joke—Albers's comeuppance, perhaps; spontaneity (in Twombly's case) carried to a self-mocking extreme. The white paintings were not entirely without precedent in modern art, of

course; the Italian Lucio Fontana had done a series of all-white pictures as early as 1946, and before that there had been the famous *Suprematist Composition: White on White* (1918) by the Russian Kasimir Malevich. The black pictures, on the other hand, struck any number of older artists as crude insults to the art of painting. "If he hates painting as much as that, why doesn't he quit and do something else?"—that was the question that kept coming back to Rauschenberg, in one form or another, long after the show had closed, and it worried and upset him for some time.

In spite of Cage's warning, Rauschenberg felt directly and personally responsible for the interpretation (or misinterpretation) of his work. Self-doubt, in fact, was a much more important part of his nature than anyone but his closest friends suspected. The white and black paintings, which the artist himself had thought rather modest and quiet, had evidently impressed a lot of people (other artists included) as aggressive, ugly, and full of the anger of negation; that being the case, Rauschenberg thought he had better find out whether there was any truth to these charges. He would test his own motives by turning from black and white to red, for him the most aggressive, the most difficult, the least austere color in the spectrum. In his Fulton Street loft, he began work on a new series of predominantly red paintings.

With several of them he began by pasting colored comic strips to the canvas, much as he had done with black-and-white newsprint in the black paintings—to make a lively ground, "so that whatever I did would be in addition to something that was already there." He also incorporated larger and more extraordinary collage elements than he had ever used before: mirrors; fabrics; a colored glass window attached to the top of the stretcher; a woman's silk umbrella flattened and glued down in a circle; electric light bulbs that blinked on and off. Ever since Picasso glued a fragment of commercially simulated chair-caning to the surface of a canvas in 1911, collage had been for many artists the most seductive of twentieth-century techniques. Collage enabled the artist to incorporate reality into art without imitating it. The method of juxtaposition, of setting one thing beside another without connective, seemed to reflect the break-

down of linear, sequential, cause-and-effect thinking in modern science, and in modern thought in general. Collage was all-at-once, like the front page of the *New York Times* (Marshall McLuhan's "information brushing information"). For the modern artist who had rejected illusionism, who wanted his creations to be "real" objects instead of imitations of the real, it was a marvelous tool. "I don't want a picture to look like something it isn't," Rauschenberg said. "I want it to look like something it is. And I think a picture is more like the real world when it's made out of the real world."

Rauschenberg had often been told, since his Betty Parsons show, that his work resembled that of the German artist Kurt Schwitters, whose exquisite collages of discarded bus tickets, cigarette papers, and other urban scraps had established him as one of the modern European masters, but in fact their work was not at all similar. With Schwitters, the collage elements took their place in tightly controlled, Cubist compositions to whose overall order they were subordinate. Rauschenberg, on the other hand, saw collage as another means to reproduce the non-order that characterized the life he saw around him. He also looked on it as a way to circumvent his own personal taste. Here again he was reacting to Albers's teaching. Albers insisted on knowing the true nature of materials so that he could exercise total control over them; Rauschenberg, who wanted no such control, sought to let the materials be themselves—or become themselves. In either case, personal self-expression was largely out the window. All his work, Rauschenberg increasingly felt, was a form of collaboration with materials. He wanted to work *with* them, rather than to have them work *for* him. He knew he could never eliminate his taste completely (here he and Cage disagreed), but it seemed to him that if only he could throw enough obstacles in the way of it, then taste might become just another element in the process, no more important or controlling than the rest.

Collage for Rauschenberg was a perpetual adventure. It was fun to search the beach or the city streets for objects he could use. He was always surprised by what he found, and the objects themselves never failed to suggest new possibilities, combinations he might never have thought of otherwise. They set up resistances that he found useful.

"Sometimes," he said, "you see a piece of metal, for example, of a certain shape and color, and you know just the place it's going to go in the picture, but then it doesn't go there after all; it's too big, or too heavy, or you don't have the tools to put it there, so you put it where it *will* go and then everything else in the picture has to be adjusted to that. Sometimes, of course, objects just insist on being themselves."*

THE STABLE SHOW HAD GONE A LONG WAY TOWARD ESTABLISHING RAU-schenberg as the new *enfant terrible* of the art world—Pollock, the previous titleholder, having ascended to the uncertain heights of America's "Greatest Living Painter?" He never particularly relished the role, and in his private life he refused to play it. When he did come uptown from Fulton Street, now and then, to attend a meeting at The Club or to nurse a single beer all night at the Cedar, he listened much more than he talked. It was really impossible to dislike him, even if you thought his work was a joke. He looked like a kind of all-American nice kid, with his neat suit and necktie, his short haircut, and his friendly grin. Besides which, he so obviously worshiped the Abstract Expressionist heroes. During the winter of 1953–54 he came uptown enough to get to know Kline, de Kooning, Philip Guston, Rothko, and one or two others fairly well. Kline fascinated him. A complete New Yorker (although he came originally from the coal country of western Pennsylvania), Kline could talk endlessly and entertainingly on virtually any subject, from Persian prints to the Brooklyn Dodgers. "When he was inspired with his images," Rauschenberg remembers, "you just couldn't believe that one sentence could follow another so brilliantly." In spite of such conversational rewards, though, Rauschenberg often found discussions at The Club pretty heavy going. There was a good deal of existentialist-derived talk about the artist's alienation from society, and the need for suffering, transcendence, and the tragic sense of

*Compare this to Picasso's statement, made in 1935: "I put all the things I like into my pictures. The things—so much the worse for them; they just have to put up with it."

life. Politics and current events in a period that saw the fall of Dien Bien Phu, the Army-McCarthy hearings, the Dulles doctrine of massive retaliation, and the Supreme Court decision on segregation—hardly anybody talked about those at The Club or the Cedar. The emphasis there was on the problems of the artist, the serious artist, in a society that ignored or sometimes threatened his existence. "They even assigned seriousness to certain colors," according to Rauschenberg. "It got into the poetry later, when the Beats started to hang around the New York artists. I used to think of that line in Allen Ginsberg's *Howl,* about 'the sad cup of coffee.' I've had cold coffee and hot coffee, good coffee and lousy coffee, but I've never had a sad cup of coffee."

Harold Rosenberg and others who were close to the first generation of Abstract Expressionists often took issue, in later years, with the tendency to describe their general outlook as gloomy, self-pitying, or "heavy." The artists enjoyed each other's company enormously, Rosenberg said; there were parties all the time, parties where you went and saw everyone else—the entire New York art world in one room!—and had a wonderful time. In the summer most of the New York artists went either to Provincetown, at the tip end of Cape Cod, or to East Hampton, Long Island, where they greatly enlivened the local scene. Tom Hess has described a famous East Hampton softball game organized by a group of artists in 1951, in the course of which Harold Rosenberg, the pitcher for one team, served up to Philip Pavia, the other side's heavy hitter, a ripe grapefruit that had been meticulously painted the night before by Willem and Elaine de Kooning and Franz Kline to look just like a softball, complete with *trompe l'oeil* stitching:

Pavia swung, and it exploded in a great ball of grapefruit juice. There was general laughter and little shouts of, "Come on, let's get on with the game."

Esteban Vicente came in from behind first base (where Ludwig Sander was stationed with a covered basket containing ammunition); he pitched the first ball over easily. Pavia swung. There was another ball of grapefruit juice in the air. More laughter. Finally they decided

that fun was fun, but now to continue play, seriously. Rosenberg came back to the mound. He smacked the softball to assure everyone of its Phenomenological Materiality. He pitched it over the plate. Pavia swung. It exploded into a wide, round cloud of coconut. "Look, look," shouted Pavia, as if he had always suspected that if you hit a baseball hard enough to break it, there would be coconut inside. Then, from nowhere, a crowd of kids appeared around home plate and began to pick up the fragments of coconut and eat them. They had to call the game.[2]

It may well be that the gloomier side of Abstract Expressionism has been overstressed; self-pity could hardly have been the predominant note of a movement that produced, after all, such magnificent results. At the same time, there is no denying that by 1954 the group solidarity of the first generation was starting to break up. Some of the artists (most notably Pollock and de Kooning) had already received fairly wide recognition, which led to occasional bad feelings on the part of others who had not. The Club (which Rauschenberg had been invited to join in 1951) had lost its intimate, friendly atmosphere. The membership was up over a hundred, and some of the founders had begun to feel that the newcomers were using it as a place to meet people who could advance their careers or help them get into the right galleries. The odor of careerism was so strong that Jack Tworkov and several others stopped going there in 1954.

Also, within the small and still very isolated art world, it had become difficult to like both Pollock *and* de Kooning. A rivalry had sprung up between the two champions, fanned by the two major critics associated with the movement. In his 1952 essay on "The American Action Painters," Harold Rosenberg had been referring mainly to de Kooning, whom he had come to see, since Gorky's death, as the strongest and most important of the New York painters. Clement Greenberg, on the other hand, remained totally dedicated to Pollock; Greenberg's writings had done much to establish Pollock's reputation, and he was so close to the artist that some people said he influenced his development.

Pollock came to the city infrequently, and when he did show up at

the Cedar his behavior was hardly endearing. On the wagon for two highly productive years, he had fallen off with a dismal crash in 1950, and his drinking had become increasingly self-destructive. Although he was doing some of his finest work between drinking bouts—his 1952 show at the Sidney Janis Gallery included both *Convergence* and *Blue Poles,* neither of which sold until later—he was also sick and depressed for long periods of time, and his appearances at the Cedar too often meant sodden, attention-begging scenes. One night, after Pollock had pulled Franz Kline off his bar stool three times in a row by grabbing his hair from behind and yanking it, Kline got up and slugged him in the stomach. Pollock, bent over in pain but laughing, gasped, "Not so hard."[3] He made offensive remarks to and about almost everybody. At The Club one evening when the discussion centered on Tom Hess's recently published *Abstract Painting: Background and American Phase,* the first important book on the new American painting, Pollock, making one of his rare appearances, disagreed angrily with several passages when they were read aloud, grumbled and cursed, and finally threw his copy of the book at de Kooning's feet.

"Why'd you do that?" de Kooning said. "It's a good book."

"It's a rotten book," Pollock shouted. "He treats you better than me."[4]

De Kooning himself admitted later that he was often jealous of Pollock, who said to him several times, "You know more, but I feel more." There is little doubt that de Kooning had been influenced by Pollock's breakthrough into his all-over, dripped-paint style, but de Kooning's own work really sprang from a profoundly different sensibility. De Kooning felt very much part of the tradition of Western European painting going back to the Renaissance. He worked slowly—incredibly slowly, scraping out and starting over again time after time, searching for the essential combination of color and form that would have the rightness, the lastingness of a Tintoretto or an Ingres. He spent nearly two years working on *Woman I,* the first painting in the "Woman" series that so upset his contemporaries. The apparition in 1953 of these overripe, appalling goddesses star-

tled artists and critics alike. To some they seemed a betrayal of abstract art, that holy cause; others simply found the figures ugly, repellent, and perverse. De Kooning himself was somewhat mystified by their monstrous proportions. "I always started with the idea of a young person, a beautiful woman," he said once. "I noticed them change. Somebody would step out—a middle-aged woman. I didn't mean to make them such monsters." Soon enough, of course, the shock subsided and they began to look quite different—as powerful and as beautiful, in their thick impastos of swirled and dragged pigment, as ancient Mesopotamian idols.

Images of the human face and form also appeared in Pollock's paintings in 1953, confounding the purists still further. Abstract theory, at any rate, held little appeal for either artist. In 1951 the Museum of Modern Art had held a symposium on "What Abstract Art Means to Me," with verbal statements by six artists. In the last paragraph of de Kooning's prepared statement (a paragraph that for some reason he did not read), de Kooning told a little story. "About twenty-four years ago," he wrote, "I knew a man in Hoboken, a German who used to visit us at the Dutch seamen's home. As far as he could remember, he was always hungry in Europe. He found a place in Hoboken where bread was sold a few days old . . . He bought big stacks of it and spread it on the floor in his flat and walked on it as on a soft carpet. I lost sight of him, but found out many years later that one of the other fellows met him again around Eighty-sixth Street. He had become some sort of Jugen Bund leader and took boys and girls to Bear Mountain on Sunday. He is still alive but quite old and is now a Communist. I could never figure him out, but now when I think of him, all that I can remember is that he had a very abstract look on his face."[5]

ALTHOUGH DE KOONING HAD A DARK SIDE TO HIS PERSONALITY, TOO—drunk, he could be as belligerent as Pollock—he often went out of his way to be kind to younger artists. When Rauschenberg and Twombly came up to New York from Black Mountain for a few days during the summer in 1952, de Kooning astonished them by

knocking on the door to Tworkov's studio, where they were staying (his own was next door), and taking them out to dinner. That night, Rauschenberg acquired his first de Kooning "drawing," idly doodled on a place mat. He got his second a year or so later; sneaking into de Kooning's studio when no one was there, he took a lot of photographs and stole a discarded drawing from the trash basket. "It was just total idolizing," he says.

De Kooning's painting style was a strong influence on Rauschenberg's own, as the new paintings made clear. The active, agitated brushstrokes, the impression of speed and energy (no matter how long a particular passage might have taken to paint), the runs and drips and splatters of wet pigment in Rauschenberg's red paintings were very much in the manner of the older artist, although when it came to collage the similarity ended. De Kooning would press newspapers down on still-wet paint, as an aid to drying it, and would sometimes allow the imprint of the text to remain in spots after the paper was removed. He would also cut out images from magazines—female mouths and eyes from *Playboy*; Miss Rheingold's toothy grin—and try them out on his "Woman" paintings, but only temporarily; collage didn't really interest him, and he would most always end up painting in his own mouths. What the two artists really shared was a certain attitude, a willingness to try anything, to include rather than to exclude, to subordinate ideas to process. De Kooning had nothing but scorn for the formalist doctrine, soon to become the dominant note in the writings of Clement Greenberg, that would reduce painting to its purest and most essential elements. "I'm not interested in 'abstracting' or taking things out or reducing painting," he said in 1950. "I paint this way because I can keep putting more and more things in it—drama, anger, pain, love, a figure, a horse, my ideas about space."[6] The multiplicity in Rauschenberg's work was of quite a different order, but the impetus behind it, the sense of affirmation, was just as strong.

De Kooning's style was so contagious, his personality so winning, and his integrity so complete that it was hard not to become a disciple. Some artists did just that. One prominent member of

The Club even took to dressing like him, wearing the same kind of sailor's woolen cap, and adapting the same slightly foreign speech patterns. To Rauschenberg's way of thinking, that sort of behavior was absurd. Wasn't it more insulting, really, to imitate the prevailing master than to try to find out something for yourself? Rauschenberg's real motive was curiosity, an intense and constantly renewed curiosity about what a picture was or was not, and his curiosity led him to test, more and more radically, the boundaries that other people had set up around art. If it was all right to use old bus tickets or bits of linoleum in a painting, he reasoned, then why not try using scraps of lumber left behind by Con Edison, or stacked-up paint cans, or an electric light bulb, or even (some irony here) cheap reproductions of famous art masterpieces?

The impulse was not a new one. Umberto Boccioni, the Futurist sculptor, had railed in 1912 against the hegemony of marble and bronze, and recommended the use of "glass, wood, cardboard, concrete, horsehair, leather, fabric, mirrors, electric light, etc." in sculpture.[7] In his book *The Cubist Painters,* published in 1913, Guillaume Apollinaire had argued for a similar catholicity of means, saying, "You may paint with whatever material you please, with pipes, postage stamps, postcards or playing cards, candelabra, pieces of oil cloth, collars, painted paper, newspapers."[8] Most of those items had found their way into art during the next three decades, along with a great many more. In Rauschenberg's case, he simply used what was available to him, wherever he happened to be.

In the winter of 1953–54 he tried using dirt as a material. He built shallow boxes and packed them with soil, which he tried to hold in place with lichens or waterglass. By chance, some birdseed got into one of the boxes and began to sprout, and this in turn gave him the idea to make a "grass painting," watered daily, which he put into the second Stable Annual in January 1954. Eleanor Ward refused at first to show it (she was not eager to lose the rest of her friends), and Tom Hess, who was helping the artists organize the an-

nual, had to talk her around. Rauschenberg made things worse by telling Mrs. Ward to think of the piece as a sculpture—"the only difference is that my grass grows a little faster than stone."

Inevitably, perhaps, Rauschenberg's probings and testings of the boundaries, to say nothing of his perennial high spirits, quick wit, and apparent self-confidence, left a number of his fellow artists feeling that he was a nice kid and all that but not, when you came down to it, a serious artist. He was not out to change the course of painting or to create a masterpiece, and he certainly was not interested in expressing the deeper emotions, his own or the age's. Jack Tworkov had been drawn to him immediately because of what he described as Rauschenberg's "high comic spirit," his attitude of "You never know how it's going to look until you do it, so let's do it," but Tworkov had a lot of difficulty persuading others to this view. The comic spirit has always been in short supply in the visual arts, of course; it sustained Picasso at several points in his long career, and it has made guest appearances in the work of Miró, Magritte, and one or two other moderns, but there was never much of it in Abstract Expressionism. Rauschenberg's antic vein seemed, for that reason among others, to put him in another camp, and maybe a hostile camp at that, along with the Philistines outside the stockade. It was tempting just to dismiss his dirt paintings as bad jokes or pranks. What else, in God's name, could you think about his wanting to *erase* a de Kooning drawing? The implications were so blatantly Freudian, the act itself so obviously a symbolic (if good-natured) patricide. The interesting thing was that de Kooning agreed to it.

"Nobody believes it yet, but the whole idea just came from my wanting to know whether a drawing could be made out of erasing," Rauschenberg rather plaintively explains. "I went to Bill and told him I'd been working for several weeks trying to do that, to use the eraser as a drawing tool. I'd been trying with my own drawings, and it didn't work, because that was only fifty percent of what I wanted to get. I had to start with something that was a hundred percent art, which mine might not be; but his work was definitely art, he was the clearest figure around so far as quality and appreciation were con-

cerned. I couldn't use the drawings I'd stolen from him, because the process required his cooperation. Bill was uncomfortable with it at first. We talked about it for quite a while—I'd gone to his studio on Tenth Street. He said he understood the idea but he didn't like it much. But finally he agreed to cooperate. He had several portfolios of his drawings, and he went to the first one and looked through it, and said, 'No, I'd miss one of these too much.' He took up another, but that one had drawings that were unfinished, that he wanted to work on some more. He went to the third portfolio, and said he was going to give me something really hard, and he did. It was a drawing done partly with a hard line, and also with grease pencil, and ink, and heavy crayon. It took me a month, and about forty erasers, to do it. But in the end it really worked. I *liked* the result. I felt it was a legitimate work of art, created by the technique of erasing. So the problem was solved, and I didn't have to do it again."

The result is a white sheet of paper bearing the faint, ghostly shadow of its former markings. Rauschenberg mounted it in a gold-leaf frame bought specially for that purpose, with a hand-lettered label that reads:

ERASED DE KOONING DRAWING
ROBERT RAUSCHENBERG
1953

DANCERS

John Cage, penniless as always, lived on the top floor of a tenement
building at the corner of Grand and Monroe streets, on the Lower
East Side. The landlord had agreed to let him renovate the derelict
premises, which he had done with the help of a five-hundred-dollar
loan from his parents, and the result was one of the most beautiful
rooms in New York, a white-walled studio with a river view that
stretched from the Queensboro Bridge to the Statue of Liberty. The
sculptor Richard Lippold, a close friend of Cage's, was responsible
for the ultra-sparse decor: a long marble table, a beige-brown studio
couch, straw matting on the floor, no chairs, a grand piano banked
with plants so that it seemed almost to be floating, and Lippold's
own exquisite wire sculpture, *Five Variations Within a Sphere*—
eventually it was joined by one of Rauschenberg's white paintings.
In the kitchen and the bedroom were other contemporary works
that Cage had been given or had bought on the installment plan, in-
cluding a Matta drawing, two of Mark Tobey's early "white writ-
ing" oils, and the Rauschenberg collage from the Betty Parsons
show that the artist subsequently "improved" by doing it over as a
black painting. The Bozza Mansion, as Cage and his friends called
the building (the landlord's name was Bozza), became a rather fa-
mous place in the fifties. *Harper's Bazaar* sent fashion models down

there to be photographed, and uptown culturati maneuvered for invitations to Cage's musical evenings, during which the host would move about the room filling people's glasses with the cheapest available domestic burgundy, which he always referred to as rare wine—"Won't you have some rare wine?"

The Bozza Mansion was also the beachhead of the Cagean revolution in modern music. Cage and his circle of like-minded subversives—the composers Morton Feldman, Earle Brown, and Christian Wolff—would meet there almost every day to discuss their ideas and often to give them immediate form, composing new works that David Tudor would study and play on the spot. (Tudor was then the only pianist who *could* play them in the spirit intended by the composer.) Since their work usually involved composing by chance procedures,* Tudor functioned more as a collaborator than as an interpreter. By 1952 the Cage group had started to compose music directly on magnetic tape, using electronically generated sounds. Although their work had a profound (and largely unacknowledged) influence on the musical avant-garde in Europe, it was rejected with predictable horror by virtually all their American colleagues, one of whom remarked, after attending a performance at Cage's studio, that it represented an "intellectual zero." The general feeling among American composers and critics at the time was that Cage had renounced all artistic responsibility.

Not many musicians bothered to listen any more to what Cage was doing. His silent piece for the piano, and, even more, his *Imaginary Landscape No. 4*—a composition for twelve radios that involved the use of chance procedures to control the volume and station selection—had convinced even former supporters such as Virgil Thomson that he had gone too far, had become in fact ridiculous. Dismissed by the musical establishment, Cage and his confreres

*It was Christian Wolff who introduced Cage to the *I Ching,* the ancient Chinese book of oracles, which had just been published by his father, Kurt Wolff; Cage has used it ever since, sometimes as a source of wisdom but more often as a means to arrive at musical decisions by random methods such as coin-tossing.

retained a loyal following among the New York artists. The small, closely knit art world turned out *en masse* for every Cage recital. Cage himself felt much closer to the Abstract Expressionists than to any of the musicians outside his own circle; he went regularly to The Club and to the galleries where its members were showing, and he welcomed them to his soirees on Monroe Street. The loyalty worked both ways, although by the nineteen fifties it was more personal than aesthetic. "I've been going to your concerts for ten years," de Kooning once told Feldman, in the Cedar bar, "and feeling like an idiot all that time. Like an idiot! But I know in my heart you can do no wrong."

When Rauschenberg got back from Europe in the spring of 1953, he lost no time in reestablishing his friendship with Cage. In many ways he felt as far removed from the Abstract Expressionists as Cage did from the music world. His work, like Cage's, was regularly dismissed as a joke. Having few friends of his own at this point, he felt at home with Cage and also with Feldman and Brown, and they spent a lot of time together. Brown and his beautiful wife, Carolyn, a dancer in Merce Cunningham's company, lived in a tiny apartment on Cornelia Street in the Village; small as it was, the apartment had a bathtub, which Rauschenberg made grateful use of (sometimes to bathe in and sometimes to develop new blueprints, for one of which Carolyn had posed). Feldman had recently moved into the Bozza Mansion, doing over an apartment on the second floor. Rauschenberg would walk up from Fulton Street, and the three of them would go out and buy potato dishes from a Jewish delicatessen—more filling and less expensive than the fare in the local cafeterias and the little Italian restaurants that featured "Hot and Cold Heroes"—and then head for McSorley's Ale House, where you could get a big glass of beer for ten cents. Another Bozza resident, the painter Sonia Sekula, was a source of continual astonishment and wonder to them all. When Cage knocked on her door one day, she opened it and said, before he could get a word out, "I won't take much time because I know you're very busy." Another time, he came in and found her painting with the brush held between her toes. When she went to live in Europe (where she later committed suicide), Lippold and Ray Johnson took over her studio.

Cage's closest personal and working relationship, however, was the long-standing one with Merce Cunningham. During the summer of 1953, when the two men were again at Black Mountain, Cunningham had put together his first permanent company of dancers (before that he had occasionally performed with groups of his students, but his work had been seen mostly in solo recitals, accompanied by Cage on the piano). He spent the summer rehearsing the company in a number of new works that they would perform that winter at the Theatre De Lys, an off-Broadway house that Cage and Cunningham had booked for a week in December. Cage gave Rauschenberg the job of designing a program for the series. Rauschenberg's design turned out to be so complex, with words superimposed on images and other words, that Cage decided it was unusable; he paid him a hundred dollars and designed another program himself. (Later, Cage says, he realized that Rauschenberg's design would have worked perfectly in photo-offset, which he did not know about at the time.) The Cunningham company's season at the Theatre De Lys went unreported in the papers, but the theater was filled each night and the performances generated a lot of excitement. Nobody was more excited than Rauschenberg, who had designed the colorful costumes for one of the dances, *Septet*. His own working relationship with Cunningham remained, for the next twelve years, one of the major preoccupations of his life.

Cunningham's work over the next decade established him as the greatest modern dance choreographer since Martha Graham, in whose company he had once been a featured soloist. Although he drew both from Graham and from the classical ballet in the development of his own choreographic style, the result was not a synthesis but something entirely new, a way of moving that stressed the body's natural articulation and made use of everyday movements such as walking and running. Cunningham freed dance from all its non-dance encumbrances—no plots, no storytelling, none of Graham's psychological or ritualistic overtones—and, in collaboration with Cage, he also proceeded to free it from its dependence on a musical beat. His dances existed entirely apart from the music, which

was simply another activity taking place at the same time; often his dancers would not even hear the score of a new work until they danced it for the first time on stage. George Balanchine, of course, was also creating plotless ballets for his New York City Ballet at this period. Both Cunningham and Balanchine were interested in dance movement for its own sake, stripped of literary or psychological meanings, and their work has more in common than is generally supposed. Where they differ mainly is in their use of stage space. Working with a large company and a corps de ballet, Balanchine directs our attention to changing centers of action, framing and accenting the flow of movement with dazzling precision. For Cunningham, whose 1953 company numbered six dancers in addition to himself, the stage is an activated field in which nothing is ever centered or fixed, and no movement is subordinated to any other. Each of Cunningham's dancers is a soloist. The way they relate to one another in this undifferentiated field is what gives each dance its particular tone and texture.

The correlation between Cunningham's use of the stage and the "all-over" painting of Pollock and de Kooning was unmistakable. The New York artists recognized it at once, and turned out for Cunningham just as enthusiastically as they did for Cage. Rauschenberg, stagestruck since childhood, was thoroughly hooked. "I felt more at home with the discipline and the dedication of those dancers than I did in painting," he said, "and I was so envious of the fact that it was such a total medium. Painting tends to remain fixed, to be made out of its external materials. The idea of having your own body and its activity be the material—that was really tempting. I even took some classes with Merce, but his mirrors were too big. So I just stayed close by giving them all the help I could."

He did his first set for the company in 1954. Cunningham had asked him to make an object to use in a new work, to be called *Minutiae*, and two days later Rauschenberg called him on the telephone and said he had something at the studio to show him. "Bob had made a very beautiful object that hung from the ceiling, with ribbons trailing from it," Cunningham recalls. "I knew right away it

wouldn't do, because it couldn't be installed in the sort of places where we performed then—college auditoriums, mostly, where there were no flies to hang anything from. Bob understood at once. He's always been completely practical in his work with us. He said he'd do something else, and what he did the second time was really wonderful. It was a free-standing construction in two sections, so that the dancers could go in between them, and there was a lot of collage. I loved it because you couldn't say just what it was. One critic, after the first performance of the piece, complained for that reason. She said she didn't know whether it was supposed to be a bathhouse at the beach or a fortune-teller's booth, or what. That was just what I liked about it."

While continuing to stay as close as he could to Cunningham, Rauschenberg also started in 1954 to design sets and costumes for Paul Taylor, who had dropped out of Cunningham's company to form his own. A broad-shouldered, athletic dancer who had been with Martha Graham before Cunningham, and, before that, had seriously considered being a painter, Taylor had visited the Stable Gallery when the Rauschenberg-Twombly show was there, and had been astonished and fascinated. When he started his own company, Taylor's dance ideas were considerably more avant-garde than they became later on. He was interested in "natural postures . . . things you'd see in everday life," and there is no doubt that Rauschenberg encouraged him to go further in this direction. They collaborated on a series of seven dance pieces that Taylor and his company presented that winter at the Hunter College auditorium in New York. For one of the seven, Rauschenberg even provided the musical score, a taped recording of the telephone operator announcing the time every fifteen seconds. *Duet* was a dance in which Taylor (standing) and his female partner (seated) remained motionless throughout—a choreographic equivalent of Cage's silent 4'33". The pièce de résistance was *Resistance,* for which Rauschenberg's "set" was a performing dog. Hired from a professional trainer for the occasion (which made him the only salaried member of the cast), the dog was supposed to come out on stage and sit down, which was the signal for the dance

to begin; when he got up and went off, the dance would end. The score for this diversion was John Cage's *Water Music,* which had more than the usual Cagean quota of loud and unfamiliar sounds. The dog had been somewhat unnerved by these noises in rehearsal, and so, just before the performance, his trainer fed him so many tranquilizers that the poor animal sank into a daze. He wandered unsteadily out on stage, but instead of sitting down as he was supposed to he came to the footlights and took a long, thoughtful look at the audience. Then he went back where he had come from. The trainer gave him an enormous push, propelling him back on stage, where he gazed in perplexity at the dancers for a moment and then ambled off to the wings on the opposite side. Both Taylor and Rauschenberg were delighted. "The effect was marvelous," said Taylor, "and we only had to pay half his fee because he hadn't done it right." Large sections of the audience were less than enchanted, however, and the critics attacked the program so violently that Taylor began to have doubts about his direction.

Both Cunningham and Taylor could see right away that Rauschenberg had that rare and indefinable quality, a sense of the theater. His costumes and his sets were always active participants in the on-stage drama, sometimes too active. "You had to watch Bob pretty closely because his ideas about costumes in some cases might have destroyed the effect of what you were trying to do," Taylor once remarked. "He'd want to get a stuffed lamb for a dancer to wear on his back, things like that." Usually, though, his theatrical sense was keen enough to recognize the difference between enhancing and overpowering the dance. For Taylor's *Three Epitaphs,* whose score was close to primitive African chants, Rauschenberg clothed the dancers in black tights and black, hooded jerseys; tiny round mirrors taped to their foreheads and to the palms of their hands reflected circles of colored light about the stage, "like bringing your own set in with you," as Taylor described it. Cunningham's *Nocturnes* was all white. This was his second set for Cunningham, who had told him that he wanted to have some sort of feeling of separation in the stage space; Rauschenberg's solution was a white

gauze scrim across part of the stage, which made dancers who went behind it look as though they were being seen at a distance. During the setup for *Nocturne*'s first performance at the Brooklyn Academy of Music, the fire inspector said they couldn't use the set because it was not fireproof. While Cunningham and the dancers were having supper that evening, Rauschenberg built a new set out of wire screening, to which he attached fresh green boughs stolen from Prospect Park.

The original Cunningham company was like an extended family. Although Cunningham himself tended to be somewhat aloof and unreachable, the dancers—Carolyn Brown, Viola Farber, Marianne Preger, Jo Ann Melsher, Remy Charlip, and (after Paul Taylor had left) Steve Paxton and Judith Dunn—were remarkably close both on stage and off. The experience of taking part, without pay, in what seemed to all of them a great creative adventure was a powerful bond. Once, on a tour, as they spilled out of their Volkswagen bus at a filling station, the attendant asked Judith Dunn if they were some sort of religious organization, which in a sense they were. They would willingly have given up anything to dance with Merce, and in spite of the inevitable quota of minor spats and irritations they got along wonderfully. Becoming part of the Cunningham family was a major event for Rauschenberg. He loved them all—especially Viola Farber, who had been a student at Black Mountain when he returned there in 1952, and Carolyn Brown, a Phi Beta Kappa graduate of Wheaton who had been doing graduate work in philosophy at Columbia before she succumbed, thanks to Cunningham, to the dancing career that she had forsworn years before (Carolyn's mother had danced with the Denishawn troupe and then had become a dance teacher). Carolyn and Earle Brown had a battered station wagon in which they would all go on weekend outings to the country; it also served to cart Rauschenberg's and Twombly's paintings to the Stable show and back again. The Browns actually bought one of the smaller black paintings from that show, for the sum of $26.30; they had just received a refund from the telephone company in that amount, and Rauschenberg, who would have given the pic-

ture to them happily enough, was coaxed into accepting it. Rauschenberg also gave a very large black painting to Cage in exchange for the Matta drawing; he needed money badly, and the Matta, unlike the black paintings, was relatively easy to sell.

The Cunningham people, who adored Rauschenberg and came to admire his work, all helped to celebrate his getting into the Egan Gallery in 1954. It had become evident, according to Rauschenberg, that Eleanor Ward at the Stable was "losing her nerve." The hostile reactions to Rauschenberg and Twombly by artists and critics alike had led in any case to a somewhat difficult situation. In addition to being one of the gallery's artists, Rauschenberg had also persuaded Mrs. Ward to hire him as a janitor there; he wanted to leave the gallery but he also wanted to keep the job. Jack Tworkov, meanwhile, was once again exerting himself on Rauschenberg's behalf. Tworkov showed with Charles Egan, whose gallery, at 46 East Fifty-seventh Street, also represented de Kooning, Kline, Guston, and the sculptor Reuben Nakian. Egan himself had been deeply involved in the new American painting. He was one of the founding members of The Club, and his hard-drinking, proletarian manner had helped him to become friendly with many of the artists. Egan had not taken on a new artist for a long time, but Tworkov kept after him, and finally Egan consented to come down with Tworkov to the Fulton Street studio. Rauschenberg was not overly hopeful about the visit, nor did Egan seem particularly enthusiastic about the gaudy new red paintings. After he had been there for a while, though, he asked Rauschenberg how soon he could be ready for a show. "About a week," said the artist. Egan gave him a month.

The Rauschenberg "red show" opened at the Egan Gallery just before Christmas in 1954, and stayed up into January. There were four major paintings, culminating in the tremendous *Charlene,* a nine-foot-long canvas with a great, circus-like variety of collage elements—a sort of summation of his ideas, images, and techniques up to that point.[1] Egan loved the show, which he referred to as "Joyeux Noël." He even agreed to Rauschenberg's suggestion of a Morton Feldman concert in the gallery—it was Feldman's first pub-

lic performance of his own work, and he was so nervous that he insisted on bringing his own piano. The show itself did not cause much of a stir, though, and its main immediate effect was to reinforce Rauschenberg's reputation as an *enfant terrible*. Stuart Preston, the *Times* critic, wrote that "there would be no point in taking it too seriously were it not absurdly symptomatic of the demon of novelty." The only really favorable review came from Frank O'Hara, the brilliant young poet, critic, and later Museum of Modern Art curator, in *Art News*. O'Hara clearly loved the "blistering and at the same time poignant collages," in which "bulbs flicker on and off, lights cast shadows, and lifting up a bit of pink gauze you can stare out of the picture into your own magnified eye . . . Doors open to reveal clearer images, or you can turn a huge wheel to change the effect at will." These were "ecstatic works," he said, by a "serious lyrical talent."[2]

There were two sales, both to the same person,[3] who paid fifty dollars for the pair.

JASPER JOHNS

Rauschenberg met Jasper Johns on a winter night in 1954, on the corner of Madison Avenue and Fifty-seventh Street. Johns was walking home from his job at the Marboro bookstore two blocks west, where he worked the night shift; Rauschenberg was with Suzi Gablik, who introduced them. Suzi Gablik, a young artist and art historian, had been at Black Mountain College with Rauschenberg, and she happened to be one of the few people Johns knew in New York.

They met again soon afterward at one of Sari Dienes's parties. Sari Dienes was an artist whose work at that time took the form of street rubbings; she used to go out late at night to make rubbings of manhole covers and other urban insignia. She had a big studio on Fifty-seventh Street near Sixth Avenue, where Cage, Cunningham, and other friends of Rauschenberg's often got together in the evenings. Johns had met her in the bookstore. He was twenty-three then, quiet and withdrawn, and extraordinary-looking. "I have photos of him then that would break your heart," Rauschenberg once told me. "Jasper was soft, beautiful, lean, and poetic. He looked almost ill—I guess that's what I mean by poetic." They became friends gradually, over a period of several months.

Johns was a Southerner, too, born in Augusta, Georgia, in 1930. His parents had separated soon after he was born, and during his

earliest years he was shunted back and forth between his grandpar-
ents in Allendale, South Carolina, and an aunt and uncle in the same
city. Eventually he went to live with his mother and stepfather in Co-
lumbia, but a year later he was sent to stay with another aunt in a
tiny rural community called The Corner. He spent the next six years
there, going to a one-room school where his aunt taught all the
grades. Many years later, at an opening at the Museum of Modern
Art, a woman charmed by his elegance of manner said to him,
"Jasper, you must be from the southern aristocracy."

"No," he replied. "I'm just trash."[1]

His grandmother painted, and for as long as John could remem-
ber he had wanted to be an artist. "People would say I was tal-
ented," he remembers. "I knew it was good to use one's talents, but
I also knew I couldn't do that where I was—there weren't any artists
there—so I guess it was also a form of escape." To please his mother
and stepfather he enrolled at the University of South Carolina in Co-
lumbia, but a year and a half later he dropped out, came to New
York, and entered a commercial art school. When he had been there
six months he applied for a scholarship. The dean called him into his
office and explained that he could have a scholarship because of his
circumstances, although his work did not merit one. Johns replied
that in that case he could not accept it. He quit school, got a job as a
messenger boy, then as a shipping clerk. Six months later he was
drafted into the Army. Returning to New York in 1954 (after a six-
month tour of duty in Japan), he entered City College on the GI Bill.
His first day there he attended a class on *Beowulf,* a French class in
which he couldn't understand a word, and a drawing class whose
teacher told him he drew "a marvelous line." Coming home, faint
with hunger and boredom, he passed out on the street and spent the
next week sick in bed. That was the end of his college career. He got
a job at the Marboro bookstore instead.

At this point Johns was doing figurative drawings and watercolors
in his spare time, mostly on weekends. He knew no other artists,
and was too private or too shy to seek them out. The friendship with
Rauschenberg changed all that. Rauschenberg appeared to know

everyone in the art world. Socially he was gregarious, brash, wide open to experience—all the things Johns was not. He was also totally involved in art. "Bob was the first person I knew who was a devoted painter, whose life was geared to painting," Johns said once. "I had never met anyone like that."[2]

That spring, Rauschenberg persuaded Johns to quit his job at the bookstore. Since losing his own regular job as janitor at the Stable Gallery (Eleanor Ward had fired him when he went to Egan), Rauschenberg had been supporting himself once again by doing window display work for Gene Moore, who was then in charge of display at Tiffany's as well as Bonwit's. Moore paid him five hundred dollars a job—his top price—which would last him a month or more; the arrangement left him plenty of time to paint on his own. Although Johns was very nervous about the idea at first, he went into partnership with Rauschenberg on commercial display jobs and began spending a lot more time on his own work as a result. Johns did a series of drawings in 1954 that both Rauschenberg and Cage greatly admired, polished lead drawings of potatoes, but so black it was hard to make out the image. Rauschenberg secretly altered one of them, which Johns had given him, and felt guilty about it later. He didn't like a certain sprout coming out of one of the black shapes because it gave the shape away as a potato, instead of something abstract and mysterious, so he penciled out the sprout.

Johns had moved from his twenty-five-dollar-a-month apartment on East Eighty-third Street to a thirteen-dollar-a-month apartment on Eighth Street and Avenue A, but he didn't stay there long. Rachel Rosenthal, a vivid young woman who studied with Merce Cunningham, painted, and wanted to do sculpture, told him she was going to look for a downtown loft building to fix up (this was before the New York artists had discovered loft living; Rauschenberg was one of the pioneers), and she asked Johns if he wanted to go in on it with her. Johns said yes. She found an ideal building—brick, solid, condemned but not slated for immediate demolition—on Pearl Street, which amused them both, because Rachel's father had been one of the leading pearl merchants in Paris before the war; after the war he had re-

established himself in cultured pearls in New York. The senior Rosenthals lived in a duplex apartment on Central Park West, and gave lavish parties for their friends in the music world. They knew the children of one of Feodor Chaliapin's marriages, and Jennie Tourel, and Leonard Bernstein, and many others; Rachel would invite Cage, Cunningham, Rauschenberg, and their crowd, and the mixture, she claims, was mutually entertaining. Rachel got her mother to buy one of Johns's early collages, for something like forty dollars; she herself had bought one of Rauschenberg's small sculptures from his 1953 show at the Stable, a rough wooden box with nails driven into it and a stone inside that rang against the nails when the box was turned.*

Rachel Rosenthal was hopelessly in love with Johns. They had a brief affair that spring, but by the time she found the loft building on Pearl Street it was over. They moved in during the summer, Rachel taking the top floor and Johns the floor beneath. Rauschenberg's Fulton Street studio was just around the corner. The three of them saw a great deal of one another that summer and throughout the following year. Rachel had installed a bathtub in her loft, which naturally appealed to Rauschenberg. (Rauschenberg had built himself a bathtub out of a fish crate lined with tar, but the water in his loft was so cold he could only use it in the summer.) The relationship was immensely stimulating for all three, and full of underlying tensions. "I used to work all night at my sculpture, with my cats, and cry because I couldn't have Jasper," Rachel remembers. "At the same time I was very attracted to Bob. He was so seductive and yet so shrewd; he knew just how to play on your weak points. We had this weird relationship. I was crazy about Jap, and so was Bob, but Bob and I used to gang up on him and tease him. Jasper had such a quality of *jeune fille* in those days, he was so shy, and his looks were

*Marcel Duchamp's readymade *With Hidden Noise,* a ball of twine compressed between two metal plates, with an unidentified small object inside that rattles when the readymade is turned, is dated 1916. When Duchamp saw Rauschenberg's box with nails in a group show in the 1960s, he picked it up, beamed, and said, "I think I recognize that tune."

so amazing; he had skin like moonstone, almost transparent, and silky platinum hair, and huge blue eyes with very long lashes. Bob was emotional where Jap was cool. There was a lot of murkiness, and games being played, and crossed signals. Actually I guess it was sort of god-awful."

Although their work for Gene Moore was purely to make money, Rauschenberg and Johns took it seriously and gave their best efforts to each job. Moore found it an ideal working relationship: "They were highly conscientious, always did the work on time, and were utterly dependable." It seemed to Moore that of the two of them, Rauschenberg was the more fertile with ideas, while Johns was the more meticulous craftsman. Actually the ideas that they came up with were so much the product of two mutually interactive and clever minds that most of the time it was impossible to say which one had originated them. Their work was never in the least abstract. Everything they did for Moore was completely realistic, usually involving meticulous simulations of natural settings—rocks, woods, a miniature highway with telephone poles, a swamp scene with real water and "a feeling of snakes" (as Moore described it). One of their most eye-catching windows, for Tiffany & Co., depicted a winter landscape after an ice storm; the branches of the trees hung down, and the ground glittered with showers of tiny diamonds. They also made Old Master still lifes in three dimensions, with painted plaster fruit. Another window for Tiffany's was all potatoes (simulated), dirt (real), and diamonds (also real).

Their displays were so striking that job offers began to come in from other sources. A medical journal asked them to design its Christmas cover. They set out seven hundred candles on an inclined plane and managed to get them all lit at the same time, and the photographer who simply stood by and snapped the picture won an advertising design prize for it. Reynolds Metals put them under contract to do the windows for its New York showroom, a lucrative contract from which they soon withdrew because, according to Rauschenberg, it turned out that the company thought aluminum was such an awful color ("They always wanted us to paint it or dis-

guise it somehow"). By this time the two artists were using a ficti-
tious name, "Matson Jones," for all their commercial work. They
took on only enough of it to keep them afloat financially. Some-
times they were able to farm out jobs to other artist friends, al-
though it usually turned out, Rauschenberg says, that their friends
did not want to work that hard at something that was not con-
nected to their art.

Considering Rauschenberg's love of materials and his boundless
curiosity, it is not surprising that aspects of their commercial work
began to turn up in his serious painting. He began to use aluminum
as a collage element (Rauschenberg loved the color of aluminum).
Having discovered the possibilities of gold leaf in Gene Moore's
workshop, he made a series of gold-leaf collages that he gave away
as presents—glass-fronted boxes inside which the fragile, paper-thin
gold strips were glued down at one end, with the other end floating
free. Once he tried duplicating the effect with toilet paper, but he
didn't like the result and threw it away.

After the red show at Egan's, Rauschenberg's palette had become
more muted. He had noticed that, although people were constantly
surrounded by color, they did not usually notice specific colors in the
environment. You would be in a room full of people, one of whom
might be wearing red shoes, another a bright green sweater, but
what you tended to see was just a general chromatic blur in which
no tone stood out. Rauschenberg set out to make paintings that
would have this nondescript quality, which he called "pedestrian
color." One of his methods was to buy, on sale in local hardware
stores, cans of paint whose labels had come off, so that there would
be no way of knowing what color was in them until he started using
it. He painted a number of pictures this way in 1955, a series that
reached its culmination in *Rebus*. The word suggests a puzzle, a
picture-word, and the painting, which is now considered one of his
most significant early works, can be "read" as well as looked at. The
images run in a horizontal line across the approximate center of the
canvas. They include a portion of an election poster, two running
athletes, part of a comic strip, a cheap reproduction of Botticelli's

Birth of Venus, a pinup shot from a girlie magazine, the same two runners photographed a few moments later, a Dürer self-portrait—along with passages of paint, dripped paint, cloth, graffiti, and a child's clumsy drawing of a woman. It is a big picture, eleven feet long by eight feet high. Rauschenberg painted it on eight cheap drop cloths (total cost: two dollars) because he could not afford to buy that much good canvas.

Rebus is a painting that cannot be taken in all at once, which makes it very different in effect from almost any Abstract Expressionist canvas. Its imagery also sets it off from much of the artist's own earlier work. The red paintings had been full of images that were vaguely nostalgic and even rural in feeling—family photographs, bits of cloth, objects worn smooth by use. After *Rebus,* nostalgia gives way to imagery that suggests an urban and thoroughly contemporary environment. There is nothing overtly autobiographical about these fragments of urban life. Rauschenberg was starting to think of himself as a reporter, someone who bore visual witness to the constantly shifting, gritty, tension-filled life he saw around him in downtown Manhattan. He was developing what Brian O'Doherty, one of the more perceptive younger critics (later he became an artist), would describe as the "vernacular glance," a mode of divided attention that "doesn't recognize categories of the beautiful and ugly. It's just interested in what's there."[3] Another change was his use of titles. Until *Charlene* in 1954, most of Rauschenberg's works had been untitled. For a virtual non-reader, however, Rauschenberg has a remarkable linguistic flair, which he now began to apply in his work. His idea was that a title should not simply describe the painting but extend it or add something to it, another (verbal) dimension.

Rauschenberg had entered an extraordinarily fertile period, whose effect on other artists was to be prodigious. Its effect on Jasper Johns has been much debated. Watching Rauschenberg work on the red paintings, Johns said once, was an exciting event for him. Rachel Rosenthal, who also spent a lot of time in Rauschenberg's studio, said that it was "incredible" to watch him work—"those long fingers of his, like a divine ape's. His decisiveness, too; it was al-

most as if he were hypnotizing the canvas with those penetrating eyes. He'd have all those open cans of paint around, and he'd take his time, and then when he was ready he would be so definite and decisive and precise. And when he'd talk about his work, for example at the Egan Gallery during his show there, it had such conviction and strength and total involvement. He was such a master of theater! I saw him open people's eyes to his work with words I knew they didn't understand."

Johns was somewhat in awe of Rauschenberg's personal style. "To me he seemed amazingly naive, but he functioned in ways I couldn't. Bob assumed that other people would support what he did, for one thing; I assumed I would have to do mine in spite of other people." Johns says that his interest then was much more in Rauschenberg as a person than as an artist. Nevertheless in 1954 Johns started to make collages and small constructions of wood and metal, some of which appeared to have a lot in common with Rauschenberg's pieces. Four of these went to friends and they are the only ones that still exist, because one day in 1954 Johns destroyed all the work he had done up to that point. It was a moment of decision in his life. "Before, when anybody asked me what I did, I said I was going to become an artist. Finally I decided I could be going to become an artist forever, all my life. I decided to stop *becoming*, and to *be* an artist" He also decided that he would "do only what I meant to do, and not what other people did. When I could observe what others did, I tried to remove that from my work. My work became a constant negation of impulses."[4]

In a sense his direction became the opposite of Rauschenberg's. Where Rauschenberg embraced multiplicity, used whatever materials came to hand, tried anything and everything in his curiosity to see what made a picture, Johns took the *via negativa*—deciding what *not* to do, to use, to investigate. For some time after he had destroyed his old work, in fact, he would just sit by the hour, alone in his studio, thinking. It seemed to Rachel Rosenthal that Johns's new aesthetic was created wholly in his mind, not as a working process (which it always was in Rauschenberg's case), but as a mental con-

struct. With Johns, however, it was not necessarily the conscious mind that constructed.

The first of Johns's obsessive new images came to him in a dream. He told Rachel Rosenthal that he had dreamed he saw himself painting a large American flag. Soon afterward he did paint the flag—red, white, and blue, stars and stripes filling the canvas from edge to edge, nothing left over. He painted it in encaustic, a virtually extinct and highly demanding technique that he learned from a book on sale at Marboro; it involved mixing pigment with hot wax, which dried very quickly and built up into a rich, encrusted surface. Johns's flag was something very strange. It was not a "real" flag, to be sure, but neither was it an artist's image or representation of a flag. Its proportions were exact, its stars and stripes in the right order. The technique of its making seemed to qualify it as a work of art, but the "realness" of the image simultaneously made one uncertain. Johns's flag was a paradox. In common with almost everything he has done since then, it asked a question about art, or about the difference between art and reality, or about the faculty of human perception that differentiates between the two—a question that remained unanswered. From flags, he went on to paint targets (concentric rings of color), Arabic numerals, letters of the alphabet. "Using the design of the American flag took care of a great deal for me because I didn't have to design it," he said. "So I went on to similar things like targets—things the mind already knows. That gave me room to work on other levels."[5]

IN THE SUMMER OF 1955, RACHEL ROSENTHAL WENT OUT TO CALIFORnia for her father's funeral. Through friends she was offered a job teaching experimental theater at the Pasadena Playhouse, and she decided to take it. Rauschenberg moved into her top-floor loft on Pearl Street. From then on Rauschenberg and Johns saw each other every day, and, equally important, looked every day at one another's work. The interchange on aesthetic terms was similar in intensity to what took place between Picasso and Braque from 1909 to 1914, the years when they were creating Cubism, a relationship that Picasso

described as being like a marriage (Braque said it was like two mountaineers roped together). Johns and Rauschenberg were not creating a new movement, to be sure; they were actually moving in different directions. But each of them was working against the grain of the dominant painting of their period, and the encouragement that they got from each other, personally and professionally, gave them "permission," as Rauschenberg once put it, "to do what we wanted."

"He and I were each other's first serious critics," according to Rauschenberg. "Actually he was the first painter I ever shared ideas with, or had discussions with about painting. No, not the first. Cy Twombly was the first. But Cy and I were not critical. I did my work and he did his. Cy's direction was always so personal that you could only discuss it after the fact. But Jasper and I literally traded ideas. He would say, 'I've got a terrific idea for you,' and then I'd have to find one for him. Ours were two very different sensibilities, and being so close to each other's work kept any incident of similarity from occurring. But we got to be so familiar with each other's sensibility! I was very envious of his encaustic, I must admit, but too respectful ever to touch it. Except once, he let me. He was painting one of the large flags. It smelled so delicious, and it looked so good, all those aromatic bubbling waxes, the colors so bright, and I just begged him to let me do one stripe. He finally said, 'All right, one.' So I decided it might as well be red. I stared at the painting, savoring the moment, and then I dipped a brush in the wax, getting as much on as I could, and made a stroke—right in the middle of a white stripe! Ooops! Needless to say I didn't ask again. There was just no way he could think I hadn't done it on purpose."

Johns painted a few Rauschenbergs during this time. He did a couple of gold-leaf collages, and a large canvas in the style of *Rebus*. "I thought I understood what went into his pictures, so that I could do one," he said. "But mine weren't convincing at all."

Looking back on those years, after the bitterness of their personal breakup, Rauschenberg remembered that Johns was often highly critical of his work. "It was my sensual excessiveness that jarred

him," he said. "He was always an intellectual. He read a lot, he wrote poetry—he would read Hart Crane's poems to me, which I loved, but didn't have the patience to read myself—and he was often critical of things like my grammar. But you don't let a thing like that bother you if you have only two or three real friends."

They were more than friends, of course; they were deeply involved with one another, both intellectually and emotionally, and the intensity of what passed between them filled up their life.

13

WHY NOT SNEEZE?

A few minutes after ten o'clock on the night of August 11, 1956, Jackson Pollock lost control of his 1950 Oldsmobile convertible and went off the road, about a hundred yards from his house in The Springs, at the eastern end of Long Island. The car hit an embankment and careened back across the pavement to the other side, where it ran into a clump of young oaks, turned end over end, and landed upside down. One of the two young women who had been riding in the front seat with Pollock, Edith Metzger, was crushed to death in the wreckage. Ruth Kligman, Pollock's mistress, was thrown clear; though severely injured, she survived. Pollock was also thrown clear, but his head smashed against a tree. He died instantly.

Within a few hours the entire New York art community knew about it. The *New York Times* put the story on its front page. Franz Kline, who heard the news late Saturday night, was still weeping uncontrollably twenty-four hours later, slumped on a stool at the Cedar bar. "He painted the whole sky," Kline choked out at one point, to the poet Fielding Dawson.[1]

One of the bitter ironies of Pollock's career is that his sudden death catalyzed the spectacular, long-delayed public success of Abstract Expressionism. In spite of his reputation as the greatest American painter of his era, Pollock himself died poor. Only a few of his

major paintings were sold during his lifetime, most of them in his last year. His top price while he was alive was the $8,000 that the collector Ben Heller agreed to pay, in installments over a four-year period, for a picture called *One*. The Metropolitan Museum considered buying *Autumn Rhythm* in 1956, but the trustees balked at the $10,000 asking price. A year after Pollock's death, the Metropolitan bought the same picture from his widow for $30,000, thus setting a whole new Pollock price range. Dr. Fred Olsen, a collector who had purchased *Blue Poles* in 1953 for $6,000, sold it four years later to Ben Heller for $32,000 (Heller held on to it until 1973, when he sold it to the National Gallery of Australia for more than $2 million). Pollock had virtually stopped painting in 1954. He was drinking more heavily than ever. His friends found him deeply, sometimes suicidally depressed, and some of them attributed his depression in part to continuing financial problems. It is true, of course, that sooner or later his prices would have gone up substantially in any case. The market for contemporary art was expanding, new galleries were working to exploit it (Sidney Janis, Martha Jackson, Tibor de Nagy), and museums here and abroad were starting to pay serious attention to the New York artists. Pollock's death nevertheless was the precipitating factor, tripling his own prices and exerting a powerful upward pressure on those of his leading contemporaries. After Pollock died, said Sidney Janis, "We had a little less trouble selling a de Kooning for $10,000 than we had a month earlier trying to sell one for $5,000."

Among the first-generation Abstract Expressionists, success in the marketplace effectively finished off the old solidarity, which had been eroding for some time. In Betty Parsons's gallery, the artists who used to help hang each other's shows had stopped speaking to one another. "It all turned from love to hate inside of a year," said Betty. One of Barnett Newman's reasons for leaving the gallery was his feud with Ad Reinhardt. The self-proclaimed conscience of the art world, Reinhardt regularly castigated his former friends in articles and lectures for succumbing to the corruptions of commerce. (Reinhardt's own work did not start to sell until the late 1950s.) In

a lecture that was reprinted in the *College Art Journal* in 1954, he lumped Newman together with a dozen other artists as representative of "the artist-professor and travelling-design-salesman . . . the avant-garde-huckster-handicraftsman and educational shopkeeper, the holy-roller-explainer-entertainer-in-residence . . ." Newman, infuriated, sued for slander, claiming that Reinhardt's attack had hurt his chances of finding employment as a teacher. He lost. Newman and Rothko quarreled, and stopped seeing each other. Clyfford Still left Betty Parsons and wrote her an angry and abusive letter when she demanded to know why. After Pollock's last show at Janis, in December 1955, Still wrote Pollock a caustic letter asking whether he had not been invited to the opening because Pollock was ashamed of the work. "At one o'clock in the morning Pollock, in East Hampton, was still upset by the letter and crying as he read it to a friend in New York," according to Pollock's biographer B. H. Friedman. "There was no way to comfort him."[2]

The mean-spirited pettiness of these quarrels and fallings-out was the underside of a truly immense achievement. Tony Smith, the architect, sculptor, and close friend of the first-generation Abstract Expressionists, once likened the effect of their visionary images to the experience of "crossing the desert and suddenly seeing the great gate of a mosque—the only other experience in art that's really comparable." To Smith, the painters he knew seemed to have fallen into some imperial madness. Hearing that Smith had admired a certain painting by Pollock, Rothko angrily demanded an explanation. "I thought you were committed to me," he complained. Several of the first-generation artists made it increasingly difficult for people to see their work. They refused to lend or show it unless they could be sure it would be hung exactly as they wished—which usually meant uncontaminated by the work of anyone else. Rothko in his later years withdrew from an important mural commission for the Four Seasons restaurant in New York because he could not stand the idea of people eating in front of his paintings. Newman, Rothko, Still, and eventually Reinhardt all sold their work at higher and higher prices after 1956, and when the decade ended, international recognition

had crowned their years in the stockade. But success on this level seemed to be one challenge they could not meet. Feuds, alcoholism, and bitterness isolated them more and more as the years went on. Kline, Baziotes, Reinhardt, and Newman all died young. The sculptor David Smith was crushed behind the wheel of his truck. Gorky had committed suicide in 1948, at the peak of his career; Rothko, a world-famous master, killed himself in 1970. The survivors—de Kooning, Motherwell, Tworkov, Still—lived to feel themselves unjustly superseded by brash young newcomers taking what seemed easy advantage of the gains they had so dearly won.

In the style of tragic heroes, the artists of the first generation tended to take themselves very, very seriously. Listen (hearken, rather) to Clyfford Still describing his own career, in a letter that he allowed to be reprinted in the catalog to a 1959 show: "It was a journey that one must make, walking straight and alone . . . until one had crossed the darkened and wasted valleys and come out at last into clear air and could stand on the high and limitless plain. Imagination, no longer fettered by the laws of fear, became as one with vision. And the Act, intrinsic and absolute, was its meaning, and the bearer of its passion."[3] Barnett Newman, who was altogether delightful in ordinary conversation, could be nearly as sententious as Still in his public statements. Painting, he said in 1958, was "a living voice, which, when I hear it, I must let it speak, unfettered."[4] Newman and Still often took a decidedly chauvinistic stance, claiming that their work was profoundly American and untainted by European culture. "They stand all alone in the wilderness—breast bared," said de Kooning, who was much amused by his colleagues' New World rhetoric. De Kooning was proud to feel himself a part of the long and complex European tradition. He could even express public admiration for Marcel Duchamp, the artist who, more than any other, represented the antithesis of the romantic, breast-beating impulse in art. Speaking at a Museum of Modern Art symposium in 1951, de Kooning had said, "And then there is that one-man movement, Marcel Duchamp—for me a truly modern movement because it implies that each artist can do what he

thinks he ought to—a movement for each person and open for everybody."[5]

Even de Kooning must have been surprised, though, to find that by the end of the nineteen sixties Duchamp was widely recognized as the most influential artist of the second half of the twentieth century. Since 1942 he had been living quietly and rather obscurely in New York. An important part of his legend had it that he no longer concerned himself with art, that he had given it up in favor of chess (like other aspects of the legend, this turned out to be untrue). Now and then he would surface long enough to help arrange an exhibition, such as the stunning "First Papers of Surrealism" show in 1942, when he used a mile of string to turn the gallery into a fantastic maze, but for the most part he remained on the outer fringes of the art world, a respected but enigmatic figure. The Abstract Expressionists knew he was there. They rather resented it that he did not come to see their shows; Duchamp after all was a link to the Surrealists, whose influence Gorky, Pollock, and others acknowledged. De Kooning remarked on another occasion that he didn't know where he was going but he was sure it was on the same train as Marcel Duchamp[6]—a somewhat perplexing comment, inasmuch as de Kooning's was precisely the sort of "retinal" art (appealing primarily to the eye rather than to the mind) on which Duchamp had long ago turned his back.

In his early career in France before the First World War, Duchamp had quickly mastered and as quickly discarded all the key developments of modernism, from Impressionism through Cubism, and he had then gone on to experiment, briefly but brilliantly, with almost every technique or idea that avant-garde artists would concern themselves with during the next fifty years. Motion, optics, pure color chromaticism, environmental art, machine art, cinema, soft sculpture—all these were touched on by Duchamp, often in single works that were sufficient to satisfy his interest, for he took pains never to repeat himself. Repetition was for retinal artists, and for the "olfactory" types who were in love with the smell of paint. Duchamp wanted "to put painting once again at the service of the

mind," as he said. This meant, of course, at the service of his own iconoclastic and profoundly original mind, a mind that coolly questioned every assumption ever made about the function of art and about art's relation to human life.

The Dada movement that erupted during the First World War welcomed Duchamp as a sort of patron saint, recognizing in his scathing intelligence the very essence of the Dada spirit that spat on all accepted dogmas, masterpieces, and other artifacts of a civilization that had gone suicidally berserk. "Art is not the most precious manifestation of life," proclaimed Tristan Tzara, Dada's irrepressible spark plug. "Art has not the celestial and universal value that people like to attribute to it. Life is far more interesting."[7] Earlier than the Dadaists, Duchamp had set out to blur the demarcation between art and life. In 1913 he produced the first of a series of objects to which he would later give the term "ready-mades"— manufactured items raised to the level of works of art by the mere fact of the artist's having chosen and signed them. The first was a bicycle wheel, inverted and attached by its fork to a kitchen stool, where it could be set in motion by anyone who felt like turning it. The second was a bottle-drying rack that he bought in a Paris bazaar, and inscribed with a phrase that is forever lost to art history because the object was thrown out when Duchamp went to New York in 1915, and he could never remember afterward what he had written.

Duchamp was surprised to find himself a minor celebrity on his arrival in New York. His *Nude Descending a Staircase* had been the sensation of the 1913 Armory Show; a San Francisco dealer had bought it (for $324), and three other paintings of his in the show had also been sold. Far from capitalizing on his success by painting more like them, he supported himself by giving French lessons, and worked a few hours a day on his *Large Glass,* the astonishing work (on glass) whose real title is *La Mariée Mise à Nu par Ses Célibataires, Même.* From time to time a new readymade appeared: an ordinary snow shovel, bought in a hardware store in New York and inscribed *In Advance of the Broken Arm;* the ball of twine com-

pressed between two brass plates and entitled *With Hidden Noise* (Duchamp had told his friend Walter Arensberg, the collector, to place a small object inside the ball of twine, without telling him what it was); the infamous *Fountain,* a porcelain urinal upended and presented as sculpture to the 1917 Independents exhibition in New York; the equally infamous *L.H.O.O.Q.,* a reproduction of the *Mona Lisa,* her well-known features enhanced by a moustache and goatee (the letters L.H.O.O.Q., when pronounced in French, become a rude phrase meaning, roughly, "She's got a hot ass"). He made no attempt to sell them. The readymades just appeared in his studio, or were presented to friends, and for years hardly anyone outside Duchamp's small circle even knew about them. The originals disappeared eventually. Their subversive power did not cease to grow.

The readymades mocked seven centuries of high art. The skill, the knowledge, all the laborious effort and craft that went into the creation of works of art—what did they add up to? A painting had an active life of about thirty years, according to Duchamp; after that it died—visually, emotionally, and spiritually. The masterworks of the Renaissance were crumbling to dust in spite of the miracles of modern restoration. "Those miserable frescoes," said Duchamp, "we love them for their cracks." A readymade, on the other hand, was chosen specifically because there was nothing *aesthetic* about it, nothing that smacked of art, taste, design, or formal beauty. If lost or destroyed it could be recreated without difficulty by anyone, which gave it a sort of permanence denied to the masterpiece. Leonardo da Vinci, to whom Duchamp has often been compared, had said that painting was *"una cosa mentale,"* and this in one sense was the hidden message of the readymades: by taking an object out of one category and placing it in another, by "creating a new thought for that object," as Duchamp put it, the artist was performing the mental action that alone characterized his true function. But was the artist's function so important after all? "Art is a habit-forming drug," said Duchamp. "Art has absolutely no existence as veracity, as truth. People always speak of it with this great, religious reverence, but why should it be so revered? The on-

looker is as important as the artist, for one thing. The work of art is always based on these two poles of the maker and the onlooker, and the spark that comes from this bipolar action gives birth to something, like electricity. The artist performs only one part of the creative process. The onlooker completes it, and it is the onlooker who has the last word, remember—posterity makes the master-piece. No, I'm afraid I'm an agnostic in art. I don't believe in it with all the mystical trimmings. As a drug it's very useful for a number of people, very sedative, but as religion it's not even as good as God."

Certainly no one could accuse Duchamp of taking himself too seri-ously. He had conceived the *Large Glass,* his magnum opus, to which he devoted the major share of his attention from about 1912 to 1923, as a "hilarious" picture, a semi-allegorical account of an impossible erotic encounter: *The Bride Stripped Bare by Her Bachelors, Even.* Neither bride nor bachelors appear in the flesh, so to speak, but their complicated erotic maneuverings are by no means abstract. The viewer willing to play Duchamp's game enters a visual and verbal world (Duchamp considered his cryptic notes about the work as im-portant as the visual images) where idea becomes form. The odd im-ages painted or scratched or drawn on the glass carry out an impeccably logical scheme of Duchampian illogic; it is a world whose maker has slightly "stretched" the laws of mathematics, physics, and chemistry, and come up with such curiosities as "oscillating density," "emancipated metal," "timid power," and "love gasoline" fueling a "desire-magneto." Duchamp took science no more seriously than art. "Every fifty years or so some new scientific law is discovered that can-cels out some old law," he said. "I have my doubts, that's all. The word law is against my principles. I just felt it would be more of a game, it would make life a little more worth living, if you could stretch these things a little."

Since the painting is on glass, the images can be looked at and also seen *through*. The outside world impinges on and enters into it continually. No viewer sees exactly the same *Large Glass*, which makes for a more invigorating game between artist and onlooker.

When he learned that the work had been shattered, while being transported from a show at the Brooklyn Museum to the Connecticut home of Katherine Dreier, its owner, Duchamp did not appear particularly upset. He spent several months reassembling the broken shards, and decided that the resulting network of cracks had added an interesting new element. "The *Glass* is not my autobiography," he said, "nor is it self-expression. Far from it."

Duchamp divided his time between Paris and New York in the 1920s and the 1930s, before settling permanently in New York in 1942. John Cage, who moved to the city that same year, met him soon afterward at Peggy Guggenheim's apartment. Cage was fascinated by the older man, whose work he knew then only by reputation, but too much in awe of him to press the relationship. Later, Duchamp became a source of continuing inspiration to Cage, and Cage became the channel through which Duchamp's influence was transmitted to a whole new generation. The corridor of humor that Duchamp had opened up clearly threatened to undermine the temple of high art; at the same time, it offered unprecedented new freedoms to every artist. "I don't believe in art," said Duchamp. "I believe in artists."

Rauschenberg's first real exposure to Duchamp came in 1953, when he saw twelve of his works in a Dada exhibition at the Sidney Janis Gallery. The next year, the installation of the Louise and Walter Arensberg Collection of modern art at the Philadelphia Museum of Art made forty-three works by Duchamp, including the *Large Glass* (bequeathed by Katherine Dreier in 1953), available to a wide public. When Rauschenberg and Johns went down to see the Philadelphia installation, they found the Duchamp gallery momentarily deserted. Rauschenberg could not restrain a sudden impulse to steal one of the marble cubes from *Why Not Sneeze?*, an "assisted" readymade in the form of a metal birdcage partially filled with marble pieces cut to resemble lump sugar. People regularly stole the thermometer that protruded through the bars of the same piece, and it was just as regularly replaced. As Rauschenberg was reaching into the birdcage, a museum guard suddenly appeared and asked him

what he thought he was doing. Rauschenberg tried to explain—he had heard that the cubes were marble, he just wanted to make sure . . .

"Don't you know," the guard said in a bored tone of voice, "that you're not supposed to touch that crap?"

MOVING OUT

Neither Rauschenberg nor Johns was influenced directly by Duchamp. Each had found his own aesthetic (or nonaesthetic) before exposure to the lessons of the master, whom they did not meet until 1960. Their discovery of the Duchampian attitude was nevertheless of crucial importance to them both, confirming and reinforcing what must often have seemed a highly questionable use of their talent.

During the three years that they lived on Pearl Street, the two young artists got very little confirmation or reinforcement from anyone. Rauschenberg no longer had a dealer. Charles Egan, whose business methods were quixotic, had lost control of his gallery and more or less vanished from the scene; his partner and successor, Elinor Poindexter, wrote Rauschenberg a letter making it clear that she did not care to represent him; she said his work was too expensive to transport back and forth. Now and then Gene Moore would put a Johns or a Rauschenberg painting in one of his windows at Bonwit's, not because he liked them (he didn't) but because he felt that part of his job was to show what was going on in New York. Moore got plenty of complaints from customers about Rauschenberg's pictures, relatively few about Johns's. The only other public showings of Rauschenberg's work in this period were the Stable Annuals.

Artists who had shown in previous Stable Annuals were allowed to propose two new artists each year, and in 1955 Rauschenberg planned to propose Johns and Susan Weil, his ex-wife, with whom he was once again on the friendliest of terms. The show's organizers changed the rules that year, though, and neither Johns nor Weil was invited to exhibit. Rauschenberg retaliated by submitting a large painting called *Short Circuit,* with two wooden doors hinged to its surface; behind one door was a Weil oil, behind the other a small Johns flag (the painting also included a collage by Ray Johnson, another young artist whom Rauschenberg thought unjustly neglected; a program from an early John Cage concert; and Judy Garland's signature). Some years later, after Johns had become famous, the little flag painting mysteriously disappeared from the mother-work. Later still, a dealer brought a small Johns flag into Leo Castelli's gallery, and asked if Castelli could identify it—he said it had been offered to him by a third party. Castelli recognized it immediately as the missing element from *Short Circuit.* He told the dealer that it had been stolen, and said he did not want it to leave the gallery. The dealer refused to part with it. He took the little painting away again, and nobody has seen it since. The empty area in *Short Circuit* was filled eventually by a replica of the missing flag, painted by Rauschenberg's friend Elaine Sturtevant.

Rauschenberg once referred to these years in the middle fifties as a period when he and Johns used to start each day by having to "move out" from the almost overpowering influence of Abstract Expressionism. De Kooning was painting more impressively than ever; the horrific "Woman" images had given way to a series of richly colored, abstract urban landscapes, which Janis sold from 1956 on at steadily rising prices (de Kooning had left Egan in 1953 to join Janis). A second generation of New York painters was hard at work exploiting the breakthroughs of Pollock, de Kooning, and their colleagues, and in art schools around the country, de Kooning-esque painting had virtually choked out all other forms of abstraction. The dominance of the gestural style struck some observers as unhealthy. Alfred Barr, speaking at The Club in 1958, deplored what he called

the "young academy" of Abstract Expressionism, and called for a "revolution" by younger artists—a revolution that was already rather well advanced by then, although both Rauschenberg and Johns have denied that they were in revolt against anything. "Our aesthetic direction was different, that's all," Rauschenberg said.

Curiously, neither Rauschenberg nor Johns felt much of an affinity to the work of Larry Rivers, an artist of their own generation who was using the techniques of Abstract Expressionism in paintings that parodied or mocked the pretensions of the older Abstract Expressionists. Rivers, a brilliant draftsman who was also a jazz musician, had the effrontery to paint a jazzy, gestural version of Emanuel Leutze's *Washington Crossing the Delaware*. He also painted *The Last Civil War Veteran* (from a photograph in *Life* magazine), and a portrait of Napoleon (loosely based on Jacques-Louis David's), which he called *The Greatest Homosexual,* and a whole series of unblushingly realistic portraits of his middle-aged mother-in-law, frontally nude and far from svelte. To Rauschenberg, whose own work had too often been dismissed as a joke, Rivers's "impossible" subjects seemed a little too close to being merely satiric. Rivers also moved with a different crowd, the crowd that centered around Frank O'Hara and that showed at the Tibor de Nagy Gallery. Although the art world was still a fairly small place, the Rivers-O'Hara group seemed "out of reach socially" to Rauschenberg and Johns, who at this point were leading an extremely isolated existence. Seeing each other's work was the most important event of the day for them both, more important than talking about it. "I think we were very dependent on one another," Johns has said of this period. "We did some work for Merce, and there was some social life, but basically we were just living and working on Pearl Street, and our world was very limited."

Rauschenberg had started in 1955 to incorporate larger and larger objects in his paintings. There was no theory involved, not even the sort of thinking that had led him to experiment with "pedestrian color" the year before. He liked having another surface to work on in addition to the canvas, and he liked having the picture

come out into the room. The Cubists had abolished the illusion of deep space in their paintings. Advanced art had been getting progressively "flatter" ever since, in the case of those artists who wanted their work to be "real" rather than a representation of the real. Rauschenberg carried the tendency a lot further, as usual; turning Renaissance perspective inside out, he built his pictures out into the viewer's space. Although the results were three-dimensional and sometimes free-standing, he felt that they lay somewhere between painting and sculpture, and so he coined a new word to describe them: "combines," or "combine-paintings."

"Oil, watercolor, pencil, fabric, paper, photographs, metal, glass, electric light fixtures, dried grass, steel wool, necktie, on wood structure with four wheels, plus pillow and stuffed rooster"—the catalog description of a combine called *Odalisk,* begun in 1955 and finished in 1958.[1] Odalisk? The title suggests a long tradition of female nudes reclining on soft cushions, Ingres's harem beauties in Turkish baths. Rauschenberg's version is a rectangular, boxlike structure, supported by a stout wooden bed leg set into a cushion atop a wheeled base. The box is covered on three sides with paint and collage in which female images predominate, among them a photograph of one of Rauschenberg's blueprint figure studies, and several snapshots from nudist magazines in which buxom young women smile self-consciously for the camera ("My husband doesn't know I'm doing this"). The fourth side is covered by thin gauze, through which one can look inside and see a blue light bulb. The rooster stands on top of the ensemble, male as a sultan.

Rauschenberg was still using "what was available" in the way of material. His studio was full of things he brought back from Staten Island or picked up on the street. Passing a taxidermist shop on Sixth Avenue one day, he saw in the window a stuffed Plymouth Rock hen that he could not resist buying—it brought back memories of his childhood pets. The Plymouth Rock found its way into a large free-standing combine (*Untitled*), where it functioned as the sole female among a host of male images, all of which related somehow to family recollections real or imagined. The same taxidermist sold him

the gorgeous white rooster that he used in the female-dominated *Odalisk*. A friend who came to his studio about this time sent him a stuffed pheasant without tail feathers that had been sitting in his backyard; it came to roost on top of a combine-painting called *Satellite*. At an auction of a sculptor's estate, Rauschenberg bought a great stuffed eagle that he tried for years to get into a painting, succeeding finally in *Canyon* (1959). The most exotic of his latter-day fauna, though, was the horned, long-haired Angora goat that he spied in 1955 in the window of a secondhand office furniture store on Seventh Avenue. The storekeeper had bought it, sight unseen, in a railroad auction (a metal plate identified it as "Angora [Mohair] Buck . . . Prepared by Angora Journal, Portland, Oregon, for Sanford Mills, Sanford, Maine. Mohair—Most Enduring of All Textile Raw Materials"), and he was not at all eager to part with it. Rauschenberg won out through sheer persistence. The price was thirty-five dollars. He paid fifteen on account, and someday, he says, he plans to go back and pay off the balance.

The goat was the largest object he had ever tried to use in a painting. When he brought it home, its fleece was matted with decades of dust and its face was bashed in on one side. He spent hours cleaning the fleece with dog shampoo, and he fixed up the face as best he could; the damage was still apparent, though, and for this reason he decided to cover it with paint. "So many people ask me why I put that awful paint on his face," he said once. "It's what seems to bother them the most." The real problem, though, was to make the animal look as though it belonged in a painting. This took him five years. At first he mounted it on a shelf so that it stood sideways against a background of collage and paint, but this bothered him because only one side of the goat showed. In the next version (1956), the goat's hind quarters were against the painting, but that was no good either—it looked as though he were pulling it. By this time the goat had acquired an automobile tire around its middle, "something as unavoidable as the goat," which served to neutralize the animal's extraordinary beauty. The third and final version, achieved in 1959, came about as the result of a suggestion by Jasper Johns. It was such

a natural solution that Rauschenberg was amazed he hadn't thought of it sooner. He made a flat, horizontal platform, painted and col- laged it in his usual manner, and placed the goat in the middle—an environment, a place for him to be, a pasture.

Most of the objects in Rauschenberg's combines were much less exotic than goats or fowl. He had always had a great fondness for the commonplace, the castoff, the worn-out and forgotten. An old sock, a piece of a shirt, a paper restaurant mat, a child's drawing res- cued from the trash—humble relics like these turned up in combine after combine, where they entered another life in a strange balance between beauty and ugliness, the real and the abstract. Some viewers would later complain that he had deliberately chosen to use materi- als that were ugly or dirty, but to Rauschenberg they were neither. Even the quilt that he used in *Bed,* the most notoriously shocking of the early combines, had nothing but pleasant associations for the artist. He had waked up one morning in the spring of 1955, wanting to paint, but with nothing to paint on—no canvas, and no money to buy any. His eye lit on the old quilt that had come up with him from Black Mountain, where it had once belonged to a fellow student named Dorothea Rockburne (now a well-known New York painter). The quilt had been well along in use when she gave it to him. He had used it to cover the hood of an old automobile he owned for a while, but the weather was balmy now. The colors and the patchwork pat- tern interested him. He made a stretcher for it, just as though it were a canvas. He tried painting on the quilt, but something was wrong. The pattern was too strong. He attached his pillow and part of a sheet to the top of the stretcher. This solved the problem—the quilt "gave up and became a bed, stopped insisting on itself," as he ex- plains it, and the pillow and sheet provided an area of white to paint on. *Bed* seemed revolting to a lot of people when it was first shown in 1958. To some it looked like the scene of a bloody ax murder. When it was sent with a group of works by twelve young American artists to the first Festival of Two Worlds at Spoleto, also in 1958, the Italian authorities refused to show it; *Bed* remained throughout the exhibition in an office, safely out of sight. Rauschenberg found

such reactions perplexing. "I think of *Bed* as one of the friendliest pictures I've ever painted," he said. "My fear has always been that someone would want to crawl into it."

The exuberant balancing acts in Rauschenberg's combines have no echo in Johns's work of this period. Johns's images were also commonplace—flags, targets, alphabets, numerals, "things which are seen and not looked at" in everyday life, as he said[2]—but the context in which they functioned was hardly exuberant. Where Rauschenberg's art opened out to include a multiplicity of unrelated objects and images, Johns's turned in upon itself hermetically, paradoxically. There was no air in his paintings, no empty space. Looking at these paintings for the first time, the critic Leo Steinberg found himself deeply depressed by what they seemed to imply about all other art: "The pictures of de Kooning and Kline, it seemed to me, were suddenly tossed into one pot with Rembrandt and Giotto. All alike suddenly became painters of illusion." In Johns, Steinberg saw "the end of illusion," and beyond that "a solitude more intense than anything I had seen in pictures of mere desolation . . . a sense of desolate waiting . . . of human absence from a man-made environment."[3] The work, he concluded, was profoundly important.

Johns's work followed an implacable logic. Since the surface of a painting was flat, he would paint only flat images on it (numbers, targets). If he wanted to use something three-dimensional, he would build or buy it and add it on. Two of his target paintings were surmounted by a row of wooden boxes containing vestiges of human anatomy: in *Target with Four Faces,* four plaster casts of the same female face,* cut off just above the nose and below the mouth, stare bleakly out at us; in *Target with Plaster Casts,* eight boxes with hinged lids contain painted casts of body parts—foot, face, hand, nipple (male), ear, penis, heel, and hip joint (an animal bone)—while a ninth remains empty. Johns started in 1956 to attach objects to the

*Rachel Rosenthal posed for Johns's first experiments in plaster casting, but she left for California before *Target with Four Faces*; Johns used the face of another friend, Fance Stevenson.

surface of his paintings. *Drawer* incorporates the front of a bureau drawer (it does not pull out). *Book* is a book, open, enclosed in a box frame and painted over in encaustic so that the text is illegible. There is something very disturbing about all these paintings, a sense of cold denial that is in stark contrast to the sensuous, virtuoso brushwork. Johns's "No" was as clear as Rauschenberg's "Yes," but it appeared to be under much tighter control. When Cage and Cunningham came to dinner at Pearl Street, as they did fairly regularly, they would usually start off the evening in Rauschenberg's loft, look at his new work, then move down to Johns's, and for a long time Cage could not really respond to what Johns was doing. He actually preferred the earlier black potato drawings. The structure in Rauschenberg's paintings and combines seemed to Cage to be related to past art, to Cubism and to Mondrian, but at the time he could see no structure at all in Johns's paintings. "We were sure no one else was interested in our work," Johns remembers. "And then Leo Castelli appeared on the scene, and something happened that looks like a beginning."

ALL THROUGH THE LATE FORTIES AND EARLY FIFTIES, NEW YORK ARTISTS had been wondering when Leo Castelli was going to open a gallery. Jackson Pollock once warned him not to try. "Don't do it, Leo," said Pollock. "You're not tough enough." Dynamic and impeccably dressed, fluent in five languages, Castelli was an engaging blend of European elegance and American enthusiasm. His father had been a prominent banker in Trieste, where Castelli grew up to become a playboy on a modest scale, interested mainly in skiing and women. Sent by his father to work for a bank in Bucharest, he married the daughter of one of Romania's wealthiest industrialists, Mihail Schapira, who generously set his son-in-law up in a banking career before financing his first, singularly ill-timed plunge into the art world. With René Drouin, a French architect and interior designer, Castelli opened a gallery in Paris in the late spring of 1939. Their first exhibition was a Surrealist group show, which attracted *le tout Paris*. Afterward they closed the gallery for the summer, went on vacation, and that was that—the war broke out in September.

The Castellis and their five-year-old daughter, Nina, made their way in 1941 to New York, where they were soon comfortably installed on the fourth floor of the town house that Mihail Schapira, who preceded them, had bought at 4 East Seventy-seventh Street. Castelli was drafted in 1943, and served during the war in Army Intelligence, as a result of which he became a U.S. citizen. For several years after the war he was at loose ends. His father-in-law, perennially helpful, set him up in the sweater business, but Castelli by this time had become passionately interested in modern art. He spent most of his time visiting galleries and studios, and gave himself what he considers his real education at the Museum of Modern Art. Castelli also did some private art dealing in European masters (Kandinsky, Klee, Miró), sometimes in connection with René Drouin, his former partner, who had started up the gallery again in Paris, and sometimes with Sidney Janis in New York. His wife Ileana also became addicted to modern art and bought a number of paintings by Pollock, de Kooning, and others of the rising New York School, most of them from Janis, and for a time the Castellis were looked upon mainly as collectors. Castelli was close enough to the artists to be elected an early member of The Club, however, and in 1951 he took an active part in organizing the famous Ninth Street Show. Willem and Elaine de Kooning shared the Castellis' house in East Hampton for two summers running. De Kooning was becoming dissatisfied with Charles Egan at the time, and one evening he demanded to know why Castelli didn't go ahead and open a gallery of his own. "I think Leo will open a gallery," Ileana replied, in her soft voice, "and that you won't be one of his artists." Why not? de Kooning wanted to know. Ileana said she thought her husband would be more interested in what was coming up, rather than in what had already bloomed.

When Castelli finally did start a gallery in February 1957, his plan was to show the work of the younger European and American artists. He and Ileana started in the quietest way possible, in the living room of their apartment at 4 East Seventy-seventh Street. Nina was away at Radcliffe then, so her room became the office. Visitors

squeezed into a small and unpredictable elevator for the ascent to the fourth floor, where they were assaulted by the furious barking of Ileana's long-haired dachshund, Piccina. The gallery's first shows featured second-generation Abstract Expressionists such as Paul Brach, Norman Bluhm, and Jon Schueler, and two young Europeans, Viseux (French) and Horia Damian (Romanian), who were not destined to electrify the art world. Castelli was not at all sure what direction to take. Lack of confidence in his own ability to run a gallery had kept him from doing so until he was fifty-one—that and his father-in-law's understandable view that modern art was riskier than sweaters. Castelli looked at everything that came along, though, and two months after opening the gallery he had what he describes as his first great epiphany. At an exhibition called "Artists of the New York School: Second Generation," organized by the art historian Meyer Schapiro at the Jewish Museum on upper Fifth Avenue, Castelli stood for a long time in front of *Green Target* by Jasper Johns—the first Johns ever publicly exhibited, not counting the two that Gene Moore had put in Bonwit's window and the small flag in Rauschenberg's *Short Circuit.*

"I saw it as a green painting, not even as a target," Castelli remembers. "A green painting with collage elements. I was thunderstruck. It was like the sensation you feel when you see a very beautiful girl for the first time, and after five minutes you want to ask her to marry you. I looked at the name under the picture, Jasper Johns, which also made a great impression on me. Could anyone really be called that? Anyway, I went home with that name going around in my head." Ileana Castelli was home with the flu that day. She recalls that Castelli sat on her bed and talked for quite a while about the green painting.

Two days later, the Castellis went to Rauschenberg's loft on Pearl Street. They had known Rauschenberg casually since 1951, when he brought his white painting with numbers to the Ninth Street Show and Ileana, struck by his looks, had asked, "Who is that prince?" Castelli had been enormously impressed by Rauschenberg's red show at Egan's, but in spite of his enthusiasm he had not bought a

painting ("to my great shame"). After Castelli opened his gallery, friends of Rauschenberg kept telling him that they had heard he was going to be in it. Rauschenberg hoped this was true. He had been without a dealer for more than two years, and great things were expected of Castelli. So far he had not been asked, though, and the Castellis' visit was therefore a momentous event. It had been arranged by Paul Brach and Morton Feldman, because Rauschenberg felt he could not just call up a dealer and invite him, in case the dealer refused.

Feldman came down with the Castellis, who also brought Ilse Getz, a young friend who was helping them at the gallery, and who liked Rauschenberg's work enough to have bought one of his paintings. It was a rainy Sunday afternoon. They climbed up the three flights to Rauschenberg's loft, and started to look at the paintings and combines. *Bed* was there, and *Satellite,* and a big untitled combine with a hinged door in the middle, and some examples of his earlier work including *Rebus*. Rauschenberg, who seemed nervous, said he was going down to Jasper Johns's loft to get ice for drinks— Johns had the only refrigerator. "Jasper Johns?" said Castelli, suddenly very excited. "The one who painted the green picture in the Jewish Museum show?" Rauschenberg said it was. "I must meet him," said Castelli. "Can you bring him up?"

Rauschenberg returned a few minutes later, bringing Johns, and it became immediately apparent to everyone that Castelli had lost interest in looking at Rauschenberg's pictures. He told Johns how much he had admired the green painting, and asked if it would be possible to see his other work. "Of course," said Johns. "Call me anytime."

"But could I see it now?" Castelli insisted.

That seemed improper to Johns, who was feeling extremely awkward in any event, but Castelli's eagerness was both flattering and compelling. A few minutes later they all went down to the third floor, where Castelli saw the original *Flag, Target with Plaster Casts, Target with Four Faces, Gray Alphabets,* a large *White Flag,* and a number of other paintings. It was a second epiphany. "I saw evi-

dence of the most incredible genius," Castelli recalls, "entirely fresh and new and not related to anything else." Before leaving, Ileana decided to buy a painting called *Figure I* (something they had not done in Rauschenberg's case), and Castelli said he would like to give Johns a show.

Afterward, Feldman and Rauschenberg and Johns went out to the local Childs for dinner. "What did Castelli say?" Feldman asked Johns. Johns said he had offered him a show. "What did he say to you?" Feldman asked Rauschenberg, who replied, "Nothing." Rauschenberg didn't seem at all disheartened. The mood was festive; the Castellis' obvious response to Johns's work was a cause for celebration. Several days later, though, Rauschenberg came to the Castelli Gallery in a state of near-despair. He told Ileana (Leo was not around) that he had to know what they planned to do about him; if they were not going to give him a show he would look for another gallery. "I was very embarrassed," Ileana remembers, "and suddenly aware of how much he had been hurt." Although Castelli himself was still not quite sure how he felt about Rauschenberg's work, they gave him a definite date for a show: March 1958. Johns had already been scheduled for January.

Johns and Rauschenberg each had a painting in Castelli's group show called "New Work" that spring (May 1957). Johns showed a red, white, and blue flag, and Rauschenberg contributed *Gloria,* a collage painting with four *Daily News* photos of Gloria Vanderbilt being wed for the third time (a rather sly touch for Rauschenberg). Of the ten artists in that show, Rauschenberg and Johns were the only ones who stayed with the gallery. Castelli had found his direction. Johns and Rauschenberg were "what was coming up."

Jasper Johns's first one-man show at Castelli hit the art world like a meteor. Even before the opening in January, *Target with Four Faces* had appeared on the cover of *Art News,* then the most respected American art journal, which under the direction of Thomas B. Hess had become strongly committed to Abstract Expressionism. Hess had heard about Johns from Rauschenberg, and he had seen *Green Target* at the Jewish Museum show. When a December snow-

storm in New York held up the shipment of *Art News*'s January cover from Europe, Hess went over to Leo Castelli's, saw *Target with Four Faces,* and asked to borrow it. Castelli readily agreed. They wrapped the picture in a plastic sheet and Hess took it by taxi straight to the engravers. Its appearance on *Art News*'s cover was a bombshell. But the real bombshell was the show.

Alfred Barr came on the first Saturday, and stayed for three hours. Although Barr had been relieved in 1944 of the Museum of Modern Art directorship ("Fired," as his wife always put it), he remained, as Director of Museum Collections, the heart and soul of the institution and the ultimate authority on acquisitions. Barr telephoned from Castelli's to Dorothy Miller, his close associate, and told her to get right over. Together they selected not one, but four works for the museum: *Green Target, White Numbers,* the first *Flag,* and *Target with Four Faces.* Barr really wanted to buy the larger *Target with Plaster Casts,* but he was nervous about the museum trustees' reaction to the green-painted plaster cast of a penis in one of the wooden boxes on top. Would it be all right, he asked Castelli, to keep the lid to that particular box closed? Castelli said they would have to ask the artist, who just happened to be in the back room. Johns came out, listened to Barr's request, and said that it would be all right to keep the lid closed some of the time but not all of the time. Barr decided to take *Target with Four Faces* instead. He was also a bit uneasy about the flag painting, which he thought some of the trustees might consider unpatriotic—the taint of McCarthyism was still in the air then—but, as was his custom in such cases, he persuaded Philip Johnson to buy it for future donation to the museum. Johns remembers Barr saying to him that he wanted several of his pictures "because there might not be any more like them." Barr also wondered aloud whether the pictures would last, physically speaking, because of the technique of encaustic on newsprint, but then he said that they would probably "last as long as we will."

Several other MOMA trustees bought paintings from the show, and so did Ben Heller, Emily Tremaine, Donald Peters, Mrs. Henry Epstein, and other important collectors. When the show closed only

two pictures remained unsold—*White Flag,* which Johns decided to keep for himself, and the problematic *Target with Plaster Casts,* which Castelli bought. *Target*'s price was $1,200 (it was the most expensive piece in the show), and in the euphoria of the moment Castelli waived his commission and paid Johns the full amount. It was the most successful debut anyone could remember, and the repercussions were felt almost immediately, from Milan to Tokyo. Leo Steinberg has reported the comments of two well-known abstract painters whom he overheard at Castelli's. "If this is painting, I might as well give up," one of them said. "Well," said the other, a little sadly, "I'm still involved with the dream."

Rauschenberg's show in March was, as usual, a *succès de scandale.* It included *Bed, Odalisk, Gloria, Satellite,* and *Rebus,* all of which annoyed some viewers and some of which annoyed nearly all of them. There were two sales. A woman in Baltimore bought a small *Collage with Red,* which she subsequently brought back, saying she had been keeping it in a closet because the delivery boys all broke up laughing at it; Castelli reclaimed the work at double what she had paid, and later sold it for considerably more to the Italian collector Giuseppe Panza. The other sale was to Castelli, who bought *Bed.* It was a major commitment (the price was $1,200), showing that his own doubts about the artist had evaporated. Barr and Dorothy Miller came to the show, but the museum bought nothing. A visitor scrawled "Fuck You" on *Rebus,* with a crayon, when nobody was looking, and Rauschenberg had to collage over it. In the guest book, someone else wrote, "This is a very good show but nothing like Jasper Johns."

TOWARDS THEATER

The New York art world, in a last reassertion of its old tribal soli-
darity, turned out *en masse* for John Cage's retrospective concert at
Town Hall in the spring of 1958. Artists pressured their dealers into
buying blocks of tickets, and large sections of the house reverberated
with the conviviality of a family reunion. The concert itself had been
conceived and organized by Rauschenberg, Johns, and Emile de An-
tonio, a former college English teacher who had become a sort of
vanguard impresario (later he found his true métier as a maker of
documentary films). De Antonio had put on an evening of Cage's
music in suburban Rockland County three years before, on a night
of such torrential rains that the local police were advising motorists
to stay off the roads; a loyal contingent of New York artists drove
out anyway, and Rauschenberg and Johns were so impressed by de
Antonio's resourceful energy that they subsequently made him their
agent—he handled their display business and also cashed their
checks, saving them from the banality of a bank account. By 1958,
thanks to their commercial sideline, Rauschenberg, Johns, and de
Antonio were able to put up a thousand dollars apiece to sponsor the
Town Hall concert.

The concert was a chronological survey of Cage's music over the
last twenty-five years, from his early percussion pieces to the *Con-*

cert for Piano and Orchestra which he had just finished writing, and the audience's reactions provided an object lesson in the effects of time on experimental art. Virtually unrestrained applause greeted the first part of the program, with a few scattered catcalls to show that not everyone present was avant-garde. Restlessness and indignant departures increased as more recent compositions were introduced, but the protests did not become general until after the second intermission, when the musicians attempted the New York premiere of an all-electronic work called *Williams Mix.* They got through it, somewhat shakily, but then midway into the *Concert for Piano and Orchestra,* which was last on the program, a group in the balcony stood up and tried to stop the performance with a sustained burst of derisive clapping and yelling, and the concert limped to its close in a cacophony of cheers, boos, whistles, shouts, and other sounds not intended by the composer. Virgil Thomson, reviewing the record album of the concert, recalled it fondly as "a jolly good row and a good show. What with the same man playing two tubas at once, a trombone player using only his instrument's mouthpiece, a violinist sawing away across his knees, and the soloist David Tudor crawling around on the floor and thumping the piano from below, for all the world like a 1905 motorist, the Town Hall spectacle, as you can imagine, was one of cartoon comedy . . . And if the general effect is that of an orchestra just having fun, it is doubtful whether any orchestra ever before had so much fun or gave such joyful hilarity to its listeners."[1] Cage himself had not been so well pleased. His most recent, "indeterminate" methods of composition allowed each musician a certain degree of freedom within the overall framework, leaving many decisions regarding what sounds would be produced, and when, and for how long, up to the performer himself, thus drawing him into the compositional process and making him, in Cage's eyes, a fellow artist and collaborator. Too often, though, the professional musicians mistook liberty for license, and simply refused to use their own imagination. During the Town Hall concert one man had interpolated a large part of Stravinsky's *Sacre du Printemps* (a score whose initial performance in Paris in 1913 had incited *that* audience

to riot). "You never can tell in rehearsals who's going to act like an idiot," Cage complained. The real problem in his work (a problem that many of his admirers and imitators have never solved) was how to be free without being foolish.

Cage taught a class in experimental music at the New School, New York's cornucopia of adult education. Actually he taught three classes there, the others being a course on Virgil Thomson and one on amateur mycology. (Cage had moved out of the city to Rockland County in 1954, when the Bozza Mansion was demolished, and in the woods near Haverstraw he had discovered the joys and nervous excitements of mushroom hunting. He was delighted to notice that the words "mushroom" and "music" were adjacent in his dictionary.) People of all ages and backgrounds signed up for Cage's mushroom walks, but the students in his experimental music class were for the most part young, impressionable, and aesthetically ambitious. Allan Kaprow, George Brecht, and Al Hansen were practicing artists; Jackson Mac Low and Richard Higgins were poets; the only musician in the class was a Japanese student named Toshi Ichiyanagi. Cage's teaching method was to introduce them to the point he had reached in his own work, following a brief general survey of modern music, and then to try to find out where they were and do what he could to stimulate them to experimental action, the results of which would be performed and discussed in class. "We all felt something terrifically exciting was going on in that class," Kaprow recalled some years later. "I just couldn't wait to get back there every week." One of the things that was happening was the birth of a new art form (speaking generously) to which Kaprow in 1959 gave the name "happenings"—performance events that lay somewhere between theater and the "environmental" trend of visual art.

"Where do we go from here?" Cage had asked himself, in a 1957 essay on *Experimental Music.* His reply was, "Towards theater. That art more than music resembles nature. We have eyes as well as ears, and it is our business while we are alive to use them."[2] Cage's definition of theater was no more restricting than his definition of music. Seeking as always to erase the demarcation between art and

life, he believed that "Theater takes place all the time wherever one is and art simply facilitates persuading one this is the case."[3] It was a concept that proved immensely liberating to Kaprow and others in the class, although, as Kaprow later made clear, Cage's thinking was only one (albeit a vital one) of the elements that shaped the happenings. Among others were the manifestos of the Italian Futurists before the First World War; the Dada and Surrealist movements, with their public provocations; and the theories of Antonin Artaud, a French actor whose writings prophesied a theater returned to its origins in mystery and ritual and freed of its slavish dependence on the verbal text. Also, the choreography of Merce Cunningham and Paul Taylor, and in particular the Cage-Cunningham "Event" at Black Mountain College in 1952; experimental films; the circus; early Hollywood comedies; and, most decidedly, the "action painting" of Jackson Pollock and others.

Kaprow himself was a curious mixture of the visionary and the academic intellectual. As a student at New York University he had majored in art and philosophy and studied painting with Hans Hofmann. He had been one of the founders of the Hansa Gallery, a cooperative whose members were nearly all ex-Hofmann students (they chose the name "Hansa" partly to honor their teacher), and in his several shows there (the first in 1953) he had moved from highly expressionistic abstract paintings to expanded collages, and then to a vast collage "environment" that filled the gallery with huge sheets of plastic, tinfoil, crumpled cellophane, tangles of Scotch tape, bands of colored cloth, Christmas tree lights, and five tape recorders playing electronic tapes. It occurred to Kaprow at this point (1958) that every visitor to his environment became a participant in it, willingly or not, and this in turn suggested giving the participants a more active role.

At the same time that Kaprow-the-artist was progressing from static environments to environmental activities, Kaprow-the-philosopher was evolving a theory to justify his progress. In the fall of 1958 he published, in *Art News,* an article called "The Legacy of Jackson Pollock."[4] Since Pollock's death, Kaprow argued, the qual-

ity of Abstract Expressionist painting had precipitously declined, and the true importance of Pollock's breakthrough had been largely missed. Pollock's canvases were so enormous that "they ceased to become paintings and became *environments*," and this was the direction in which post-Pollock art ought to move. Painters should go beyond paint and canvas, in order to immerse themselves in everyday life. "Objects of every sort are materials for the new art: paint, chairs, food, electric and neon lights, smoke, water, old socks, a dog, movies, a thousand other things . . . all will become materials for this new concrete art." (The description sounds like an inventory of the objects lying around Rauschenberg's studio; Kaprow later told Alan Solomon that he had drawn on a recent visit there in writing it.) As for the element of "action" in Pollock's "action painting," Kaprow saw it leading "not to more painting, but to more action." What he proposed was a rather astonishing synthesis of two seemingly incompatible modes—Cage's anti-expressive commingling of art and everyday life, and Pollock's violently self-expressive attempt to transcend life. Kaprow was a skillful and highly articulate polemicist, but his theories got him into difficulties with his fellow artists. Nearly all those who became involved with the happenings insisted at some point that Kaprow did not speak for *them*.

The first happening took place at George Segal's chicken farm in New Jersey, in the spring of 1958. Segal, an artist who showed at the Hansa Gallery but supported himself by raising chickens, had invited the Hansa group to a picnic at his place. Kaprow thought it would be a fine opportunity to test out some ideas. He and Segal made rude props out of one-by-two lumber and plastic sheeting, and Kaprow wrote a scenario that called for the picnickers (about a dozen in all) to jump through the plastic sheets, sit in chicken coops rattling noisemakers, paint a collective canvas, and indulge in a variety of slow, ritualistic movements. Since it was a hot day and the Hansa artists had put away a good deal of beer by the time the activity got started, nobody paid much attention to the script, and Kaprow decided that they were hostile to the whole idea.

Undaunted, Kaprow presented what he called "18 Happenings in

6 Parts" that fall at the Reuben Gallery, a new cooperative at 61 Fourth Avenue between Ninth and Tenth streets. This event took place in three separate rooms (environments) with the audience moving from one to another to watch human and non-human actors (there was a dancing toy and a pair of wheeled constructions) perform activities that varied from performance to performance. Words were spoken, both live and on tape, but there was no plot or story, no development, and no meaning or message. "Happenings," as he explained in a subsequent article, "are events which, put simply, happen . . . they appear to go nowhere and do not make any particular literary point."⁵

The appeal of such a spectacle might seem on the surface to be somewhat limited, but to everybody's surprise, Kaprow's included, "18 Happenings in 6 Parts" was well attended, and when a rash of other "artist's theater" events broke out in downtown lofts and galleries shortly thereafter, the word "happening" suddenly captured the attention of a lot of people. The early happenings were all highly individualistic, although their spontaneous emergence suggests a common animating spirit. Claes Oldenburg's pieces managed to seem both literary and psychological, without a shred of spoken dialogue; Jim Dine and Robert Whitman, both of whom turned out to be extraordinarily gifted (though untrained) actors, gave vivid one-man performances with fantastic props. Red Grooms's very brief "The Burning Building" was an explosion of primitive energy and intensity—firemen laying about them with cardboard axes and flour-filled socks, people diving out of windows, a lot of yelling and noise-making, and a final chase that erupted into the audience. By contrast, Kaprow's carefully arranged animated environments struck many observers as humorless and boring, which was one reason neither Whitman nor Oldenburg wanted their pieces referred to as happenings. Most of the happenings defy verbal description, having no relationship to the cause-and-effect structure of traditional theater or even the anti-rational theater of the absurd. One of the few that did make a clear point was Dine's "The Smiling Workman" (1960), which featured Dine, a blank canvas, and a table with three jars of

paint and two brushes. As Dine himself recalls it: "I was all in red with a big, black mouth; all my face and head were red, and I had a red smock on, down to the floor. I painted 'I love what I'm doing,' in orange and blue. When I got to 'what I'm doing,' it was going pretty fast, and I picked up one of the jars and drank the paint, and then I poured the other two jars of paint over my head, quickly, and dove, physically, through the canvas."[6] The action painter's need to "get into the painting" could hardly have been expressed more graphically.

New York was not the only place where young artists were moving toward theater. Oldenburg had read an article in the Sunday New York Times in 1957 about the activities of the Gutai group in Japan, a band of young artists who since 1955 had been doing performance events in a pine forest near Kobe—throwing paint-soaked balls of paper at a white sheet, decking the trees with plastic bags full of colored liquids, inflating and deflating huge vinyl balloons, digging holes in the ground and illuminating them.[7] In Paris, Yves Klein, the leader of a group that would later become identified as Les Nouveaux Réalistes, had a show in 1957 called "Le Vide" (the void) during which the Galerie Iris Clert contained nothing whatsoever but the announced "presence" of the artist; hundreds of spectators became participants at the opening, where the main actors were two resplendently uniformed Republican Guards, whose services at the door Klein had secured through an influential relative, and who were subjected by Klein's skeptical friends to such indignities that they left in a rage and filed charges against Klein and Iris Clert for insulting the state. Klein went on afterward to paint pictures with "living brushes"—nude girls who anointed their bodies with paint and then pressed themselves to canvases according to Klein's instructions, sometimes before an invited audience and accompanied by a small orchestra playing Klein's Monotone Symphony, which consisted of a single note indefinitely repeated. This sort of mise en scène was rather different in spirit from the New York happenings, where the emphasis was on objects and materials, and the humblest sort of materials at that. Taking their cue from Rauschenberg and other rag-

and-bone fanciers such as Richard Stankiewicz, who welded sculptures out of scrap metal, or John Chamberlain, the great reassembler of smashed auto parts, the happening artists subscribed, for aesthetic as well as for practical reasons, to the poetry of junk. The live actors in happenings were often treated as inanimate materials, swathed in burlap bags or shrouds and carted here and there, and the audience was treated much the same way—pushed into uncomfortable spaces where it was difficult to see what was going on, teased and insulted and otherwise used as another material to be manipulated by the artist-*régisseur*. In New York, where people are accustomed to being bullied by nightclub comedians and headwaiters, the happenings became wildly chic. "By 1962 the whole thing had become totally commercial," according to Oldenburg. "People were arriving in Cadillacs." Oldenburg, Whitman, Grooms, and Kaprow continued to do sporadic happenings after that, for the most part outside of New York. But with the exception of Kaprow the New York artists did not look on the happening as a major art form, and after 1962 they all went back to painting and sculpture, or moved on into film and video.

Neither Rauschenberg nor Johns showed much interest in happenings. During this period they were both working with Merce Cunningham, making sets and costumes, and, in Rauschenberg's case, learning about theatrical lighting. Cunningham's theater seemed to them far more innovative, more truly contemporary, than anything else on the horizon. Kaprow had seen the happening as a step beyond Abstract Expressionism, which he considered moribund, but the other artists in the happening movement were as expressionist in sensibility as Pollock or de Kooning, and in some ways more so. Cage rather disliked the happenings, partly for that reason but also because it seemed to him that the artists who did them were lazy. They would take a single action or idea and spread it out in time, often far too much time. In his *Water Walk*, a piece of music-theater that he had made out of materials available to him in an Italian television studio in 1958, Cage had used a bathtub full of water, a pressure cooker, a siphon, a bottle of Campari bitters, a bucket of

ice, a Waring Blender, five radios, a piano, a tape machine, bells, whistles, party poppers, a large vase of roses, an old-fashioned garden sprinkler, and a rubber fish that flopped its tail. Since *Water Walk* was only three minutes long, and every prop was used, it required split-second timing and a great deal of rehearsal; the fish, for example, started off inside the piano, flopping its tail against the strings, and ended up swimming in the bathtub. Cage's musical training and his sense of theater had given him a very acute understanding of the use of stage time. Visual artists, trained to use space rather than time, were all too often inclined to drag things out on stage to what seemed interminable lengths, even in pieces that lasted a mere twenty minutes. A good many of the happenings were more interesting to talk about than to watch, more interesting for the performers than for the audience, and most interesting of all for the artist-producer.

The theater of Merce Cunningham provided a much broader focus. Cunningham wanted to collaborate on equal terms with musicians and artists. His concept gave to music and decor an independence and a weight equivalent to the dance itself, and Rauschenberg's sets and costumes had always been far more than simply visual supports to the stage action. For *Summerspace,* made in the summer of 1958, Rauschenberg and Johns painted a forty-foot backdrop in a pattern of pointillist dots; the costumes were dyed in the same pattern, so that when a dancer stopped moving he or she blended with the background and became virtually invisible (the dance, with its exquisitely delicate score by Morton Feldman, is one of the loveliest in the Cunningham repertory; it has been done by a number of classical ballet companies, including Balanchine's New York City Ballet). *Antic Meet,* a marvelous loony dance choreographed that same year, was full of bizarre visual effects; at one point Cunningham came on stage with a chair strapped to his back, and Carolyn Brown, in a nightgown that Rauschenberg had found in a thrift shop, stepped through an onstage door and sat down in it. The comic muse is even rarer in dance than in painting, but Cunningham, who was open to everything, could be superbly droll at

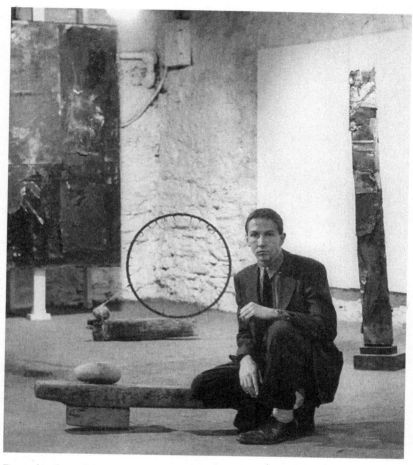

Rauschenberg in 1953, with *White Painting* and early sculptures.
Photo credit: Allan Grant.

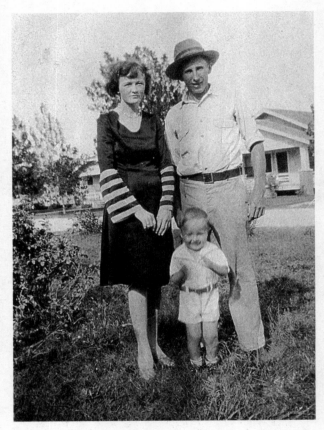

Port Arthur, Texas. Rauschenberg and parents.

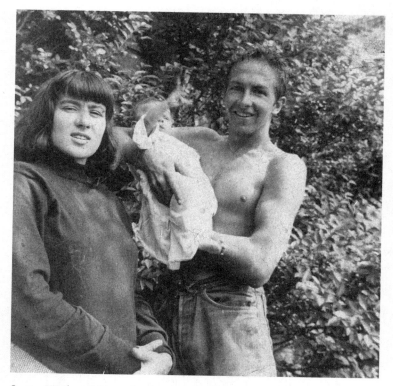

Susan Weil and Rauschenberg with six-month-old Christopher.

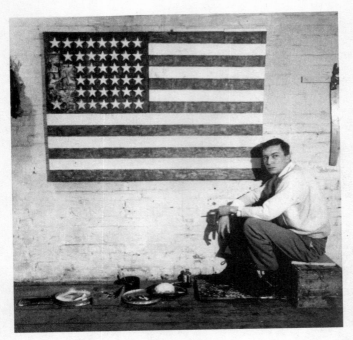

Jasper Johns with an early *Flag* painting.
Photo credit: Robert Rauschenberg.

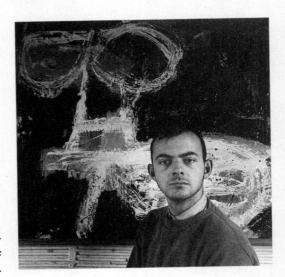

Cy Twombly.
Photo credit:
Robert Rauschenberg.

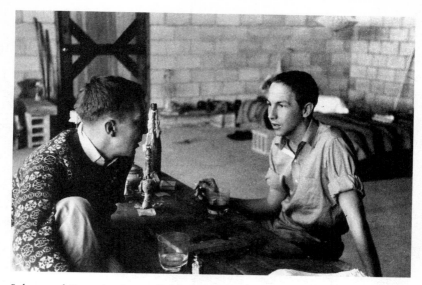

Johns and Rauschenberg. Johns's Pearl Street loft, 1954. *Photo credit: Rachel Rosenthal.*

Jasper Johns, 1954.
*Photo credit:
Robert Rauschenberg.*

John Cage in 1954.
Photo credit: Robert Rauschenberg.

Merce Cunningham in
Changeling (1957)—
costume by Rauschenberg.
Photo credit: Richard Rutledge.

Monogram at the Jewish Museum, 1963. *Photo credit: Hans Namuth.*

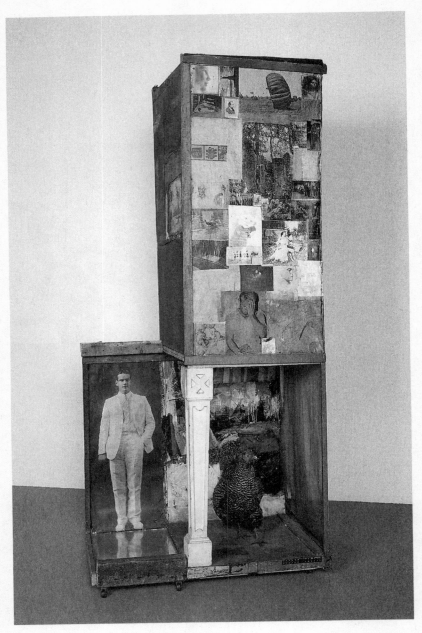

Combine, *Untitled*, circa 1954. *Photo credit: The Museum of Contemporary Art, Los Angeles, The Panza Collection.*

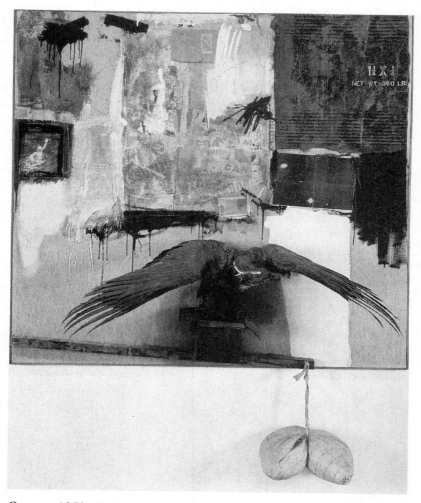

Canyon, 1959. *Photo credit: Sonnabend Collection, New York.*

Cunningham world tour in 1964: (*above, left to right*) Carolyn Brown, Merce Cunningham, John Cage, unidentified woman, David Tudor, unidentified man; (*below*) Steve Paxton, Karlheinz Stockhausen, Rauschenberg.

Festive gallery openings enlivened the scene: Marisol, Rauschenberg, Leo and Toiny Castelli. *Photo credit: Cosmos courtesy Leo Castelli Gallery.*

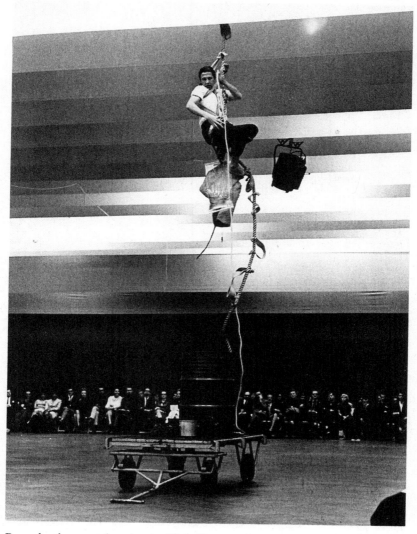

Rauschenberg performing in *Elgin Tie,* Moderna Museet, Stockholm, September 1964. *Photo credit: Stig T. Karlsson.*

Rauschenberg with his visual *Autobiography,* which includes a life-size
X-ray of the artist, a verbal summary of career highlights, and
a photo of him appearing in his roller-skate dance, *Pelican.*
Photo credit: Fred McDarrah.

Retroactive I. JFK's image appears in eleven Rauschenberg works of the 1960s. Wadsworth Atheneum, Hartford, Connecticut. Gift of Susan Morse Hilles. *Photo credit: Rudolph Burckhardt.*

Big Pile of Bones, 2005, from another scenario series.
Photo credit: Ed Chappell.

The studio in Captiva: "A cross between the Taj Mahal and the Pentagon." *Photo credit: Ed Chappell.*

Rauschenberg in his Captiva studio, circa 2000. *Photo credit: Ed Chappell.*

Rauschenberg and friends, Captiva, 1971. *Photo credit: Hans Namuth.*

times. In those days his audiences were often too perplexed or too reverent to notice.

Although the antic spirit did not prevent Cunningham from being considered a serious artist, both Rauschenberg and Cage were continually being dismissed as clowns, deliberate *farceurs.* "Eulenspiegel is abroad again, and one must be patient," the anonymous *Art News* reviewer wrote of Rauschenberg's *Short Circuit,* in the 1955 Stable Annual.[8] Cage had learned through experience not to be bothered by this sort of put-down. When a young Korean music student named Nam June Paik asked him, after a European concert, whether he intended compositions such as *Water Walk* to be funny, Cage replied that he did not, but that when funny things happened as a result of his chance methods he could accept them without difficulty. "In general I prefer laughter to tears," he said. Rauschenberg, however, found himself increasingly troubled by people who saw his work as a joke.

His curiosity about what a painting actually was, or could be, kept leading him to make things that seemed like jokes—for example, *Factum I* and *Factum II,* two 1957 collage paintings that looked identical at first glance (same paint strokes, same collage elements), and which were interpreted as a satiric thrust against Abstract Expressionist spontaneity. His *Coca Cola Plan* made a sort of small-scale *Winged Victory* out of three ordinary Coke bottles; his *Odalisk* could be viewed as a travesty of the female nude. *Monogram,* the famous Angora goat with a tire around its middle, had a prodigious effect when it was first shown at Castelli's in 1959, in a three-artist group show. The image was indelible and shocking (no small accomplishment in 1959), and over the next few years it became Rauschenberg's most widely illustrated work, the one that identified him in the public mind. But a goat with a tire—the work of a serious artist? Surely *that* was going too far. Of course the same thing had been said about Cézanne, about Matisse, about Pollock—for that matter about Michelangelo—but the line had to be drawn somewhere, et cetera.

The desire to be taken more seriously as an artist almost certainly

influenced Rauschenberg's decision, early in 1959, to make a series of drawings illustrating Dante's *Inferno*. He had always loved to draw. The intimacy of the medium appealed to him, and recently he had discovered a technique that allowed him to apply the collage methods of his paintings and combines to the smaller scale of drawings. He had found that by moistening newspaper or magazine photographs with solvent, placing them face down on drawing paper and rubbing the back of the clipping with an empty ball-point pen, the reversed image would be transferred more or less intact. After making several drawings this way in 1958, he wanted to do more, but he needed a subject to keep him going. With paintings and combines, one led naturally to the next, but each drawing seemed to end in itself. One morning, out of the blue, the idea of illustrating the *Inferno* came to him. He had never read the poem, of course, but he had heard enough about it to know its general outline and its status as a masterwork. He had also seen some of the Botticelli illustrations and those of Gustave Doré (but not the more recent series by George Grosz); Botticelli's had struck him as far superior, because he had "treated it like a combination road map and cartoon." Rauschenberg bought a paperback copy of John Ciardi's translation and went to work, in his no-nonsense way, on the first canto. His plan was to do one drawing for each of the thirty-four cantos, illustrating what happened in it rather than trying to select the high points. He never read more than two cantos ahead of the one he was illustrating. Now and then he would check an image in Ciardi against the corresponding passage in Henry Wadsworth Longfellow's and Dorothy Sayers's translations, both of which he had acquired, but usually it was the Ciardi that seemed right to him.

For the first time in his professional life, Rauschenberg found himself working with symbols, visual equivalents of the characters, events, and landscapes that Dante, that intensely visual poet, had rendered in words. Not wanting to invent his own, which would have involved him in personal taste, he took his symbols from the limitless inventory of images in current magazines, especially the publications of Henry Luce. Rauschenberg's Dante came from a

Sports Illustrated advertisement for golf clubs—a man with a towel around his waist, "the most neutral popular image I could find in that scale." The ad, which ran for many weeks, featured clubs the whole family could use; father, mother, and two children were pictured standing against graph paper to show their height. The father appears in almost every one of Rauschenberg's illustrations, an exception being the canto where Virgil carries Dante across a river, picking him up so easily "he might have been a child"—here Rauschenberg used one of the two children.

His Virgil is Adlai Stevenson, "the man of intellect," the good guide. Other current political figures crop up here and there, as they do in Dante (Richard Nixon boils in a river of blood with the Violent Against Their Neighbors). Racing cars suggest the roar and violence of Hell, handless clocks connote eternity, riot police with helmets and gas masks become demons and tormentors. There is also a good deal of freehand drawing—stabbing lines for the stinging wasps, flashes of color for hellfires and blue ice-pits, a recurrent arrow for transitions from one scene to the next. Although the overall tonality of the series is restrained and almost "pedestrian," there is a velocity and a sense of violent beauty that comes from the juxtaposition of images and passages of pure drawing, Rauschenberg's unmistakable net of images held together not in balance but in a state of tension.

When he had finished six drawings, he decided to apply for a Guggenheim Fellowship so that he could spend the next year working exclusively on the series. Although the Guggenheim art jury did not look with favor then on avant-garde applicants, Rauschenberg thought that Dante might impress them, and he chose his sponsors with great care: the Museum of Modern Art's Dorothy Miller, the respected art book publisher and seller George Wittenborn, and John Ciardi. As examples of his work he submitted one of the Dante drawings, a recent painting that he considered "embarrassingly lyrical," and photographs of several others—he had discovered that his things often proved more acceptable in photographs than in the original. The day after the art jury met, a secretary of the Founda-

tion telephoned Rauschenberg and said he was "very lucky"; the committee members liked his project, but they wanted to see a little more of his work—in the original. "I knew right then I was cooked," said Rauschenberg. He sent over two more paintings, and soon afterward received a notice saying his application had been turned down.

By this time he was too immersed in the series to give it up. Fortunately some of his earlier paintings were starting to sell to adventurous collectors, which meant he no longer had to take time out for commercial jobs. But he had to get away from New York. The natural interruptions of city life undermined the sustained concentration that the series required; besides which, Rauschenberg was carrying on a private quarrel with Dante. "I was so irritated by his morality—the self-righteousness, the self-appointed conscience imposing guilt on old friends. He was the hero *and* the author, the man who made the world he described. Everybody else had illustrated Dante the writer, you see, but I wanted to show Dante the character in the story, and that forced me into isolation. I was looking for an old fisherman's shack in the wilderness, something that doesn't exist in this country any more. I went down to Florida because I wanted warm weather, and on Treasure Island I found a storage room, built out on the end of a wharf, that belonged to a motel in a dilapidated part of town. The day I moved in the woman who owned the motel had to shut down because her sister had fallen ill up north. I persuaded her that she would be lucky to have me look after the place. So it actually turned out to be the closest thing to what I was looking for. Both Jasper and Ileana came down to visit me, and both left after two days. They found it sordid. But it was just what I wanted. I stayed six months and never knew anyone. I did the last half of the drawings there. The *Inferno* builds up in intensity all along, and I really needed that isolation."

The Dante drawings did a lot to establish Rauschenberg's reputation as a serious artist. Even Stuart Preston, the *Times* critic, came through with faint but discernible praise when they were shown at Castelli's in December 1960 (". . . the attempt is a brave one, and, in

its odd way, moving"), and some of the people who knew that *Monogram* was a joke grudgingly conceded that perhaps Rauschenberg was more than a prankster.

The Museum of Modern Art acquired the Dante drawings in 1963, in a rather curious fashion. Ivan Karp, Castelli's associate in the gallery, was approached one day by a gentleman who said he was interested in buying the drawings to give to the museum. Karp was skeptical, never having seen the gentleman or heard his name before, but later that afternoon Castelli called Alfred Barr and learned that the customer was an architect and that he had indeed approached Barr, saying he wanted to make a gift to the museum, and Barr, who felt somewhat embarrassed that he was unable personally to appreciate Rauschenberg's paintings and combines, but who did like the Dante drawings, had suggested to him that he give those. The architect returned to the gallery a few days later and had a chat with Castelli. From time to time he produced a hip flask, from which he offered the fastidious dealer a slug of Jack Daniel's (Rauschenberg's favorite beverage). At the conclusion of their chat, he agreed to give the museum a check for thirty thousand dollars, the price of the series, explaining that it was income tax time and that he would rather give to the museum than to the Internal Revenue Service. Later, Castelli learned that he had been on the verge of a legal separation from his rich wife, and that this was in the nature of a last little bagatelle—he knew she would not rescind the funds once the gift had been announced. The museum, at any rate, got the drawings.

INTO THE SIXTIES

Saint Patrick's Day, March 17, 1960. An icy rain falls throughout the day on the high school bands marching up Fifth Avenue, and it is still falling at six-thirty that evening when Governor Nelson Rockefeller, a host of distinguished guests, and three television crews gather in the sculpture garden of the Museum of Modern Art. There, in the freezing slush, the Swiss kinetic sculptor Jean Tinguely is still hard at work on his *magnum opus,* a huge construction whose sole purpose is to destroy itself in one glorious act of mechanical suicide. The piece is composed of scrap metal, bicycle parts, a washing machine drum, an upright piano, a radio, several electric fans, an old Addressograph, a baby's bassinet, three dozen bicycle and baby carriage wheels, uncounted small motors and fan belts, two Tinguely "meta-matics" (motor-driven devices that produce instant abstract paintings by the yard), several bottles of chemical stinks, an apparatus to make smoke, bells and Klaxons and other noisemakers, and yards and yards of metal tubing, the entire apparatus painted white and topped by an inflated orange meteorological balloon. It is called *Hommage à New-York.*

An hour more passes while Tinguely, who looks like a Cuban revolutionary in his threadbare storm coat and two-day growth of beard, and his several assistants hasten to complete the construction

phase of the machine on which they have worked practically non-stop for the last three weeks. At seven-thirty the construction ends and the destruction begins. The great white machine rattles and shivers in all its members. Smoke pours from its interior, temporarily blanketing the audience. The piano catches fire and burns, accompanying its own demise with three mournful notes repeated over and over. Parts of the structure break loose and scuttle off to die elsewhere. Crossbeams sag as electric charges melt the previously weakened joints. A Rauschenberg "money-thrower" (Tinguely had invited contributions from artists he liked) goes off with a blinding flash, scattering silver dollars. One of the meta-matics tries but fails to produce a black-and-white abstract picture on a long roll of paper. The other unreels a streamer proclaiming "Yang Is Ying." A fireman, summoned by Tinguely, comes out to extinguish the blaze in the piano; he is angrily booed by the spectators. After about twenty minutes it becomes clear that the machine will not perish unaided; firemen's axes finish the job, and *Hommage à New-York* returns to the junk piles from which it was born. The nineteen sixties have begun.

Today the sixties have taken on something like the romantic aura of the twenties. History does not divide itself into neat decades, of course, and what we loosely call the sixties encompasses an astonishingly wide range of social evolution, from the champagne optimism of John F. Kennedy's inauguration to the rage and despair of civil rights battles, assassinations, and Vietnam. If there is any unifying note running through the decade it is the note of disorientation and change. In 1960, for example: the first Negro sit-ins took place in the South; the Food and Drug Administration authorized the sale of oral contraceptives (the Pill); President Dwight David Eisenhower, everybody's authority figure, was caught in a whopping lie when he denied that U.S. aircraft were flying spy missions over the U.S.S.R.; Nikita Khrushchev banged his Soviet shoe on a desk at the United Nations; Clark Gable died, and Federico Fellini finished shooting *La Dolce Vita*. And forty-three-year-old John F. Kennedy, accepting the Democratic presidential nomination in Los Angeles,

told eighty thousand delegates and others that "the world is chang-
ing. The old era is ending. The old ways will not do."

The first President born in this century, "the contemporary man,"
as Adlai Stevenson once called him, Kennedy symbolized much more
than any leader could possibly deliver, which became one of his
problems. It was soon fashionable to criticize his administration for
being "all style" and not enough substance. But the Kennedy style
was one of the forces that shaped the era. His candor and wit, his ir-
reverence toward the pieties of previous generations, his skepticism,
his ironic detachment—all this coincided with and deeply influenced
the shift in our national sensibility that led so many Americans to
value "coolness" above all things. Coolness was variously defined: as
grace under pressure, as a refusal to be conned, as the elevation of
intellect over feeling. Ghetto youths admired the gang leader who
never lost his cool. Richard Nixon, the Great Perspirer, had the tele-
vision studio chilled to sixty degrees before his second debate with
Kennedy. The cool style might be "just" style, just surface, but, as
John Cage pointed out, the surface was a part of the depth, and in
the new fields of human awareness into which we were moving in
the sixties (according to Cage) it was vitally important to move
freely; clinging to fixed traditions and beliefs would keep you from
realizing the vast range of human possibilities that was opening up.
After the stagnant Eisenhower years, JFK's promise to get the coun-
try moving again struck a supremely contemporary note, spreading
enthusiasm and anxiety in approximately equal measure.

There had never been anything cool about Abstract Expression-
ism, of course. De Kooning, Pollock, Still, Newman, and the other
stars of the New York School, as it was beginning to be called, had
reached the zenith of their influence in 1958, when the Museum of
Modern Art's great exhibition of "The New American Painting"
toured eight European cities and then returned to New York trailing
clouds of glory. Europe had responded with anger, awe, and amaze-
ment to what the critic of *Le Figaro* called "these contagious here-
sies." A year later, the London *Times Literary Supplement* devoted a
special number to "The American Imagination: Its Strength and

Scope," in which one author stated that "the flowering of the American imagination has been the chief event in the sphere of living art since the end of the First World War."[1] International recognition coincided with soaring prices. De Kooning's 1959 show at Sidney Janis sold out the first day, for a total of $150,000 (ten years later a single de Kooning might bring that much). Oddly enough, now that the New York School had become the art establishment, its members came under sustained and vicious attack by the new art critic of the establishment's own *New York Times*, John Canaday. Canaday's diatribes against the Abstract Expressionists, whom he accused of fraud and incompetence, led forty-nine leading figures in the arts to sign a letter of protest that the *Times* printed in February 1961.[2] This in turn generated hundreds of letters from *Times* readers, running twelve to one in Canaday's favor (according to Canaday, who reprinted a sampling of them in his book *Embattled Critic*). Canaday further antagonized the art establishment by devoting two columns in 1960 to Tinguely's *Hommage à New-York,* which he called "a legitimate work of art" and "an elaborate witticism on a subject of deadly seriousness, man's loss of faith."[3] The latter interpretation rather amused Tinguely, who saw *Hommage* more simply as a piece that had evolved "in total anarchy and freedom," a machine that had rejected its machine nature to become humor and poetry.

Clement Greenberg, a critic whose audience was smaller but more influential than Canaday's, had also turned against the gestural wing of Abstract Expressionism, represented by de Kooning. In his 1955 essay on " 'American-Type' Painting,"[4] Greenberg argued that "painterly painting" in the de Kooning manner was not truly modern after all, because its turbulent contrasts of dark and light tonal values set up an illusion of space, and thereby denied the essential flatness of the painted surface. In Greenberg's view the basic modernist characteristic was the tendency of an art to purify itself of everything except what was unique to the medium of that art. What was unique to painting was the flat plane, and for this reason the non-gestural, non-painterly (and relatively cool) work of Barnett Newman, Mark Rothko, and Clyfford Still now seemed to Green-

berg the true path, "the most radical of all developments in the painting of the last two decades." Greenberg subsequently came to the conclusion that painterly painting was degenerating into a set of mannerisms, a formula that had proved all too easy to imitate. It was a view evidently shared by Tinguely, who parodied the formula so disconcertingly with his meta-matic painting machines.

As a consultant to the contemporary section of the French and Company gallery on Madison Avenue, Greenberg organized several exhibitions of the sort of work he now favored. The first, in 1959, was a show of Barnett Newman's austere stripe paintings. Newman had not shown in New York for eight years, and the exhibition re-established him as a major figure. This was followed by shows of Kenneth Noland and Morris Louis, two abstract painters who had borrowed from Greenberg's close friend Helen Frankenthaler the technique of pouring thinned pigment on unprimed canvas, so that it soaked into the fabric rather than remaining on top (true flatness could go no further). Noland painted concentric rings of color that appeared to have been inspired by Jasper Johns's targets. Louis poured his paint in veils that spread out and faded toward the edges, like ink on blotting paper. These undeniably flat and unmistakably cool abstractions ushered in the "color field" school of painting that certain collectors and museum curators, who retained an almost mystical faith in Greenberg's judgment, started in the early sixties to buy and exhibit with notable enthusiasm.

An even more drastic reduction of painting to its bedrock essentials appeared in 1959 in the work of a twenty-three-year-old Princeton graduate named Frank Stella. Reacting quite consciously against the romance of Abstract Expressionism, Stella had begun while he was still in college to "feel very strongly about finding a way that wasn't so wrapped up in the hullabaloo," as he put it, ". . . something that was stable in a sense, something that wasn't constantly a record of your own sensitivity."[5] He looked very hard at the paintings in Jasper Johns's first show, and he was struck by "the idea of repetition" in the flags and numbers. Here was something stable. But Johns's method of applying paint still smacked of

the personal touch; his brushstrokes were as expressive in their way as de Kooning's. Stella wanted to get rid of that, too. In 1959 he did a series of rectangular canvases on which precisely ruled black stripes evenly separated by narrow bands of raw canvas formed a concentric set of interior rectangles. Leo Castelli took Dorothy Miller to see them, in Stella's downtown studio, and each made haste to appropriate the artist—Castelli for his gallery, Miller for her 1959 group show at the Museum of Modern Art, called "Sixteen Americans" (among her other choices were Rauschenberg, Johns, Ellsworth Kelly, Robert Mallary, Richard Stankiewicz, Jack Youngerman, Louise Nevelson, and Alfred Leslie—Leslie being the only gestural abstractionist in the entire group).

Stella's stark, geometrical black paintings outraged the easily outrageable critics such as Emily Genauer, who dubbed him "the pinstripe boy." Some older Abstract Expressionists were equally annoyed by his work and by the attitude behind it. Newman, Rothko, and Still placed the highest moral value on their own painting; they believed in the ultimate statement, the sublime or transcendent emotion. Even Ad Reinhardt, who had been attacking this sort of "transcendental nonsense" in his contemporaries since the late forties, and who by 1960 had reduced his own "art-as-art" aesthetic to all-black canvases in which, after determined scrutiny, the viewer could make out a cruciform shape in a slightly different tone of black—even Reinhardt insisted that true art, pure art, must have a spiritual basis. Stella emphatically did not. "I always get into arguments with people who want to retain the old values in painting—the humanistic values that they always find on the canvas," he said. "If you pin them down, they always end up asserting that there is something there besides the paint on the canvas. My painting is based on the act that only what can be seen there *is* there . . . All I want anyone to get out of my paintings, and all I ever get out of them, is the fact that you can see the whole idea without any confusion . . . What you see is what you see."[6] This was going too far for Greenberg, but not for a whole galaxy of young artists who found in Stella's work and in Stella's thinking the strongest possible proof that the old era was ending, and the old ways would not do.

Clearly the sixties were not going to be dominated by any single style, as the fifties had been. Stella's ruthlessly reductive approach (inspired by Johns) could coexist quite comfortably with the messy, all-inclusive, art-as-an-extension-of-life aesthetic of Rauschenberg, Tinguely, and other impure adventurers, as well as with the proliferation of new directions—Pop, Op, Minimal, Process, Earth Art, Conceptual Art—that made the sixties such a visual Tower of Babel. What did appear to be incompatible with the new mood was the spirit of high seriousness that emanated from the mighty (but already crumbling) fortress of Abstract Expressionism. High seriousness was out of place in the early sixties. The new President ran his televised press conferences like a master showman, disposing of foolish or boring questions with a bright quip, singling out the next questioner before he had quite finished with the last, enjoying the rapid-fire give-and-take to the hilt. It would have been hard to imagine President Eisenhower's naming his kid brother to the post of Attorney General and then saying, as JFK did, "I can't see that it's wrong to give him a little legal experience before he goes out to practice law." The same sort of irreverent humor was turning up in the books and the movies, the television programs (the commercials, at least), and the rock music that became for millions of young Americans the real art of the sixties. Even the poetry of the previous decade was coming under attack. Frank O'Hara, who wrote lyrics during his lunch hour at the Museum of Modern Art, and who believed that you could put anything you wanted into a poem (as Rauschenberg believed you could put anything into a painting), said once that Robert Lowell's "confessional" manner let him "get away with things that are just plain bad but you're supposed to be interested because he's supposed to be so upset."[7] To a whole generation of cool young artists, the heavy emotions and hot rhetoric of the fifties had begun to seem phony, absurd, embarrassing. And it was at this precise moment, by one of those historical quirks that seem inevitable, that Marcel Duchamp reemerged from the shadows of the New York art scene.

He did it quietly, as one would expect. A major book on his life

and work, by the French critic Robert Lebel, appeared in 1959 in Paris, where it was largely ignored, and in New York, where it was read and reread with passionate interest.[8] Duchamp, then seventy-two, a U.S. citizen, married to an American woman and living on West Tenth Street, submitted gracefully and wittily to a number of interviews, in which he gave the impression that he did nothing to speak of, that he was merely a *"respirateur,"* a breather, for whom art (his own included) held little interest. But he *had* started to take an interest in some of the new, post-Abstract Expressionist artists such as Rauschenberg and Johns, to whom he was introduced in 1960 by the critic Nicolas Calas. Johns bought one of Duchamp's *Green Boxes* (a multiple edition of boxes containing replicas of his notes for the *Large Glass*) and Duchamp obliged him by signing it. Rauschenberg, who had bought for a tiny sum a replica of the Duchamp *Bottle Rack* readymade, was thereby emboldened to ask if he would sign that, too, and Duchamp did so happily, inscribing inside the bottom rim a phrase, in French, reading, "It is impossible to remember the original title." Soon afterward, Rauschenberg made a large combine-painting called *Trophy II (for Teeny and Marcel Duchamp)*,* which incorporated his last remaining necktie and several capital letters that could be read as "Tini" or "Win."

Duchamp went to happenings, and now and then to the openings of shows by young artists he liked. He made cryptic appearances on discussion panels at MOMA and elsewhere. He gave his blessing to Tinguely's self-destructive machine, commenting at the time that he thought it a healthy idea to "destroy art before it's too late." A number of his works were featured in the big "Art in Motion" show in Amsterdam and Stockholm in the spring of 1961, and that fall MOMA's "The Art of Assemblage" devoted more space to Duchamp than to any artist except Kurt Schwitters. This important show, which also included two Rauschenberg constructions and one

Trophy I was dedicated to Merce Cunningham. Rauschenberg made three more *Trophies* during this period, dedicated respectively to Tinguely, Cage, and Johns.

by Johns, focused attention on the widespread use (in the affluent fifties and sixties) of junk and other lowly materials by contemporary artists, a tendency that Duchamp described as "our taste for the miserable." Picasso, who had started the modern collage tradition in 1912, was represented by three small collage-pictures. In New York, at any rate, there was no question that Duchamp's influence was going up at about the same rate that Picasso's was going down.

HOT AND COLD HEROES

Allan Kaprow made his living teaching art history at Douglass College, the female side of Rutgers in darkest New Jersey. Kaprow got around a lot in the art world, though, and one day in 1961 he told Ivan Karp, Leo Castelli's hyperenergetic assistant, that he ought to look at the work of a colleague of his on the Douglass faculty named Roy Lichtenstein.

A few days later Lichtenstein turned up unannounced at the Castelli Gallery, with a bunch of paintings under his arm. Castelli had gone to lunch, and Karp was guiding a group of Finch College art students through the current exhibition when Lichtenstein appeared and introduced himself. Several of the Finch students started to giggle over his paintings, which looked like blowups of comic strips. Karp waved the girls into the main gallery and ushered Lichtenstein into the back room, where they stood the paintings against the wall. To Karp's astonishment they really *were* blowups of single frames from the comics—love comics, with text blocks spelling out blighted passion, and war comics, with bursting shells that went WOMP! and VROOM!—and also blowups from commercial advertisements: a girl catching a ball (for a Pocono resort hotel), a foot stepping on a garbage-can lift. "They were strange, unreasonable, outrageous," Karp said later. "I got chills from those pictures. I de-

cided that I'd have to show them to Leo, so I told Roy to leave them with us and I hid them in a closet. When Leo came back from lunch, I said, 'Leo, I've got these very peculiar pictures,' and he said, in his quick way, 'Yes? Where are they?' and I tried to prepare him a little but he was too impatient. So I brought them out. And Leo was not distressed! Leo didn't even know the comics they were based on, he didn't have the American background, but he saw right away that there was something going on there."

Roy Lichtenstein had grown up in Manhattan, gone to Ohio State, and studied with Reginald Marsh at the Art Students League. For several years he had painted realistic, American Scene paintings not unlike Marsh's, and then in the fifties he had become an Abstract Expressionist, in thrall to de Kooning. Married, with two children, he supported himself by teaching, first at the State College of New York at Oswego, then at Douglass. Nobody thought much of his abstract work; in 1960 he had shown some paintings to Castelli, who was unimpressed. While he was still at Oswego, though, he had done a couple of Abstract Expressionist paintings with images from comic strips, somewhat along the lines of de Kooning's "Woman" paintings. A year later, at Douglass, he met Kaprow, saw some happenings, and absorbed great drafts of the developing Kaprow aesthetic. His own moment of truth arrived when one of his young sons pointed to a Mickey Mouse comic book and said, in the endearing way sons have, "I bet you can't paint as good as that." Accepting the challenge, Lichtenstein painted a much-enlarged version of a frame that showed Donald Duck struggling with a fishing rod whose hook is caught in the seat of his own pants, and entitled it *"Look, Mickey, I've Hooked a Big One!"* It was not an exact replica of the original; certain details were suppressed and others accentuated. But it looked the same. He even painted in the Ben Day dots that appear in the background of commercial lithographic reproductions (Lichtenstein's were greatly enlarged, in keeping with the scale). What his son thought about the effort is unrecorded, but there was something about its "dumb," banal look that fascinated the artist. From that moment, Lichtenstein abandoned de Kooning and began painting

pictures based on comics and commercial ads, painting them in the flat, mechanical style of commercial art, in simple colors, with Ben Day dot backgrounds.

Three weeks after he met Lichtenstein, Karp was sitting in a restaurant in Peck Slip, near the south end of Manhattan, eating a hero sandwich, when a blond young man came over and asked if he would like to look at some stonecarving—Karp's hobby was preserving decorative stonework from buildings that were being demolished. Karp went with him to a loft building in nearby Coenties Slip, where he saw (the stonework soon forgotten) several large paintings in which details from billboard ads were juxtaposed in a startling way: giant coils of Franco-American spaghetti, toothpaste grins, automobile tires, a giant green pocket comb. The young man's name was James Rosenquist. Until a few months before he had been employed as a billboard artist for Artkraft Strauss, working all over Manhattan and the other boroughs, painting Hebrew National salami displays in Brooklyn and Man Tan ads over Times Square, among other compelling images. It had come to pass when he was painting a Times Square billboard for a movie called *On the Beach*—red Day-Glo letters ten feet high against white—that he suddenly paused and said to himself, "*You're* on the beach." Rosenquist had recently seen another sign painter fall from his platform and go through a roof twenty stories below. It was dangerous work, and he was sick of it. "I went in to the boss and asked for a huge raise, thirty dollars, and when he said no, I quit." Rosenquist had come to New York (from Minnesota) in 1955 for a year's scholarship at the Art Students League. He knew a lot of the New York artists, including Rauschenberg, who had put him on to Gene Moore and helped him get several window display jobs, and a month or so before quitting his job with Artkraft Strauss he had rented the studio in Coenties Slip from Agnes Martin, an abstract painter who was leaving the city. For the last two months he had been holed up in that studio, planning to paint until his savings ran out. "I thought I could paint pictures that used fragments of real objects," as he explained it, "and put them in greatly enlarged scale so they'd be hard to recognize, very blunt and powerful and also mysterious."[1]

Karp made Castelli come down and look at the Rosenquist paintings. Richard Bellamy also saw them—Bellamy had been co-manager (with Karp) of the now-defunct Hansa Gallery, and he had just opened his own Green Gallery on West Fifty-seventh Street. Castelli was not quite as enthusiastic about the paintings as he had been about Lichtenstein's, so it was decided that Rosenquist would join the Green Gallery. Castelli also had doubts about Andy Warhol, who turned up about the same time. Warhol then was one of the highest-paid commercial artists in New York, winner of the Art Directors Club medal in 1957 for his I. Miller shoe campaign (Warhol drew *portraits* of shoes; his style was so original and so sly that he could kid the product and make the client feel witty), a very shrewd and very hard-working and deceptively fey young man who wanted very much to be a famous artist. He had come to Castelli's to buy a Jasper Johns drawing. When he happened to see two of Lichtenstein's comic strip pictures in the back room he said to Karp, in a wan little voice, "I do paintings like that." Karp and Castelli visited Warhol's studio on Lexington Avenue soon afterward and saw paintings based on Dick Tracy, Popeye, Superman, and the Little King, together with paintings of Coca-Cola bottles, and a whole series of paintings of Campbell's soup cans, perfectly captured in exact likenesses. Castelli didn't think he could show Warhol's work because it seemed too close to Lichtenstein's and not as strong. Karp tried hard to help Warhol find another gallery, but Warhol's odd looks and personality put people off. He had prematurely white hair and deadly pale skin, and a manner so nebulous and passive that you wondered how he got himself out of bed. Dick Bellamy didn't respond to his work, nor did Martha Jackson. Finally Eleanor Ward agreed to give him a show at the Stable.

What astonished Karp and Castelli was that none of these people knew what the others were doing. Out of the blue, it seemed, and simultaneously, they had broken with the whole modern abstract tradition and adopted a realistic subject matter of the most unexpected kind. They were not using real objects as their models, but *pictures* of real objects—pictures from the crassest, most banal commercial

sources, from the mass media that all truly cultured persons despised. Lichtenstein, Rosenquist, and Warhol, moreover, were by no means the only ones who were doing this. Tom Wesselmann had already begun painting his "Great American Nudes" in up-to-date bathrooms, often with real bathroom fixtures as part of the decor. Robert Indiana was painting iconic canvases of what looked like road signs, lettered "EAT" or "DIE." Jim Dine was doing men's neckties and bathrobes. George Segal (the chicken farmer) had hit on a process for making ghostly plaster casts of his friends, which he placed in real-life settings such as doorways or telephone booths.

Claes Oldenburg, taking time out from happenings, had even opened a "Store" down on East Second Street, a real storefront that he stocked with painted plaster and papier-mâché replicas of food, clothing, and the sort of cheap household goods available in cut-rate shops on Fourteenth Street. Neighborhood kids wandered in and out on opening day ("The Store" opened in December 1961 and ran through January), pocketing small items that the uptown culturati were purchasing for fifty dollars and up—a nice example of the mounting confusion between art and life. A month later, in February, Rosenquist's first show at the Green Gallery overlapped Lichtenstein's debut at Castelli. *Time, Life,* and *Newsweek* took note of these developments in articles whose tone was one of bemused condescension; the media seemed to take a certain, not unnatural interest in the new art.

That summer, Gene Moore put a few of Warhol's Campbell's soup can paintings in the windows of Bonwit Teller, and the Ferus Gallery in Los Angeles showed the entire set of thirty-two. Irving Blum, the Ferus's adventurous director, actually sold several of the soup can paintings at a hundred dollars apiece, but a week later he persuaded the buyers to take their money back and purchased the whole set himself. Oldenburg had his first one-man show at the Green Gallery in September: representative items from "The Store," and also a giant soft sculpture of an ice-cream cone, made of canvas stuffed with kapok, and an even larger slice of chocolate layer cake, also canvas. Jim Dine showed his necktie paintings that fall at

Martha Jackson, and Warhol filled the Stable Gallery with his portraits of soup cans and Coke bottles and paper money.

The art world, a considerably larger and more diverse body than it had been only a few years before, reacted to these shows with a mixture of incredulity, amusement, and dismay. Attempts were made at once to name and identify the new thing. Ivan Karp suggested the term "Commonism," which did not take. Others called it "neo-Dada," a catchall category that had already been applied to the work of Rauschenberg and Johns. The English critic Lawrence Alloway was the first to call it Pop Art. He had coined the term in the middle fifties to refer to products of the mass media, and it had subsequently been applied to the work of a group of London artists and art students who were fascinated by these products several years before the Americans started to paint them, but whose own work had excited no particular attention. Alloway's term, with its overtones of "popular" and its punning echo of Dada, caught on instantly. Journalists picked it up, and critics vied with one another to put it down. The Museum of Modern Art held a "Symposium on Pop Art" in December 1962, at which the only panelist who had anything good to say about the subject was Henry Geldzahler, the young assistant curator of American painting and sculpture at the Metropolitan Museum. Geldzahler had appeared in Oldenburg happenings, and he spent much of his time visiting artists' studios and looking at new work. He found out later that when he had asked James Rorimer, the Metropolitan's director, whether it would be all right for him to appear on the MOMA panel, Rorimer, who had never heard of Pop Art, thought that the topic of discussion was to be "Pop" Hart, a long-dead American folk artist. The new thing had arrived so suddenly that there were still a few pockets of ignorance.

No movement in art history ever established itself so swiftly. The reaction of the serious critics was contemptuous: Clement Greenberg dismissed it as "a new episode in the history of taste,"[2] and Art News's Tom Hess as "A nostalgic eclecticism . . . launched among the cocktails"[3] (but Hess, an astute editor, devoted three issues of Art News in 1963 to interviews with the Pop artists). Peter Selz, the

MOMA curator who had served as moderator at the December symposium, announced at one point that Pop's embrace of the American consumer culture demonstrated "profound cowardice."[4] But Pop, unlike Abstract Expressionism, seemed to thrive without benefit of friendly critics or curators. Several collectors bought it right from the start, none of them with greater enthusiasm that Robert C. Scull. The roughhewn owner of a fleet of New York taxicabs ("Scull's Angels"), Scull had started buying contemporary art in 1956— European at first, then Rothko and Kline and others of the New York School, then Rauschenberg and Johns. Ivan Karp introduced him to Richard Bellamy, and in 1961 Scull financed the Green Gallery by agreeing to buy $18,000 worth of pictures a year from it. He had great faith in Bellamy's eye, and great admiration for Bellamy's elegance and taste. But Scull loved to get to the artist before anybody else, even Bellamy. In 1961 he went down to Rosenquist's studio in Coenties Slip, announced himself by yelling from the sidewalk (there being neither telephone nor doorbell), climbed up, and bought a painting called *The Light That Won't Fail*; this was the artist's first sale. By 1963 he owned more than forty Pop paintings or sculptures, and more were arriving every week at his house in Great Neck. "I didn't even know it was a movement," he said. "I just loved the work, and I loved having those guys in my house."

Scull might be put down by the serious critics as a vulgarian, part of the rabble that had started to invade the art galleries (Max Kozloff, writing in *Art International* in 1962, plaintively described this new element as "the pin-headed and contemptible style of gum-chewers, bobby soxers, and, worse, delinquents").[5] But several important Abstract Expressionist collectors, people of established taste and discrimination, were also buying Pop. Burton and Emily Tremaine, for example, and the Albert Lists, and the enigmatic Count Panza di Biumo, who came regularly to New York and who was filling his eighteenth-century palazzo in Varese, north of Milan, with the most "difficult" new work. Panza owned a dozen major Rauschenbergs. In 1962 he came down to Coenties Slip and bought eight Rosenquists. "He sat there and nodded his head at everything

you showed him," said Rosenquist, "and sometimes he'd say, 'Very nice.' Those were the ones he bought."

What could these people see in such paintings? For years, authorities had been predicting a "return to humanism" in modern art, a turning away from abstraction and toward the figurative. Alfred Barr himself had expressed such an idea, saying privately that he thought the new realism would have a philosophical basis that was essentially religious.[6] The philosophical basis of Pop Art was a little hard to pin down. Were these artists satirizing their subject matter, the garish and tawdry images of mid-twentieth-century middle-class culture? In interviews most of them denied any such intention, and their paintings bore no signs of satiric manipulation. Did they, then, *like* these images? Warhol told an interviewer that Pop Art was "liking things," but Warhol was a notably untrustworthy witness. Another explanation was provided by Richard Hamilton, one of the leaders of the London Pop group (Hamilton had painted in 1956 a prophetic picture of a "modern" interior in which a muscle man held an outsize lollipop labeled "Pop"). During the long period when modern artists abandoned the natural world for an abstract one, Hamilton wrote, they had "failed to notice that the visual world was becoming something radically else. The surprising thing is that it took until the mid-fifties for artists to realize that the visual world had been altered by the mass media and changed dramatically enough to make it worth looking at again in terms of painting."[7]

In the opinion of Hamilton and others, the Pop artists were simply looking out at the world around them and painting what they saw. And what they saw, by and large, was an incredible proliferation of mass-produced objects (intended for temporary use and rapid obsolescence) and an even more incredible flood of commercially designed images, washing over everybody from billboards and neon signs, from newspapers and magazines, and (especially) from the flickering home screen in the living room. The Abstract Expressionists liked to listen to jazz or classical records while they worked; in a Pop artist's studio you found the television set going all day long, often with the sound turned off. The Pop artist claimed neither

to like nor to dislike what he saw around him, this new landscape of the American Dream. He was not even interested in his emotional reactions to it. He was simply reflecting (quite coolly) what another English critic, John Russell, has called the "Mississippi-like flood of information, cajolery, overstatement, and plain bamboozledom from which few Americans are ever free for long."[8] The mass media had shaped our environment—why ignore it? "I suppose I would still prefer to sit under a tree with a picnic basket rather than under a gas pump," said Lichtenstein, "but signs and comic strips are interesting as subject matter. There are certain things that are usable, forceful, and vital about commercial art. We're using those things—but we're not really advocating stupidity, international teenagerism, and terrorism."[9]

Of course, by involving themselves with comics and TV commercials and Coke bottles and other such "low" subjects, the Pop artists inevitably appeared to be thumbing their noses at high culture in general, and especially at the kind of transcendental nobility that some of the Abstract Expressionists proclaimed for their art. Duchamp's corridor of humor appealed to them for a number of reasons, not the least of which was that it led out, into the world, rather than inward to the self. But derision was never the point of Pop Art, and Duchamp's influence on it was not nearly as strong as Rauschenberg's. "There is no poor subject," Rauschenberg had written, in a statement reproduced in the catalog to MOMA's "Sixteen Americans" show in 1959.[10] "A pair of socks is no less suitable to make a painting with than wood, nails, turpentine, oil and fabric." Rauschenberg's use of Coke bottles and comic strips and other "found" materials of everyday urban America had obviously caught the attention of younger artists who were bored by noble means. If he could get away with that sort of total freedom, why couldn't they?

The way Rauschenberg used objects in his combines was actually quite different from the way the Pop artists used them. Rauschenberg's interest was sensual and indiscriminate. He could incorporate a mason jar full of oil sludge from the beach, and he could also use gold leaf; he was not a bit concerned with the "common" per se. "If

I start out to use an image of George Washington in a picture," he said once, "I may start out thinking of George Washington, but then later it becomes just 'that green shape.' " What impressed the Pop artists was the extreme freedom and openness of his approach. Rauschenberg once defined his overall themes as "multiplicity, variety, and inclusion," and in this respect it had never made much sense to call his work "neo-Dada." The original Dadas were primarily and overwhelmingly *against* things—against politics, against European culture, against art both past and present. Rauschenberg was never against anything. He had found his way out of the Abstract Expressionist stockade (a way that was now open to others), but he did not hesitate to apply paint in the de Kooning manner, with all the well-known drips and spatters and "personal" brushmarks; most of the Pop artists, on the other hand, rejected Abstract Expressionist techniques in favor of the slick, impersonal surfaces of commercial art. What Rauschenberg wanted was to remain unfamiliar with what he was doing, to preserve an open situation in which he himself could be continually surprised. Total control was to be avoided because it ruled out surprise. He accepted the world as it was and tried to work with it, not by imposing order but by collaborating with the disorder around him.

"Painting relates to both art and life. Neither can be made (I try to act in the gap between the two)."[11] Like a lot of famous statements, this one of Rauschenberg's (first printed in the "Sixteen Americans" catalog) could be interpreted in various ways, which was all right with Rauschenberg. What it seemed to mean to him, at least, was that the big abstract concepts of Art and Life lay outside the focus of his own highly practical interest. "It's never bothered me a bit when people say what I'm doing is not art," he said once. "I don't think of myself as making things that will turn into art. I do what I do because I want to, because painting is the best way I've found to get along with myself. And it's the moment of doing it that counts. When a painting is finished it's already something I've done, no longer what I'm doing." Rauschenberg's famous "gap" seemed to be a terrain unique to Rauschenberg. None of the Pop artists

chose to work there—they were all pretty sure that what they were doing was making art.

JASPER JOHNS'S INFLUENCE ON POP ART HAS BEEN SOMEWHAT EXAGGER-ated. As the critic Barbara Rose points out, Johns's targets and flags fill the entire space of the painting—there is no "background," and therefore no sense of something being depicted; it is not a picture of a flag, it is simply a flag.[12] Johns's early work made all previous paintings, even those of Pollock and de Kooning, seem like representations of something, which is what Leo Steinberg meant when he said that Johns made them look like painters of illusion. Far more than his involvement with common objects, it was this technical development, this pushing forward of one of the most persistent trends in twentieth-century painting, that made Johns so impressive not only to the Pop artists but also to the new abstractionists including Stella, Noland, and Ellsworth Kelly. Johns's "gap" was the ambiguity between reality and illusion.

A series of small Johns sculptures in the late fifties carried the ambiguity even further. His *Painted Bronze* (1960) was a sculpture of two Ballantine Ale cans, made first in plaster of Paris and then cast in bronze and meticulously painted, the labels so exact that you could mistake them for real ale cans until you tried to pick one up. Someone had told Johns that de Kooning, disgusted with Leo Castelli over the direction his gallery had taken, had said, "You could give that son of a bitch two beer cans and he could sell them." Johns was making small sculptures of flashlights and light bulbs at the time, and beer cans struck him as a fine idea. Castelli sold them, all right, to Robert Scull, for $900, and when Scull put the piece up for auction in 1973 it brought $90,000. It is a mysteriously beautiful work, mysterious because of its beauty: how can two ale cans give back so much?

Johns and Rauschenberg came soon enough to be seen as transitional artists, with roots in the previous, Abstract Expressionist generation as well as ties to the bumptious young Pops. Johns himself had a hard time accepting Lichtenstein's work when he first saw it at

Castelli's; it took him nearly a month to change his mind. Rauschenberg hated the comic strip images at first, too, but his antipathy lasted only a day or so. Curiously enough, the general public, or that part of it that had started going to art galleries, adjusted itself to Lichtenstein and the other Pop artists with remarkable alacrity. Various reasons were advanced to explain this. After years of looking at difficult abstract art, it was said, the beastly bourgeois at last had found something he could identify with. The public was reacting against Abstract Expressionism, which it had never really liked or understood; the new artists and their admirers met on the common level of their own mediocrity. Robert Motherwell remarked scathingly of the Pop artists that it was "nice to see those young fellows having such a good time." Real art, of course, was no fun for anybody.

The event that capped Pop Art's lightning-like triumph was Sidney Janis's two-gallery show of what he called "The New Realism" in November 1962. Janis dealt in blue-chip moderns. He had shown Mondrian, Léger, and other European masters before he took on the leading Abstract Expressionists, and the Abstract Expressionists had benefited accordingly—if Janis believed in them, they must be blue-chip. But now his Abstract Expressionists felt betrayed. Janis had put together a group show that included most of the Pop artists and a number of European *"Nouveaux Réalistes"*—Yves Klein, Jean Tinguely, Martial Raysse, César, Arman, and others; the show was too big for his Fifty-seventh Street gallery, so he rented a storefront on Fifty-seventh between Fifth and Sixth avenues, and opened in both places simultaneously, drawing unusually large crowds and a great deal of attention in the press. Mark Rothko, Robert Motherwell, Adolph Gottlieb, and William Baziotes were so angry that they resigned from the Janis Gallery in protest. "It took me completely by surprise," Janis said. "Here we had been showing Pollock cheek-by-jowl with Léger, and de Kooning with Mondrian, and Kline with Klee, but when we took up the next generation our artists were furious. They didn't want to be associated with these people who became artists overnight." The only one of Janis's Abstract Expres-

sionists who didn't quit the gallery then was de Kooning. He came to the opening, paced back and forth in front of the pictures for an hour or more, and left without saying a word.

The Abstract Expressionists' anger was not really so hard to understand. They had struggled for many years in total obscurity, their achievements recognized only by one another. As late as 1961, according to Tom Hess, only about twenty-five artists of the older generation were "making what any forty-year-old college graduate would call a 'living' in New York." The recognition that they had so recently and so arduously won was now being usurped, or so they believed, by a new generation of brash youngsters who had become "artists overnight," who had not earned anything the hard way, and whose most apparent common bond seemed to be mockery and rejection of all serious art, especially Abstract Expressionism. Pollock and de Kooning and Rothko and Newman had not repudiated Picasso, Mondrian, and Léger. They had worshiped the European masters, while striving heroically to go beyond them. Now, suddenly, heroism and high art were out of style.

THE CONSTRUCTION OF BOSTON

The quickening tempo of events in the art world struck Rauschenberg as a welcome development. He felt close to Dine, Rosenquist, and Lichtenstein, both personally and professionally, and they in turn were encouraged by his response to their work. Rauschenberg's own reputation was not yet firmly established—he was still to some extent the reigning *enfant terrible,* in spite of the favorable reception of his Dante drawings, and in spite of his having been included in important group shows such as MOMA's "Sixteen Americans" and "The Art of Assemblage." At the same time, he had been showing in New York for ten years, and to many of the younger artists he was a star, more visible and less remote than de Kooning or Newman.

His personality was an important part of it. The shyness and naiveté had been supplanted long ago by a boisterous and sometimes flamboyant public manner. He and Johns had acquired a secondhand white Jaguar which they used mainly to drive out to East Hampton on weekends. Rauschenberg was drinking a lot more than he used to; alcohol helped to free him from inhibitions when he worked, he said—it was hard to imagine *what* inhibitions. Nobody had a better time at the loft dancing parties that had largely taken the place of the older generation's Club and Cedar bar gatherings, and in the brief intervals between blasts of rock music his high, cackling laugh usu-

ally served to identify the liveliest conversation in the room. Physically he had changed hardly at all. He was still boyishly handsome, his hair was neatly trimmed, and he wore a dark suit on most public occasions. But his increasing self-confidence had released something new, a physical presence that Ivan Karp once described as giving off "a kind of celestial light." His high spirits were infectious. "He could be excessively happy over anything at all," said Ileana Sonnabend. "Over its being a nice day, over seeing a particular shade of red somewhere, over noticing that flowers in Europe looked different from flowers at home. And at the same time he could be excessively sad."

After the long, isolated period of work on the Dante drawings, he had come back to New York with a renewed appetite for painting. His collages and combines continued to knock against what other people had decided were the limits of art. The freely brushed paint in *Pilgrim* (1960) flowed over a wooden chair attached to the front of the canvas; the chair's legs rested on the floor, and visitors to Rauschenberg's studio were sometimes embarrassed to find that they had deposited their overcoats on a work of art. *Winter Pool* (1959) was really two paintings joined together by a wooden ladder that seemed to be holding them apart. *Empire I* and *Empire II* were free-standing sculptures made out of urban found materials—scrap lumber, metal wheels, a roller skate, a ventilation duct of the sort seen on the roofs of so many New York buildings. *Black Market* (1961) invited the viewer's participation. It was a combine-painting to which four numbered metal clipboards were attached; in an open box on the floor below were assorted small objects, each one stamped with a number from one to four; a drawing of each object was on the clipboard with the corresponding number. Instructions in the box told the viewer to remove an object from the box and replace it with another object of his or her own choosing, to stamp the new object with a number from one to four, using the rubber stamps in the box, and then to make a drawing of the new object and attach it to the proper clipboard. When *Black Market* was shown at the "Art in Motion" exhibition in Amsterdam and Stockholm, in the

spring of 1961, viewers removed objects without adding others, stole the drawings, and used the clipboards to write angry and sometimes obscene comments on Rauschenberg, the exhibition, and the United States. His work still evoked instant hostility in some people, but this only made it more impressive to younger artists.

Rauschenberg had started to travel a good deal. In 1961 he became the lighting designer and stage manager for Merce Cunningham and Dance Company, which meant that for the next few years he traveled and lived with the company whenever it was on tour. Earlier that year, in the spring, he went to Paris for his first one-man show there. Leo Castelli considered it essential for his artists to establish European reputations (something that nobody had done for the Abstract Expressionists), and he had arranged for Rauschenberg to have a show at the gallery of Daniel Cordier, an astute and influential dealer who also happened to be deeply involved in French politics. Unfortunately the opening of Rauschenberg's show coincided with the revolt of the French generals in Algeria, as a result of which Cordier had very little time for the gallery or the artist. His assistants managed to hang some of the pictures upside down, and to exhibit separately several panels that were meant to go together as single combines. Rauschenberg was further annoyed by the gallery's exclusion of a number of artists from the *vernissage* because of their style of dress. The show nevertheless had a powerful effect on the younger French artists and critics, most of whom had only recently assimilated the shock of Pollock and de Kooning. The French were also impressed by an interview with Rauschenberg that appeared in the Paris weekly *Arts*. André Parinaud, the *Arts* editor, started off the interview with a series of barbed questions that convinced Ileana Sonnabend, who was present as translator, that he was extremely hostile to Rauschenberg's work. Rauschenberg replied with disconcerting candor. When Parinaud asked him, for example, "If somebody proposed that you become President of the United States or president of General Motors, would you stop being a painter?" Rauschenberg's thoughtful reply was, "Those are good jobs. I'd think seriously about it." Midway through the interview Parinaud

called in an English-speaking colleague, to make sure the replies were being interpreted accurately. Rauschenberg continued to reveal a consistently modest and intelligent attitude toward his own work, and in the end Parinaud, completely won over, said, "Well, obviously we can't nail you to the cross." The interview got a full page in *Arts,*[1] and was widely read. Its title, *"Un 'misfit' de la peinture newyorkaise se confesse,"* was taken from the Marilyn Monroe film *The Misfits* then playing in Paris, in which the American brand of hero-as-renegade was acted by Clark Gable. "Rauschenberg did become a hero to the French artists," Mrs. Sonnabend said afterward. "He took them out of painting, you see, into something else—life, maybe."

Jasper Johns also had a one-man show in Paris that spring, at the Galerie Rive Droite. Rauschenberg stayed over for it, and renewed his acquaintance with Jean Tinguely, the motion sculptor. Tinguely was living with an American-born artist named Niki de Saint-Phalle, whose latest technique was to secrete pellets of paint in white plaster or papier-mâché constructions and then shoot at them with a .22 rifle, thus enabling the paint to ooze out and color the work of art. Tinguely, Mlle. de Saint-Phalle, and Rauschenberg went up to Stockholm together for the opening of the "Art in Motion" show. Pontus Hulten, the director of the Moderna Museet there, was a great admirer of the work of all three of them—he subsequently raised the money for his museum to buy the infamous goat-and-tire construction, *Monogram*—and they had a riotous time together. After the opening everyone went to a theater-in-the-round where they danced to the music of Thelonious Monk. Small plastic bags of paint had been inserted between the carpet and a huge canvas laid between carpet and floor, so that the dancers, in a modified version of Niki de Saint-Phalle's method, would unwittingly create an abstract painting. After everyone else had gone home, Rauschenberg and Hulten pushed back the carpet, rolled up the canvas, and carried it through the streets to Hulten's house.

Tinguely was allied with the group of Paris artists who called themselves *"Nouveaux Réalistes."* Like the American Pop artists,

the French New Realists wanted to involve themselves in what Klein, their leading spirit, called "the theater of everyday," i.e., in the actual, non-abstract world of contemporary objects and sensations. Unlike the Pop artists they were not interested in "popular" or mass-market images. Another difference was their relatively traditional view that in order for an object to function in a work of art, it had to be "transformed" in some way by the artist—a notion that Rauschenberg emphatically did not share. César's sculptures were automobiles, transformed by giant industrial compressors into dense cubes. Arman assembled great numbers of small objects— scissors, washers, spark plugs, etc.—in glass-fronted boxes. Spoerri glued the remains of breakfasts or cafe meals to the tops of tables, removed the legs, and called the resulting collages "snare pictures," pieces of "assassinated reality." Klein and Tinguely, who shared a passion for freewheeling philosophical speculation, liked to discuss a new, future art that would be wholly immaterial, free of all dependence on objects and images, pure spiritual mind-play in which everyone, artists and non-artists alike, could join. Both were agreed that the artist's future role must be primarily social: the artist, the only free human being, would help others to find this sort of imaginative freedom in their everyday lives. Yves Klein's death, of a heart attack in 1962 when he was only thirty-four, cut short a career that was clearly moving "towards theater" in the Cagean sense.

In this excited Paris milieu, Rauschenberg (who spoke only a few words of French) seemed to embody the new reality that the Europeans talked about at such length, the new freedom in which an artist could dispense with all fixed positions and move at will in the expanding field of human awareness. Invited to take part in a group exhibition in May called *"Les 41 présentent Iris Clert"* (Iris Clert's Left Bank gallery showed Tinguely, Klein, and other innovators; Mlle. Clert herself was a flamboyant, black-haired beauty who used to carry around little stickers reading "Iris Clert, the world's most advanced gallery" which she would affix to people's hands or clothing at parties), Rauschenberg forgot to make the portrait he had promised, so at the last minute he sent a telegram worded "This is a

portrait of Iris Clert if I say so—Robert Rauschenberg." The French artists, who knew only vaguely about Marcel Duchamp at the time, were dazzled. In June he persuaded Dorothea Speyer, who was in charge of the American Cultural Center in Paris, to pull strings so that he, Tinguely, Niki de Saint-Phalle, and Jasper Johns could use the exquisite little theater in the American Embassy for a "concert" in honor of David Tudor. Tudor had turned up in Paris at the start of a concert tour, and Rauschenberg and Johns were so happy to see him that they offered to arrange "something interesting" if he would stay on for a few extra days. Although the Embassy, shy of publicity, refused to allow any advance notice, and the concert took place three days after it was first conceived, it attracted a large and curious audience, which witnessed something roughly resembling but considerably more theatrical than a New York happening.

While David Tudor played John Cage's *Variations II* on the piano at one side of the stage, Rauschenberg painted a picture on the other side; the canvas's back was to the audience, and the artist was invisible behind it, but he had attached contact microphones to the easel so that his brushstrokes and other activities would be audible. Tinguely's contribution was a self-stripping machine that kept going from one side of the stage to the other shedding metal parts. Niki de Saint-Phalle had engaged what she referred to as "the world's second-best sharpshooter" to stand in the audience and fire at one of her white plaster sculptures (Rauschenberg said later that he wished she had hired the best instead of the second best, because he was moving around a lot behind his canvas and the stage "wasn't all that big"). Jasper Johns, who firmly resisted all pressures to appear on stage, painted a sign saying "Entr'Acte," which was placed on stage during the brief intermission, and also contributed a spectacular "target" made of different colored flowers, which might have but apparently did not tempt the sharpshooter. Ten minutes before the performance was to end, an alarm clock that Rauschenberg had installed in his combine-painting went off; this was the signal for an assistant to come out and help Rauschenberg wrap up the finished painting in brown paper and carry it out through the audience,

which was to be "without the gratification of seeing the result." The rest of the cast wandered away, and the audience, after some perplexed moments, divined correctly that the show was over. Rauschenberg later traded his on-stage painting (called *First Time Painting*) to René Magritte, the veteran Surrealist, for a Magritte oil that is one of the prizes of his private collection.

The artists, at least, had enjoyed the Paris concert so much that when Tinguely and de Saint-Phalle came to New York the next spring they decided to put on another performance there. This time they wanted to have a script, and de Saint-Phalle asked Kenneth Koch, a young New York poet and teacher, to provide one. The subject, for no easily discernible reason, was to be "The Construction of Boston." Koch approached the manager of the Maidman Playhouse, a relatively well-appointed off-Broadway theater on West Forty-second Street, and talked him into letting them have the house for one night at the low rental of one hundred and fifty dollars. After this rather auspicious start, the collaboration went rapidly downhill.

Koch wrote a script, to which none of the principals paid much attention. Each of them had decided what he or she would do on stage, but their ideas tended to change from day to day, or from hour to hour. Tinguely had elected to play a female architect who would build a "rubber city" out of large inflatable balloons; as he pumped up one, the others would slowly deflate. Niki de Saint-Phalle would bring culture to Boston, or perhaps war, or both. Rauschenberg said that the two things he liked most about cities were weather and people, so he was going to build a rainmaker, and also an apartment with real people living in it. None of them wanted to speak lines, so they enlisted doubles to speak for them—Tinguely chose Henry Geldzahler; Rauschenberg chose Frank Stella; and Mlle. de Saint-Phalle chose Maxine Groffsky, a striking young woman who worked for *The Paris Review*. The Stewed Prunes, a two-man comedy team that had also been appearing there on Monday nights, were also engaged as a sort of on-stage chorus to announce the events, and Merce Cunningham was persuaded, somewhat against his will, to direct the whole ensemble. Rauschen-

berg and his colleagues were in definite agreement on one point: the event would not be a happening. Rauschenberg thought happenings were important as an idea, but in his opinion the idea had been a good deal more interesting, so far, than any actual happenings. "I wouldn't make a happening, myself, any more than I would make a Pollock," he said. "It's just not my thing." Koch and John Wulp, the Maidman's manager, and the Stewed Prunes, and even Merce Cunningham kept trying valiantly to find out what sort of thing "The Construction of Boston" was supposed to be, but the artists refused to be pinned down.

Two small ads in the *Times*, paid for by Leo Castelli, were the only advance publicity. Tickets went on sale at ten o'clock on the morning of the performance, at three dollars apiece, and the box-office telephone never stopped ringing all day. By 1 P.M. chaos had taken over. The house was badly oversold, and there was a waiting list of several hundred people. Somebody on the staff of Senator Jacob Javits had called for reservations for the senator and his wife; told there were none, the caller had refused to believe it. Backstage, things were even more chaotic. Rauschenberg had installed his complicated rainmaking machine in the flies: a barrel of water, and a long length of perforated garden hose, with a cork and string at the barrel end to let the water flow. Billy Klüver, a Bell Labs scientist who had helped Tinguely build his famous self-destroying machine in the garden of the Museum of Modern Art, got back from Mexico, where he had gone for his divorce, just in time to come backstage, become curious about the string, and pull it; everybody stopped what they were doing to mop up the stage, and Rauschenberg laboriously refilled the barrel. Just before John Wulp stepped out in front of the curtain to announce the performance to a packed and tumultuous house (the Javitses were there, seated on camp stools in the aisle; Marcel Duchamp and his wife were there; an army of standees had overwhelmed the box office) Merce Cunningham took him aside and said quietly that he did not want his name mentioned as the director.

The curtain rose. At one side of the stage was Rauschenberg's set

of a small apartment, with a bed, a dresser, two chairs, a bathtub, a framed Maxfield Parrish print, and other homely details. Viola Farber and Steve Paxton, two dancers from the Cunningham company, got out of the bed and began a series of "everyday" activities such as brushing their teeth, doing calisthenics, dressing, and making coffee. Tinguely made his entrance from the other side of the stage, wearing a wide-brimmed picture hat with a satin bow and a white ball gown with a large flounce at the bottom; he was pushing a wheelbarrow full of cinder blocks, which he dumped at center stage. Henry Geldzahler, similarly gowned, carrying a script and a cigar, followed him closely, declaiming, "I am ze spireet of Jean Tinguely."

Rauschenberg and Stella came on in oversize rain capes with photoflood reflectors where their heads should have been. Since Stella had decided that he did not care to speak lines, either, when the script called for Rauschenberg to say something Stella would project the words on the back wall of the stage with a portable slide projector. The Stewed Prunes ordered Rauschenberg to make weather for Boston, and he set in motion a curious mechanical contraption that made a feather duster spin around and scatter ping-pong balls. The Stewed Prunes then commanded him to provide rain, whereupon he pulled the cork string and released a downpour. The audience cheered loudly.

Tinguely, meanwhile, had been marching back and forth with his wheelbarrow, dumping cinder blocks. When the pile was sufficiently large he started to build a cinder-block wall across the stage, working alternately from both sides toward the middle (Tinguely had changed his mind about the rubber-balloon city; a cement wall between audience and performers was more his style, and also more in keeping with the anti-happening aspect of the event—happenings were supposed to include the spectators). The flounce of his gown kept getting caught in the blocks. At length he tore off the offending garment and hurled it into the wings, provoking more cheers from the audience. The Stewed Prunes then called on Niki de Saint-Phalle to provide culture for Boston. She made her entrance striding down the center aisle through the audience, slim and vivid in the uniform

of a Napoleonic artillery officer. An assistant wheeled a plaster copy of the Venus de Milo out on stage, another assistant handed Mlle. de Saint-Phalle a rifle, and she began firing away. Chips of plaster flew from Venus, and liberated paint oozed down her bosom. In the apartment, Viola Farber and Steve Paxton listened imperturbably to the news on a radio, and washed up the breakfast dishes. Tinguely rushed back and forth building his wall, aided now by several other cast members. As the wall rose higher between the performers and the spectators, Henry Geldzahler took to speaking his lines through a small hole in it, while Niki de Saint-Phalle's alter ego, Maxine Groffsky, climbed a ladder and spoke from there. A cannon was wheeled out and loaded with gunpowder; it was supposed to fire a charge of white paint that would turn the Venus de Milo white again, but instead it hurtled backward and almost fell into the first row of seats. Shortly afterward, Tinguely and his helpers finished building the wall, completely sealing off the stage, and the house lights came up. The entire performance had lasted no more than fifteen minutes.

According to John Wulp's subsequent account of the evening in *Esquire*, everybody was astounded to find that the performance had netted a profit of more than six hundred dollars—considerably more than any previous performance at the Maidman. " 'It just goes to prove what I've always suspected,' said Niki de Saint-Phalle. 'People are tired of the theater and movies. They want *real* entertainment.' "[2]

ONE NOTABLE NON-PARTICIPANT IN "THE CONSTRUCTION OF BOSTON" was Jasper Johns. Although Johns and Rauschenberg had remained very close personally, they were going in opposite artistic directions. Soon after his hugely successful first show at Castelli's, Johns's work had changed radically. He switched from encaustics to oil paint, and from the imagery of targets and flags and numbers (to which he would later return) to densely painted, agitated abstractions such as *False Start* (1959), in which the different areas of color were overlaid with stenciled words for colors that often did not match—the word "WHITE," for example, being painted in red on a patch of

yellow. Whereas Rauschenberg's work usually seemed to reach out and include a variety of references to the outside world, the verbal and intellectual elements of Johns's enigmatic pictures did not relate to anything outside the paintings themselves; everything referred back to the hermetic world of the canvas and its own internal relationships. Johns had become deeply immersed in the philosophy of Ludwig Wittgenstein. He also thought increasingly about the work of Duchamp. His own work, he said, was "a constant negation of impulses," and he seemed at times obsessed with the need to cover up his own tracks. "I've attempted to develop my thinking in such a way that the work I've done is not me—not to confuse my feelings with what I've produced," he said, several years later. "I don't want my work to be an exposure of my feelings."[3]

Sometime in 1961, Johns began spending a large part of his time in a house he had bought on Edisto Island, off the coast of South Carolina. Rauschenberg had moved, meanwhile, from Front Street to a huge, fifth-floor loft in a commercial building on Broadway near Twelfth Street, in Greenwich Village. They continued to live together when they were in New York, but their friends felt a growing strain between them. Before, as Ileana Sonnabend once said, they had been "so attuned to one another that sometimes it was hard to tell who was who," but now Johns was guarded and withdrawn, and sometimes bitingly sarcastic.

They both went up to Connecticut College in the summer of 1962, to work with Merce Cunningham, who was there under the college's dance residency program. By the time the summer ended they were no longer together. The break was bitter and excruciatingly painful, not only for them but for their closest associates— Cage and Cunningham and a few others—who felt that they, too, had lost something of great value.

RECOGNITION

The objects that found their way into Rauschenberg's combines were bigger and more aggressive than ever: an automobile tire nailed to the bottom of the stretcher in *First Landing Jump*; parts of a broken police barrier in *Coexistence* (also a Roman religious medallion enclosing the tooth of a saint); a pair of electric fans bolted to the sides of *Pantomime*, where they appeared to be blowing two agitated rivers of paint, black from one side, white from the other. The passages of abstract painting in these works (all dated 1961) were bolder, brighter, and more lyrical than in the past, setting up maximum tension between collage elements and lush color. Early in 1962, though, Rauschenberg began to feel the urge to paint "flat" again. He had noticed that collage was turning up everywhere, in dozens of New York galleries and museum shows. Too often, it seemed to him, the technique was used for its own sake, or as a facile means to make pictures that did not look Abstract Expressionist. After eight years of his own combines and assemblages, Rauschenberg was suddenly bored. His methods had become too familiar to him.

He attacked the problem that spring in *Ace*, a very large (nine-by-twenty-foot) canvas done in an extremely painterly manner, with few and relatively insignificant collage materials. *Ace* was a beautiful

painting, but it did not really solve anything. He started another combine, which he couldn't seem to finish. It was at this point that he began to experiment with two techniques that would be the basis of his work for the next three years. One was the use of commercial silk screens; the other was lithography.

Andy Warhol had discovered in 1961 that he could use the silk screen process to duplicate an image over and over on a canvas. The method involved having the image reproduced on a photosensitive silk screen, placing the screen against the canvas, and forcing special, viscous inks through the porous silk with a squeegee. Rauschenberg had often thought and talked about the possibility of transferring photographic images directly onto canvas. His fascination with photography had never left him; a photograph seemed to him as mysterious as the real object or scene that it depicted (and with which, in our photo-saturated century, it was often confused). He had used magazine photographs as the basis of his Dante drawings, rubbing against the back to transfer the image. Now he saw that he could do virtually the same thing in large-scale paintings, by using the silk screen method.

In his first series of silk screen paintings, done in the late summer and fall of 1962, he limited himself to black and white. "I'm such a pushover for color," he said, "and I didn't want that to interfere with what I was trying to work out." Some of the images he used were from photographs he took himself, deliberately prosaic, non-arty shots of rooftop water towers, storefronts, and the humble objects that one saw every day without noticing. Others came from magazines. He had them enlarged on silk screens in whatever scale he chose. One of his first silk screen paintings, *Crocus,* showed a large military vehicle at the top, and beneath it a small bouncing football (circled in white), a reproduction of the Velázquez *Venus and Cupid* from the National Gallery in London, several magnified images of a mosquito in flight, and the Velázquez Cupid again, this time alone. There was also an area of white and gray painting, and, near the center, a thick white painted X with dribbles of paint running down from it. It was called *Crocus,* he said, "because the white X emerges from a gray area in a rather dark painting, like a new season."

The technique opened up a wide range of possibilities. While Warhol used silk-screening as a sort of metaphor for the mass production of "popular" images, Rauschenberg rarely employed the same image more than once in a painting—at least not in the same way. Images reappeared in different pictures, where they entered into new relationships with other images, merged in superimposition, separated, were painted over, in a continuity that seemed, if anything, more complex even than the clash and opposition of real objects in the combines. The freedom of the new method! He ordered more and more screens made up, expensive as they were. He worked on three or four canvases at a time, building up his networks of visual information. A CBS television producer called to propose making a film on Rauschenberg, and Rauschenberg obliged by painting the largest canvas he had ever done, the thirty-two-foot-long *Barge,* with its horizontal flow of silk-screened images whose central theme was transportation. He worked on it for twelve hours straight, stimulated by vodka, by the presence of the camera crew, and by his own excitement in the process. Afterward, when the painting was finished, he went to an opening of a Niki de Saint-Phalle show at the Iolas Gallery, where he began to feel as though he were burning up. His skin turned a tomato-soup red. He went home and called a doctor, who found that he had an acute allergic reaction, caused by inhaling the fumes from the silk screen paints. The fan in his studio had been turned off all day because it interfered with the CBS sound recording. The sickness passed; the marvelous painting remained. On Leo Castelli's advice he had taken to keeping one out of every four of his works for himself, partly to have some share in what looked like a continuing rise in his prices. *Barge* was definitely a "keeper."

DURING THIS SAME SUMMER, TATYANA GROSMAN TALKED HIM INTO making his first lithographic print. Tatyana Grosman was a formidable persuader. She had grown up in Ekaterinburg in Siberia—her father published the principal newspaper there, and when the Czar and his family were executed by the Bolsheviks in 1918 the heads of

the local soviet came to the house to make sure that the event would go unreported. Soon afterward she had fled with her family to Japan, then to Germany, where she finished school, and where she met and married a young artist named Maurice Grosman. They moved to Paris. When the Nazis swept across France in 1940 and began arresting Jews, the Grosmans escaped over the Pyrenees into Spain and eventually made their way to New York, where Maurice gave art lessons and made silk screen reproductions of famous paintings. In 1955 Maurice had a severe heart attack. Mrs. Grosman, searching for some means to support them both, discovered two old lithographic limestones in the path outside their house in West Islip, Long Island, and then and there embarked on a quixotic project—to publish books illustrated by the best American artists she could find.

The most complex of the various print techniques, lithography requires, for its use as an art medium, painstaking collaboration between the artist and a highly trained printer. After the artist has drawn with a greasy substance on the smoothly ground block of limestone, the printer takes over. The stone is "etched," or fixed, with a solution of weak acid; moistened with water, which the greasy markings reject; then rolled with printer's ink, which sticks to the greasy portions and is rejected by the moist portions. A sheet of paper placed on the stone and run through the press absorbs the ink, and the result is a reversed impression of the artist's drawing, which the artist may either accept or reject. The stone is then reinked and the process repeated (with changes, if the artist was not satisfied with the previous impression) until the drawing eventually wears out. By using more than one stone an artist can achieve a wide and subtle range of color, which is why lithography is considered a more "painterly" medium than etching or engraving. The tradition of fine-art lithography has remained a strong one in Europe, and most of the major European painters of this century have taken full advantage of it. In America, though, where the medium's commercial applications always took precedence, the shift to photolithography after 1890 led to a steady decline in the number of printers who could hand-pull an impression from a stone. None of the Abstract

Expressionists made lithographs, mainly because there were no printers skillful enough to work with them.

Starting in 1957 with Larry Rivers, then, Mrs. Grosman had initiated the rebirth of a lost art, while out on the West Coast an equally dedicated woman named June Wayne was developing the Tamarind Lithography Workshop that would train a new generation of printing technicians. At Universal Limited Art Editions (ULAE), the rather grandiose title chosen by the Grosmans for the printing studio in their garage, the emphasis right from the start was on serving the artist. No expense was ever spared to help the artists whom Mrs. Grosman invited to discover themselves in the medium. She invited only those she considered outstanding—Rivers, Sam Francis, Grace Hartigan, Jasper Johns, Helen Frankenthaler, Robert Motherwell. The prints published by ULAE (it quickly became clear that the artists were more interested in prints than in books) were of such amazingly high quality and originality that museums and collectors soon began competing for them. Jasper Johns, who started working with her in 1960, was fascinated by the complexity of the lithographic process; he tried, with signal success, to complicate it further. Rauschenberg had met Mrs. Grosman when she brought two lithographic limestones to Front Street for Johns to work on; he and Johns had paid a Bowery bum to help them drag the enormously heavy stones upstairs. The whole idea of "drawing on rocks" had seemed somewhat antediluvian to Rauschenberg at the time, and for two years afterward Mrs. Grosman, nervous about Rauschenberg's reputation as an *enfant terrible,* had hesitated to ask him. In 1962 she summoned up her courage, though, and invitations ensued—a good many of them, by telephone and also in person, when she just happened to be in the neighborhood of his studio or caught sight of him on the street. It was a little difficult to understand what she said, in her soft voice with its freight of Russian accents and inflections, but it was even more difficult to withstand what Larry Rivers called her "gentle fury."[1] Rauschenberg eventually decided that his only escape was to draw on a rock.

He fell instantly in love with the medium. The flexibility and re-

sponsiveness of the stone and the fact that each stone felt a little different to work on, the sensual pleasure of drawing with the special rubbery lithographic crayon or painting with liquid tusche on that glossy surface (like drawing "on the skin of the stone," he said) delighted him beyond measure. He also liked the collaborative side of it, the need to work so closely with a master printer (Mrs. Grosman had managed to find one in New York, Robert Blackburn), the intricate technical "cookery" of etching and inking the stone, the suspense of putting it through the hand press for the first time, the consultations over details and improvements, the selection of a paper (always something of a mystical choice at ULAE; if there were only five sheets of a certain paper, Mrs. Grosman would publish an edition of five)—all this fitted in perfectly with Rauschenberg's sense of the creative act as a collaboration with materials. He was eager to explore the new medium, to try things that nobody else had tried. He pressed all sorts of objects to the stone, to see if they would leave impressions that could be printed: leaves from trees, magazine pages, his own fingerprints. He went to the *New York Times* morgue and bought leaded type and zinc cuts of old news photos, which he dipped in the tusche and used to create transfer images on the stone. By such means he found he could adapt his collage techniques to lithography, making prints that were visual reports on the contemporary world of nature, technology, sports, politics, fine art and commercial art, the urban landscape, and common everyday images.

Rauschenberg's visits to West Islip left the crew out there exhausted. He liked to work through the night and sometimes into the next day. "With Rauschenberg to work is something heroic," said Mrs. Grosman, who had become tremendously fond of him. "There is always a conquest, a subduing of something unexpected. Always some new discovery." One day in 1963, a Rauschenberg stone cracked in half when it was put through the press for proofing, a rare but not unprecedented occurrence in stone printing. He recreated the images on another stone. When that one cracked too (a small piece of cardboard lodged under the roller was causing uneven pressure), Rauschenberg told them to try printing from the broken

stone. He took some of the chips that had fallen from the break, dipped them in tusche, and pressed them into the lower portions of the stone, leaving marks that resembled the debris of a break. The printer managed with difficulty to make an edition of twenty-nine, and the result, which Rauschenberg naturally called *Accident,* was one of the most striking of all ULAE prints, a swarm of images that seemed somehow to be unified by the jagged fissure running down the middle. *Accident* won first prize at the Fifth International Exhibition of Prints that year in Ljubljana, Yugoslavia, where it was in competition with works in all the graphic media by artists from forty-two countries. It confirmed the old adage that, while the vast majority of prints are made by professional printmakers, the important ones are almost always by major artists for whom printing is one activity among others.

Recognition as a major artist, something that meant much more to Rauschenberg than he generally let on, was gradually coming to him. The Museum of Modern Art still did not own a Rauschenberg painting or sculpture, but it had included him in important exhibitions. He had even been asked to take part in a symposium in connection with its 1961 "The Art of Assemblage" show, along with Marcel Duchamp, Lawrence Alloway, the ex-Dadaist Richard Huelsenbeck (who had become a New York psychiatrist), and the historian Roger Shattuck. True recognition could be conferred only by MOMA, of course, although it was often said that the museum had fallen sadly behind in terms of contemporary art, that the trustees had decided somewhere along the line to make that once-pioneering institution a repository of the masterworks of the first half of the twentieth century, rather than a continuing beam of white light on new movements and styles. The Guggenheim and the Whitney were not much better about advanced art, although in the spring of 1963 the Guggenheim did mount a show called "Six Painters and the Object" that included Rauschenberg, Johns, Dine, Lichtenstein, Rosenquist, and Warhol. A few dealers and a handful of collectors had brought Pop Art to public notice, with little or no help from the museums. A lot of museum people had been extremely

shocked, therefore, when they learned that the Jewish Museum was planning to devote a major retrospective exhibition to Robert Rauschenberg.

The Jewish Museum, in the former Warburg mansion on Fifth Avenue at Ninety-second Street, had never been known as a promoter of modernism. Its collection of liturgical and religious objects was occasionally leavened by a show of works by some contemporary Jewish artist, but the artists were generally well known (Chaim Gross, Jack Levine), and the shows excited no great attention. The museum had recently launched an expansion and modernization program, though, and Albert and Vera List, important patrons who were also collectors of contemporary art, had persuaded their fellow trustees to choose as the new director Dr. Alan Solomon, the young and relatively unknown curator of the Andrew Dickson White Museum at Cornell. Solomon was committed to advanced art. At the Andrew Dickson White Museum he had put on shows of Dine and Oldenburg, and his first thought, when he took the job in New York, was to do a major Pop Art show there. This collapsed when Sidney Janis's two-gallery "New Realism" exhibition served essentially the same function. At that point Solomon decided to "go back to the beginning," as he phrased it, with Rauschenberg.

Solomon thought of Rauschenberg as the old master of post-Abstract Expressionist art. He had come to Rauschenberg's first show at the Castelli Gallery, in 1958, and had bought a painting for the museum at Cornell—the first Rauschenberg painting to enter a public collection. Since then he and Castelli had become close friends. "Alan was a man of very modest appearance then," according to Castelli. "He wore a rather skimpy suit, and he used a hearing aid. Getting the job in New York was a whole new life for him. He got rid of his rather cumbersome wife. He had an operation that let him dispense with the hearing aid, and he became very elegant—he grew a rich, Oriental sort of beard, and started to dress with great originality, and he had many deep relationships with women. He was so incredibly sure of himself that nobody could resist him."

The Rauschenberg exhibition was the first in the newly reno-

vated and enlarged museum, and the first under Solomon's authority there. The new director was understandably nervous about it, as he later admitted. He had to deal with some rather bizarre technical problems, such as finding a taxidermist to fix the goat in *Monogram*; when it was on exhibition in Europe a few months before, a man had sat on the goat's back to have his picture taken, and one of its legs had collapsed. The taxidermist fixed it, and then asked whether Rauschenberg would be interested in a stuffed dog he had at home; Solomon told him the artist wasn't "in that period" any more. One of the electric fans in *Pantomime* had broken down, and it proved almost impossible to find another one like it; electricians kept trying to sell them more streamlined models. *Broadcast,* a combine incorporating three radios whose dials the viewer was supposed to turn, needed an expert radio repairman. According to Solomon, his most helpful assistant in installing the show was Rauschenberg. "Whenever he made a suggestion it was exactly right," Solomon said afterward. "For example, I'd put *Bed* on the wall facing you as you came into the first room. It was an important piece, and I felt it should be prominent. But it wasn't right there. It fought with *Charlene,* for one thing. Bob took one look and said, 'No, put it on the end wall.' That's where it went, and it was perfect. He felt it had had enough made of it already."

There were fifty-five works in the show (counting the thirty-four Dante drawings as a single catalog item), ranging in time from the 1949 *White Painting with Numbers* to the recently completed *Barge.* Seeing them all together—*Bed* and *Monogram* and other combines in the context of the artist's evolution through the austere white and black paintings, the gaudy red series, the "pedestrian color" *Rebus,* the Dante drawings, and the later works—was an experience that changed a lot of opinions about Rauschenberg. Even Emily Genauer concluded that "Rauschenberg is an interesting painter—rather, he has recently become one."[2] Brian O'Doherty, in the *Times,* described him as "one of the most fascinating artists around,"[3] and Max Kozloff, writing later in the year in *The Nation,*

went all out and called his "the most significant art now being produced in the United States by anyone of the younger generation."[4]

The opening, on the evening of March 29, 1963, was an astonishing event in itself, the first of the wide-open, see-and-be-seen, roaring art world galas that became such a part of the sixties scene. All the younger New York artists were there, and the still somewhat unfamiliar, sweetish scent of marijuana cut through the haze of cigarette smoke in the dignified, high-ceilinged rooms. Ascending the mansion's baronial staircase, men and women in evening clothes gazed with amazement and apprehension at the mass of disheveled art lovers above and below, some of whom looked almost as outlandish as the art on display. A number of the Jewish Museum's older members were deeply offended. They thought a few of the works looked sacrilegious—a stuffed goat with a tire around it? by an artist who wasn't even Jewish?—and they had no doubt that most of it was dirty, ugly, and intensely disagreeable. Their misgivings could not mute the note of triumph in the air. An important New York museum was honoring a thirty-seven-year-old artist whose work, seen now for the first time in all its power and multiplicity, was not only dazzling in itself but a source of inspiration to almost any artist of his own or younger generations. Here was the "aesthetic tightropewalker" (as Alan Solomon called him in his catalog essay),[5] up on the high wire without a net, and not falling. Youth had taken over contemporary art, just as it had taken over American politics. The high spirits, the wit, the energy, the lightness of touch in Rauschenberg's work seemed to echo similar tendencies in John F. Kennedy's televised press conferences—and underlying both was a heady sense of power linked to imagination, of new approaches to old problems, of optimism without sentimentality.

Something new and exciting was being given its due that night. Victor Ganz, probably the leading American collector of Picasso, stood for forty minutes in front of *Odalisk*, scrutinizing the collaged images (nudists, comic strips, old family photos), walking around it, "seeing" Rauschenberg for the first time; the next day he went to Castelli's and bought *Winter Pool*, the first of his many Rauschen-

berg purchases. Alfred Barr, coming upon Jasper Johns in one of the crowded galleries (Johns could not avoid the opening, although he managed to avoid the artist of honor), asked for help in understanding the work. Barr said he knew Rauschenberg was important but that he still could not respond to him. Which of the works would Johns suggest the museum buy? Johns recommended *Rebus*. The museum did not buy *Rebus* (Victor Ganz did, several years later) but in 1964 Barr prevailed on Philip Johnson to buy *First Landing Jump*, the other combine with an automobile tire, and donate it. That way he didn't have to submit it for the trustees' approval.

After a dozen years of having MOMA trustees and other serious people (artists included) dismiss his work as a joke, Rauschenberg was riding a wave of vindication, and the wave was building up. Less than a year after the Jewish Museum show, a second Rauschenberg retrospective, at the Whitechapel Gallery in London, reaped superlatives from the British critics: "The most important American artist since Jackson Pollock" (*Sunday Telegraph*); "The most exhilarating art exhibition in London" (*The Times*); "The most influential and enjoyable show of the year" (*Sunday Observer*). "Every now and then a figure emerges from the bewildering currents of modern art who visibly marks a stage, a kind of distance post," added the *Observer*. "Rauschenberg is one of these."

Four months later he won the Venice Biennale. It was almost too much to take in, and more than a little disorienting. He began to feel, as he said that June day on the island of Burano, after his Biennale victory lunch, that he had "slipped into the wrong skin," and he began to worry about how difficult it might be to stay in touch with himself. So much had changed so quickly, in his own life and in contemporary art. A crisis was coming, and he knew it.

THE SISTINE ON BROADWAY

The doors of the freight elevator opened directly into Rauschenberg's loft at 809 Broadway. Sam, the taciturn black superintendent who operated the lift during the day, had agreed to let Rauschenberg have the key after 6 P.M., so he could get up and down. Sam and Rauschenberg were great friends. It was still illegal then (June 1963) for people to live in commercial lofts, and Sam was taking his own chances by letting Rauschenberg and Steve Paxton stay there. One night, Rauschenberg had managed to get the elevator stuck between the basement and the ground floor, so that Ileana Sonnabend, Virginia Dwan (in a full-length white fur coat), and his other dinner guests had been obliged to climb out through the opening at the top of the car.

The loft was about a hundred feet long by thirty wide. A row of supporting columns ran down the middle, but otherwise it was clear, unobstructed space. Tall, grimy windows let in the distinctively white light of downtown New York—also the roar of trucks on Broadway. Near the windows was a big, ramshackle wire cage containing a pair of kinkajous, Sweetie and Guy, who supposedly qualified as pets, although they made everyone but Rauschenberg extremely nervous. Sweetie made people so nervous that Rauschenberg had recently gone to Florida to buy a mate for her (Guy), think-

ing that would calm her down; Viola Farber, who volunteered to come in every day to feed Sweetie while he was gone, had received for her trouble a nasty bite on the hand, which she did not have treated because she was afraid that would get Rauschenberg in trouble. In the daytime the nocturnal kinkajous were usually curled into compact balls of yellowish brown fur in opposite corners of the cage, their huge eyes and long tails hidden from view.

Beyond the cage stood a group of large objects—a car door, a window frame, a roof ventilator mounted on wheels—components of an unfinished five-part sculpture called *Oracle* that would eventually be activated, with the help of Billy Klüver, by an electronic system that linked the components through sound.[1] Paintings, combines, and sculptures from the recently concluded Jewish Museum retrospective were stacked against the wall farther along. There was a big table in the middle of the room, its surface cluttered with magazines, pictures clipped from magazines, felt pens and pencils, and tubes of paint and other materials. Toward the back of the room, a counter projecting from the end wall formed an alcove for the refrigerator, the electric stove, and the bed—a mattress laid on the floor. All the rest of the loft was work space. Several stretched canvases, untouched as yet, stood facing the wall. Four more lay face up on the floor, surrounded by silk screens in wooden frames and gallon cans of opened and unopened paint. Rauschenberg had started work that day on a new series of silk screen paintings, his first in color. He was having a lot of problems with the four-color separation process, which required a separate screen to lay in each color. At first he had tried sticking pins through the canvas to get the screens lined up right, but his natural impulsiveness and dislike of control had soon put an end to that. After a while the imperfect registering of the colors had ceased to distress him. Putting down one color while the others were still wet, he had achieved hues that reminded him of badly exposed color photographs. "At least it doesn't remind me of the work of any other painter," he said, standing back to look at his canvases. "The color is so far from what I'd choose myself that it keeps putting me off, making it really impossible for

me to manipulate." And, a minute or so later: "I know how to describe this kind of color—delicious! It's like movie candy. It's so glamorous—every color is trying to be a star. That pink, now, it's not a color at all, it's more like fingernail polish. Helena Rubenstein could bring it out next season: Rauschenberg pink, created by Helena Rubenstein."

At some point during the long June afternoon it dawned on me that Rauschenberg had set up what was for him an ideal working situation. We were just getting to know each other then—I was starting a *New Yorker* profile on him, and this was only our third meeting—and for a while it had puzzled me that he went about his work in such a seemingly haphazard way, laying in the colors too quickly or out of register, scrubbing the canvas clean again with benzine and starting over, paying little or no attention to the technicalities of what was after all a highly exacting process. "It's such an indirect way of working," he mused, sipping from a tall glass of vodka and grapefruit juice. "You do something, and then five hours later you find it was a mistake. I'm thinking of giving these up. I get so full of frustration and hostility. And I'm not an Abstract Expressionist, you know; I can't *use* all that!" He didn't show any signs of frustration or hostility, though, and I began to see that the technical problems and uncertainties of the silk screen process were made to order for him. The process was unfamiliar and full of surprises. The materials stubbornly asserted their own particularity. "The material is never wrong," Rauschenberg said. "It's only me that can be wrong." He was working, so to speak, in the gap.

The elevator door banged open and Steve Paxton came in, carrying a bag of groceries. Paxton was a dancer with the Cunningham troupe, a clean-cut, self-contained young man who had been born and brought up in Arizona and who (unlike Rauschenberg) would never look entirely at home in New York. The two of them discussed Cunningham's new dance, *Winterbranch*, which Paxton had been rehearsing all afternoon at the Cunningham studio, and for which Rauschenberg was designing the set, costumes, and lighting. In this period Rauschenberg devoted more time to Cunningham than to his

own painting. The company toured constantly, and Rauschenberg, the stage manager and lighting designer, went with it. Before going out on tour, he would stretch a lot of canvases and order a bunch of new silk screens made up by the commercial jobber he used, so he could start to paint as soon as he returned. Later that year, he ordered a silk screen made up from a news photograph that showed John F. Kennedy in action at one of his televised press conferences. Rauschenberg and the dancers were driving through Louisiana when they heard that the President had been shot. Back in New York, he faced a dilemma. The Kennedy image now carried a weight of emotion and grief that he had never foreseen. But a decision not to use it for that reason would be as impure, he felt, as the decision to use it. "I was thinking of the image as a fact, rather than as a personality," he explained. "Kennedy and his presidency had merged to become a fact. He reestablished what a President is supposed to be— somebody special, not somebody you're comfortable with. One of the things that was so shocking about his death was that it was so believable; it wasn't out of scale with the strength and abruptness of all the things he'd done in office." Rauschenberg used the JFK image in twelve silk-screen paintings.

While he and Paxton talked, Rauschenberg continued working. He went over to the end wall where several dozen old black-and-white silk screens had been stacked, pulled out one on which a complex, clockwork diagram was imprinted, and brought it over to where the canvases were laid out on the floor. After a period of contemplation, he put the screen down near the center of one canvas, poured black paint over it, worked the paint around with a squeegee, then lifted the screen away. He had superimposed the clockwork diagram on a four-color blowup of the Sistine Chapel, "making," as he cheerfully noted, "a modern painting out of *The Last Judgment.*"

The telephone rang. Rauschenberg picked it up, and entered into an extended conversation with Andy Warhol. The telephone was on a long cord, which allowed him to pace back and forth across the room as he talked. Warhol and Rauschenberg and a number of other

artists had been commissioned by Philip Johnson to do large, out-door works for the facade of Johnson's New York State Pavilion at the 1964 New York World's Fair, and Warhol wanted to know what Rauschenberg was going to paint. Warhol had idolized Rauschen-berg and Johns in the years when he was still a commercial artist. In an interview he had said that Rauschenberg's use of objects in the combines had made it possible for him, Warhol, to do what he did later with soup cans and Coke bottles and S&H Green Stamps and paint-it-by-the-numbers diagrams and dollar bills and multiple por-traits of Marilyn Monroe and Elvis Presley and Troy Donahue. Warhol was still painting in 1963. In his Forty-seventh Street studio, known as "The Factory," he was turning out silk-screened pictures by the dozen, with the help of Gerard Malanga and other assistants, and selling them almost as fast as he could turn them out to people like Philip Johnson and the Burton Tremaines and Robert Scull.

Warhol, in fact, was rapidly stamping Pop Art with his own in-delible label. Pop Art shows were the hot ticket that year at modern museums from Oakland, California, to London and Stockholm. Sev-eral New York dealers, carried away by the instant success of the new style, were urging collectors to switch from Abstract Expres-sionism to Pop; the bottom had dropped out of the market for an en-tire second generation of Abstract Expressionist painters (it had not affected the sales of de Kooning, Rothko, or the other leaders of the first generation), and there was great bitterness as a result. Mean-while, it was beginning to be clear that Pop Art was not really a *movement,* any more than Abstract Expressionism had been. A number of artists had chosen to work with roughly similar subject matter, but subject matter was not, perhaps, as central to their work as it had at first appeared; there was a world of difference between Roy Lichtenstein's deadpan reworkings of comic strips, for example, and Claes Oldenburg's transformations of common objects into soft sculptures. What was largely cerebral and ironic in Lichtenstein became sensual and emotional in Oldenburg.

The Pop movement, at any rate, was rapidly diversifying and spreading out. Oldenburg left New York in the summer of 1963,

and spent the next year living in Los Angeles. A lively group of California artists had emerged out there (several of whom were giving Pop a California Sunkist tint), and the activities of two or three galleries, one or two collectors, and an ambitious new monthly magazine called *Artforum* had made it seem as though Los Angeles would soon rival New York as a contemporary art mecca. (It never did.) In New York, meanwhile, attention was shifting from the Pop Art phenomenon to color field painting, as exemplified in Alan Solomon's second major exhibition at the Jewish Museum. Called "Towards a New Abstraction," it was focused on the pure chromatic paintings of Kenneth Noland, Morris Louis, and Frank Stella. A year later several critics would decide that Pop Art's aggressive, "despicable" subject matter had blinded everyone to its more important formal qualities, and that Lichtenstein and Rosenquist had more in common with Noland and Stella than they did with Oldenburg.

In the end, it seemed, the only real Pop artist was Warhol. Warhol epitomized the mass-media spirit of Pop. He had banished every trace of "fine art" from his work, every vestige of the artist's hand and personality. His silk-screened Coke bottles and soup cans could just as well have been done by someone else, as a good many of them were. The images he selected all seemed to come from the absolute, magnetic center of America's media-lulled forebrain. Warhol's art was the art of publicity, as his commercial clients at I. Miller had known all along. Rauschenberg rather admired Warhol's unerringly banal paintings. "Us silk-screeners have to stick together," he said, after he had hung up the telephone.

While Rauschenberg fixed himself a fresh drink, Steve Paxton came over to look at the new batch of color silk screens, which had just arrived that morning. They included a fabric advertisement from the *New York Times Magazine;* the Statue of Liberty, seen dramatically from below; the framework of a New York office building under construction; another *Times* ad showing a row of folded, bright-colored blankets; a U.S. Army helicopter in flight; a troop of marching Boy Scouts, with flags; a series of four high-speed photographs of a bird in flight; astronaut Gordon Cooper's reentry cap-

sule floating in the Pacific, with frogmen on the flotation collar; something that looked like a many-hued shaft of light (actually an iron rod heated to the melting point); the nebula of a star; the New York skyline; a typically cluttered New York lamppost with two stop signs and below them signs for Nassau and Pine streets; a glass of water; a close-up of oranges; the Sistine Chapel. Rauschenberg was also using several of the older black-and-white screens. He had to be careful not to put in too much black and white, he said; there was a point at which the colors ceased to function and the painting became predominantly black-and-white.

It seemed to me that he was enjoying his work more and more, gaining energy from hour to hour. "It's as much like Christmas to me as using objects I pick up on the street," he said. "There's that same quality of surprise and freshness. When I get the screens back from the shop, the images on them look different from the way they did in the original magazine cutouts because of the change in scale, so that's a surprise. They look different again when I transfer them to canvas. And they constantly suggest different things when they're juxtaposed with other images. Some images absolutely insist on being themselves no matter what you do with them. Look at this baby—" He held up to the light a screen with the head of a bald eagle in close-up. "How's that for authority?"

He began to work more rapidly, moving from canvas to canvas, wholly absorbed but easily interrupted. He laid in the images from six or seven screens, sometimes using the same image in more than one canvas but always in a different context (the Statue of Liberty went in upside down on one). Standing back to examine them, he occasionally cheered himself on: "*That* was a good stroke!" The level of vodka and grapefruit juice in his glass declined, not fast but not too slowly either. The telephone rang several times, and he dealt with each caller cordially and at length, pacing back and forth at the end of the long cord, then coming back to work with his concentration as sharp as before.

Nicolas Calas, a tall and saturnine art critic, dropped in shortly after 6 P.M. Calas, who had written with insight about the European

Surrealists, had never cared much for Abstract Expressionism; as a result he had fallen into something of an eclipse during the fifties, from which he was just emerging. At the moment he was writing an article on American painting of the twenties and thirties, and he wanted to know which painters of that era Rauschenberg admired. Rauschenberg said he liked Edward Hopper, and some of Stuart Davis. He didn't like Ben Shahn, who had ruined himself as a painter, he said, by trying to swallow the latest European line. Rauschenberg kept right on working while they talked. Calas commented on the new canvases, saying the color reminded him of Rauschenberg's stage lighting for Merce Cunningham.

"I don't use light as color," Rauschenberg said.

"You use it as movement," said Calas, whose conversational style tended toward pronouncements.

Rauschenberg was delighted. "Why didn't you tell me that before?" he asked. He went on to talk about how much he envied the situation of the dancer, for whom there was no fixed, permanent work of art. "I feel very close to that situation in my own work," he said. "I always want to put off the final fixing of a painting as long as possible, but of course you can't. Once it's done, it's done."

"But you put it off with ambiguity," said Calas.

Later still, after Calas had gone, Rauschenberg stood the four canvases he had been working on against the wall and looked at them for ten or fifteen minutes. Two of them had "broken loose," he said. There was always a moment, for him, when a painting acquired its own momentum, when he could tell just where it was going. He took a paintbrush and started to work on the two that had broken loose, using the black-and-white silk screen paints to get a whitish gray which he applied here and there, tying together different images. Rummaging through the material on the big worktable, he found a tube of artist's color, crimson, squeezed some out, and rubbed it on the canvas with his fingers. He stepped back to look, wiping his long fingers on a rag. He stared at the canvas, his shoulders slightly hunched, his expression interested and alert. The painting he was looking at had a dozen or more different images in it:

office building, Statue of Liberty, blankets, water glass, the Sistine Chapel with the superimposed clockwork diagram, birds in flight, lamppost with signs. Eventually he started to work on it again with a paint rag soaked in benzine. He scrubbed at one of the four close-ups of the bird in flight, blurring and dissolving it, giving that section a paler tonality that made it less competitive with the red stop signs. He stepped back again to look. "Look at that," he said, marveling. "The birds have freed the stop signs."

INCIDENTS OF TRAVEL IN EUROPE AND ASIA

Merce Cunningham's 1964 world tour required the sort of blind faith that small dance companies are often obliged to subsist on. When the troupe left that spring for Europe, on the first leg of a journey that would last for six months and take them to thirteen countries, they were still $20,000 short of the amount that Cunningham and Cage had estimated they would need. They had their round-trip airplane tickets, purchased with the proceeds of a benefit art sale organized by Jasper Johns and others to help finance a season on Broadway for Cunningham; when that plan fell through, the money (about $17,000) was diverted to the world tour. The John D. Rockefeller 3rd Fund had given them an additional $20,000 for the Far Eastern leg of the trip. An application for U.S. State Department funds had been turned down (Cunningham was still too controversial), but Johns and other friends in New York were hoping to raise more money, and the company's projected performance fees and box-office receipts were expected to bring in about $40,000. Cunningham had decided to go ahead with what they had, assuming that the deficit would get made up somehow.

The company that went abroad numbered sixteen people in all. There were ten dancers, two musicians (Cage and David Tudor), two managers (an innovation—until then Cunningham and Cage had

handled everything themselves), and two designers (Rauschenberg and his assistant, a young artist named Alex Hay). It was a larger and less homogeneous group than the company of previous years, and the unfamiliar presence of what the dancers called a "managerial class"—Lewis Lloyd and David Vaughan—had altered the delicate personal relationship between Cunningham and the others. Always somewhat remote, Cunningham had often seemed more relaxed and approachable when the company was on tour, which was one reason the dancers liked touring. Now they had to deal with Lloyd or Vaughan instead. Carolyn Brown, the nearest thing to a star in this non-star company, suspected that Cunningham was troubled by personal problems that he confided to no one; although he had never danced better, he seemed withdrawn and unhappy much of the time, and this, she thought, was an important factor in the problems that arose. The main problem was the accumulating tension between Rauschenberg, on one side, and Cunningham and Cage, on the other.

The tension had been building up for two years. On the opening night of a 1962 engagement in Montreal—an engagement that marked Rauschenberg's debut as the company's official lighting designer and stage manager—Cunningham had held the curtain for twenty minutes because nobody could find Rauschenberg backstage. They learned later that he had gone to see how his lighting looked from the orchestra, but Cage and Cunningham, who thought he might be in a bar somewhere, were furious. Cage took him aside after the performance and delivered a blistering lecture on the subject of time; in the theater, he said, one simply could not take a relaxed attitude toward it. Rauschenberg was shaken by Cage's anger. Cage believes that Rauschenberg's three subsequent *Time* paintings, all of which incorporate clocks, were in some sense reactions to the Montreal incident, which nearly destroyed their friendship on the spot.

Rauschenberg was utterly dependable during performances after that, and Cunningham and Cage valued his work so highly that they were able to ignore his offstage lapses ("Anything that wasn't a performance," according to Viola Farber, "you just sort of hoped he would get there"). He had wanted to learn stage lighting because he

found that other people's lighting tended to alter the look of his costumes and sets. Having mastered the technical details on the job, he lit Cunningham's dances in the clear and undramatic style that Cunningham had always wanted. Cunningham felt that stage lighting should be like daylight, something the dancers moved through. "Bob agreed with that completely," he said. "He thought of lighting in flexible terms, a layer here and a layer there, like brushstrokes. Mostly white light. And he could understand just what you wanted. With *Winterbranch,* for example, I told Bob I wanted the dance to look as though it were taking place at night—not moonlight, but the quality of artificial light that you get when you're driving on a road in the dark, with other cars coming at you. He knew exactly what I meant, and he got it."*

An innate sense of theater coupled with a highly inventive practicality—these were qualities that Rauschenberg shared with Cunningham. In the days when the company still toured in a Volkswagen bus that Cage had bought with the money he won on an Italian television quiz show (he had answered every question put to him on the subject of mushrooms, becoming in the process an Italian media hero), Rauschenberg's sets could always be broken down for easy packing and reassembling. He worked with whatever lighting arrangements were available in the gymnasiums and college auditoriums where they so often performed, and frequently he turned obstacles into assets. The dancers responded to his energy and inventiveness; so did Cunningham and Cage. Their work together was a true collaboration, and one of the marvels of the postwar theater.

Rauschenberg loved the collaborative aspect of working with dancers. He almost seemed to enjoy the discomforts and privations

*Rauschenberg got it by using no proscenium lights at all. He and his assistant operated a pair of powerful searchlights in the wings and from stage rear, moving them around and switching them off and on in response to a random procedure that differed with each performance. Sometimes the dancers were in total darkness; sometimes a searchlight beam momentarily blinded the audience. *Winterbranch* was one of Cunningham's most controversial pieces of stage magic.

of being on tour, and his sunny good nature helped to keep the others' spirits up. He and Viola Farber used to make up endless stories to tell each other during the long hours of driving in the Volkswagen; for a while they each had an imaginary horse, whose care they would discuss in intricate detail ("On tour one becomes mindless," Farber explains). The company was like a family then, with a great deal of mutual affection and respect. By the time they left on the world tour, however, this intimacy was already somewhat eroded. Rauschenberg had become what Viola Farber called "a sort of link between us and the grown-ups." He refused to acknowledge any hierarchies. To him the company was still a group of people freely committed to a common purpose. As Cunningham and, to a lesser extent, John Cage appeared to withdraw from the dancers, Rauschenberg tended to move in the opposite direction. He would take several dancers out to dinner at a good restaurant after a performance; sometimes, to Cunningham's annoyance, they would stay out quite late. Rauschenberg never seemed to get tired. He could afford to be generous because his work was finally selling. The Montreal incident, Cage said, was also the start of "a change between Bob with no money and Bob with a lot of money," a change that Cage and Cunningham did not entirely welcome. Rauschenberg often talked about buying a place in Florida where the company could go to rehearse, or to rest after touring; the year before, he thought he had found just the thing, a houseboat on Sanibel Island, off the Gulf Coast, but the deal had fallen through (he did buy a small house on Captiva Island, which adjoins Sanibel; it would be several years, though, before he spent much time there). To Cunningham and Cage, it sometimes seemed as though Rauschenberg were trying to take over the company.

In a sense their fears were not entirely groundless. Dedicated as he was to the ideal of collaboration, Rauschenberg's personality had a tendency to dominate, and his energy made him impatient. The friendship between Rauschenberg and Tinguely had faltered over this very issue, during the "Dylaby" exhibition in Amsterdam in the fall of 1962. Invited by the Stedelijk Museum to participate in a col-

laborative project ("Dynamic Laboratory") with Tinguely, Niki de Saint-Phalle, Martial Raysse, Daniel Spoerri, and Per Olof Ultvelt, Rauschenberg had been irritated and disillusioned by the others' reluctance to collaborate on a single work, and by Tinguely's penchant (as it appeared to Rauschenberg) for giving orders and generally running the show. Each of the six artists ended up making separate exhibits in separate rooms, and Rauschenberg and Tinguely never worked together again. It is possible that Rauschenberg's notion of collaboration struck the Europeans as ingenuous, considering the undeniable force of his own ego.

Cage once said, a little ruefully, that Rauschenberg embodied the kind of spontaneity and freedom that he, Cage, espoused in theory. Cunningham was ambivalent about spontaneity. Cunningham had freed modern dance from its dependence on narrative, on psychology, and even on music, but his choreography was as precise and as disciplined as Balanchine's. Some of the actual movements in his dances might have been arrived at by chance methods, but, once established, they were strictly adhered to by the dancers. Cunningham was afraid that if he allowed dancers the kind of freedom of choice that Cage sometimes allowed his musicians, they would start bumping into each other at high speeds and there would be injuries. At the same time, the idea of greater freedom appealed to him strongly, and he was aware that others, including Rauschenberg, were experimenting in that direction.

A group of dancers, most of whom had either danced or studied with Cunningham, got together in Cunningham's studio in 1960 for a series of experimental dance workshops led by Robert Dunn, a composer very much under the influence of Cage (Dunn's wife, Judith, was a Cunningham dancer). This became the Judson Dance Theater—so called because it worked and performed in the Judson Memorial Church on Washington Square. The Judson group was the new dance avant-garde. Picking up where Cunningham left off (or so they believed), its members sought to free dance of its dependence on trained dancers and fixed choreography. Yvonne Rainer, Steve Paxton, Simone Forti, Lucinda Childs, Judith Dunn, Trisha

Brown, and several others made dances out of commonplace movements such as walking or sitting down. Yvonne Rainer invented the term "task movement" for what they were aiming at, and many of their pieces did give the impression of people carrying out, seriously and without a shred of theatrical "accent," certain assigned tasks. Others resembled complicated games, in which the players took their cues from one another (much of the movement was improvised during performance). "The Judson meant that we could all do choreography, which was simply unheard of," Steve Paxton said, recalling those days. "In the tight little world of modern dance most people have no chance to develop their own ideas. It took at least six weeks to make a dance, and maybe a thousand dollars to get it performed—the restrictions were just prohibitive. We began with this idea of Bob's that you work with what's available, and that way the restrictions aren't limitations, they're just what you happen to be working with." The Judson people were quite certain that what they were doing was dance. They did not want their work confused with happenings, which were more expressionistic and object-oriented.

Rauschenberg spent a lot of time with the Judson group. He went to all their workshops, worked backstage, and handled the lighting for most performances. If somebody wanted him to perform in a piece he did that, too—one of the ideas being explored was that you did not need special skill or training to be a dancer. The fact that "we were all each other's material," as he put it, pleased him enormously. It was inevitable, sooner or later, that he would want to make a dance himself (the Judson people "made dances"; nobody used the word choreography). In the spring of 1963 Alice Denney, the assistant director of the Washington, D.C., Gallery of Modern Art, put on a Pop Festival in Washington. Her program of events mistakenly listed Rauschenberg as one of the choreographers. Rauschenberg decided to accept the challenge. Learning that the festival performances were to be held in a rollerskating rink, he worked out a *pas de trois* for a ballerina *en pointe* (Carolyn Brown) and two men on roller skates—himself and the Swedish artist Per Olof Ultvelt, who happened to be visiting New York at the time. They re-

hearsed for three weeks, first in Rauschenberg's Broadway studio, and then, when the costumes were ready, in a roller rink in Brooklyn. For Ultvelt and himself, Rauschenberg had devised a huge sail-like apparatus made of parachute silk, on a wire frame strapped to the skater's back; they couldn't rehearse with these in Rauschenberg's studio, because the tops of the frames caught in the sprinkler system. The dance, called *Pelican,* turned out to be highly romantic in feeling, with the two men in their fantastic parachutes circling and occasionally lifting the ballerina, who wore toe shoes and a sweat suit. There was some anxiety that one of them might drop the incomparable Carolyn Brown, but both Rauschenberg and Ultvelt worked hard at learning to skate, and Carolyn declared afterward that she was never worried. *Pelican,* at any rate, was the hit of the festival.

It was a little disconcerting for Cunningham and Cage to find themselves on the conservative side of the new dance revolution. Cage sometimes suspected that the Judson direction was the right one. "Bob's spirit is so fantastic that he can do anything and it will turn out to be interesting," he said at the time. "In his work with the Judson he's trying to free theater of all that complexity and difficulty that we usually think of as being a part of it." Cunningham himself moved a certain distance toward improvisation and greater spontaneity with two 1963 works, *Field Dances* and *Story,* in which the dancers were allowed some freedom of choice during performance. He gave each dancer a series of relatively simple movements (different movements for each dancer), some of which could be performed as solos, others in conjunction with one or more people. The dancers were free to perform these in any order and in any part of the performance area, and they could also enter and go off stage at will. The trouble was, Cunningham never liked the way either *Field Dances* or *Story* looked in performance. "Dancing is very tiring, and when you're tired you're likely just to do the easy thing," as he explained it. "Whereas when you know what you have to do, you can usually jump the fatigue, go beyond it." During the world tour, *Story* (with its set improvised anew each time by Rauschenberg) became pro-

gressively more fixed in performance, but even so Cunningham was often furious with the cast when it ended. The conflict was really a philosophical one. "We were always being represented by John Cage's philosophy," Steve Paxton once observed, "but the truth was that John's philosophy did not coincide with what either John or Merce did in practice. They're both very formal at heart, and incredibly disciplined. Bob Rauschenberg is not."

There were tensions, then, both personal and artistic, before the Cunningham company left on its world tour, and circumstances soon conspired to make them worse. After performances in Strasbourg and Paris, the company was scheduled to appear at La Fenice in Venice. They arrived two days before the opening of the Biennale, when suspense over the announcement of the prizes was rising to fever pitch. A lot of people assumed (wrongly) that Cunningham's arrival was timed to coincide with the campaign for Rauschenberg; the violently partisan response to the first performance at La Fenice made this eminently clear. The company was still in Venice when Rauschenberg won the major international prize for painting, an event that the European press treated as big news. As the artist and *enfant terrible* of the moment, Rauschenberg was besieged by reporters everywhere the company went after that. News stories about Cunningham tended to devote most of their space to Rauschenberg, and it did not help matters when several articles reported that Rauschenberg was doing choreography as well as sets, costumes, and lighting. It helped even less when Rauschenberg, in an interview with a British journalist, said that he thought of the stage as the largest canvas he had ever had to work with. "He made it sound as though the company were his, not Merce's," Cage said angrily.

From Venice the company traveled to Milan, Vienna, Mannheim, Cologne, Les Baux, and then to London, where it had an unexpected triumph. The British, who were supposedly impervious to modern dance, showed such enthusiasm for Cunningham that a week of performances at Sadler's Wells was extended by three more sold-out weeks at the Phoenix. London's dance critics were overwhelmed. "At a blow," wrote the *Observer*'s Alexander Bland, "ballet has

been brought right up in line with the front-rank experimenters in the other arts—something which has hardly happened since the days of Diaghilev."[1] Several British theater directors and designers (among them Peter Brook, Lindsay Anderson, and Jocelyn Herbert) came again and again to see the programs, which Bland described as "so full of invention that they will be a mine for imitators for years."

The London season was a watershed for Cunningham. As so often happens with American artists, his success there led to his being taken far more seriously at home. Behind the scenes, though, Cunningham was more remote than ever. He was annoyed with Shareen Blair, an extremely pretty dancer who could never quite please him. Once, finding her still on stage when he came out to dance a solo, he lifted her up by the elbows and carried her off; the audience laughed, but it was not a joke. Shareen, who had been receiving nightly deliveries of flowers and marriage proposals from an enchanted English admirer, left the company to marry him at the end of the London engagement, a sudden decision that was prompted, the others felt, by unhappiness over her situation. Relations between Cunningham and Rauschenberg remained polite but distant. At the Dartington School in Devon, where they gave one performance, the theater was so barren that Rauschenberg could find nothing backstage to use for the *Story* set, so he and Alex Hay brought in two ironing boards and proceeded to iron their shirts at the rear of the stage during the performance. In London, Rauschenberg's *Story* set for two nights running was himself, back to the audience, painting a picture. The dancers felt somewhat upstaged.

In Stockholm, where they went next, Rauschenberg was rather a well-known figure. He had been there for the "Art in Motion" show in 1961, and Pontus Hulten's enthusiasm for his work had made it regularly visible at the Moderna Museet. When the company arrived in Stockholm, Hulten suggested that Rauschenberg, Alex Hay, Steve Paxton, and David Tudor do an additional series of "New York Evenings" at the museum, along the lines of the events that Rauschenberg and Tinguely and Niki de Saint-Phalle had done in Paris and New York. The idea was broached to Cunningham, who said he didn't mind, so long as it didn't interfere with his own rehearsals.

Rauschenberg, Alex Hay, and Hay's wife Deborah, the company understudy who had taken Shareen Blair's place, immediately started work on *Elgin Tie,* which Rauschenberg later said had been inspired by the Elgin marbles in the British Museum, "that fantastic combination of men and animals." The animal he chose to associate himself with in Stockholm was a cow, an unusually large and pregnant cow belonging to a farmer who was Pontus Hulten's brother-in-law. "The idea was that I'd be carrying a bag of flour, and the flour would join me and the cow together," Rauschenberg explained. "Being from Texas I didn't expect problems from cows, but it seems that Swedish cows are more like bulls. We rehearsed out in a field, in the rain. The cow was wet, I was wet, and in a matter of moments we were both a mess." Rauschenberg decided at this point to find another manner of combination.

The Moderna Museet in those days consisted of two huge, rectangular rooms (it had been a naval barracks before becoming a museum). Folding chairs converted the outer one into an auditorium for the events that Hulten liked to stage there, such as jazz concerts and film showings, and the announcement of *Elgin Tie* drew a capacity audience. Rauschenberg had enlisted David Tudor to provide a score for the performance—a tactical mistake, he later realized. Cage was afraid that if Tudor ever got a taste for composing, the entire musical avant-garde in New York would collapse, because nobody else could perform the music they were writing. Tudor attached contact microphones to the museum's fluorescent lights, so that they picked up and amplified the tiny ping-ping sounds the lights made when they came on, and the score was achieved by his turning lights on and off. The program opened with *Shotput,* a brief piece that Rauschenberg had made for the Judson group's "Surplus Dance Theater" performances in New York that spring. It was danced (if that is the word) in almost total darkness by Rauschenberg, who had a flashlight fastened to one foot. As soon as it was over, he ran around to the back of the building, scrambled up a ladder, and came in through a skylight. *Elgin Tie* commenced with Rauschenberg climbing down a rope that hung in

the middle of the performing area. Various objects had been attached to the rope at intervals, and he dealt with these as he descended—changing into a new pair of socks, unraveling a ball of twine, eating a sandwich. There had been no rehearsal for this part, because he was too afraid of heights (he said) to do it more than once. The rope ended in a barrel of water placed on the bed of a large farm wagon. The star descended into the barrel, emerged dripping, and walked to the front of the wagon, where he stepped into a pair of extra-large boots. He produced from his pocket a white necktie, which was the signal for the farmer to enter the hall leading his cow. The cow had been unable in rehearsal to pull the wagon off as planned because the museum's polished wood floor was too slippery. An assistant pulled it instead, while the farmer led his cow off again, and Rauschenberg, leaning forward at an incredible angle (the boots were nailed to the wagon bed), tied and untied and retied his (Elgin) tie. The cow's majestic deposit just prior to her exit was unrehearsed, and greatly appreciated by the Swedish audience.

From Stockholm the company went to Copenhagen and Helsinki, where a financial crisis engulfed it. Because Shareen Blair had left the tour, Air France informed them that they had forfeited their air travel group rate, and would have to pay several thousand dollars additional fare. Since the tour was already running a larger deficit than had been anticipated, this was a heavy blow. "I guess old Bob will have to take out the Crayolas," said Rauschenberg, none too tactfully. Telegrams flew back and forth between Helsinki and New York, and within twenty-four hours Rubin Gorewitz, the accountant who looked after the affairs of Cage, Cunningham, Rauschenberg, and a number of other artists (for difficult decisions he consulted the *I Ching*), had arranged for the sale of a painting by Jasper Johns and the forwarding of sufficient funds to get the company out of Finland. Rauschenberg took over the payment of Alex Hay's salary. The tour continued.

Tremendous excitement attended their next performances, in Prague and Warsaw. Eastern Europe had seen very few American

dancers since the war; in Prague the posters read "Style of *West Side Story*." After doubling back for engagements in Brussels, Antwerp, and Toulon, the company flew east again for the last leg of the tour, to India and Japan. In Ahmedabad they were the guests of the wealthy Sarabhai family, whose daughter had studied music with John Cage in New York years before. The audience in the expensive orchestra seats there watched them in puzzled silence, but the galleries went wild. In Chandigarh, the new city built by Le Corbusier, an overflow audience was in a constant turmoil of astonishment. They performed for Thailand's King Bhumibol and Queen Sirikit in Bangkok ("The King asked a good many questions," Cunningham recalls), and flew on to Tokyo. By this time, Cunningham and Cage were barely communicating with Rauschenberg. Nobody can remember a specific breaking point, but it was depressingly clear to everyone that a friendship of more than twelve years' standing was disintegrating.

Neither Cage nor Cunningham went to see Rauschenberg perform *Shotput* at the Sogetsu Art Center in Tokyo. And when Cunningham's Tokyo engagement was finished, Rauschenberg and Paxton let it be known that they were no longer with the company. Cunningham called a meeting of the others, to ask what their plans were. Deborah and Alex Hay said they were quitting, too, and so did William Davis, the only other male dancer besides Paxton and Cunningham. Viola Farber had been planning to leave the company anyway. She had hurt her foot during a master class in Paris, had continued dancing on it in spite of increasing pain, and as a result she had severely strained her Achilles tendon; unwilling to join the general walkout, she told Cunningham she would stay on for the time being. Carolyn Brown could not make up her mind. "I went back home and sulked," she said. Her mother, recalling her own Denishawn days, told her she thought they had all been terribly insensitive to Cunningham, and Carolyn eventually went back and danced with him (magnificently), for ten more seasons. At the end of the world tour, though, she and most of the others believed that the Cunningham company was defunct. After six months of hard

touring—more than seventy performances in twenty-nine cities—they returned to New York with a deficit of $85,000. The deficit would be paid off eventually, and the company would reform itself, but not as the old, affectionate family of dancers that it had been before.

NINE EVENINGS

The day after he won the Biennale, Rauschenberg telephoned from Venice to a friend in New York, a Judson dancer named Tony Holder who occasionally helped out in his studio. He asked Holder to go to the Broadway loft, cut all the old silk screens out of their wooden frames, and burn them. There were about a hundred and fifty screens all told, representing a sizable financial investment as well as a rich bank of images. Destroying them was a form of insurance against the pressure to repeat himself.

In spite of the vitriolic articles about the Biennale,* Rauschenberg's international reputation was soaring. Less than a year later he took first prize at the Corcoran Gallery's Biennial of Contemporary American Painting, and a jury of one hundred French intellectuals, asked by the Paris *Arts* to name the ten greatest artists under fifty years of age, had put him in first place (the only American on the list, he was followed by Jean Tinguely, Pierre Soulages, Georges Mathieu, and Yves Klein). By this time, Rauschenberg had virtually stopped painting. More and more infatuated with the "total

*The Vatican's *L'Osservatore Romano* saw in it "the total and general defeat of culture." The Paris left-wing *Combat* called the award to Rauschenberg "an affront to the dignity of artistic creation."

medium" of theater, he had taken the breakdown of his association with Cunningham as a release into full-time theatrical activities of his own.

The Judson Dance Theater had outgrown its informal, workshop beginnings. Judson performances in the big, Stanford White-designed Baptist church on Washington Square were attracting large audiences, and were being reviewed by regular dance critics on the *Times* as well as by Jill Johnston in *The Village Voice*. Robert Morris's 1965 *Waterman Switch*, which Morris (a sculptor) and Yvonne Rainer danced in the nude, brought publicity of another sort, to say nothing of efforts to have the Judson Church expelled from the American Baptist Convention. A *New York Times* article had been headlined "Nude Dancers at Judson Church," and some shocked Baptists around the country had assumed that this meant church-sponsored social dancing in the buff. The Reverend Howard Moody and Al Carmines, the Judson's assistant minister, stood up as usual for the artist's right to operate without censorship, and as usual they prevailed. Moody had revitalized his ministry by making the old church available to artists, many of whom lived in the vicinity. An unflappable Texan who looked like (and was) an ex-Marine and who by his own admission had been "close to a Philistine" in art matters when he took over the church in 1956, Moody believed that there was no issue so controversial or so difficult that the church should stay out of it. The Judson was a haven for artists. Oldenburg and Dine had their first one-man shows in its basement, and a number of the early happenings took place in the gymnasium; it also became a center for drug rehabilitation, community action, and the antiwar movement. By 1965, though, the church had largely served its purpose as incubator of the new dance. Individual ambitions were expanding, careers were being launched, and new performing spaces were opening up.

Alan Solomon emerged at this juncture in the novel role of a theatrical impresario. Solomon had resigned from the Jewish Museum soon after the 1964 Biennale (he felt that the trustees were losing their nerve, and that groundbreaking exhibitions such as the

Rauschenberg retrospective and the equally influential Jasper Johns show the following year would no longer be possible there). Early in 1965, Rauschenberg and Steve Paxton asked Solomon if he would like to produce a series of dance performances, and Solomon, whose art-historical imagination never slept, conceived the idea of putting on a series that combined the new dance and the happenings. The happenings movement had petered out in New York in the early sixties, but Solomon knew that Claes Oldenburg and Jim Dine were interested in starting it up again. He also believed that the Judson dance activities, which had flourished as the happenings waned, were directly related to happenings in several ways, and that it would be illuminating to present them together. This was the origin of the First New York Theater Rally, whose manifold absurdities unfolded that spring in an abandoned CBS Television studio at Broadway and Eighty-first Street, at the Judson Church, and in the swimming pool of Al Roon's Health Club on West Seventy-third Street.

The First New York Theater Rally (Solomon hoped there would be others) was not exactly a crowd-pleaser. Seen in the clammy, concrete expanses of the old TV studio (it had once been a movie house), dance pieces by the Judson innovators seemed more austere and somehow less energetic than they had in the church. Dine's largely static *Natural History (The Dreams)* disappointed those who remembered the peculiar intensity of Dine's performances in his earlier happenings, and Robert Whitman's *The Night Time Sky,* for which the audience sat on the floor inside a tent-like canopy and watched (among other things) films of defecation that appeared to have been shot by a camera located inside a toilet, seemed to many viewers to require rather too great a suspension of disbelief. Most of the early happenings had been brief—fifteen minutes or less. Stretched to an hour or more, the new ones tended to bear out John Cage's observation that visual artists rarely understood how to deal with time. Even Claes Oldenburg's *Washes* had its longueurs, although the audience standing around the steamy perimeter of the swimming pool at Al Roon's clearly enjoyed such images as Henry

Geldzahler in a rubber boat, wearing a striped bathrobe and smoking a cigar, and the pretty young swimmer, Lettie Eisenhauer, with twenty-seven red balloons tied to her body, who was pursued by a young man (David Whitney) frantically biting the balloons. Oldenburg's theatrical imagination was as intense and surprising as Rauschenberg's. Some of the Judson group's pieces, however, probed previously uncharted levels of boredom. Since the seating at the TV studio was limited and the audiences consisted largely of people who knew what they were in for, this was not a major catastrophe ("There are no catastrophes," Morton Feldman once said, of the new music), but it did raise a question or two. Was boredom intended? Were the new theater artists perhaps interested in exploring boredom, as a long-neglected theatrical resource? Or was it simply a question of audiences clinging stubbornly to outdated assumptions, expecting to sit back and be entertained? "Theater doesn't have to be entertaining, just as pictures don't have to be beautiful," Rauschenberg observed some years later.[1]

A great many artists in the mid-sixties did seem to be inexplicably in love with the muse of ennui. The new dance, the underground cinema, Minimal Art, the "trance music" of La Monte Young and others all shared a deliberate poverty of means and of surface incident, a reduced focus that brought to mind Duchamp's remark about "our taste for the miserable." One frequently advanced explanation was that all this reflected the sixties drug culture; people who were turning on and dropping out had no need for interesting art, which would only distract them from the multimedia wonderland ("Oh, wow!") within. Nam June Paik, the Korean-born guru of video art, has suggested that boring art is simply a reaction to popular culture—since the avant-garde artist must define himself in opposition to mass culture, and since American mass culture (rock music, James Bond movies, stock car racing) is so exciting, vanguard art has no choice but to be boring. But for many sixties artists in America there was no longer any need to be against popular culture. It was no longer either/or, it was both/and—the Beatles *and* Beethoven, Donald Duck *and* Picasso.

Rauschenberg, Cage, and the other breakers-down-of-distinctions wanted the viewer to do much more than sit back and be entertained (or bored), of course. They wanted him to participate with his enlivened imagination, to assume responsibility for the creative process along with the artist; if someone was bored, it meant that he was boring himself by refusing to enter into the new spirit. On the other hand, perhaps the artists who were drawn "towards theater" (fulfilling Cage's prediction) were failing to consider the nature of the medium. Theater had existed for thousands of years, and its demands were not the same as the demands of the plastic arts. By abandoning all claims to virtuosity and special skill the Judson people and the makers of happenings were following a well-marked trail in twentieth-century plastic art—a trail blazed by Duchamp when he signed his first readymade—but it could be argued that the visual arts lay in a different part of the forest. Gallery or museum visitors are in full control of the time element, but theatergoers are more or less stuck in their seats, which they have presumably paid for, and which can come to seem extremely hard.

Rauschenberg's contributions to the First New York Theater Rally were certainly less boring than some of the others. One was a revival of *Pelican*, with Carolyn Brown, himself, and Alex Hay (taking Per Olof Ultvelt's place). The other was a new work called *Spring Training*. It opened with Christopher Rauschenberg, the artist's thirteen-year-old son, coming out on the darkened stage with a laundry hamper containing thirty large desert turtles (rented from Trefflich's animal store on Fulton Street) which he proceeded to turn loose. Each turtle had a flashlight strapped to its back, and each performed in an exemplary fashion, moving at dignified speed and sending shafts of light in all directions until Christopher came out and collected them again. Rauschenberg then made his entrance wearing a sport shirt over jockey shorts, and did a sort of slow sidle across the stage, wiggling his toes and fingers. Steve Paxton followed with ungainly looking movements, and Paxton and Rauschenberg took turns carrying each other about like large timbers. Three young women dressed as brides served Saltines to the audience, then

danced together. Deborah Hay came out in a black leotard and a shoulder harness that supported a screen, on which Rauschenberg projected Kodachrome slides of canned goods, the Empire State Building, and other images. She then slid into an old-fashioned tap dance. Paxton danced with a tin can strapped to one knee. Chris Rauschenberg sat down next to a microphone and tore up pages from a telephone book. The finale was Rauschenberg, solo, on stilts, wearing a white dinner jacket, with a bucket of dry ice slung from his waist; as he poured water from a pitcher into the bucket, clouds of steam rose to envelop him—an ending that he subsequently decided had been "too dramatic."

Later that night, carrying the turtles back to 809 Broadway in a taxi, Rauschenberg said he had realized while performing it that his piece was too long. He would shorten it somewhat for the second performance, from forty-five to thirty minutes. "But the turtles turned out to be real troupers, didn't they?" he said happily. "They were saving it all for the performance. They don't have very much, so they saved it." One of the rented turtles did not go back to Trefflich's. A fearless and lethal-looking reptile named Rocky, it remained to share the Broadway loft with Laika, the part-Samoyed puppy that Rauschenberg had bought to replace his ill-tempered kinkajous. He had Laika for seventeen years; Rocky is living yet.

The stagestruck Port Arthur schoolboy who had yearned to be in every play was clearly having the time of his life. All his energy went into his own or his friends' theater and dance projects. His *Map Room II,*† presented at the Film-Makers Cinémathèque in New York, featured Trisha Brown, Alex Hay, Steve Paxton, Deborah Hay, four blindfolded men in tuxedos, five automobile tires, and a bedspring fitted out with contact microphones. Debbie Hay appeared girdled with a wire mesh birdcage containing three live doves. The ending was spectacular: Rauschenberg, his shoes encased in twenty-

†*Map Room I,* an earlier and (Rauschenberg felt) unsuccessful version, was done at Goddard College in Vermont.

pound blocks of clear plastic (made up for him by the French artist Arman), walked across the stage holding two unwired but lighted neon tubes—the current that lit the tubes came from a contact sensor attached to his body, and the plastic blocks prevented his electrocution. *Linoleum,* which premiered at the 1966 "Now Festival" in Washington, D.C., incorporated slow-moving sculptures by Robert Breer, an ambulatory chicken coop with live white chickens, a "wearable electronic feedback system" designed by Billy Klüver, and fantastic masks for the Rauschenberg repertory ensemble. Rauschenberg himself had an odd sort of presence on stage. He never cracked a smile or projected anything but intense concentration upon the task at hand, his movements were jerky and rather diffident, and yet, perhaps for these very reasons, it was hard to take your eyes off him.

He had acquired a new base for his expanding operations. Tired of living illegally in lofts, and amazed to find that rising prices for his paintings enabled him to dispose of an annual income that approached six figures, he had decided to find a really big space, one that he and his friends could use for rehearsals and perhaps even for performances. He had negotiated for a former art gallery on LaGuardia Place, but the owner had sold it to New York University instead. The next prospect was the former St. Joseph's Mission of the Immaculate Virgin, an abandoned orphanage on the corner of Lafayette and Great Jones streets, on the fringe of what was coming to be called the East Village. It had five floors and two basements, a vast kitchen, and half a chapel (the other half had been demolished to make way for a parking lot). Rauschenberg bought it for $65,000 in 1965, and spent another $15,000 on renovations before moving in a year later. His plan was to turn the building into a communal headquarters for activities of all kinds—dance, theater, film-making, and videotape as well as painting and sculpture.

It came as a surprise and a disappointment to him to find, as he did soon after the Rally, that some of the people he had been working with were not interested. "They were becoming personalities," as he put it. A more likely explanation was provided by Yvonne

Rainer, whom Rauschenberg both loved and feared; her personality was so powerful, he said, that she often made him feel weak. According to Rainer, the problem of working with Rauschenberg was that "those of us who appeared with him became the tail of his comet." Lafayette Street never got to be home base for the Judson Dance Theater, which was in a process of dispersal in any case. It became, instead, and almost immediately, the headquarters for a different sort of collaboration, on a much larger scale, the end result of which was a series of performances at the 69th Regiment Armory called "Nine Evenings: Theater and Engineering." To nearly everyone except the participants, "Nine Evenings" was a theatrical disaster. To Rauschenberg and Billy Klüver it was a landmark event, a milestone in the eradication of barriers between art and life.

The moving spirit behind "Nine Evenings" was Klüver, the Swedish-born research scientist who had helped Tinguely construct his *Hommage à New-York* and had gone on to solve various technological problems for Johns, Rauschenberg, and several other artists. Klüver spent much of his free time with artists. Nearly every afternoon, after he finished work at the Bell Telephone Laboratories in Murray Hill, New Jersey, he would drive to Manhattan and stay there until late at night, talking with his artist friends, seeing performances at the Judson or elsewhere, taking in the scene. He had come to believe that the artist was a primary but largely untapped resource in society. Art's function had changed radically in recent years, he felt. The best contemporary artists were no longer interested in the creation of luxury objects for an elite and privileged class; Rauschenberg, Tinguely, and a few others seemed to yearn for a much greater involvement with society as a whole, but they were groping in the dark, for the most part, because society still looked on the artist as an "outsider" and did not realize what he had to offer and to teach. Klüver saw many parallels between contemporary art and science, both of which were concerned basically with the investigation of life. He had read Marshall McLuhan's recently published *Understanding Media*, with its dazzling insights into the ways in which the new electronic technology influenced everyone's daily life; he had also read Buckminster Fuller

and John Cage,‡ both of whom prophesied a more central role for the artist in society. Klüver had it in mind to write a book about art and engineering, but for the moment he had no time.

When the president of the Fylkingen Society for experimental music in Stockholm came to New York in the fall of 1965 to solicit American participation in a symposium on the subject of art and technology, Oyvind Fahlstrom, a young Swedish artist who was living then in Rauschenberg's old Front Street studio, sent him right down to Bell Labs to talk with Klüver. Klüver's response was immediate. He agreed to assemble a group of American artists and engineers, who would work together on projects to be presented in Stockholm the following fall. Rauschenberg, to whom Klüver went first, was equally enthusiastic. They both decided that in order to put together something as complicated as this in so short a time, the best procedure was simply to invite their friends. Rauschenberg enlisted Steve Paxton, Alex and Deborah Hay, Lucinda Childs, Robert Whitman, Yvonne Rainer, John Cage (with whom he had reinstated relations professionally, if not personally), David Tudor, and Oyvind Fahlstrom. Klüver had a somewhat more difficult time lining up engineers. "All the art projects that I have worked on have at least one thing in common," he once said. "From an engineer's point of view they are ridiculous." But Klüver was endlessly persistent. He spoke two languages, contemporary art and contemporary science; although he sometimes spoke them both at the same time, with a Swedish accent that added to the confusion, his somewhat unfocused conviction was often, in the end, remarkably persuasive. Thousands of man-hours of work had gone into the design of the Princess telephone, Klüver kept saying; wasn't it possible that the artist's imagination, working in concert with the engineer's skill and knowledge, could come up with something more rewarding? Some thirty Bell Labs engineers eventually became involved in "Nine Evenings," doing so on their own time and without pay, and a number

‡*Silence,* a volume of Cage's collected essays, was published in 1961.

of lives were changed as a result. "I'll do it but I don't want to have to go near any artists," one man said at the beginning of the project. By the end of it this suburban householder was spending almost every night at 381 Lafayette Street.

All the early discussions assumed that the exhibition, or seminar (nobody was quite certain then just what it would turn out to be), would take place in Stockholm. It gradually became clear, however, that the Swedish sponsors were distinctly unhappy about the American group's approach to the project. Klüver and the New York artists wanted to keep it experimental and open-ended; they were much more interested in the *process* of artist-engineer collaboration than in any conceivable results, and some of their ideas were so far out that the Swedes could hardly believe they were serious. Communications between the two groups faltered and then broke down completely in the summer of 1966, at which point Klüver, Rauschenberg, and the other principals made the decision to go ahead on their own, without the Swedes. Several possible locations in and around New York were scouted. Rauschenberg argued against caution and economy. He wanted them to do a series of performances before large audiences, in Manhattan, and it was his concept that prevailed. The place they found to perform in was the 69th Regiment Armory on Lexington Avenue and Twenty-fifth Street, already famous in art history (although neither Rauschenberg nor Klüver realized this until later) as the site of the 1913 Armory Show.

Having lost their Swedish sponsorship, Klüver and Rauschenberg plunged into the novel (for them) enterprise of large-scale fund raising. They wrote letters to individuals and corporations and foundations, stressing the conscience of industry. Rauschenberg went to all the leading art dealers and collectors. The results were disappointing. By mid-August, only $12,000 had been raised toward an estimated budget of $80,000. Nervous but undeterred, Rauschenberg set to work designing a poster, and Klüver hired a high-powered public relations firm and began issuing press releases. Loans were taken out, with Rauschenberg paintings as collateral. Meanwhile other problems—technical, administrative, and personal—were piling up.

In the last few weeks the Lafayette Street orphanage became the nerve center for the entire operation. Rauschenberg had moved in only a month before. The household was chaotic, and would have been a lot more so if it hadn't been for Susan Hartnett, a sculptor who had quit her job at the New York Botanical Garden to bring some order into Rauschenberg's increasingly disorderly life (he paid her $1.75 an hour, and she brought her own lunch). Folding cots were set up on several floors for engineers who didn't feel like going home to the suburbs late at night. Deliveries of food and drink continued more or less around the clock. "Bob was drinking a lot then, but he wasn't really in the bottle," according to Sue Hartnett. "You could get through to him." Almost everybody was trying to get through to him at the same time, though, and the circuits were often clogged. His relationship with Steve Paxton was falling apart. In whatever time he could spare from the administrative tangle, Rauschenberg worked on *Open Score,* his own contribution to "Nine Evenings," which required a highly complex electronic system linking sound and light, a closed-circuit TV hookup, infrared illumination, and a cast of five hundred people.

The thirty Bell engineers were by this time totally engrossed in the project. Engineers, however, are not often obliged to work against theatrical deadlines. As the October 13 opening night approached, the artists became increasingly frustrated; none of the various technological marvels seemed to be taking shape on schedule. The artists stood around the cavernous armory, unable to test out the equipment, unable to rehearse. Some of the engineers were becoming equally disgruntled. They felt they had been made subservient to the artists, who monopolized the decision-making process and who would reap all the glory. Rauschenberg's idea had been that all collaborations would be on a one-to-one basis, with artist and engineer sharing responsibility equally for the result, but in practice it had not worked out quite that way. The artist would try to describe what he wanted, the engineer would go off and try to make it, and in too many cases what emerged was the result of mutual misunderstandings.

There would be a lot more disgruntlement before "Nine Evenings" ended, and more than one working relationship would deteriorate into harsh recriminations. "I thought those engineers should be tied up," John Cage said later. "They were so unable to conceive of a performance situation, so committed to the laboratory where you have endless time to solve a problem. They ruined the performance of my piece. I'd arranged to have telephone lines opened in several places, but when an engineer saw a phone off the hook he went and hung it up. And when I'd ask them, during the performance, to go and do something, they were so stagestruck they didn't even hear me."

Cage's *Variations VII*, a "collage" of live sounds piped in from various locations outside the armory and mixed by Cage and David Tudor, working behind a vast fortress of sound equipment, was not the only piece marred by engineering failures. The first four of the nine evenings offered an almost unvarying litany of electronics that did not perform as planned (or at all), sophisticated vehicles that broke down, lighting that failed, and similar malfunctions. The artists blamed the engineers, and so did Clive Barnes, one of whose reviews in the *New York Times* said "If the American engineers and technologists participating in this performance were typical of their profession, the Russians are sure to be first on the moon."[2] Barnes's review stunned the engineers, few of whom had ever considered the possibility of public criticism. One of them went around afterward muttering that he was going to "punch out" the critic. The returns, however, were by no means all negative. Every performance drew an audience of more than a thousand not entirely unappreciative spectators, and during the last five evenings things began to go more smoothly on stage. Each work was performed twice, and in almost every case the second performance was better, technically and otherwise. Not much better, but enough to salvage self-respect.

What did the audiences in that vast and gloomy drill hall actually see? My own recollection is of many long periods when nothing at all seemed to be happening, interspersed with a few vivid moments when something not terribly interesting did. I recall John Cage and

David Tudor enclosed within their hollow square of electronic equipment, fiddling with oscillators and amplifiers and mixing sounds while more and more spectators came down from their seats to watch them up close. Also, from Oyvind Fahlstrom's *Kisses Sweeter Than Wine*, a blond girl in silver vinyl, standing in a rigger's cage close to the ceiling and throwing soap flakes into the path of moving searchlights. Also a pair of buckets filled with red light, in Lucinda Childs's *Vehicle*. It seemed to me that the engineering failures mattered less in the end than the artistic ones. Given a situation of great potential interest, the artists had neglected (as usual, I thought) to give due consideration to the fact that it was a *theatrical* situation (the series's full title after all was "Nine Evenings: Theater and Engineering"). While the artists later maintained that Ruder & Finn, the public relations firm, had misrepresented what they were trying to do by stressing the theatrical aspect and ignoring the experimental, open-ended nature of the project, there remained the inescapable fact that tickets had been sold (at $3.00 apiece), and large numbers of people had come in expectation of something more than experimentation. "We made a lot of people awfully happy," Rauschenberg said afterward, "but not the audience."

Rauschenberg's *Open Score* began with a tennis match between a man (Frank Stella) and a woman (Mimi Kanarek), players of something above average skill, on a regulation court set up on the armory floor. Their rackets were wired, and each time one of them stroked a ball the sound activated a switch that extinguished a bank of overhead lights. They played until the armory was dark. "The darkness is illusionary," Rauschenberg explained in his own notes on the performance. "The hall is flooded with infrared (so far invisible to the human eye)." Unseen by the audience, a "modestly choreographed" cast of approximately five hundred people (recruited from the Downtown Community School near the armory) assembled on the tennis court. They performed simple actions designated by the artist ("Touch someone who is not touching you"; "Women brush hair") which gradually became visible to the audience by means of television cameras that used the infrared light to project ghostly images

on large screens suspended from the ceiling. When the house lights came on again, the five hundred had disappeared from the floor as mysteriously as they had come.

The closed-circuit TV system did not work well for *Open Score*'s first performance, and the piece seemed slow and diffuse. It was shorter and tighter the second time. There was also a new ending. While the cast of five hundred dispersed in darkness, a dim spot picked out Rauschenberg, carrying something heavy in a burlap sack. The something was Simone Forti, who sang in a clear, sweet voice an old Spanish folk song. It was a beautiful and striking image that had nothing whatsoever to do with engineering or technology but a lot to do with theater. As Herb Schneider, one of the chief technicians on the project, said later, "We could have made life easier for him. As slight as Simone is, it was quite a feat for Bob to carry her around—and we could have done the job so simply using an FM receiver, a power amplifier, a battery, and a speaker, weighing possibly ten pounds in a burlap bag. But then it would have not have been a Rauschenberg."[3]

THE NOT SO GREAT SOCIETY

The idea of artist-engineer collaboration emerged from "Nine Evenings" miraculously unscathed. A month before the opening performances, Rauschenberg, Klüver, Robert Whitman, and the engineer Fred Waldhauer had taken steps to perpetuate their "revolutionary sociological process" by setting up Experiments in Art and Technology (E.A.T.), an unmistakably nonprofit foundation designed "to catalyze the inevitable active involvement of industry, technology, and the arts."[1] "Inevitable" did not seem too strong a word at the time. At its peak in the late sixties, E.A.T. listed approximately six thousand members, evenly divided between artists and engineers. It received grants from AT&T, IBM, Xerox, the AFL-CIO, and the New York State Council on the Arts, and its "projects outside art" attracted the interest and support of labor negotiator Theodore Kheel, Senator Jacob K. Javits, and other prominent persons. Donald M. Kendall, the friend of Richard Nixon and president of PepsiCo, Inc., was actually persuaded to put E.A.T. in charge of the Pepsi-Cola pavilion at Expo '70 in Osaka, Japan, a decision that all parties lived to regret. E.A.T.'s technology was spectacularly successful this time, but Klüver's insistence on experimental programming in the mirror dome, and the ever escalating costs of such experiments, eventually exhausted PepsiCo's tolerance for revolu-

tionary processes. Klüver and his colleagues* were ejected from the premises, and E.A.T.'s relations with big business went into a precipitous decline.

The flowering and deflowering of E.A.T. could have taken place only in the superheated atmosphere of the middle and late sixties. The decade that had begun with such an upwelling of optimism and youthful high spirits had become a period in which anything and everything seemed possible, from the assassination of a President to the birth of a radical democratic society. Tremendous new energies were loose in the culture; the Pill, the joint, the civil rights movement, the escalating antiwar protests, black power, radical feminism—all could be seen as elements of a widespread challenge to white adult authority in America, a challenge that became progressively angrier and more violent as white adult authority showed itself progressively more frightened and vindictive. Jerry Rubin, the New Left activist, showed up at his 1966 hearing before the House Committee on Un-American Activities dressed as a Revolutionary War soldier. Two years later drollery of this sort had gone out of style.

Before the humor and the high spirits were overwhelmed by rage and frustration, though, the sixties offered an unparalleled range of possibilities for change, for breaking down barriers of all kinds. As Morris Dickstein pointed out in *The Gates of Eden,* the sixties "tried to combine the quest for social justice with the search for personal authenticity. The civil rights movement and the 'human potential' movement were agreed on one thing: man's right to happiness in the here and now."[2] Billy Klüver's vision of American technological genius humanized and made wiser by the imaginative perception of its artists was in this sense a sixties vision, and so was the response it engendered. To a significant minority of American artists in the sixties, the making of individual paintings or sculptures was no longer enough. The exemplary figure for these artists was

*Not including Rauschenberg, who was then in the process of withdrawing from E.A.T.'s endless demands on his time and his resources.

Rauschenberg, who had made his art out of the real world and then had left it to move into dance, theater, and advanced technology. "What we are getting is not the demise of art, but a transformation of the function of art," wrote Susan Sontag. "Art today is a new kind of instrument, an instrument for modifying consciousness and organizing new modes of sensibility."[3]

It was also a way of being in the world. At the memorial service for Frederick Kiesler in 1965, Rauschenberg was one of a number of people asked to say a few words. Kiesler, the Austrian-born sculptor and architect, had been wonderfully generous and encouraging to many young New York artists, and his friends had loved him deeply. Instead of speaking, Rauschenberg, when his turn came, went into the vestry and came out carrying an automobile tire that he had stashed there before the service. He rolled it down the aisle—at one point it got away from him and actually jarred the coffin—and then, working fast, he proceeded to paint it, using colors he had brought with him. "I divided the circle of the tire into irregular shapes and contours," he recalls, "using as happy a palette as I could manage." Nearly everyone present found his wreath both moving and appropriate.

There is always another side of things, of course, and in the New York art world of the middle sixties the other side was represented by Minimal Art. While Rauschenberg and then the Pop artists were busy letting the world enter into their work, the Minimalists were rigorously squeezing it out. Minimal Art (which did not get its name until 1966) hewed to the twentieth-century tradition of reduction and renunciation. Its immediate sources were the unified "field" paintings of Barnett Newman, Mark Rothko, and Ad Reinhardt; the geometrically striped canvases of Frank Stella; and especially the critical writings of Clement Greenberg. After turning against the gestural (de Kooning) wing of Abstract Expressionism in the fifties, Greenberg had propounded the "formalist" line that would influence American art criticism—and a number of American artists—for some years to come. Greenberg argued that the one true course in modern painting was the course of "self-definition," through which every element that was not essential to the art of painting must be ruthlessly elimi-

nated. No "painterly" striving for emotional or atmospheric effects, no recognizable images, and above all no illusionistic spatial depth that might divert attention from the essential *flatness* of the canvas support, the "integrity of the picture plane."[4] Greenberg had organized an exhibition of "Post-Painterly Abstraction" for the Los Angeles County Museum in 1964; it included the work of thirty-one American and Canadian artists whose paintings, as he put it, "move toward a physical openness of design, towards linear clarity, or towards both." Greenberg's approval descended like manna upon the work of Kenneth Noland, Morris Louis, and Jules Olitski, and upon the late canvases of the veteran Hans Hofmann, who in the sixties became even better known as an artist than as a teacher. It did not descend, curiously, on Frank Stella, the most rigorous of all the excluders and eliminators. Stella nevertheless exerted a powerful and direct influence on the Minimalists. Stella had gone further than anyone else in asserting the flatness of the picture plane. He had done this by altering the shape of the canvas, dispensing altogether with rectangles and squares and making his stretchers conform to the projections of his geometric designs. His paintings were flat objects that could not possibly refer to anything outside themselves because they were complete in themselves—you saw "the whole idea without any confusion," just as he intended.

The Minimalists carried formalist logic into three dimensions. They made what Donald Judd, one of their leading theorists, called "specific objects," simple geometric forms such as cubes or triangles, whose smooth, impersonal surfaces could have been (and often were) executed by industrial jobbers. Some were painted in bright, primary colors; others were left unpainted to reveal the basic material—often a synthetic such as plastic or Styrofoam. Judd's impeccably machined metal boxes were attached to the walls like modular shelving (one of the Minimal premises was to erase the distinction between painting and sculpture). Dan Flavin worked with fluorescent light tubes, made up and installed by an electrician according to his designs. Carl Andre's floor pieces of flat metal plates were supposed to be walked on, although most gallery-goers ner-

vously refrained from doing so. Robert Morris, a protean artist who had passed through several earlier phases before Minimalism (his theater work included the famous nude dance at the Judson Church), made very large, geometrically shaped objects in wood or Fiberglas, and also wrote enigmatic essays on the Minimal aesthetic. The first comprehensive showing of this new work was the Jewish Museum's "Primary Structures" exhibition in the spring of 1966. It generated a great deal of interest and established Kynaston McShine, who had put it together from the work of forty-two "Younger British and American Sculptors," as one of the rising young curatorial tastemakers (McShine later rejoined the staff of the Museum of Modern Art, where he had begun his career in 1959).

Never before in American art had aesthetic practice been linked so closely to critical theory. Several of the Minimal artists in addition to Morris also wrote criticism. For years Judd had been turning out some of *Artforum*'s most impenetrable reviews, and Judd and Flavin continued to publish often and extensively in *Artforum*† and other journals. Both enjoyed striking the belligerently reductive note. "I believe that art is shedding its vaunted mystery for a common sense of keenly realized decoration," Flavin stated in 1967. ". . . We are pressing downward toward no art—a mutual sense of psychologically indifferent decoration—a neutral pleasure of seeing known to everyone."[5] This was really reducing things, since everyone knew that modern art was not supposed to have anything to do with decoration. Stella also claimed that he wanted to "make what is popularly called decorative painting truly viable in unequivocal abstract terms," but he went on to say that he hoped his best paintings were "so strongly involved with pictorial problems that they're not conventionally decorative in any way."[6]

Minimal artists and Minimalist critics constantly referred to aesthetic "problems," in terms that made the art process sound like a branch of higher mathematics. Most of the artists were university-

†Which moved its office from Los Angeles to New York in 1967.

educated, and several were or had been teachers, which set them off from earlier generations of American artists. Harold Rosenberg made ironic sport of their academic verbiage, suggesting that "the rule applied is: The less there is to see, the more there is to say." Three boards nailed together and hung on a wall "could yield an almost inexhaustible supply of the aesthetic minutiae discovered in Minimal masterworks," according to Rosenberg.[7] Clement Greenberg did not care for the Minimalists, either, feeling perhaps that they had carried formalism a bit too far. "Minimal Art remains too much a feat of ideation, and not enough of anything else," Greenberg decreed. "Its idea remains an idea, something deduced instead of felt and discovered."[8]

Aside from a small number of critics and collectors, in fact, nobody seemed to *like* Minimal Art. Most people failed to see its "decorative" attractions, and found its severe, repetitive forms acutely boring, although one hesitated to say so because of the inevitable countercharge that the boredom lay in the mind of the beholder. Michael Fried, a young formalist critic, ingeniously accused Minimal of being "a new genre of theater." Taking his cue from Robert Morris's statement that the best Minimal sculpture "takes relationships out of the work and makes them a function of space, light, and the viewers' field of vision," Fried argued that the resulting game of perception between object and viewer was essentially theatrical and therefore meretricious, for in Fried's balefully formalist opinion, "The success, even the survival, of the arts has come increasingly to depend on their ability to defeat theater."[9] In spite of generally negative reactions, though, Minimal Art became an established force in the art world of the later sixties. The movement seemed historically inevitable, the next step in a long line of modernist reductions, a kind of penance everyone had to pay for the Dionysian excesses of artists like Picasso and Rauschenberg. All the leading Minimalists found respectable galleries. Judd, Flavin, and Morris went with Leo Castelli, who had considerable difficulty selling their work and even more difficulty meeting their need for large monthly stipends (Minimal artists did not seem to choose minimal standards of living). Un-

like Sidney Janis or André Emmerich, Castelli was always in a somewhat shaky position financially. If it had not been for a few resolute collectors like Count Panza, who was devoting entire rooms of his palazzo in Varese to installations by Judd, Flavin, Morris, and others, the gallery might have gone under at the very moment when the art world seemed to be expanding in all directions.

Seemed to be—for the art world was never as large or as expansive as it appeared, even in those boom years of the middle and later sixties. Alan Solomon, shortly before his death of heart disease in 1970, estimated the number of "significant activists" at about two dozen artists, "three or four dealers, four or five critics, five or six museum people, maybe ten collectors. And no more."[10] But the significant activists were operating by then inside an increasingly intricate and widespread network of money, publicity, and excited interest on the part of a growing audience. Art, contemporary advanced art, had become the height of chic among New York's socially ambitious upper middle class. It was more advantageous (and a lot more fun) to be on the board of the Museum of Modern Art or the new Whitney Museum (which moved into its Marcel Breuer ziggurat on Madison Avenue and Seventy-fifth Street in 1966) than it was to be on the boards of a dozen hospitals or private schools. Openings of major exhibitions at the museums and the leading galleries were social events of the first magnitude, supercharged displays of the latest in far-out sixties dress and behavior patterns, media events covered by television and the paparazzi. To the older generation of artists, such mob scenes offered melancholy proof that the isolated and difficult practice of art had been totally debased. Most of the surviving members of the pioneer Abstract Expressionist group had long since moved out of town. They could afford to do so because the booming art market kept pushing up their own prices. De Kooning was building and tearing down and endlessly rebuilding his ideal studio in The Springs, not far from where Pollock had lived and died. Although rich and famous, de Kooning was reported to feel passed over and shunted aside by art history, and he was not alone in his chagrin. Harold Rosenberg regularly and elo-

quently lamented, in *The New Yorker*, the end of the heroic (Abstract Expressionist) period in American art. *Art News*'s Tom Hess assailed the new art public, the parasitic "vanguard audience" that was "out for money, prestige, and kicks, in approximately that order."[11] According to Hess the vanguard audience could accept anything as art because the question of quality no longer arose. All the artist had to do was to keep coming up with something new and surprising—a new image, a new idea, a new sensation. The vanguard audience had extinguished the very notion of the avant-garde.

If further proof of debasement were needed, one had only to point out the intimate relationship that had sprung up between the art world and the fashion industry. In the heyday of miniskirts and the youthquake, many young designers were stealing their ideas from the wilder dress fantasies of the art crowd, as seen at the circusy exhibition openings.‡ Barriers were falling in the fashion trade, too, and new design ideas, instead of filtering down from the Parnassus of Paris, were erupting from the unlikeliest sources. Tiger Morse made paper dresses on which you could paint your own patterns. Also handbags in the shape of lunchboxes, silver motorcycle suits, vinyl party dresses with maximum cleavage both fore and aft, and nifty little-nothings made out of burlap bags or tapestries or flags that sold for upward of a thousand dollars apiece. Until the midsixties she had been plain Joan Morse, a tall, skinny, nervous, and not particularly successful designer, but in 1965 she came back from an extended stay in London with a trove of secondhand fabrics and bric-a-brac, changed her Christian name, and for the next two years, operating out of a series of tiny boutiques on the Upper East Side, she burned as brightly as Blake's beast. Tiger Morse loved artists. She threw spectacular parties for them, and bought their work, and spent part of every evening hanging out in the back room at Max's Kansas City, the restaurant down near Union Square that had become the new mecca for artists and their friends. (Mickey Ruskin,

‡"Pow! Op Goes the Art. Op Goes the Fashion"—*Vogue* cover, Vol. 145, No. 10, New York, 1965.

the proprietor, let artists eat and drink there on credit, and often took paintings in exchange; the place got its name, he explained, because Kansas City was "nowhere" and Max was "a grand old American name.") Tiger showed up at one of the "Nine Evenings" in 1966 wearing white vinyl and carrying a portable sunlamp that bathed her face in an unearthly violet glow. Her makeup sometimes included a black butterfly pasted to one dead-white cheek. Jacqueline Kennedy bought from her, and so did the sort of New York society matron who invited artists to dinner and hoped to get her parties photographed for *Women's Wear Daily*. But sixties fame was fleeting. When Tiger Morse died of an overdose of sleeping pills in 1971, hardly anyone remembered who she was.

The mingling of art and fashion reflected the general erosion of the line between high and popular culture that characterized the sixties. New York's popular Senator Jacob Javits, whose wife, Marion, collected contemporary art and went to all the gallery openings and parties, actually managed to get "costume and fashion design" listed among the "major art fields" in the bill that established the National Council on the Arts (enacted in 1965), thereby making fashion designers more than ever inclined to see themselves as "artists" engaged in the "creation" of new forms. Certainly there were correspondences between the humorous and satiric aspects of Pop Art and the antiestablishment bumptiousness of the new dress styles, just as there were between Tiger Morse's use of burlap, paper, and other materials never before applied to fashion and Rauschenberg's willingness to make art out of whatever he picked up. Some people saw social correspondences as well. The sexual ambiguity that had always seemed to mark the world of fashion appeared to have made increasingly deep inroads in the New York art world. The leading artists of Pollock's and de Kooning's generation had been, almost without exception, aggressively male, hard-drinking, and heterosexual. Quite a few of the sixties artists were either bisexual or homosexual, and not a bit uptight about it. The attention and money lavished on the newcomers led to talk of a "homintern," a network of homosexual artists, dealers, and museum curators in league to

promote the work of certain favorites at the expense of "straight" talents. It was even suggested, without too much conviction, that there was such a thing as homosexual art, and that its characteristics—narcissism, camp humor, and decorative intent—were visible on all sides. The argument did not bear very close scrutiny. There were elements in the work of Cage, Cunningham, Rauschenberg, Johns, Warhol, and others that could be described as decorative or even "campy," but these were outweighed and over-shadowed by other elements that clearly had nothing to do with the so-called homosexual sensibility. Exactly the same thing could be said about Pollock or de Kooning. The real irritant was not homo-sexuality in any case. Everyone knew that homosexuals had been prominent in the arts since at least the fifth century B.C. The real ir-ritant was publicity.

Ad Reinhardt, who spent the last decade of his life painting black-on-black pictures and denouncing everyone in sight, spoke for many of his generation when he identified Andy Warhol as the ulti-mate debaser of high art. Warhol, the ex-commercial designer, had become the first real art celebrity since Picasso and Salvador Dali. Housewives in Iowa who had never heard of Rauschenberg or Johns knew about Warhol; his name, as Reinhardt said, was "a household word." Warhol virtually quit painting in 1966. Having produced several thousand silk-screened paintings (up to eighty a day when the Forty-seventh Street "Factory" was going full blast), he turned his attention to film-making (a movie a week, on the average) and then to rock music and multimedia discotheques. Whatever he did seemed to mesmerize the press and certain elements of the public. *The Chelsea Girls,* his three-hour, twin-screen examination of as-sorted freaks, drug addicts, and transvestites, was the first commer-cially successful film of the underground cinema. Warhol had removed the artist from art through the use of commercial tech-niques; he went on to subtract movement, incident, and narrative in-terest from movies, grinding out epically boring, technically awful films that failed signally to live up to their sex-and-perversion billings—Warhol also managed to remove eroticism from sex. His

entourage of male, female, and indeterminately sexed "super-stars"—Brigid Polk, Ultra Violet, Viva (named by Warhol after a roll of paper toweling; her real name was Susan Hoffman), Gerard Malanga, and the others—shared, along with their Catholic backgrounds, an almost complete lack of talent for anything beyond personal ego trips, captured remorselessly on film. As a filmmaker, Warhol's method was simply to start the camera rolling and encourage his pathetic oddballs to exercise their oddness. His camera was a passive voyeur. Like the tape recorder that he carried around at all times (his "wife," he called it), the unblinking camera lens was the stand-in for Warhol himself, the "machine" that he once said he would like to become, the anesthetized witness to the seedy and sometimes scary emptiness of the half-life around him.

No doubt about it, Warhol's ultimate product was Warhol. In a time of confrontations and passionate role-playing, the self-image that Warhol projected through all his activities—passive, voyeuristic, silver-haired, and pale as death—had a prodigious negative power. Far more effectively than Duchamp, Warhol succeeded in ridiculing the very notion of art as a high and noble calling. In his tape-recorded "autobiography" he said that art was "just another job," and defined the artist as "somebody who produces things that people don't need to have but that he—for *some reason*—thinks it would be a good idea to give them."[12] This of course could be interpreted as part of the general Warhol put-on, the deadpan mixture of naiveté and sophistication that underlay everything he had done, from his I. Miller shoe drawings to his eight-hour, fixed-focus movie of the Empire State Building, but there was always the possibility that Warhol meant it. The negative message that emerged from the Warhol factories (he moved in 1967 to an office building on Union Square, a stone's throw from Max's Kansas City) was really a *memento mori*, a chilling reminder of the sixties' dark side. What the critic David Antin referred to as the "deteriorated image" in his silk-screened portraits of famous figures—the loss of pictorial definition between the original photograph and its newspaper reproduction, rephotographed, blown up several times, and transferred to silk

screens—gave to each portrait a mask-like unreality; these were images from which life had fled, leaving only a crude and fading memory. The long series of Warhol death images was more disturbing still, the blowups of gruesome auto wrecks from police files, of suicides in midair, of the electric chair at Sing Sing—deteriorated images whose emotional charge barely made it through the blurring of detail and the overlay of arbitrarily applied color.

Not too much has been written about the presence of death in Warhol's paintings (death trivialized by crude reproduction), or about the bad trips that afflicted so many in Warhol's personal entourage. Edie Sedgwick, his pretty, blond, waiflike "girl of the year" in 1965, descended into heroin addiction and was in and out of mental hospitals until her death in 1971. Others freaked out (sometimes on camera) and then disappeared; none of the Warhol people ever seemed to be able to make it on their own. And then, one June day in 1968, a young woman named Valerie Solanas, age twenty-eight, came out of the elevator at the Union Square factory and started shooting. She had a .32-caliber automatic pistol and a .22 revolver in her handbag. She shot Warhol twice, and Mario Amaya, a visiting critic, once, and she probably would have shot Warhol's business manager, Fred Hughes, who was down on his knees begging for mercy, if the elevator door had not clashed open again bringing more visitors; she got into it and left, to be picked up by the police a few hours later. "He had too much control over my life," she explained. She was an aspiring actress and playwright, and also the founder and sole member of an organization called the Society for Cutting Up Men, or SCUM.

Warhol nearly died. He was in surgery for more than six hours, and given only a fifty-fifty chance to survive. And then, by a truly ironic twist of fate, he was denied the publicity the event would normally have brought because forty-eight hours after the shooting another maniac killed Robert Kennedy in a hotel kitchen in Los Angeles. Months later, when Warhol was out of danger but still in constant pain, he told a reporter that his life had become a sort of dream to him. "Like I don't even know whether or not I'm really

alive or—whether I died," he said. "It's sad. I can't say hello or goodbye to people."

The early sixties had been festive; the later sixties were strident. Nobody danced at loft parties any more; the rock music was too orgiastic or too demented for that. During a huge party at Rauschenberg's house on Lafayette Street, a girl was gang-raped by three black men in the downstairs hallway—nobody heard her screams because the music was so loud. Watching the news on TV was becoming an ordeal. Race riots in Newark, Detroit, Cleveland, and other cities seared the optimism of the civil rights workers. Mounting opposition to the war in Vietnam caused many people to view American society in terms of absolute evil or absolute good. During the March on the Pentagon in the fall of 1967, a group consisting of the Fugs (rock band), the San Francisco Diggers (radical social activists), and the Liberation News Service (underground press) performed an impromptu, half-serious exorcism; standing on a flatbed truck in the Pentagon parking lot, they chanted, "Out, demons, out!" But the demons did not vanish. The United States was losing a war that a great many of its citizens thought it deserved to lose, but not even the humiliation of Lyndon B. Johnson, forced to forgo a second term as President because his war policy had split the nation, could seem to bring the end of the accursed war any nearer. It was not a good time to be an American.

It was not a good time for Rauschenberg, either, personally or professionally. He had not stopped making art, as some people thought. From time to time he went out to Tatyana Grosman's house in West Islip to do some new lithographs, and starting in 1967 he also printed at Gemini G.E.L. in Los Angeles, a studio whose founders, Kenneth Tyler and Sidney Felson, had set out to develop new print technologies to produce large-scale, high-quality lithographs and also object-multiples that would do for sculpture what lithography did for drawing and painting. Rauschenberg also made a number of large sculptural pieces involving advanced technology. His *Revolvers,* shown at Castelli's in 1967, were mechanized Plexiglas disks on which various images had been inked by silk-screening; sev-

eral disks were mounted parallel in an aluminum base, and the viewer could make each one revolve by flipping a switch, thereby affording endless combinations of images. *Solstice* (1968) had images printed on four rows of automatically operating Plexiglas sliding doors, through which one could walk. *Soundings* (1968), more than thirty-seven feet long, carried out an idea that Rauschenberg had wanted to put into practice for some time. Its highly complex electronic system responded to sounds around it—even soft voices—by triggering interior lighting that illuminated images of plain wooden chairs, printed on three rows of Plexiglas panels. The technology in each of these works was more successful than the aesthetics. *Soundings* was exhibited at the Museum of Modern Art and at several museums in Europe, and it was eventually purchased by the German chocolate manufacturer Peter Ludwig, whose collection of recent American art by then rivaled even Count Panza's. Something was missing, though, some intrinsic element that made Rauschenberg's earlier work in any medium instantly recognizable. *Soundings* responded to the viewer, but the viewer, once the technology had proved itself, could not really respond to it. There was none of the familiar tension between beauty and ugliness, form and anti-form, the real and the imagined.

On a personal level, his own voice had grown a little strident. Rauschenberg was in his dude period, as he later termed it. He let his hair grow below his shoulders and had it elaborately curled. He owned a Pierre Cardin dinner jacket, which he never wore, and a wide blue plaid suit by Bill Blass—Brice Marden, his new studio assistant, called it his Bozo the Clown suit. He also had a porcupine quill jacket that he did wear to openings and parties—with his long hair, it made him look like a dissolute Indian—and a sealskin coat for winter. This kind of costuming was no novelty in a period during which men often dressed more colorfully and more outrageously than women, but Rauschenberg's colossal intake of bourbon and his frequently sodden behavior sometimes gave the impression that he no longer knew how far to go too far. When *Soundings* traveled to the Stedelijk Museum in Amsterdam in 1968, Rauschenberg flew

over for the opening and then spent the next few weeks driving around Europe with a handsome young European dealer who knew everybody. They stayed out late every night, getting drunk and out-dancing everyone else and swimming in the nude, if the party-giver happened to have a pool.

In New York, several doyennes of the uptown art world had stopped inviting him to dinner because he never came less than two hours late and he always brought people with him—sometimes half a dozen or more. Rauschenberg had surrounded himself with a pro-tective entourage. Susan Hartnett, tired of having to do all the work, had hired Dorothea Rockburne to handle the housekeeping—Rauschenberg had known her years before, when they were both at Black Mountain College; it was her quilt in his *Bed*. Alex Hay was almost always at the Lafayette Street house, and cronies from the Judson or from E.A.T. dropped by regularly. Ever since Steve Paxton had left, Rauschenberg seemed to need people around him all the time. He had hired Brice Marden as a studio assistant, but not much was going on in the studio. Marden and his wife Helen, and Alex and Debbie Hay, and whoever else happened by would spend most of the afternoon (Rauschenberg never got up before noon) sitting around the big kitchen table on the third floor, drinking bourbon or pear brandy, talking, and staring at the color television set that was always on. "It was really a weird job," Marden remembers (both Marden and Dorothea Rockburne became abstract artists). "Techni-cally you're his assistant, but also you're being paid to sit around and drink with him. He was very lonely then, and sort of shaky in some ways. He couldn't really go out to bars because people would just hassle him. Once I remember a guy coming up to him at Max's and saying, 'You Rauschenberg? I'm going to get you'—not angry or anything, but Bob was the big guy, the one on top. And then there was the question of whether he was ever going to paint again."

Marden was much more impressed by Jasper Johns's work than by Rauschenberg's, but he considered Rauschenberg the most intelligent person he had ever met. To the painters of Marden's generation, Rauschenberg and Johns were the first *young* artists to have made it;

from that moment, art students who might formerly have dreamed of starving romantically in garrets dreamed of making it big in New York. Rauschenberg's generosity to younger artists was well known, but there were times now when it was decidedly unpleasant to be around him. He wanted everybody to love him, and when he was drunk and self-pitying he was sure that nobody did. "He's a bottomless pit of needs," Sue Hartnett had decided. "Bob just eats people. He can be really vicious and insulting when he wants to, and not many people can tell him the truth any more. Bob is so strong. There's something inside him, some fantastic kind of power or energy that he can suddenly focus on you. He can say something that just gathers up all the currents in the room and turns them on you." Marion Javits, whose energy in its way matched Rauschenberg's, felt the currents more deeply than most. They met first in the early sixties, when he was still living on Front Street, and then again in 1965, when she invited him to collaborate with Norman Mailer on a large-format, words-and-image book on the war in Vietnam that was to be one of a series sponsored by herself, the publisher Clay Felker, and the designer Milton Glaser. Rauschenberg declined the collaboration because he was too busy organizing "Nine Evenings," but Marion Javits began spending a lot of time at Lafayette Street; it became her refuge from the rigors of political life. Two years later she, Glaser, and Felker financed the printing of Rauschenberg's visual *Autobiography,* a three-panel, sixteen-and-a-half-foot-tall offset lithograph that includes an almost life-size X-ray of his body, a written record (in circular form) of the major events in his career as he saw them,* and a photo blowup of him performing in *Pelican*. Mrs. Javits contributed generously to "Nine Evenings" and to E.A.T. Although she came in time to feel that Rauschenberg did not always treat their relationship with the kindness it deserved, she considers it one of the more important friendships in her life.

A star himself, Rauschenberg was drawn to stars in other fields.

*Appendix, page 291.

He was almost speechless with pride when Abba Eban accepted an invitation to dinner at his house. It was at the time of the six-day Arab-Israeli War in 1967, and Eban's masterful speeches at the United Nations had riveted the world's attention; Rauschenberg thought of him as "the Joe Namath of the UN." They met through the Javitses. When Eban said he desperately needed a place to relax, Rauschenberg suggested his house on Lafayette Street—"Nobody would think to look for you there"—and to his amazement Eban agreed to come to dinner two days later. Rauschenberg remembers his first words on sitting down at the table: "If it were not for the UN, peace could break out at any moment."

One night at Max's Kansas City, Rauschenberg was handed a penciled note reading: "We're the only two people who ever got out of Port Arthur, Texas." It was from Janis Joplin. He knew and admired her recordings, and that night they talked for hours, mostly about growing up in Port Arthur. "I saw her many times after that," he said. "The week before she died, she said to me, 'Bob, you know, I'm singing so well that I stay sober while I'm performing now, so I can hear myself. I've just been howling all those years.' " He used her photograph in a 1968 transfer drawing called *Yellow Body,* and again in a 1970 print, *Signs,* that is a small masterpiece, his own microcosmic summing up of the sixties.

Movie stars fascinated him. He met Warren Beatty and Faye Dunaway when *Time* commissioned him to do a cover drawing on *Bonnie and Clyde* in 1967; Dunaway and Marcello Mastroianni, whom she was "seeing" then, wanted to own a Rauschenberg, and Rauschenberg had an early black painting picked out to give to them, but they split up before he could get it there. He did give a number of drawings to Jane Fonda, and invariably contributed to her liberal causes. The pleasure that he took in these encounters was genuine and a little naive; he was the one paying court. He had wanted for years to meet Picasso, whom he plotted to charm with the gift of a Seminole chief's jacket. Rauschenberg had seen many pictures of Picasso dressed up in odd costumes, and he was sure the master would not only appreciate but actually wear the many-

colored Seminole jacket that he had found in Florida. In preparation, he wore it to the opening of a New York exhibition of photographs by David Douglas Duncan, Picasso's close friend. The moment he and Duncan were introduced, Duncan began admiring the Seminole jacket, which he said was a real beauty, "*much* better than the one I just gave Pablo," so that was the end of that.

The travel, the clothes, the entourage, the Lafayette Street house all cost a good deal of money, of course, but that was no longer a problem. Rauschenberg had kept enough of his early work in storage, and now, with the prices for 1950s or early 1960s combines and paintings climbing steadily, he could always sell something to pay off his debts. He paid off the $60,000 deficit from "Nine Evenings" himself, by buying up the unsold editions of a lithographic portfolio of prints done by several artists for E.A.T.'s benefit; the portfolio had found few buyers, but Rauschenberg was able to donate the prints to museums and take the tax deduction. He was forever contributing a print or designing a poster for some sympathetic cause—CORE, *The Paris Review,* the Judson, Senator Javits's reelection, Earth Day, Merce Cunningham.† The Internal Revenue Service came down on him heavily one year, refusing to allow several major deductions because the records to sustain them had burned up in a basement fire at Lafayette Street; he sold *Rebus* to Victor Ganz to pay the fine. Rubin Gorewitz straightened out his record-keeping after that and largely took over his financial affairs. Rauschenberg's annual income was well into six figures by this time, and most of it came from sales of past work. There was not much new work, aside from prints and a few drawings.

He redid the white paintings in 1968. To Ivan Karp, who was leaving Castelli's to set up his own gallery downtown, this seemed a pathetic gesture, an attempt to ride the new wave of Minimal Art by proving that Rauschenberg had "done" Minimal in 1951, and done

†Rauschenberg and Cunningham had gradually overcome the bad feelings generated during the 1964 world tour. In 1977 they worked together again on a dance called *Travelogue,* for which Rauschenberg provided sets and costumes.

it more radically than any of the new boys. Rauschenberg denied any such intention. "They were never meant to collect history and dust," he said, of the originals, most of which had long ago disappeared into other paintings. In 1962, when Pontus Hulten wanted to show the white paintings in Stockholm, Rauschenberg had simply sent him the measurements and a sample of the intense-white pigment and canvas, and Hulten had had them re-created. This time around, Brice Marden did the job. They were shown at Castelli's and then returned to storage. Rauschenberg had decreed that they were not for sale.

Later that year he started work on *Carnal Clocks,* a series of collage-paintings whose predominant and graphic sexual imagery came from photographs that Rauschenberg took himself, using friends as his models. He had bought a bunch of the new pornographic magazines "to see what was going on there," but had found them so boring and obvious that he decided to find out whether he couldn't do something more interesting. Some of the collages were sufficiently pornographic to be held up by Canadian customs officials when they were being sent to a gallery in Toronto, but they caused little stir at Castelli's. Not a single one was sold.

At this low ebb in his career, Rauschenberg's friends were seriously concerned about him. He was drinking more than it seemed possible for a man to drink and stay alive. His endurance was phenomenal; he could still get up the next day and work. But it had been some time since he had worked on the precarious high wire of his native talent.

"THERE IS NO SOLUTION BECAUSE THERE IS NO PROBLEM"

—MARCEL DUCHAMP[1]

In Japanese zen teaching, the recommended attitude toward life, death, and other burdensome issues is *wu-shih,* which can be translated as "no fuss." No one ever led a more Zen-like life in this respect than Marcel Duchamp, whose death, on October 2, 1968, was characteristically unassuming. The Duchamps had spent a pleasant evening dining with close friends at their modest flat in Neuilly, on the outskirts of Paris (the flat had belonged for years to Duchamp's sister Suzanne, and since her death Marcel and Teeny had used it as their *pied-à-terre* on visits to Paris). Duchamp was at his best all evening, witty and relaxed, carrying his eighty-one years with the habitual grace of a perennially youthful intelligence—"You must remember," he used to say, "I am ten years older than most of the young people." It happened quite suddenly, soon after the guests had left; his heart just stopped beating. Having chosen to become an American citizen and to live much of his life in New York, he was not nearly so well known in France as he was in America. The French obituary writers were hardly aware, for the most part, that he had supplanted Picasso as the most influential artist of the twentieth century.

Duchamp's lifelong distaste for fame or fuss had not prevented his admirers from turning him into a modern icon. The great Duchamp retro-

spective at the Pasadena Art Museum in 1963, organized by Walter Hopps, marked the end of his "underground" period, when his ideas and the knowledge of his work were transmitted indirectly through John Cage and a few others. Since then, Duchamp had become an increasingly visible figure on the New York art scene, and his work had exerted a much more direct influence on younger artists. The Duchamp market was suddenly big business, with collectors and museums vying for every scrap and scribble by the master. Duchamp told Walter Hopps that he was entering his "sex maniac phase," in that he was "ready to rape and to be raped by everyone." He even consented in 1964 to authorize the re-creation of his thirteen most important readymades, in exact replicas; eight copies of each were made up, numbered and signed by the master, and sold at $25,000 a set by the Galleria Schwarz in Milan (the edition sold out instantly). For the first time in his life Duchamp could travel first-class. He and Teeny spent their summers at Cadaqués, on Spain's Mediterranean coast north of Barcelona, where they were not nearly as prominent as their neighbor and friend Salvador Dali. Otherwise they lived quietly in New York, in a pleasant old brownstone on West Tenth Street. Increasingly sought out by interviewers, Duchamp would occasionally let fall an ironic comment on the commercialization of art during the current era. He urged young artists to "go underground" if they wanted to achieve anything. Duchamp himself was no longer underground because, as everyone knew, he had long ago stopped making art.

Entire careers in art were being devoted to colonizing territories that Duchamp had opened up. Jasper Johns never hesitated to acknowledge his indebtedness. A significant number of the objects and images that Johns put into his paintings could also be found in Duchamp's early works: books, doors and windows, rulers and other measuring tools, paint manufacturers' color samples, cast shadows, verbal and visual puns. But it was the mental attitude underlying the innovations that mattered to Johns, the Duchampian field of action that Johns once described as a place where "language, thought, and vision act upon one another."[2] Duchamp had decided at the outset of his career to put painting once again at the service of the mind, to make it a mental act rather than a merely "retinal" or sensuous ex-

perience. André Breton and the Surrealists had revered him for this reason, among many others, but Duchamp's insistence on complete freedom to pursue his own iconoclastic and original ends had ruled out allegiance to Surrealism or any other movement. With Abstract Expressionism the pendulum of art history had swung all the way back toward the retinal. In the fifties and sixties, though, the antidote to heroic self-expression and the romance of flung paint turned out to be art-as-a-mental-act, *una cosa mentale*. And what made Duchamp so fascinating to post-Abstract Expressionist artists was that his mental act was a rigorous and lifelong investigation of the most basic aesthetic question: What is art?

The invention of photography had made it certain that, whatever art might have been in the past, it was going to be something different in the twentieth century. The artist could no longer hold the mirror up to nature. He had been freed of that subservience, and it was both his curse and his blessing. Duchamp saw the implications of this radical change more clearly than anyone else. The bastions of aristocratic, elitist art were still relatively intact when he began quietly to undermine them with his readymades. For years scarcely anyone noticed what he was doing—although Guillaume Apollinaire, the self-proclaimed spokesman for the Cubists, prophetically suggested as early as 1912 that "Perhaps it will be the task of an artist as detached from aesthetic preoccupations, and as intent on the energetic as Marcel Duchamp, to reconcile art and the people."[3] Without making any sort of fuss about it, Duchamp dismantled the elaborate and priestly structure of art history. His investigation was rooted in doubt, the Cartesian doubt that questions every accepted position, every rule, every "law" of science or art or human nature. Art, he decided, was anything made by man; that was the sole definition he could accept. Art was not all that important in the scale of things; turned into a religion by certain moderns, as he said, it was "not even as good as God." What mattered was life, not art, and if art were to have any real value it must be part of life—not an *interpretation* of life, not a description of life, not an attempt to comment or improve on life, but a piece of life itself. The process of art,

moreover, could no longer be monopolized by superior beings called artists. It could continue to exist only as an activity shared by artists and spectators, a game that the artist might initiate but that required the active participation of others. Part of the Duchampian myth was that the game of art did not offer him sufficient rewards or satisfactions. He played when he felt like it, but on the whole he preferred chess. Gradually, however, the reverberations of his mental act, and the subversive energy of the works that it had produced, made the old aesthetic structure virtually untenable for more and more young artists.

It was true, of course, that if you wanted to be as free as Duchamp you had better be intelligent. The best American artists of the post-Abstract Expressionist generation were exceptionally intelligent, and several of them were also equipped with a sense of humor—a rare enough quality among artists but a particularly useful one in the chaotic and calamitous 1960s. Where Duchamp's influence was pernicious, in fact, the recipient usually showed a conspicuous lack of humor. Conceptual Art, which announced its arrival in Kynaston McShine's 1970 "Information" show at the Museum of Modern Art, was a case in point. In Conceptual Art the idea, the mental act, is all-in-all; the most extreme Conceptualists do not consider it necessary to embody their ideas in any material form, being content merely to state them verbally as possibilities.* While this can be seen as the inevitable "next step" beyond Minimal Art, and (presumably) the final step in the reductionist tradition, a number of observers including this one have been impressed mainly by the numbing obtuseness of most of the ideas conceived by the Conceptualists.

Taking your own logic too seriously could be the worst sort of trap, as Duchamp well knew. "I have forced myself to contradict myself in order to avoid conforming to my own taste," he once told James Johnson Sweeney.[4] Duchamp did not believe in absolutes.

* "The world is full of objects, more or less interesting; I do not wish to add any more. I prefer, simply, to state the existence of things in terms of time and/or place."— Douglas Huebler, Conceptual artist, 1972.

Many of his important works dealt with the moment of change, the "passage" from one state to another (Johns is obsessed with the same passage), and Duchamp himself never remained in any aesthetic arena long enough for his admirers to catch up with him. His admirers did not even suspect that for the last twenty years of his life he had been at work on a new piece, a room-sized "environment" that would contradict almost every assumption made about his own aesthetic practice. It had taken shape very slowly, a little bit at a time, in a room across the hall from the studio that he kept for years on West Fourteenth Street; in his "official" studio the rare visitor saw nothing but a bed, a table and chair, and a chessboard. Duchamp had not stopped making art after all. He had gone underground, just as he advised young artists to do. His wife knew about it, but no one else did until the year before he died, when he let his old friend William Copley in on the secret; Copley, an artist with private means, promptly arranged to buy the work and donate it to the Philadelphia Museum of Art where the major part of Duchamp's *oeuvre* is on permanent display. The new work, entitled *Étant Donnés: 1) La chute d'eau; 2) Le gaz d'éclairage*,† was installed according to Duchamp's precise written instructions, and opened to public view in 1969. The Duchamp studies industry has not yet recovered from the shock.

Étant Donnés is situated in a small, windowless room behind the gallery where Duchamp's *Large Glass* and several of his other major works are displayed. The room is bare, except that against one wall is an ancient wooden door, set into a brick portal with an arched top. The door is shut and barred. Up close, however, one finds two small holes in it, just at eye level. The view through these peepholes is arresting, to say the least: a low brick wall on the other side of the door, with a break in it through which we see an extremely realistic-looking nude woman, life-size, lying with her feet toward us and her head thrown back, the features obscured by a mass of blond hair; she lies on her back on a bed of dry twigs and branches (real twigs

†*Given: 1) The Waterfall; 2) The Illuminating Gas.*

and real branches), holding in one raised hand an antique gas lamp; her sex is explicitly modeled, and hairless; behind her, a naturalistic, "pretty" landscape (painted in perspective) with woods, hills, a pond, white clouds in a blue sky, and at the far right a sparkling waterfall (mechanical). The scene is bathed in brilliant light, the theatrical light of an afternoon in midsummer.

"It's the strangest work of art any museum has ever had in it," Jasper Johns said to John Cage, after his first look. Cage found himself thinking that "Marcel's insistence on paradox was absolutely intransigent." Clearly the new work referred back in all sorts of ways to the *Large Glass* (whose full title is *The Bride Stripped Bare by Her Bachelors, Even*) as well as to other, earlier paintings, but it contradicted them at the same time. The *Bride* had been stripped bare at long last. Instead of being abstract, though, as in the *Large Glass,* she was here literally in the flesh (pigskin stretched over a metal frame), and splayed so indecorously that she achieved that almost-obsolete power to shock an unprepared viewer. The literal realism was itself less shocking than it might have been, because a whole new school of young artists, the so-called Photo-Realists, had emerged in the seventies—realists who imitated, not contemporary reality, but *photographs* of contemporary reality. Once again, it now appeared, Duchamp had been ten years ahead of "the young people."

The transparency of the *Large Glass,* which changes constantly according to what one sees through it, more or less ensures that every viewer will see it differently. Only one person at a time can gaze on *Étant Donnés,* and that person must see it exactly as Duchamp intended. Instead of a free game between artist and spectator, the last work is a fixed confrontation, a duel, a trap. The barrier between art and life that Cage and Rauschenberg and Duchamp himself had worked so untiringly to remove is here reinstated with a vengeance—barrier after barrier, brick wall and door, contradiction and perplexity. The old fox had turned on his pursuers in the end and devoured them. "Painting is a language of its own," he warned Arturo Schwarz, whose massive, "definitive" book on Duchamp had

to be held up at the last minute before publication because Schwarz did not know about *Étant Donnés* until after Duchamp died. "You cannot interpret one form of expression with another form of expression."[5] Attempts to interpret *Étant Donnés* have gone on at a great rate since 1969, but Duchamp, as always, remains free of that.

END OF AN ERA

In the boom market of the late sixties, contemporary art's growth potential seemed virtually unlimited. Nearly a hundred New York galleries now dealt in contemporary work—in 1957 there had been no more than a dozen. Parke Bernet regularly announced new record highs for living artists. Major new paintings by Jasper Johns, Roy Lichtenstein, and other blue-chip artists often left the country because American collectors, who had bought their work when it sold for less than $1,000 a picture, hesitated to pay the sort of money that wealthy Germans, Belgians, and Italians were willing to spend for what they considered the best contemporary art. Peter Ludwig bought Jasper Johns's largest *Map* in 1971 for a price reported to be $200,000. Ludwig was buying on a huge and systematic scale, building a collection that would eventually fill a new public museum in Cologne. He considered Cubism and American Pop Art the two most important aesthetic movements of the twentieth century—Pop Art because it was the first to represent and acknowledge modern industrial society—and he purchased accordingly. There were no important French collectors. Having failed to recognize or to buy the masters of the School of Paris in the period between the wars, the French were not inclined to acknowledge the School of New York.

Museum retrospectives in mid-career—a rarity until Rauschen-

berg's and Johns's Jewish Museum shows in 1963 and 1964—
solidified the reputations of Claes Oldenburg and Frank Stella (the
Museum of Modern Art), Roy Lichtenstein (Guggenheim), Jim
Dine, and Andy Warhol (Whitney). It was becoming clear that Pop,
Color Field, Minimal, and other labels were hopelessly misleading;
there were too many resonances and crossovers from one to another,
and besides, as in every period, the major artists of each movement
sooner or later transcended that movement's limits and went their
own idiosyncratic way. The amazing thing was that so many strong
and original artists had emerged in America in the twenty years since
the war. There was no critical consensus in this matter, of course, as
the Metropolitan Museum's show of "New York Painting and
Sculpture: 1940–1970" amply demonstrated. The first in a series of
lavish exhibitions to celebrate the Metropolitan's centennial, this
huge gathering together of four hundred and eight works by forty-
three artists generated furious controversy, centering mostly on the
issue of who got left out (Louise Nevelson, Larry Rivers, Jim Dine,
Richard Poussette-Dart, among others). Hilton Kramer, a *New York
Times* critic who managed to take most advanced art as a personal
affront, attacked the show and its organizer, Henry Geldzahler, in
three separate articles, calling it an example of "moral and intellec-
tual abdication."[1] John Canaday, then the *Times*'s leading critic, saw
in it the evidence of "an esthetic-political-commercial power com-
bine promoted by the museum's Achilles' heel, Henry Geldzahler."[2]
The intensity of the diatribes may have had something to do with the
fact that art critics in general (and *Times* critics in particular) had
played so negligible a part in the triumph of postwar American art.
They had been either lukewarm or disdainful toward Abstract Ex-
pressionism, Pop, Color Field, Minimal, and all the other develop-
ments that Geldzahler had now enshrined in thirty-five nobly
proportioned galleries of the nation's greatest museum. "Henry's
Show," as it came to be called, certainly did reflect the taste of
Henry Geldzahler, who had been since 1960 an active and highly en-
thusiastic participant in the new art scene. He described his show as
"a marriage of history and the pleasure principle,"[3] and to a great

many visitors what came through was the sheer gorgeousness of so much of the work, the high-spirited energy and daring and beauty (now that the shock had worn off) on display in what amounted to single-room retrospectives of de Kooning, Pollock, Gorky, Hofmann, Johns, Rauschenberg, Stella, and the rest. The English critic John Richardson called it "the most important exhibition held in this country since the famous Armory Show,"[4] and several other out-of-town reviewers expressed similar views. The artists who *were* included generally praised Geldzahler's installation. Nearly all of them came to the opening-night party on October 18, 1969, along with several thousand invited and uninvited guests. It was the last of the great sixties art spectaculars, a full-scale rout at which the stately, black-tie world of the Metropolitan trustees found itself mingling with now-generation swingers dressed as American Indians, frontiersmen, Cossacks, Restoration rakes, gypsies, houris, and creatures of purest fantasy. There were six bars, a dance orchestra, and a rock band blasting out the latest tribal rhythms. What no one realized at the time was that the whole gaudy event—the paintings and sculptures, the behavior, the baroque costumes, the din, the excitement arising from brilliant work recognized and rewarded—would come to be regarded as a sort of valedictory, the exotic last rites of an era that was ending.

It was not the end of the art world, far from it. The art world (after a brief attack of nerves during the 1970–71 recession) kept right on expanding and exfoliating, in New York and elsewhere. The transformation of the area between Houston and Canal streets from a decaying neighborhood of small commercial jobbers into SoHo (*South of Hou*ston), with its spacious art galleries and atrociously expensive boutiques and restaurants, took place largely after 1971, the year that Leo Castelli, Ileana Sonnabend, André Emmerich, and John Weber moved into a renovated former paper mill at 420 West Broadway. Castelli's spreading network of satellite galleries, with which he shared his artists on a commission basis, was successfully extending the market to what Castelli spoke of as "the provinces" (meaning Los Angeles, San Francisco, St. Louis, Minneapolis, Hous-

ton, and Toronto). The conquest of Europe by advanced American art was being facilitated meanwhile by huge art fairs such as the Venice Biennale, the Documenta shows in Kassel, West Germany, and similar exhibitions in Basle and Bologna. Each year, more and more new galleries were opened to exploit the rapidly expanding market for prints and photographs, the only art works that some formerly ardent American collectors could now afford to buy; when Castelli moved to SoHo, his old gallery space on East Seventy-seventh Street was taken over by Castelli Graphics, run by his wife. Within this interlocking international support system for contemporary art, however, an important shift was starting to make itself felt. More and more artists were withdrawing from the art world, or trying to, or at least talking about trying.

Spellbound by Duchamp, these artists seemed to want to go beyond the art object and its commercially tainted existence. The Conceptualists emphasized art-as-a-mental-act, with the idea as its sole value. Sol LeWitt's wall drawings, which were usually executed by other people, had no *object* value; when it became necessary to repaint the wall, anyone could remake the drawings by following LeWitt's precise written instructions. Body Art was a species of performance—Vito Acconci plucking hairs from his arms and chest, or Chris Burden having himself tied down to the floor of an open garage, in such close proximity to live wires and pails of water that any viewer, if he cared to kick over a pail, could presumably electrocute the artist. Such performances usually took place in art galleries, and so did the various accumulations of mill-ends, felt strips, lead castings, lard piles, and other disagreeable substances that came under the rubric of "anti-form" or "Process Art." The irony in this was frequently noted—the fact that the post-art-object artists never really tried to remove themselves or their work from the commercialized and discredited art world. Several of the Body and Process artists also proved to be remarkably adept at getting foundation grants and teaching positions. In a sense they were reaping benefits built up over the last twenty years. Because of the widespread and growing interest in the visual arts in America that had developed in

large part because of what American artists had achieved since 1945, the newcomers could afford to keep on investigating the question of art's true nature, and to locate art's value in the artist rather than in the work.

The earth artists, on the other hand, proposed to engage material reality in the most direct way. What could be more appropriate, more in the spirit of the twentieth-century artist's infatuation with real objects in real space than Michael Heizer's multi-ton "displacements" of dirt and rocks in the Nevada desert, or Robert Smithson's 1,500-foot *Spiral Jetty* at the northern end of Utah's Great Salt Lake? In their grandiose visions and their feeling for untrammeled open spaces the earth artists recalled such nineteenth-century American landscape painters as Albert Bierstadt, Frederick Church, and Thomas Cole, who had seen nature as the key to "the sublime." Heizer, Smithson, and Walter de Maria were not a bit sentimental about nature, but they had all formed, during the late sixties, an intense antagonism to the commodity aspect of art. Heizer stopped making abstract paintings abruptly in 1967, convinced, as he put it, that "art in New York was really dead." He went out to the Mohave Desert and started building and digging in an experimental sort of way, until Robert Scull, who was losing interest in Pop Art about that time, heard about what he was doing and decided to bankroll his more ambitious excavations. Smithson, a well-known Minimal artist, began about the same time to exhibit his "non-sites," topographical maps of particular areas, together with samples of rock, shale, dirt, and other natural debris from that same area. "Painting, sculpture and architecture are finished, but the art habit continues," Smithson said in an interview.[5] De Maria was also a Minimalist when he began to think about using bull-dozers to cut one-mile-square tracks in the deserts of three continents (North Africa, India, North America). It seemed to de Maria that he and his fellow earthworkers (who did not much like one another's work) might very well be making "a jump beyond style," stepping right out of the historical succession of Cubism, Surrealism, Expressionism, Abstraction, Pop, and so forth. "This may be something beyond all that," he

said, "a quantum leap. I think the experience of this work will make you feel different than you've ever felt before in the presence of art."

The trouble was, most of the earthworks were situated in such remote areas that very few people *could* experience them directly, and the photographs that were shown in art galleries and magazines, while giving some indication of the size and scale, falsified the experience ("Photographs steal away the spirit of the work," said Smithson).[6] The other large problem was financial. It cost a good deal to hire bulldozers and earthmoving crews, and the number of patrons interested in financing such operations was limited at the time to three: Robert Scull; Virginia Dwan, who closed her New York gallery in 1971 to become a private patron; and Heiner Friedrich, an alarmingly energetic German dealer who was responsible for selling much recent American art to European collectors.

Christo, the Bulgarian-born environmental artist, financed his own monumental undertakings by establishing a private corporation and issuing stock that was redeemable in works of art by Christo, many of which took the form of working drawings for his current project. Using this novel funding technique, he "wrapped" in white plastic a million square feet of rocky coastline near Sydney, Australia, in 1969, at the cost of a mere $80,000, and went on in the seventies to suspend a *Valley Curtain*—250,000 square feet of bright orange nylon—between two cliffs in Colorado, for upward of $400,000; to erect an eighteen-foot-high, white nylon *Running Fence* across twenty-four miles of rolling ranchland in California's Sonoma and Marin counties (more than $3 million); and to plot the future wrapping of the Reichstag building in Berlin and the construction of a mastaba larger than the Great Pyramid of Cheops, made entirely of oil drums, in the Arab emirate of Abu Dhabi. Christo is not really an earth artist. His vast enterprises engage the efforts, either in aid or in opposition, of hundreds of other people, and he refers to what he does as "public art." Nothing infuriates his detractors more than to be told that by their opposition they become part of his projects, but the theatrical panoply of social interaction is what motivates Christo. The final work is documented exhaustively

in still photographs and on films and videotapes, but the real point of it, Christo insists, is the public process of its creation.

The New York art world has tended to ignore Christo, perhaps because he has always operated outside of it. He has no regular gallery. His wife Jeanne-Claude, an extravagantly charming Frenchwoman who is the daughter of a general, handles all the business details of their far-flung operations. So far, although they live permanently in New York, more than 90 percent of the support for their projects has come from Europe. The Christos have demonstrated, in fact, that it is no longer necessary for an artist to "make it" in New York. At some point in the sixties the art world ceased to have a geographical basis. The old New York-Paris rivalry became obsolete; contemporary art is as much at home today in Tokyo or in Düsseldorf. The artist can live anywhere and do his work, and his work seems to lie, in many instances, outside the studio.

Few established critics have found much to admire in post-studio art. "The uncollectible art object serves as an advertisement for the showman-artist, whose processes are indeed more interesting than his product and who markets his signature appended to commonplace relics," Harold Rosenberg observed. "To be truly destructive of the aesthetic, art *povera* would have to forsake art action for political action."[7] It was an interesting point. As Rosenberg and others pointed out, the New York artists responded hardly at all to the radical politics of the sixties. The brutal police riots at the 1968 Democratic National Convention in Chicago did inspire a group exhibition at the Feigen Gallery there of works done in protest. Claes Oldenburg, who had grown up in Chicago, contributed a drawing of Mayor Richard J. Daley's severed head on a platter, and a model of a Chicago-style fireplug painted blood-red. But a proposed artists' strike against showing their work in Chicago never materialized. Opposition to the Vietnam War could be read into a few isolated art works, the most spectacular of which was James Rosenquist's gigantic, eighty-six-foot painting *F-111* (1965), which was thirteen feet longer than the Air Force fighter-bomber that figured as one of its central elements. But there were no organized antiwar actions

among the New York art community until 1969, when the newly formed Art Workers Coalition broadened its artists' rights program to include agitation against the war. The AWC's activities—picketing the Metropolitan when it refused to close in support of the moratorium for peace; printing and distributing fifty thousand copies of a poster showing murdered Vietnamese civilians, victims of the Song My massacre, with the caption: "Q. And Babies? A. And Babies"—received a good deal of publicity. But 1969 was a little late to be joining the antiwar movement, and the AWC's activity was not sustained. "What is sad is how few artists will even acknowledge their political burden," the critic and AWC leader Lucy Lippard wrote toward the end of 1970, "how many seem to feel that art, and thus their own art, is so helpless that it needs no conscience."[8]

Rauschenberg's involvement with E.A.T. made his political position somewhat anomalous. Gregarious and socially concerned as he was, he naturally lent his name and gave his work to the right (left) causes. He was one of twenty-six artists who withdrew from the exhibition of American prints at the 1970 Venice Biennale, "as an act of dissociation from U.S. Government sponsorship" (a nice irony-six years before, the first government-sponsored U.S. exhibition at the Biennale had been capped by Rauschenberg's prize). He donated a painting to the thirty-two-gallery "Art for Peace" exhibition in New York that fall; the donated art works were auctioned by Parke Bernet and the proceeds went into a fund to help elect antiwar candidates to Congress. At the same time, E.A.T.'s relationship with large corporations that might or might not be manufacturing war materials had become a subject of harsh criticism. Since 1968, Rauschenberg himself had been working closely with engineers of the Teledyne corporation in Los Angeles on a collaborative project for a large "Art and Technology" show sponsored by the Los Angeles County Museum of Art. Maurice Tuchman, the show's organizer, had "placed" a number of artists with West Coast firms, several of which were directly involved with the military; Teledyne was reportedly making the tiny sensors that were dropped along the Ho Chi Minh Trail to trace troop movements. Rauschenberg saw no

merit in the guilt by association charge. His project was not going to trace any troops, or make any money for the corporation. His project, which took three years to complete, was called *Mud-Muse*. Rauschenberg had come to the conclusion that too many E.A.T. artists associated technology with mystery and fun houses. "I thought that Hollywood movies dealt perfectly adequately with that side of things," he said. "So we decided to do something that did not have to be seen with the lights off." *Mud-Muse* is a nine-by-twelve-foot tub of industrial drilling mud, which bubbles and spurts in response to auditory signals. The effect is a little like Yellowstone National Park brought indoors. It was one of the more popular offerings in the "Art and Technology" show, especially with young children.

Rauschenberg accepted an invitation from NASA to watch the launching of Apollo 11, which landed the first men on the moon. The National Aeronautics and Space Administration had a policy of bringing artists to the Kennedy Space Center to watch launchings— James Wyeth was also there for Apollo 11. Rauschenberg was amazed by the openness and availability of NASA press director James Dean and the other government officials. He went everywhere, talked to astronauts and technicians, and spent hours looking through NASA's photo archives. Shortly before the blastoff he managed to slip through a barrier and watched the huge Atlas rocket frost up as it took on liquid nitrogen. "It turned into the most beautiful icicle," he said. "The incredibly bright lights, the moon coming up, seeing the rocket turn into pure ice, its stripes and U.S.A. markings disappearing—and all you could hear were frogs and alligators! That combination just seemed wonderful to me. The whole project seemed one of the only things at that time that was not concerned with war and destruction. I've never been a cause-er. I don't march in parades. But I think I relate more to society than to any idea about art history. I feel the world is here to do something about and with. What really impressed me in that space shot was the attitude of the people involved, the trust, the teamwork."

Afterward he collected all sorts of visual material on NASA, the

space program, and the history of aviation going back to the Wright Brothers and took it out to Gemini G.E.L. in Los Angeles. The result was *Stoned Moon,* a series of thirty-three lithographs that the critic Lawrence Alloway has described as "a technological equivalent of Rubens's Medici cycle . . . in its pomp, wit, and fidelity."[9] Charts and diagrams, gantry rigs, machinery, oranges, palm trees, long-necked shore birds, photos of the astronauts, images from the tele-vised moon landing, and swarms of other details are juxtaposed in the Rauschenberg manner, with a verve and brio that lifts the series well beyond official or commemorative art. The Museum of Modern Art acquired a complete set, and so did the Vatican in Rome, the Na-tional Collection of Fine Arts in Washington. D.C., and a number of other public collections. *Stoned Moon,* among other things, was a clear signal that Rauschenberg had somehow regained the ability to work on the high wire. Once again he was a reporter looking at pub-lic events and putting down what he saw in unique visual terms. He was back in the world.

When he had finished work on the series, he stayed on in Califor-nia for a while, in a house he had rented on the beach at Malibu. A fire in the basement had made his New York house temporarily un-inhabitable, and he felt no particular urge to be in New York any-way. He had a new friend named Robert Peterson, a soft-spoken young man who had grown up on an Iowa farm, moved to Califor-nia when he was eight, graduated from the state college in Long Beach in 1968 and then gone to work for Gemini G.E.L. It was while he and Peterson were living in Malibu that Rauschenberg de-cided to make "the largest and most beautiful drawing in the world."

The material he chose to work with was the daily newspaper—the *New York Times,* the *New York Daily News,* and the *Los Angeles Times,* for the most part. As the scissored images and the headlines piled up and worked their way into collage-studies for the big draw-ing, though, Rauschenberg found himself dealing in one way or an-other with a sense of unrelieved disaster, the legacy of a catastrophic decade whose later stages had been scarred by Cambodia and My

Lai, Kent State and Jackson State, race riots in the cities, saturation bombings and the ghastly litany of body counts in Southeast Asia, the pollution of the earth's fragile resources, the killings of Martin Luther King, Jr., and Robert Kennedy, the Manson murders, Chappaquiddick, the bloody, endless conflicts in the Middle East and Northern Ireland, strikes and generational hatreds and domestic turmoil—the hope and optimism of the early sixties swept aside by the savage spectacle of events that were apparently out of control. Rauschenberg the artist-reporter wanted this time to report "the hot news," to take two months of actual events and to "make that my material and not obscure its potency with any artistic facility." He cut and pasted, refusing to draw on or around the words and images. *Currents,* finished toward the end of 1969, is without question the largest drawing ever made. It measures six feet high by sixty feet long; when not on display it can be rolled up like a scroll. As a work of art it is not really successful, though, and as reporting it is too diffuse to have the sort of impact he hoped it would. His conceit had been to attempt the impossible; no single work however large could sum up the passion and despair of those years.

"The whole thing was a reaction on my part," he said, some time afterward. "It probably came from a futile desire to escape the responsibility of feeling depressed by the things going on all around us. Luckily I didn't succumb. And I'd still like to do the biggest and most beautiful drawing in the world."

CAPTIVA

Captiva Island, a six-mile sliver of white sand and cabbage palms off the Gulf Coast of Florida, is one of the great shelling beaches of the world. The variety and abundance of molluscs that wash up there attract seashell fanciers in vast numbers; men and women who tend to be past the first blush of youth, they walk slowly up and down the beach from early morning until sunset, carrying their pails and shovels and folding stools, their eyes so stubbornly fixed to the sand that occasionally they bump into one another. The shellers do not bother Rauschenberg, whose modest wood-frame house is right on the beach, about two thirds of the way toward the island's northern tip. Now and then a younger person—usually an art student—pauses to point out the house to a friend, or even to introduce himself if the owner is visible, but even these interruptions are rare.

When Rauschenberg first came to Captiva in 1962 it was a much more isolated place. You took a ferry over from Fort Myers on the mainland, and the last one back left at 4 P.M. Only about fifty families lived on the island then. There was one policeman, and a ship-to-shore telephone at the post office. A year later the automobile causeway linking Sanibel Island to the mainland was completed and opened to traffic, and Sanibel's real estate develop-

ers started carving up Captiva, which is really an extension of Sanibel to the north. Rauschenberg protected himself by gradually buying up as much of the land around him as he could. Eventually he became the island's largest private landholder, with six houses and property that, at current rates, should be worth more than a million dollars—at least until the developers build so many condominiums that the island sinks into the Gulf. He does what he can to resist the developers, but that seems more and more a losing battle.

For years Captiva was his occasional retreat, his place to come when city life and the New York art world became too oppressive, but since 1971 it has been his home and principal workplace. In 1971 he was feeling a little disillusioned with art and technology, and a little tired of focusing on "world problems, local atrocities and in some rare instances . . . men's accomplishments."[1] After finishing work on *Currents,* he and Bob Peterson came straight to Captiva. Rauschenberg alternately loafed and made drawings, working at the kitchen counter. The drawings financed a down payment on the house next door to his, which he planned to turn into his studio. Cy Twombly arrived for an extended visit, and Twombly, Peterson, and Rauschenberg all worked on the design of the new studio. The plans stayed out on the kitchen counter, and when two weeks had gone by without anyone's adding anything new to them, they decided it was time to call in the builders.

The printing studio came next. In a house on the other side of the palm and palmetto jungle that he had saved from the developers, Rauschenberg installed a small lithographic press (named "Little Janis," after the late Janis Joplin), which he invited other artist friends to come and work on—the first to do so were Twombly and Susan Weil. Later on he bought a bigger and more sophisticated press that Jim Rosenquist had recommended (Rosenquist also owned property in Florida, on the Gulf Coast north of Tampa). Drawings, prints, and after 1971 a prolific output of new work in various media emerged from Rauschenberg's working

periods on Captiva. He kept the Lafayette Street house in New York, staying there when he came to town and using it as storage vault, office, and headquarters for his ventures into social activism. With the help of Rubin Gorewitz he had set up a private foundation called Change, Inc., whose function was to make small but immediate grants (with no strings attached) to artists in desperate need of medical funds. Change itself received sizable grants from Mobil Oil, the Museum of Modern Art, the National Endowment and the New York State Council on the Arts; it was also supposed to receive donations of works by successful artists, to be sold for the benefit of those less fortunate, but the principal donor was usually Rauschenberg himself. Rauschenberg was also heavily involved in the artists' rights movement, which began in 1973 to press for congressional legislation that would restore the full tax deduction for artists who donated their work to museums (in 1969 the tax law had been revised so that artists could deduct only the cost of their raw materials); the movement also was working on a bill to require that collectors who resold a living artist's work at a profit would pay a percentage of that profit to the artist. A succession of resourceful secretaries took care of Rauschenberg's affairs in New York, while Hisachika Takahashi, a young Japanese artist who had come to stay at Lafayette Street for a few days in 1970 and quickly made himself indispensable, looked after the house itself.

Rauschenberg had his own separate entourage on Captiva. In addition to Bob Peterson it included a studio assistant who also ran the litho press, a master carpenter, three large dogs, and fluctuating numbers of part-time helpers and visitors. Christopher Rauschenberg came down occasionally. Chris had become a professional photographer; he lived in Portland, Oregon, where he was part owner of the Blue Sky photo gallery. He had come to know his father well only in the last few years, in which they had worked out an easy, bantering relationship with plenty of admiration on both sides. Rauschenberg's tolerance for the freeloaders and rip-off types

of his dude period had declined significantly; most of the people around him now were hard-working and highly competent. Rauschenberg could still put away an astonishing amount of bourbon. By 1979, though, visitors to Captiva would usually find him on the wagon. He had not quit drinking, exactly—"If I told myself that," he said, "I'd be so depressed I'd have to go out and get drunk." When he went to New York he would sometimes drink as prodigiously as ever for several days, then stop the moment he got back to Captiva. It was evidence of a new kind of discipline, a maturity that amazed his friends.

Rauschenberg's typical day on Captiva began at about 1 P.M., when he came out to the kitchen and switched on the "Good Morning, America" show (recorded hours earlier on his brand-new Betamax). It progressed through leisurely afternoons during which he might take a few telephone calls, read the mail, swim or fish a little, and chat with whoever happened to be around; then came to a focus about six or seven in the evening, when he went to work in the studio or the print shop. He and his studio assistant worked for six or seven hours at a stretch, after which everybody convened at the beach house for dinner, the only real meal of the day, a joint effort (Rauschenberg did a lot of the cooking himself) that was served, depending on how long the working night had lasted, sometime between midnight and two in the morning. The nocturnal schedule was immensely productive. For the first time since 1964 Rauschenberg was turning out a great deal of new work, and the critics, several of whom had decided that he was through as an important artist, were obliged once again to come to terms with his cornucopia of surprises.

Cardboards, the first series of new works done on Captiva, was also the first to be shown in Castelli's new SoHo gallery. The material was used cardboard boxes, flattened out, torn, bearing the printed brand names or the addresses of their destinations, punctured and stapled, lacerated and stained. After five years of being concerned with world events, Rauschenberg explained in a catalog

note, he had felt a desire to work "in a material of waste and soft-
ness. Something yielding with its only message a collection of lines
imprinted like a friendly joke." Cardboard boxes were lying around
wherever you happened to be, he had noticed, even on Captiva; once
again he was using what was available, assembling discarded bits
that bore the stigmata of another life in the real world. He nailed the
fragments to plywood supports, adding nothing that was not al-
ready present—no painting or drawing, no artful "arrangement" of
shapes. The effect, as the *Times* critic Peter Schjeldahl noted, was
"somehow fresh as a daisy."[2] Several reviewers treated the show as a
major comeback, which was a little annoying. Rauschenberg did not
really feel that he had been away.

The spare, uncluttered look of the *Cardboards* was characteris-
tic of his work in the early seventies. It was an obvious reaction to
his surroundings, which were no longer the gritty, refuse-strewn
streets of downtown Manhattan. A sense of fragility and distance
entered into almost everything he did now, a kind of airy spacious-
ness. When he traveled, which he did fairly often, his work re-
flected the look and feel of the places he had been: the rotting
elegance of Venice; the variously colored sands of Israel and Egypt;
the mud and dust of India. In spite of his love for humble materials,
something new was becoming evident in his work, an unapologetic
surface beauty. It was clearly apparent in the *Hoarfrost* series,
hanging cloth pieces on which photographic images had been
printed by a transfer process. It was unmistakable in *Jammers,*
combinations of wooden poles and unstretched fabrics (without
transfer images) sewn into simple patterns. The *Hoarfrosts* and
Jammers were the first Rauschenbergs since the color silk-screen
paintings of the early sixties that Castelli found relatively salable.
Critics who had long ago dismissed Rauschenberg's work as "dec-
orative" saw their judgment confirmed; those who were used to
calling it ugly were nonplused. Rauschenberg's own explanation
was that India had changed his way of looking. The sight of a
gold-embroidered sari trailing in the mud had made him realize, he

said, "that everything is relative, that everything is acceptable, and that you don't have to be afraid of beauty, either."[3] But the *Hoarfrosts* had been done a year before he went to India. Besides, you could find traces of the same fragile loveliness again and again in his past work. It was there not in spite of everything else but along with everything else. How could it be otherwise for an artist who defined his overall themes as "multiplicity, variation, and inclusion"?

Rauschenberg's reputation was definitely on the rise again. In Europe it had remained high, higher even than Johns's, although the meagerness of Johns's output and the intense competition for it among American and European collectors had pushed his prices far above those of any of his contemporaries. In Basle Ernst Beyeler, the most respected of all the European dealers, had entered the Rauschenberg market; Beyeler let it be known that he considered Rauschenberg a modern master comparable to the great post-Impressionists, and his opinion influenced other dealers.

The Scull auction established new auction price records for Rauschenberg, Johns, and several other New York artists. Robert and Ethel Scull sold the major part of their collection at Sotheby Parke Bernet in 1973 for a total of $2,242,900, realizing thereby a profit of several thousand percent. Rauschenberg's combine-painting *Thaw,* which Scull had bought for $900 in 1958, brought $85,000. Jasper Johns's *Double White Map,* which had cost Scull $10,000 in 1965, went to the Italian industrialist Gianni Agnelli for $240,000. The auction itself was covered extensively by the press and television. A film documentary showed Rauschenberg coming up to Scull after it was over, giving him a not-quite-friendly shove in the chest, and saying, "I've been working my ass off for you to make that profit?"

"How about yours?" Scull countered. "You're going to sell now, too. We've been working for each other."

"You buy the next one, OK?—at these prices," Rauschenberg said, laughing and pushing him again. "Come to my studio."[4] It

was the Scull auction that induced Rauschenberg to throw his considerable weight behind the campaign for an artist's royalty on resales, a campaign that at the present moment has been enacted into law in one state, California, where it is proving extremely difficult to enforce.

WALTER HOPPS, THE CURATOR OF TWENTIETH CENTURY PAINTING and Sculpture at the National Collection of Fine Arts in Washington, D.C., had been wanting for some time to do a major Rauschenberg retrospective. Hopps was one of the little-known powers and dominions in American art. As director of the Pasadena Museum he had organized in 1963 the first big Duchamp show, a stunning revelation that contributed signally to Duchamp's reemergence during the sixties. Hopps was not an easy man to work with. His concepts of administration and his unreliability in keeping appointments were often the despair of his colleagues (one of whom once had lapel buttons made up reading "Walter Hopps Will Be Here in Fifteen Minutes"). On the other hand, his installations were brilliant, and his art-historical imagination was original and stimulating. Early in 1973, when every U.S. public institution was in the throes of planning for the nation's bicentennial celebrations, Hopps decided that his museum (which falls under the general jurisdiction of the Smithsonian Institution) should focus its bicentennial budget on Rauschenberg. "Nobody else was doing anything to celebrate a particular living artist," as he later explained his reasoning. "And here was Bob, in the heart of mid-career—he would be fifty in 1976, which made him one quarter as old as the country—Bob who seemed to me the great example of the 'Citizen Artist,' in the eighteenth-century sense that our Founding Fathers so revered, someone who felt a great responsibility to the life of his time, who was deeply involved in it in all sorts of different ways." Hopps told his board of directors that he did not consider Rauschenberg the greatest living American artist. It was impossible, he felt, to make that sort of

judgment about the present. But he was certainly one of the great-est, and in many ways he seemed to Hopps the most deeply and quintessentially American.

The directors agreed, and Hopps proposed the idea to Rauschen-berg on an airplane flight from New York to Stockholm. He had taken the flight for that purpose, knowing that an airplane was one of the few places where one could have a private conversation with the artist. "Bob asked for time to think it over," he recalls. "He thought for about twenty minutes, and said yes."

It was a major commitment of time and energy for both of them. The show would travel to four other U.S. museums after leaving the capital,* and Rauschenberg naturally would want to have a hand in all the installations. He also would have to look long and carefully at things he had not looked at for twenty years or more, and this promised to be difficult. Could the early work stand up to the myths that had been woven around it? Reputations were fragile things, and Rauschenberg's had only recently emerged from semi-eclipse. The challenge was nevertheless irresistible. There had been a number of major and minor Rauschenberg retrospectives in Eu-rope during the last decade, but no really large-scale exhibition at home since the Jewish Museum show in 1963. Besides which, Rauschenberg knew that the Whitney Museum was planning a big Jasper Johns retrospective for 1977. Rauschenberg's undiminished competitiveness embraced the idea of himself as Bicentennial Artist. His survival instinct drove him back, after every session with Hopps in Washington or New York, to his Captiva studio, where he sought to "equalize" the pressure of the past by doing new work.

The show opened in Washington in the fall of 1976. Hopps had installed the one hundred and fifty-eight works that he and Rauschenberg had selected in reverse chronological order, so that

*The Museum of Modern Art in New York; the San Francisco Museum of Modern Art; the Albright-Knox Art Gallery in Buffalo; the Art Institute of Chicago.

the viewer began in the present, with the immense *Spreads* and *Scales* that matched in exuberance his most dazzling sixties combines (*Rodeo Palace* incorporated three doors that opened and a lot of fabric and newspaper collage and even a pillow embedded in the surface). From the first room with *Rodeo Palace* and similar recent pieces one moved backward in time through *Jammers* and *Hoarfrosts* and *Cardboards,* art-and-technology works, silkscreen paintings, transfer drawings, combines, sculptures, the complete Dante drawings, *Monogram* and *Bed, Rebus, Charlene* and other red paintings, the black paintings, the white paintings (in their most recent reincarnation), the *Erased de Kooning,* all the way back to the blueprints and the little white painting with numbers, now called *22 The Lily White,* that was the sole survivor of his 1951 show at Betty Parsons. Along the way were selected prints and multiples, posters he had designed, and a sampling of the photographs he had taken at Black Mountain and later, together with photographic documentation by others of his dance and performance pieces. Hopps had decided to start with the present because that was Rauschenberg's tense. "He operates completely in the present, always, working with what's there and with the people he's with. He never wants to be influenced by what he's done before. I felt there was a straight line leading back to his earliest things, but it made sense to start in the present because that's where he is."

Discovering or rediscovering Rauschenberg in this way was an adventure, a journey into the mind of an artist who had responded more directly than any other to certain aspects of American life in the years since the Second World War. The work "in all its formal, technical, metaphorical and iconographic variety, encompasses a range of human experience that no other artist in our time has dared to take on," Benjamin Forgey wrote in *Art News.*[5] There were dissenters, of course, critics who continued to find Rauschenberg a minor decorative talent, a "Mannerist of postwar American vanguardism" (Harold Rosenberg), but the show as a whole had an emotional and visual power that made even favorable criticism seem

superfluous. The openings in Washington and New York brought back much of the excitement of the sixties. Nearly every artist in New York came to the opening night at the Museum of Modern Art, where Rauschenberg's larger-than-life presence as he moved slowly through the jammed galleries, oversized bourbon glass firmly in hand and television cameras hovering overhead, gave off a sort of numinous glow. Everybody wanted to touch him or shake his hand. Jasper Johns, who had generously loaned the important early Rauschenbergs from his own collection, did not appear at either opening. The breach between Johns and Rauschenberg had never really healed. They no longer avoided meeting in public, and now and then, at an opening or a dinner, they chatted together amiably enough. Johns, surprisingly, appeared to be the more relaxed of the two on those occasions. Johns made no secret of his deep admiration for Rauschenberg as an artist. Rauschenberg, he said, had "invented more than any artist since Picasso." At a dinner party at Victor Ganz's apartment, Ganz ventured the opinion that Rauschenberg was the most influential living artist, then turned to Johns, who was there, and said, "After you, Jasper." Johns said, "No, including me."

The contrast between these two artists whose work still means so much to one another, personally and professionally, has never ceased to fascinate the art world: Johns moving always deeper into himself, into paradox and enigma, Rauschenberg turning outward to the world at large, trying to annex as much of it as possible into his work. The opening night of the Johns retrospective at the Whitney, in the fall of 1977, was by comparison to Rauschenberg's a formal and awe-inspiring event; many of the paintings seemed as difficult and hermetic, as closed to any response but mute admiration, as they had on first viewing. Rauschenberg came to Johns's opening (he had been an equally generous lender; each owned key examples of the other's work), and at one point in the evening he even tried to tell Johns how he felt about seeing the paintings all together, but it was no use, they could not talk to each other any more on that level.

■ ■ ■

POSTERITY MAKES THE MASTERPIECE, AS DUCHAMP POINTED OUT. FU-
ture generations choose and select, apply their own criteria, and
decide which works retain the power to communicate their myste-
rious energy. "Permanence doesn't really interest me," Rauschen-
berg said one day. We were lying on the beach in front of his
house on Captiva, watching the shellers stoop and sift. "Some of
the things I've done will probably last longer than others—I'm
sure *Barge* will. *Monogram. Charlene. Rebus.* Possibly *Rodeo
Palace.* But I'm not working in a clinic. My whole focus has been
on the activity of my life. Out of the activity has come a mass of
works, which are really just evidence that I'm still paying atten-
tion."

We had talked years before about the trap of art—the pressure to
repeat yourself, to continue turning out a product instead of remain-
ing in the unfamiliar terrain of experiment and discovery. At the
time he had said that he thought he could continue to elude the trap,
because his only real incentive as an artist was curiosity about what
a picture could be, and his curiosity was apparently insatiable. Now,
when I asked him whether he still thought he could escape it, there
was a silence. "I don't think so," he said finally. "I think the shadow
of the escape has cut me off at the pass."

Both of us laughed. But it seemed to me then that he was right.
Even Duchamp had not managed to get completely free of the
trap—Duchamp, who undermined and subverted all the traditional
notions of art's nature and purpose. Art as a mental act, art as an
extension of life, art as theater, art as behavior, art as perceptual
training—all the motley heresies of the sixties that had come tum-
bling out of Duchamp's green box were now loose in the world,
adding greatly to the general confusion of values. And yet,
Duchamp had spent the last twenty years of his life patiently assem-
bling a work of art that could be seen by only one person at a time.
"I'm nothing else but an artist, I'm sure, and delighted to be,"
Duchamp had told an interviewer in 1963,[6] at the time of his
Pasadena retrospective.

When I mentioned this remark to Rauschenberg that day, on the beach at Captiva, he looked, as he often does, overjoyed. "That's so wonderful," he said, nodding repeatedly and smiling. "That's so wonderful I'm going to pretend I said it myself. I know Marcel wouldn't mind."

EVERYTHING IN SIGHT
(REVISITING RAUSCHENBERG, 2004–2005)

Captiva and Sanibel, two small barrier islands off Florida's south-west coast near Fort Myers, caught the full force of Hurricane Charley in the summer of 2004. The Category 4 storm caused an estimated fourteen billion dollars in property damage on the islands, snapping coconut palms in half, flinging boats around like clam-shells, and turning uprooted Australian pines into airborne missiles. Robert Rauschenberg, a full-time resident of Captiva since 1970 and the largest private landholder on the island, resisted leaving until Charley had roared through; he was then evacuated by helicopter, because conditions on the island had become unsafe, and he couldn't get back to his studio for three weeks.

All his properties—he owns ten houses there, in addition to a stretch of carefully preserved palmetto jungle—took a beating. The house that came through with the least damage, luckily, was the studio, which he and his companion, Darryl Pottorf, designed and built in 1993. The studio, a white bunkerlike building that overlooks the Gulf of Mexico—Rauschenberg once described it as "a cross between the Taj Mahal and the Pentagon"—has storage and workshop space for his assistants on the ground level and, on the second floor, a forty-by-eighty-foot room with six huge worktables, where Rauschenberg lays out the

images that will become his paintings. Bob (nobody calls him anything else) was sitting beside one of the tables when I visited him in December 2004. He was in a high office chair on wheels, chatting with Pottorf and one of his studio assistants while he watched a cooking show on TV. He'd had a run of medical misfortunes—a broken hip with internal complications in 2001, and a year later a head injury and a stroke that paralyzed his right side—but, as long as he stayed in the chair, Rauschenberg, at seventy-nine, seemed improbably youthful.

Eight paintings from his new "Scenarios" series were hanging on the studio walls—large pictures, seven feet high by ten feet wide, with colorful images of exceptional clarity and crispness, and with more white space than you usually find in Rauschenberg's work. For several months after his stroke, he had been depressed and unable to work, but gradually the habits of a lifetime reasserted themselves, and a little more than a year ago he started the new series. I had seen a few of them the week before, at his studio in New York; they struck me as the strongest, most lyrical pictures he had produced in a long time.

The biggest change in the new paintings was that he had not taken the photographs reproduced in them. "I can't do that now, because of my arm," he said. His paralyzed right hand lay in his lap, cocked at a right angle to his wrist, the long, tapering fingers bent backward. "I get other people to take them for me." His tone was matter-of-fact.

I asked whether he directs the photographers. "Now and then," he replied. "I tell them, 'Don't do any selecting. And if you think something would be a bad shot, take it.'" (Wide smile and a short, high-pitched burst of laughter, from a man who appreciates his own humor.) Rauschenberg has been using photographic images as art material since the nineteen-fifties, and the current flood of photo-based art throughout the world is traceable in some part to his influence. Being unable to take his own photographs hurts, but not to the point of self-pity: "I can't stand myself or anyone else if they start whining. I just have to figure out ways to continue without getting so distraught I can't function."

The day nurse who looks after him came from the kitchen to see if

he needed anything, and he indicated that he'd like his glass refilled—white wine and soda, which he likes in a big glass, "with too much ice." Czar, a docile white Samoyed, ambled over and flopped down by Rauschenberg's chair. I was thinking of a time twenty years ago, sitting with the artist, with three big dogs at our feet and a soap opera playing soundlessly on a TV. I'd always assumed that TV was something he watched without really watching, a flow of images that might feed into the endlessly replenished visual storehouse he draws upon for his work. That morning, though, looking at a man and a tearful young woman on the screen, he nodded sagely and said, "He's married to her, but he doesn't know it yet, because he has amnesia." It reminded me of what he'd told the critic Dore Ashton several decades earlier: "I have a peculiar kind of focus. I tend to see everything in sight."[1]

WHILE HE WENT TO THE BATHROOM, USING A WHEELED WALKER AND attended by the nurse, I took a closer look at the paintings. Many of the images had the Rauschenbergian look of something ordinary seen in a new way—a multicolored umbrella, a bicycle, urban detritus, street signs or crudely lettered advertisements ("Pappy's Parking"), discarded tires, run-down houses, trucks and cars and people walking—but instead of brushing against each other or overlapping, most of the images existed in a separate, clearly defined space. In one painting, a photograph filled the upper right quadrant; it showed a group of young men and women in bathing suits, lying or standing on large rocks near water, in front of a concrete wall on which someone had painted the word "REMOVE" in big orange letters. The bathers coexisted with other images—a rusted manhole cover, an industrial pipe with gauges and dials attached, the rainbow-hued beach umbrella—working against each other with such exuberant energy that you feel the jolt. As nearly every critic has observed, Rauschenberg is the artist who reinvented collage by inviting the whole world into it. In the matter of influence, he is ranked with Duchamp and Pollock. The open-ended attitude toward collage materials, photographs, reproductions of other art, perfor-

mance activities, and various aspects of popular culture has been so thoroughly assimilated by younger artists, such as Kiki Smith and Julian Schnabel, that some of them might not even realize they're quoting Rauschenberg.

A number of new exhibitions were in the works. The "Scenarios" (which made their debut at the Pace Wildenstein Gallery, in New York, a few weeks after my visit) were shown at the Miami Art Museum two months later, and a clutch of one-man shows would take Rauschenberg to Los Angeles, Valencia, Nice, and, in January, 2007, Houston, where the Menil Collection is preparing a show of his 1971 "Cardboards"—pictures made from used and flattened cardboard boxes. By far the most significant event, however, would be an exhibition of his "combines": the prodigiously influential works, done between 1954 and 1964, that include elements of both painting and sculpture—along with such three-dimensional shockers as stuffed chickens, a painted-on quilt from his bed, and, in the infamous *Monogram,* an angora goat with a tire encircling its middle. The combine exhibition would open at the Metropolitan Museum of Art in December, and then travel to the Museum of Contemporary Art in Los Angeles, the Pompidou Center, in Paris, and the Moderna Museet, in Stockholm. Paul Schimmel, MOCA's chief curator, who organized the show, has identified a hundred and sixty-two works as combines or combine-paintings, and he planned to put seventy of them on view. "Rauschenberg's legacy begins with the combines," he told me. "Artists who change the way other artists look at art—that happens very infrequently. Pop art, Fluxus, Arte Povera, the performance art of the sixties, conceptualism in the seventies, environmental art, installation art, political art—all that erasure between the art object and the person who made it began with the combines."

IT TAKES RAUSCHENBERG A WEEK OR MORE TO COMPLETE ONE OF HIS "SCE-narios," a lot longer than it used to when he had the use of both hands and did most of the manual work himself. He signs each painting with his left hand, in laborious and somewhat wavering

capital letters. The process, as Darryl Pottorf explained it to me, requires a lot of complex and expensive equipment and many helpers. (Pottorf, who is fifty-three and an artist himself, stopped helping in the studio after Rauschenberg had his stroke; mindful of the rumors about studio assistants in Willem de Kooning's last years, he doesn't want anyone suggesting that he does the paintings.) The photographic images are scanned into a computer and adjusted for size and color; they are then fed into a specially designed digital printer, which uses water-based pigment dyes to reproduce them on acetate sheets. Rauschenberg then has his studio assistants move the images around until he gets what he wants, and the assistants, using only water and squeegees, transfer the result to the paper, which has been laminated under pressure to an aluminum backing. The paper has a matte finish and looks like canvas. It gets three coats of the same ultraviolet-deflecting solution used to protect outdoor display ads, which is supposed to last for two hundred years. Counting the eight "Scenarios" in the studio, he had finished twenty-seven of them so far. "I'll do them until I get good at it," Rauschenberg told me, "and then I'll stop."

He was back in his chair, sipping from a fresh glass of iced white wine. Rauschenberg used to go through about a bottle and a half of Jack Daniel's a day, and I wondered how anyone could drink so steadily and still function, let alone keep working at his level of energy and inventiveness. A few years ago, when his health broke down, he spent a month at the Betty Ford Center, in Rancho Mirage, California. He didn't drink for a couple of months after leaving the center, and he still hasn't gone back to whiskey, but he takes in more than a bottle of white wine a day, and when he goes out to dinner he sometimes allows himself a vodka-and-soda, or maybe two. "One of the things they teach you at Betty Ford's," he said, "is 'Don't ever be without something to drink.' I still don't enjoy wine, but it's the easiest thing." Didn't "something to drink" mean something nonalcoholic? I asked. "That's what *she* means!" he said, with his cackling laugh.

He was feeling good about the "Scenarios." "Each one of them is a puzzle to put together," he said. "One of the reasons these paintings are tighter is that I don't have the freedom that I had, like being able to slop around with paint. They've simplified themselves. The focus is more exact. I know when these are finished, more quickly than I did when they were looser." When I asked him about the title, he said, "I don't know. Sort of a fulfillment, I guess. But it could also be that it's just a nice word."

In the past, he would have talked more and revealed more, said things about the work that surprised me and probably surprised himself, too, but now he was getting tired. I got up to go. He agreed that he was in the midst of a new career phase. "I hate to say it," he announced, "but I think I'm playing a cripple."

AT THE RECENTLY REOPENED MUSEUM OF MODERN ART ON FIFTY-third Street, a large fourth-floor gallery is devoted mainly to the work of Rauschenberg and Jasper Johns. Until quite recently, MOMA and Rauschenberg never quite hit it off. Alfred Barr, the museum's founding director and presiding genius, came to the opening of Johns's first one-man show, at the Leo Castelli Gallery in 1958, stayed for three hours, and selected four pictures for acquisition. When Rauschenberg had his first show at Castelli, two months later, the only work sold was *Bed,* the combine with the painted-on quilt, and Castelli was the buyer. Castelli once told me that in 1959, soon after he exhibited Rauschenberg's *Monogram* (the combine with the goat and the tire), the taxi magnate and avid collector Robert Scull had offered to buy and donate it to the Museum of Modern Art—he said he couldn't keep it at home, because his two sons would climb on the goat—and that Barr, after asking Castelli some uneasy questions, such as whether the piece might harbor vermin, had declined the gift. (Stockholm's Moderna Museet acquired *Monogram* a few years later.) At the opening of Rauschenberg's Jewish Museum retrospective in 1963, as we have seen, Jasper Johns urged Barr to buy *Rebus,* the 1955 combine-painting. Barr didn't buy *Rebus,* but a year later he got Philip Johnson to buy *First Landing Jump,* a 1961

combine with an automobile tire, a working lightbulb, and other un-ingratiating items, as a promised gift to the museum.

There are some important Rauschenbergs on view at MOMA. In 2004, they included *First Landing Jump*; *Bed,* which Leo Castelli gave in 1989, in honor of Alfred Barr; *Factum II,* a 1957 combine-painting acquired in 1999 (it hung alongside its twin, *Factum I,* on loan from the Museum of Contemporary Art in Los Angeles); and *Mint* a 1974 transfer painting on unstretched silk, from the artist's "Hoarfrost" series. Not a bad showing, but there were no silk-screen paintings, and no examples of his work after 1974, and the ensemble on view was somewhat less compelling than the Johns in-stallation in the same room.

MOMA was not alone in its unresponsiveness to Rauschenberg's work—especially his later work. The critical rap on him is often that he stopped breaking new ground around 1965. Part of the problem is that art just keeps pouring out of him, more than six thousand individual works so far, not counting prints and multiples. The Abstract Expressionists used to dismiss Rauschenberg as some-body who wasn't out to create a masterpiece every time. Creating masterpieces—precious objects for the discerning few—has never been his goal, although art historians now assign perhaps a dozen Rauschenbergs, including *Bed* and *Rebus,* to that rarefied category. "I do what I do because . . . painting is the best way I've found to get along with myself," he said, back in the sixties. "And it's always the moment of doing it that counts. When a painting is finished it's al-ready something I've done, no longer something I'm doing."

SINCE 1965, A LOT OF HIS WORK HAS BEEN LINKED TO SOCIAL OR COMMU-nal causes—the environment, opposition to the war in Vietnam, artists' rights, international understanding. This makes collectors ner-vous. "We like our artists to be working out of private imperatives," John Elderfield, MOMA's chief curator, told me the other day. "St. Jerome is the model: the hermit in the cave with the pig, or the hermit of Sharon"—an allusion to Jasper Johns, who now lives in Sharon, Connecticut, and is renowned for producing very few paintings. "I

think something else that's hurt Bob is the sense that minimalism has been the defining aspect of the art of the last thirty years. It's been thought of as the American art, which makes a more messily autobiographical art seem to be less central." Minimal art was profoundly influenced by Rauschenberg, who did his all-white and all-black paintings a decade before the movement was born. His work has always fluctuated between what the critic Barbara Rose once described as "a minimal austerity and . . . an elaborated, celebratory, florid excess," but it has never stayed in one place long enough for him (or anyone else) to feel comfortable about it.

Elderfield agrees that the Museum of Modern Art needs to upgrade its Rauschenberg holdings. A few weeks after he told me that, in June 2005, the museum announced with great fanfare that it had acquired *Rebus,* the combine-painting that Johns advised Barr to buy in 1963; the purchase price was said to be as much as thirty million dollars. MOMA would also love to get a major silk-screen painting, and it has long coveted *Canyon,* the great 1959 combine incorporating a real (stuffed) bald eagle with outstretched wings, which is owned by Ileana Sonnabend. "I can't think of an image that has more power than *Canyon,*" Jeff Koons, an artist who freely acknowledges his debt to Rauschenberg, said recently. (He also said, "The chaos in my work—the acceptance of chaos—couldn't exist without Bob.") *Canyon* cannot legally be sold outside the United States, because of government regulations against traffic in endangered species, but it could be donated to a museum. Sonnabend, who still presides, in her nineties, over the New York gallery that bears her name, is characteristically sibylline about her plans for this work. When I asked her about it a few years ago, she said, smiling slightly, "I might take it with me."

THE HERMIT OF SHARON WAS IN HIS OTHER HOUSE, ON THE CARIBBEAN island of St. Martin, when I reached him by telephone in December 2004. These days, Johns is much less isolated than his reputation suggests, and less reticent than Rauschenberg on the subject of their

former relationship. We talked about the nineteen-fifties, when they both were finding their way out of Abstract Expressionism and experimenting with new forms and attitudes. They lived in the same loft building on Pearl Street then, saw each other's work every day, and gave one another the kind of encouragement that was hard to come by elsewhere. I knew that in 1954 Johns had destroyed all the work he'd made up to that time. Did this, I asked him, have something to do with Rauschenberg's influence?

"It had to do with a change of mind about what art meant—what it meant to be an artist," Johns replied. "When I met Bob, I wanted to be an artist but I wasn't an artist. Bob was an artist. He was the first real artist that I had any contact with. He'd had shows in Europe, and he'd shown in important New York galleries like Betty Parsons and the Stable, and he was very knowledgeable about the New York art scene. He knew most of the people in it. I believed that what Bob was doing was of extreme importance—and of course he believed it! That may have helped to convince me."

I reminded Johns of something he had said years ago: that Rauschenberg had "invented more than any artist since Picasso." "I think when I said that," he mused, "I was referring to his complex sense of structure, and . . . his constant reinvestigation of possibilities. You know, he was working then with paint, canvas, and real objects—such things as lightbulbs and three-dimensional structures. It was a fantastically prolific conception of what art was. We were very close and considerate of one another, and for a number of years we were each other's main audience. I was allowed to question what he did, and he could question what I did. He once brought me the equivalent of a mimeographed map of the United States, simply gave it to me, and I took it as something to work with." (Johns painted three huge maps of the United States in the nineteen-sixties; they are among the most celebrated paintings of that era.)

The exchange of ideas between Rauschenberg and Johns in those years has been likened to the interaction between Picasso and Braque from 1908 to 1912, when they were jointly inventing Cu-

bism. Johns gave Rauschenberg the title for his *Erased de Kooning Drawing* in 1953. Johns also did the precise lettering for the title, on the framed matte below the very faint, wraithlike ghost of the erased image. (This famous icon of conceptual art was offered to the Museum of Modern Art a few years ago, as part of a package of Rauschenbergs put together by his current dealer, the PaceWildenstein Gallery's Arne Glimcher; the museum turned it down, and the package, which included some very important early works, went to the San Francisco Museum of Modern Art.) Johns recently told Joachim Pissarro, a curator at MOMA, that he thought the term "combine" had been his suggestion. Pissarro asked him what he thought it meant, and Johns said, "It's painting playing the game of sculpture."

Rauschenberg doesn't recall that the word "combine" came from Johns. When I asked him about it, he said it was related in his mind to the term "mobile," which Marcel Duchamp had coined, in 1931, for Alexander Calder's moving sculptures, and also to farm machinery, but he agreed that in the fifties he and Johns had often traded ideas. What, I asked him, was the most important thing he got from Johns in those days? He thought for a moment, and said, "Courage. Persisting upstream." Neither one of them likes the Picasso-Braque comparison, because they feel that the work they were doing was never a joint or related effort. "Our work was very different because we're such different personalities," Johns said. "He had a different kind of imagination from mine. I remember once, I was reading Gertrude Stein's *Autobiography of Alice B. Toklas* to him, reading it out loud in the studio, and Bob turned and said, 'One day they'll be writing about us like that.' This kind of thought had never entered my mind."

THE GUGGENHEIM'S RAUSCHENBERG RETROSPECTIVE IN 1997 FILLED THE entire museum on upper Fifth Avenue and spilled over in two additional exhibitions downtown. Nearly everybody agreed that it was too big, but how could it have been anything else from an artist who

defined his themes as "multiplicity, variation, and inclusion"? The reviews were overwhelmingly positive. "This . . . is the artist of American democracy," wrote *Time*'s art critic, Robert Hughes, "yearningly faithful to its clamor, its contradictions, its hope and its enormous demotic freedom, all of which find shape in his work." At the opening, Arne Glimcher saw the mid-career artist Kiki Smith looking a little distraught. Smith, a highly innovative worker in many different media, said, "Everything I've ever dreamed of doing, he did before I was born."

The exhibition did a lot to revive Rauschenberg's flagging reputation—and his prices—something that doesn't always happen with retrospectives. It also mobilized some of my own contradictory feelings about the artist. Anyone who produces as much as he does, and continues to experiment rather than play it safe, can't avoid bad work, and Rauschenberg has contributed his share of that. For a while after he moved to Captiva, in 1970, I missed the rough, street-scavenger look of his New York combines and paintings. I fell hard for the fragile, unapologetic beauty of his "Hoarfrost" series (1974–76), whose photographic images were imprinted on un-stretched fabric, but some of the later metal-and-wood constructions (*Spreads* and *Scales*) that he turned out with the help of carpenters and other assistants struck me as too slick and well made—not random enough to be Rauschenbergs. And then, a decade later, came ROCI—the Rauschenberg Overseas Culture Interchange—which took over his life from 1984 to 1991, and did little to enhance his reputation. ROCI was the artist's bid to further international under-standing through art. He went to ten countries—Venezuela, Mexico, Cuba, China, Japan, Tibet, Malaysia, Chile, the German Democratic Republic, and the Soviet Union—and worked with local artists and artisans in each one to produce a body of large-scale paintings and sculptures, which were then exhibited in the host country. He was sure some corporation would sponsor this dreamy concept, but none did, and he ended up spending eleven million dollars to finance it himself. This required selling much of his art collection, including an

early Johns painting, Warhol's *Popeye,* and many key Rauschen-
bergs, and when that wasn't enough he mortgaged his Captiva houses.
ROCI took him out of the art world, and earned some of the worst
reviews he'd ever had—"at once altruistic and self-aggrandizing, mod-
est and overbearing," the *Times* critic Roberta Smith wrote of the
venture. When I asked Rauschenberg about the project recently, in
Captiva, he said it had done what he wanted it to do—"except that I
don't see any excess of world peace"—and that, in any case, he
wasn't interested in regretting things. "If it's a successful mistake,"
he said, "then you applaud."

SOMEDAY, A MUSEUM WILL PUT TOGETHER A FOCUSED, HIGHLY SELECTIVE
exhibition of Rauschenberg's work since 1971. In every series, there
are usually two or three paintings or sculptures, or both, where his
unique gifts conspire to produce something original, surprising, and
mysteriously engrossing—for instance, the 1981 sculpture called
The Ancient Incident (Kabal American Zephyr) that was in his Cap-
tiva studio in my last visit there. It is a pyramid made from a
matched pair of rough wooden stepladders, back-to-back, with two
wooden chairs balanced on top of them, face-to-face, so that their
front edges touch. Leo Steinberg, who has written penetratingly
about Rauschenberg since his first brief review in *Arts,* had this piece
reproduced on the jacket of a published lecture he delivered at the
Guggenheim in 1997, called "Encounters with Rauschenberg." "It's
the sort of image that stays with you," he said the other day. "It sim-
ply takes on a kind of permanence, and I can't imagine the world
without it."

Twelve "Scenarios" were shown at the PaceWildenstein Gallery
in January and February of 2005. Aside from a glib putdown in the
New York Sun—the critic called the works "cool, bleak, faceless,
and mildly professional"—there were few reviews; Rauschenberg's
long career has made this sort of criticism irrelevant. Arne Glimcher
reports that the show sold out.

Rauschenberg takes more than a passing interest in upcoming ex-

hibitions of his work. "I'm wondering how far they're going to mis-interpret combines and what that's going to lead to," he said in January. We were in the kitchen of his New York establishment, a former Catholic orphanage on Lafayette Street, which he uses as a pied-à-terre and an office for his private curator, David White, and a small staff; the large rooms on three of its floors also serve as galleries where curators, selected graduate students, and others can come to look at recent or vintage Rauschenbergs. Rocky, the desert turtle who has lived here for forty years, was thumping around on the kitchen floor. Lethal-looking but harmless, Rocky, whose name resonates in the ROCI project, was one of the thirty turtles that Rauschenberg rented from Trefflich's animal store to participate in his 1965 performance piece called *Spring Training,* during which they were let loose on a darkened stage with flashlights taped to their shells. When I arrived, on the day after his "Scenarios" show opened at PaceWildenstein, Bob was sitting at the kitchen table, watching *Dr. Phil.*

"My career is unknown to me," he said. "Other people seem to understand it, but I'm not that interested. I think it's sort of indecent to have things so worked out that they end up like you thought they should. You think I want to be what I am?" (Much laughter at this.) "You just have to expose yourself to more, and see what the consequences are."

I asked if he could define the strongest element in his work. He thought for a minute or so, nodding, still not taking his eyes from the TV screen. "Perseverance," he said. "Curiosity. That I don't know where I'm going but I'll get there on time."

For some reason, we started talking about John Cage, the composer, who had been, in the nineteen-fifties, the closest thing to a mentor in Rauschenberg's life. "John and I just had simultaneous thoughts, mutually," he said. "He would do something, and I would think, God, that's brilliant, and then I would do something and it wouldn't surprise him. We made each other feel comfortable in the world, and that's a big one."

In a 1961 essay called "On Robert Rauschenberg, Artist, and His Work," Cage wrote what may be the best statement about an artist I've ever read: "Over and over again I've found it impossible to memorize Rauschenberg's paintings. I keep asking, 'Have you changed it?' And then noticing while I'm looking it changes."

APPENDIX

AUTOBIOGRAPHY

Port Arthur Texas Oct. 22, 1925. Mother: Dora. Father: Ernest (grandparents): Holland Dutch, Swedish, German, Cherokee. De Queen Gr. Sch., Woodrow Wilson Jr. H. Sch., Thomas Jefferson H. Sch. Grad. 1942./U. of Tex. $^1/_2$ Yr. U.S. Navy 2$^1/_2$ Yrs. Neuropsychiatric Tech. Family moved to Lafayette La. with sister, Janet, Born Apr. 23, 1936. After Navy: returned home, left home. Worked in Los Angeles. Moved to Kansas City to study painting K.C.A.I. Went to Paris, 1947, Met Sue Weil. Std. Acad. Julian. 1948 Black Mountain College N.C. Disciplined by Albers. Learned photography. Worked hard but poorly for Albers. Made contact with music and modern dance. Felt too isolated, Sue and I moved to NYC. Went to Art Students League. Vytlacil & Kantor. Best work made at home. Wht. painting with no.'s best example. Summer 1950, Outer Island Conn. Married Sue Weil. Christopher (son) Born July 16, 1951 in NYC. First one man show Betty Parsons: Paintings mostly silver & wht. with cinematic composition. All paintings destroyed in two accidental fires. Summer Blk. Mt. Coll. N.C. Started all blk. & all wht. paintings. Winter divorced. Sue & Christopher living in NYC. I went to Italy with painter & friend Cy Twombly. Ran out of money in Rome. Took chance getting job in Casablanca at Atlas Construction Co. Worked 2 mo. got sick, left. Traveled Fr. & Sp. Morocco. Returned to Rome. While traveling constructed rope objects & boxes. Showed in Rome & Florence. Critic in Florence said work should be thrown in the Arno. I did. Returned to NYC 1952. Loft on Fulton Street.

Made growing dirt paintings. Show of all wht. & all blk. paintings and elemental sculpture made from rocks, wood & rope. Closest friends at this time dancers and musicians. Few painters. Began doing theater work with Merce Cunningham and Paul Taylor. Blk. & wht. show at Stable NYC 1953 Misunderstood as gestures & antipaintings. The wht. paintings were open composition by responding to the activity within their reach. Began red paintings using comic strips as color ground. Included lights and reflectors. 1956 had show Egan Gall. NYC. New Year's Day had a Feldman Concert with paintings. *"Charlene"* largest and last example of red pictures. Earned living by doing free lance jobs in display mostly for Gene Moore. Began a series in *"Crowd"* color, insisting the object material keep its identity. Paintings became awkward physically, began being free standing: Combines. Stuffed animals. Bed. Shoes. Wrote fugue type plays and word spoken music; never performed. Moved to Pearl Street off Fulton. Jasper Johns lived in the same building and had just painted his first flag. It would be difficult to imagine my work at that time without his encouragement. John Cage was also a generous source of inspiration. It was a rich exchange. Rebus, Wager, Hymnal, Odalisk, Canyon, Coca Cola plan, Curfew, Satellite were all done in the next couple of years. 1958 show at Leo Castelli. Jasper Johns, Emile De Antonio and I pooled funds, made John Cage 20 Yr. Retrospective Concert at Town Hall NYC. Moved to Front St. off wall. Trophy I, monogram, broadcast, allegory, 4 summer rentals, pilgrim. 2$\frac{1}{2}$ yrs. making 34 drawings for Dante's Inferno, The last 6 mo. in Florida. Isolation needed for concentration. I became the lighting man & designer for Merce Cunningham Dance Co. Summerspace, Crises, Antic Meet, Winterbranch, Field Dances, Nocturnes, Spring Weather & People, Paired, Suite, Changling, Night Wandering, & Story. Local touring with dance co. was awkward, but beautiful addition to my work. The dances, the dancers, the collaboration, the responsibilities and trust which are essential in cooperative art because the most important & satisfying element in my life worked positively with the privateness and loneliness of painting. Carolyn Brown, Viola Farber & Steve Paxton inspired me to the challenge of deserving their love and confidence. First one man show of paintings in Europe, Galerie Daniel Cordier, Paris. First one man show in Italy, Galleria Dell Ariete. Trip to Stockholm. American Embassy, Paris: *"Collaboration for David Tudor"* Me, Niki De St. Phalle, Jasper Johns, Jean Tinguely & David Tudor. Time Paintings, First Landing Jump, Blue Eagle, Blue Exit, Rigger, Pantomime, Trophy II & III, Black Market, Wall Street, Slug, Reservoir, Floor Pieces: Empire I & II, Aen Floga, Red Rock, 19346,

Trophy IV (blue light bulbs, by Michael McClure). Started Lithography, Universal Ltd. Art Editions, Tanya Grosman, Long Island. Big influence on paintings. *"The Construction of Boston,"* a collaboration by Niki De St. Phalle, Kenneth Koch, Jean Tinguely & Me, Dir. by Merce Cunningham, NYC. Starring, with collaborators, Oyvind Fahlstrom, Frank Stella, Billy Klüver, Steve Paxton, Viola Farber & Henry Geldzahler. Moved to Broadway & 12th St. began *"Oracle,"* A five piece sculpture with remote control sound and fountain. Collaborator Billy Klüver assisted by Harold Hodges. *"Oracle"* interrupted by *"Dylaby"* in Amsterdam, Sandburg, Dir. of Stedelijk. Met Martial Raysse & Per Ultvelt. Ace, Stripper, Cartoon, Trophy V. began silk screen paintings to escape familiarity of objects & collage. Barge, Dry Run, Sundog, Quarry, Brace, Shortstop, Overcast I, II, III, Strawboss, Crocus, Exile, Glider, Calendar, Buoy, Gift for Ileana, Payload, Archive, Estate, Manuscript, Overdrive, Bait, Kite, Die Hard, Dry Run, Tadpole, Cove, Express, Junction, Roundtrip, Bicycle, Transom, Spot, Shaftway, Tideline, Star Grass, Stop Gap, Trellis, Dry Cell, Wooden Gallop. Worked with Judson Group, Theatre/Dance. Workshop experimental exchange. Lighting for Yvonne Rainer's *"Terrain."* 1st Prize 5th International Exhibition of Prints, Ljubljana, Yugo. Show at Galerie Ileana Sonnabend, Paris. Ileana is a special person. First dance/theater piece: *"Pelican"* Washington, D.C. 1963. Carolyn Brown, P. Ultvelt & Me. Carol On Pointe, Men on Roller Skates. Sound: Collaged; Radio, Record, Movie, T.V. Source. Alice Denney, Prod. Jewish Museum Comprehensive Survey Show. First Goy in new wing. Alan Solomon, Dir. Surplus Dance Theater; Artists: Lucinda Childs, Judith Dunn, Alex Hay, Deborah Hay, Robert Morris, Yvonne Rainer, Albert Reed, Steve Paxton & Me. *"Shot Put"* dance in darkness with flashlight on right foot. Music excerpt from *"Swedish Bird Calls"* by Oyvind Fahlstrom. Steve Paxton, Prod. Flush, Tracer, Persimmon, Retroactive I & II, Buffalo, Skyway, Choke, Stunt, Trapeze, Whale, Press, Harbor, Quote, Tree Frog, Creek, Round Sum, Hedge, Lock, Trap. Whitechapel Show (retrospective) London, Bryan Robertson, Dir. broke attendance records. Included Dante Drawings. Went to London before opening, met London artists & made B.B.C. T.V. special. World tour with Merce Cunningham & Dance Co. as tech. Some of the sets & costumes had to be made in the particular environment, not to be duplicated. The lighting was done spontaneously because of esthetics & practicality. Strasbourg, Paris, Bourges, Venice (While we were there I won the 1st Prize at the Venice Biennale), Vienna, Mannheim, Essen, Cologne, Les Baux, Dartington, London, Stockholm (Extra concert: Deborah

Hay, Steve Paxton, Alex Hay, Oyvind Fahlstrom, David Tudor & Me. *"Elgin Tie,"* Duet with Swedish. Cow.), Turku, Helsinki, Prague, Ostrava, Warsaw, Poznan, Krefeld, Brussels, Antwerp, Scheveningen/Den Haag, Bombay, Ahmedabad, Chandigarh, New Delhi, Bangkok, Tokyo (Extra concert. Exchange: Japanese/American. 10 Japanese painters, musicians, dancers & Deborah Hay, Steve Paxton, Alex Hay, & Me.), Kobe, Osaka. End of tour I stopped in Hawaii. Amazing. Abrams publishes Dante Illustrations. More lithos; Universal Ltd. Art Editions. Drawing Show Dwan Gallery Los Angeles. Fossil for Bob Morris, N.Y. Birdcalls for Oyvind Fahlstrom, sleep for Yvonne Rainer. Finished *"Oracle"* (1965). Real work in progress, improved equipment & info. 1st Prize Corcoran Biennial, Washington, D.C., *"Axle."* Dance/theatre pieces: *"Spring Training"* sketch for A.F.A. in Boston. First N.Y. Theater Rally Artists: Carolyn Brown, Trisha Brown, Jim Dine, Judith Dunn, David Gordon, Alex Hay, Deborah Hay, Tony Holder, Robert Morris, The Once Group, Claes Oldenburg, Steve Paxton, Yvonne Rainer, Robert Whitman & Me. Prod. by Steve Paxton & Alan Solomon, Inc. *"Dark Horse"* a concert by Alex, Deborah & Me superimposed on final 3 dance concerts of rally. (I did Pelican, Alex Hay replacing Ultvelt, and spring training in full with Christopher R. debuting with 23 turtles with lights on their backs for organic lighting.) Map Room II for Cinematheque. 1966 Museum Mod. Art Dante Drawings Show. 3 concerts for L.A. County Museum of Art. Theater piece for Washington, D.C. *"Now Festival."* *"Linoleum"* Simone Whitman, Deborah Hay, Steve Paxton, Alex Hay, Christopher & Jill Denney. Linoleum televized for Ch. 13 NYC using superimpositions with mixer. 9 evenings of Art & Technology at 69th Reg. Armory. A collaboration between artists & scientists & technology *"Open Score"* with a cast of 500 &, and closed circuit infra red T.V. projection, a tennis match in control of the lights. The beginning of E.A.T., experiments in art & technology to function as a catalyst for the inevitable fusing of specializations creating a responsible man working in the present.

NOTES

1 VENICE, 1964

1. The information in this chapter is based on the author's interviews with Alan Solomon, Leo Castelli, and others, for an article in *Harper's Magazine,* April 1965 ("The Big Show in Venice"). Here and throughout these Notes, if the source of a quotation is not cited, it is from an interview with the author.

2. Dore Ashton, *Art News,* Summer 1958.

2 PORT ARTHUR

1. *Robert Rauschenberg,* catalog to retrospective exhibition organized by the National Collection of Fine Arts, Smithsonian Institution, Washington, D.C., 1976. Page 25.

2. *Time,* November 29, 1976.

4 BLACK MOUNTAIN

1. Martin Duberman, *Black Mountain: An Exploration in Community,* E. P. Dutton, New York, 1972—primary source for this chapter.

2. Ibid., page 56.

3. A. Z. Freeman, letter to the *New York Times Book Review,* October 30, 1977.

5 TRAGEDY, ECSTASY, DOOM, AND SO ON

1. The phrase, coined in Berlin in 1919, was "re-invented" by Alfred Barr about 1929 to describe Wassily Kandinsky's early abstractions, which "in certain ways do anticipate the American movement"—Alfred Barr, *The New American Painting*, The Museum of Modern Art, New York, 1959. Introduction, page 16.

2. Rosenberg's famous essay appeared first in *Art News*, September 1952.

3. Ibid.

4. Selden Rodman, *Conversations with Artists*, Devin-Adaro, New York, 1957.

5. See Harold Rosenberg, *The De-definition of Art*, Horizon Press, New York, 1973. Page 26.

6. Ibid., page 35.

7. Thomas B. Hess, *Barnett Newman*, The Museum of Modern Art, New York, 1971. Page 88.

8. Robert Motherwell, "Notes on Mondrian and Chirico," *VVV* No. 1, June 1942. Page 12.

9. Harold Rosenberg, *Arshile Gorky: The Man, The Time, The Idea*, Horizon Press, New York, 1962. Page 25.

10. Clement Greenberg, *Art News*, Summer 1957.

11. Jackson Pollock, "Jackson Pollock," *Arts and Architecture*, February 1944 (answers to a questionnaire). Page 14.

12. Peggy Guggenheim, *Confessions of an Art Addict*, Macmillan, New York, 1968. Page 91.

13. Clement Greenberg, *The Nation*, April 7, 1945.

14. *Life*, October 11, 1948.

15. *Life*, August 8, 1949.

16. B. H. Friedman, *Jackson Pollock: Energy Made Visible*, McGraw-Hill, New York, 1972. Page 222.

17. The Club is sometimes confused with "The Subjects of the Artist" school at 35 East Eighth Street, which was started in 1948 by William Baziotes, David Hare, Robert Motherwell, and Mark Rothko. Friday night lectures on advanced art were given here, too (the lecturers included John Cage, Hans Arp, and Willem de Kooning), and the practice continued for a while after the school was taken over by New York University's School of Education and renamed Studio 35. The Club was

an entirely separate organization, and its atmosphere was quite different. According to Philip Pavia, a charter member, "we thought they [Motherwell et al.] were a bunch of Surrealists coming down and invading our territory" (Philip Pavia, Archives of American Art, oral history project).

18. Willem de Kooning, "What Abstract Art Means to Me," Museum of Modern Art Bulletin, XVIII, No. 3 (Spring 1951).

19. Thomas B. Hess, *Willem de Kooning,* Museum of Modern Art, New York, 1968.

6 WHITE NUMBERS

1. The song was "Green Grow the Rushes O." The line that Rauschenberg remembered was: "Two, two, the lily-white," which he transcribed, with Rauschenbergian economy, as *22 The Lily White*—the little picture's present title.

7 A PLACE WHERE ART GOES ON

1. Clement Greenberg, *Ten Years,* Betty Parsons Gallery, 1956.

2. Thomas B. Hess, *Barnett Newman.* Page 26.

3. Barnett Newman, *Northwest Coast Indian Painting,* Betty Parsons Gallery, New York, 1946 (catalog text).

4. Barnett Newman, *The Ideographic Picture,* Betty Parsons Gallery, New York, 1947 (catalog foreword).

5. Ibid.

6. Stuart Preston, *New York Times,* May 18, 1951.

7. *Art News,* May 1951.

8 JOHN CAGE

1. John Cage, *Silence: Lectures and Writings,* Wesleyan University Press, Middletown, Conn., 1961.

2. Jackson Pollock, "My Painting," *Possibilities I,* Winter 1947–48.

3. John Cage, "On Robert Rauschenberg, Artist, and His Work," *Metro 2,* May 1961.

4. Martin Duberman, *Black Mountain: An Exploration in Community,* op. cit.

10 ENFANT TERRIBLE

1. Harold Rosenberg, *The De-definition of Art,* op. cit. Page 91.

2. Fred W. McDarrah, *The Artist's World in Pictures,* E.P. Dutton, New York, 1961. Introduction by Thomas B. Hess.

3. B.H. Friedman, *Jackson Pollock: Energy Made Visible,* op. cit., pages 231–32.

4. Ibid., page 221.

5. Willem de Kooning, "What Abstract Art Means to Me," op. cit.

6. Willem de Kooning, in the *New York Times Magazine,* January 21, 1951. Section 6, page 27.

7. Umberto Boccioni, "Technical Manifesto of Futurist Sculpture," April 11, 1912—in Joshua C. Taylor, *Futurism,* The Museum of Modern Art, New York, 1961.

8. Guillaume Apollinaire, *The Cubist Painters,* trans. by Lionel Abel, Wittenborn & Schultz, New York, 1949.

11 DANCERS

1. *Charlene* was purchased in 1964 by the Stedelijk Museum in Amsterdam.

2. Frank O'Hara, *Art News,* January 1956.

3. John Blair Lynn Goodwin, half brother of the sculptor David Hare.

12 JASPER JOHNS

1. Michael Crichton, *Jasper Johns,* Harry N. Abrams, in association with the Whitney Museum of American Art, New York, 1977. Page 20.

2. Ibid., page 33.

3. Brian O'Doherty, *American Masters: The Voice and the Myth,* Random House, New York, 1974. Page 112.

4. Leo Steinberg, "Jasper Johns: The First Seven Years of His Art" (1962), in *Other Criteria: Confrontations with Twentieth Century Art,* Oxford University Press, New York, 1972. Page 27.

5. Ibid.

13 WHY NOT SNEEZE?

1. B.H. Friedman, *Jackson Pollock: Energy Made Visible,* op. cit., page 239.

2. Ibid., page 224.

3. Clyfford Still, letter to Gordon M. Smith, January 1, 1959, in catalog of an exhibition, *Paintings by Clyfford Still,* Albright-Knox Gallery, Buffalo, New York, 1959.

4. Barnett Newman, "Statement," catalog of an exhibition, *The New American Painting,* Museum of Modern Art, New York, 1958.

5. Willem de Kooning, "What Abstract Art Means to Me," op. cit.

6. Thomas B. Hess, conversation with author, 1968.

7. Tristan Tzara, "Lecture on Dada," 1922, in *Dada Painters and Poets: An Anthology,* Robert Motherwell, editor, Wittenborn & Schultz, Inc., 1951.

14 MOVING OUT

1. The original spelling of this work was *Odalisk.* It graduated to *Odalisque* in the catalog of the National Collection of Fine Arts exhibition in 1976.

2. Jasper Johns, interview with Walter Hopps, *Artforum,* March 1965.

3. Leo Steinberg, "Contemporary Art and the Plight of Its Public," *Harper's Magazine,* March 1962.

15 TOWARDS THEATER

1. Virgil Thomson, *The Saturday Review of Literature,* June 1960.

2. John Cage, *Silence: Lectures and Writings,* op. cit.

3. Ibid.

4. Allan Kaprow, "The Legacy of Jackson Pollock," *Art News,* May 1958.

5. Allan Kaprow, " 'Happenings' in the New York Scene," *Art News,* May 1961.

6. Jim Dine, "A Statement," in Michael Kirby, *Happenings,* E.P. Dutton, New York, 1965. Page 185.

7. *New York Times,* December 8, 1957.

8. *Art News,* January 1956. The anonymous reviewer was Leo Steinberg, who later wrote penetrating and highly favorable essays on Rauschenberg and Johns.

16 INTO THE SIXTIES

1. *The Times Literary Supplement,* London, November 6, 1959.
2. *New York Times,* February 26, 1961. Section 2, page 19.
3. *New York Times,* March 18, 1960.
4. Clement Greenberg, " 'American-Type' Painting," *Partisan Review,* Spring 1955. Pages 179–96.
5. William S. Rubin, *Frank Stella,* Museum of Modern Art, New York, 1970. Page 13.
6. "Questions to Stella and Judd," interview by Bruce Glaser, *Art News,* September 1966 (originally broadcast over WBAI-FM radio, New York, 1964).
7. Marjorie Perloff, *Frank O'Hara: Poet Among Painters,* Braziller, New York, 1977. Page 13.
8. Robert Lebel, *Marcel Duchamp* (translated by George Heard Hamilton), Grove Press, New York, 1959.

17 HOT AND COLD HEROES

1. James Rosenquist, video interview with Barbaralee Diamonstein, New York, 1977.
2. Clement Greenberg, in catalog of the exhibition *Post-Painterly Abstraction,* Los Angeles County Museum of Art, 1964.
3. Thomas B. Hess, "The Phony Crisis in American Art," *Art News,* Summer 1963.
4. Peter Selz, "Pop Goes the Artist," *Partisan Review,* New York, Fall 1963.
5. Max Kozloff, "Pop Culture, Metaphysical Disgust, and the New Vulgarians," *Art International,* February 1962.
6. Thomas B. Hess, conversation with author, May 1968.
7. Richard Hamilton, "Roy Lichtenstein," *Studio International,* January 1968.
8. John Russell and Suzi Gablik, *Pop Art Reconsidered,* Praeger, New York, 1969. Page 34.
9. Gene Swensen, "What Is Pop Art?" interviews with eight painters, Part I, *Art News,* November 1963.
10. *Sixteen Americans,* Museum of Modern Art, New York, December 1959.

11. Ibid.

12. Barbara Rose, *Claes Oldenburg,* Museum of Modern Art, New York, 1970. Page 128.

18 THE CONSTRUCTION OF BOSTON

1. *Arts,* Paris, No. 821, May 10–16, 1961.

2. John Wulp, "Happening," *Esquire,* November 1963.

3. Vivian Raynor, "Conversation with Jasper Johns," *Art News,* March 1973.

19 RECOGNITION

1. Larry Rivers, "Life Among the Stones," *Location,* New York, Vol. 1, No. 1 (Spring 1963).

2. Emily Genauer, *New York Herald Tribune,* April 7, 1963.

3. Brian O'Doherty, "Robert Rauschenberg," *New York Times,* April 28, 1963.

4. Max Kozloff, *The Nation,* December 7, 1963.

5. Alan Solomon, *Robert Rauschenberg,* The Jewish Museum, New York, 1963.

20 THE SISTINE ON BROADWAY

1. *Oracle* is now owned by the Centre National Georges Pompidou, in Paris.

21 INCIDENTS OF TRAVEL IN EUROPE AND ASIA

1. Alexander Bland, "Ballet," *The Observer Weekend Review,* London, August 2, 1964.

22 NINE EVENINGS

1. Richard Kostelanetz, *The Theater of Mixed Means,* Dial Press, New York, 1968. Page 85.

2. *New York Times,* October 15, 1966. Page 33.

3. Herb Schneider, "A Systems Approach to Robert Rauschenberg's *Open Score,*" unpublished report on "Nine Evenings," E.A.T. archives.

23 THE NOT SO GREAT SOCIETY

1. E.A.T. Prospectus written jointly by Rauschenberg and Klüver, 1966.

2. Morris Dickstein, *The Gates of Eden: American Culture in the Sixties,* Basic Books, New York, 1977.

3. Susan Sontag, "One Culture and the New Sensibility," in *Against Interpretation,* Farrar, Straus & Giroux, New York, 1966.

4. Clement Greenberg, "Modernist Painting," *Arts Yearbook 4* (1960).

5. Dan Flavin, statement in exhibition catalog, *The New Aesthetic,* Washington Gallery of Modern Art, Washington, D.C., 1967.

6. William S. Rubin, *Frank Stella,* op. cit., page 149.

7. Harold Rosenberg, "Defining Art," *The New Yorker,* February 25, 1967.

8. Clement Greenberg, "Recentness of Sculpture," in exhibition catalog, *American Sculpture of the Sixties,* Los Angeles County Museum of Art, 1967.

9. Michael Fried, "Art and Objecthood," *Artforum,* June 1967.

10. Alan Solomon, *New York: The New Art Scene,* Holt, Rinehart & Winston, New York, 1967.

11. Thomas B. Hess, "A Tale of Two Cities," *Location,* Vol. 1, No. 2 (Summer 1964).

12. Andy Warhol, *The Philosophy of Andy Warhol (From A to B & Back Again),* Harcourt Brace Jovanovich, New York, 1975. Page 144.

24 "THERE IS NO SOLUTION BECAUSE THERE IS NO PROBLEM"—MARCEL DUCHAMP

1. *The Bride Stripped Bare by Her Bachelors, Even,* a typographic version by Richard Hamilton of Marcel Duchamp's *Green Box,* trans. by George Heard Hamilton, George Wittenborn, New York, 1960. (See Appendix, "Inside the Green Box.")

2. Jasper Johns, "A Collective Portrait," *Marcel Duchamp,* ed. by Anne d'Harnoncourt and Kynaston McShine, Museum of Modern Art, New York, 1973. Page 203.

3. Guillaume Apollinaire, *The Cubist Painters,* op. cit.

4. Interview with Marcel Duchamp at Philadelphia Museum of Art, 1955.

5. Arturo Schwarz, *The Complete Works of Marcel Duchamp,* Harry N. Abrams, New York, 1962.

25 END OF AN ERA

1. Hilton Kramer, *New York Times,* October 18, 1969.
2. John Canaday, *New York Times,* October 12, 1969.
3. Henry Geldzahler, *New York Painting and Sculpture: 1940–1970,* E. P. Dutton, New York, 1969.
4. John Richardson, *The Listener,* London, February 19, 1970.
5. Robert Smithson, *Arts,* February 1967.
6. Robert Smithson, *Avalanche,* No. 1, Fall 1970.
7. Harold Rosenberg, *The De-definition of Art,* op. cit.
8. Lucy Lippard, "The Art Workers' Coalition: Not a History," *Studio International,* November 1970.
9. Lawrence Alloway, "The Graphic Art of Robert Rauschenberg," in catalog for exhibition organized by the Institute of Contemporary Art, University of Pennsylvania, Philadelphia, 1970.

26 CAPTIVA

1. Robert Rauschenberg, statement to accompany edition of *Cardbirds,* Gemini G.E.L., Los Angeles, 1971.
2. Peter Schjeldahl, *New York Times,* October 31, 1971.
3. Barbara Rose, *Vogue,* January 1977.
4. John Schott and E. J. Vaughn, *America's Pop Art Collector: Robert C. Scull—Contemporary Art at Auction,* 1974. Distributed by Cinema 5, New York.
5. Benjamin Forgey, *Art News,* January 1977.
6. Interview with Marcel Duchamp by Francis Roberts, *Art News,* December 1968.

INDEX